THE NORTH: THE LOWLANDS AND ENGLAND

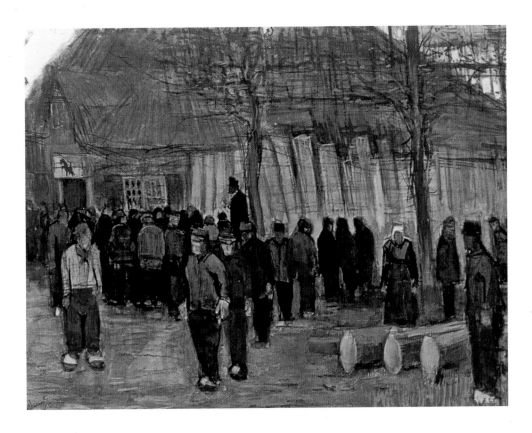

Van Gogh grew up in rural Holland, where he sketched and painted the local landscapes and people. From the very first, Van Gogh's innate sympathy and sensitivity to the human condition is apparent – it remained the engine that drove his art, until his death. Van Gogh travelled around northern Europe, spending time in France, Belgium and England as well as his native Holland. During this period the stark vision of the lives of ordinary people was his subject, painted in the muted colours of the north. His paintings and drawings were created with a raw directness that suggests an understanding of life as an unending struggle – such works are veritable social and religious tracts.

Above: Lumber Sale, *December 1883. Van Gogh liked to paint ordinary people as they were, rather than asking them to pose for him in a studio. Left:* Self-Portrait with Dark Felt Hat, *Spring, 1886.*

A STRANGE BEGINNING

Vincent's problematic relationship with his family played a large part in shaping his undeniably tragic life, which was to be dominated by suffering, rejection, alienation, illness and eventually suicide. His troubles began in his childhood.

Vincent Willem van Gogh was born on 30 March 1853 at the parsonage attached to the tiny Protestant church in the predominantly Catholic village of Groot Zundert in Holland, close to the Belgian border.

THE VAN GOGH FAMILY

Van Gogh's father, Theodorus, was a pastor in the Dutch Reformed Church, like his father before him. He was a modest man, learned and ascetic in outlook. He was not a gifted preacher – even to his tiny congregation of 56 – and he and his wife Anna Cornelia Carbentus lived in relative obscurity in the Brabant region all their lives, moving from one small parish to another. Anna was kind, hard-working and strong-willed, with a gift for watercolour painting and an interest in botany. The Van Gogh family was a significant one in Dutch political, ecclesiastical and cultural life. Van Gogh's Uncle Johannes was a

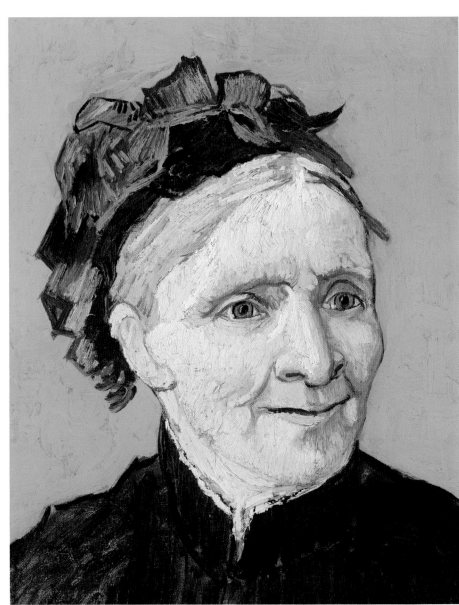

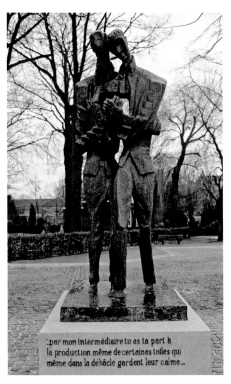

Above: Portrait of the Artist's Mother, October 1888, painted from a photograph while in the south of France. Van Gogh wrote to his brother about his distaste for the "colourless photograph" of his mother and how he wanted to make instead "a harmony of colour, as I see her in memory".

Left: Van Gogh's close relationship with his brother is movingly commemorated in this highly stylized sculpture by Ossip Zadkine (1890–1967), erected in his birthplace, Groot Zundert, in 1963.

vice-admiral, the highest naval rank in Holland, and three others were successful art dealers: Hendrick ('Uncle Hein') in Rotterdam and then Brussels, Cornelius Marinus (known to the family as C.M.) in Amsterdam, while the third, Van Gogh's godfather, Uncle Vincent ('Cent'), was the most successful of all. His gallery in The Hague became part of Goupil and Co. (Goupil et Cie), which under his influence became one of the foremost art dealers in Europe and the USA.

Right: Self-portrait, August 1889. In depicting himself in an artist's smock and showing the tools of his trade, this painting is a clear declaration of Van Gogh's identity as an artist. It is one of 36 surviving self-portraits, and was painted after he had suffered a severe mental crisis that left him unable to work for several weeks.

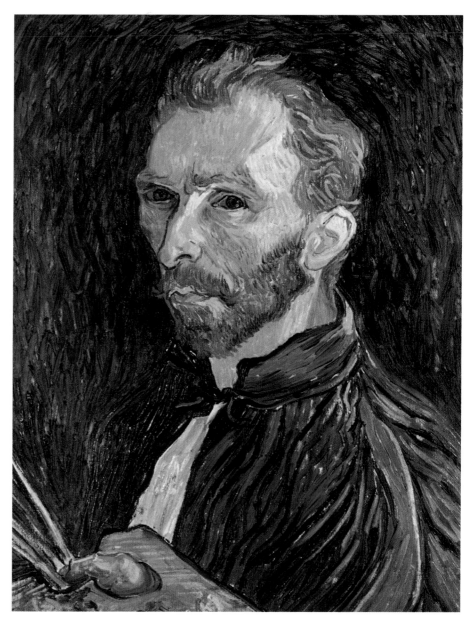

Van Gogh himself would go on to work at Goupil's, although he soon grew tired of selling the work of other artists and decided to concentrate on his own painting.

Anna was 34 years old when Vincent was born and she would go on to have another 5 children: Anna, Theo, Elisabeth, Cornelius and Wilhelmina. Both Vincent and Theo had wiry red hair and intense blue eyes, but Theo's good looks and delicate build contrasted with Vincent's more homely features and stocky, robust physique. According to Theo's wife, Johanna van Gogh-Bonger, Vincent and his younger brother Theo developed a close and interdependent relationship as children, one that has since passed into legend. Theo became his elder brother's protector, supporting him financially and emotionally throughout his short, difficult life.

Left: Portrait of Vincent van Gogh, the Artist's Grandfather, July 1881. Van Gogh produced few portraits of his family.

In later life, Van Gogh was a troubled character, suffering from depression. From his earliest years, as one of his sisters remembered, he was "intensely serious and uncommunicative, [he] walked around clumsily and in a daze, with his head hung low…. Not only were his little sisters and brothers like strangers to him, but he was a stranger to himself."

VINCENT'S TOMB

Van Gogh's early sense of otherness might have been aggravated by a disturbing coincidence that may have had a profound effect on his life. Exactly a year before he was born, his mother had given birth to a dead child, who was also named Vincent. Every Sunday, the young Van Gogh would have cause to pass the grave of his dead brother as he walked to his father's church and would have seen his own name, Vincent van Gogh, written on the tombstone.

Although it may well have affected Van Gogh, it is important that we do not read too much into this event however, as infant mortality was a common occurrence at the time and Van Gogh's Christian name was one which was shared by many other members of his extended family, including his godfather, Uncle Cent.

AN UNRULY CHILD

As he grew up, Van Gogh retained the somewhat solitary character of his early years.
He developed a love of nature, a flair for languages, and an acute talent for recalling
imagery, both visually and verbally.

As an adult, Van Gogh described his childhood as "gloomy, cold and sterile". As a child he was frequently at odds with his family and was remembered by one of the household servants as being odd and aloof, with strange manners, more like an old man than a child. Like many similar children, Vincent was happiest in his own company, tramping across the Brabant countryside, alone with his thoughts and sensitive to the subtle beauty of the flat landscape.

A LOVE OF NATURE

The village where the Van Gogh family lived was far from any bustling centres of industry. It was an agricultural community dependent upon the potatoes, rye and buckwheat that were cultivated to the north and east of the village. To the south and west lay open country; a wild heathland, interspersed with pine forests and marshes. Such a landscape is defined by light and the

changing seasons, and to one who knows it, it is never the same from one moment to the next. Van Gogh was such a person. All through his life the experience of rambling, whether through countryside, town or city, was central to his being.

Above: The Van Gogh family home in the village of Groot Zundert, in the North-Brabant region of Holland.

His sensitivity to his environment was allied to a strong visual memory. The places and people, images, books and objects he encountered throughout his life remained with him, wherever he travelled. "There will always remain in us something of the Brabant fields and heath," he wrote to his brother Theo. Again, during one of his last illnesses, he wrote how he "saw again every room of the house at Zundert, every path, every plant in the garden, the view from the fields round about, the neighbours, the graveyard, the church, our kitchen garden behind – down to the magpie's nest in a tall acacia in the graveyard."

Much of Van Gogh's work, like that of his one of his favourite artists, Jean-François Millet, centres upon

Left: As a young boy, Van Gogh enjoyed walking through the Brabant countryside, which later would inspire much of his work.

the ceaseless round of the seasons, which in turn suggest the round of life, through conception, birth, adolescence, maturity and death. As a pastor's son living in an agricultural community, he would no doubt have been familiar with the following lines from Genesis 8:22: "While the earth remaineth, seedtime and harvest, and cold and heat, and summer and winter, and day and night shall not cease."

BOARDING SCHOOL

Vincent briefly attended the local school, but his parents felt that mixing with the village boys made him "too rough" and he was taken home and put under the care of a governess. At the age of 11, he was enrolled at Jan Provily's boarding school at Zevenbergen. Not for the last time, his correspondence presents a vivid insight into his inner life, for he revisited the moment of his parents' departure on at least two occasions in his letters. How, one autumn day, he had "stood on the steps… watching the carriage in which father and mother were driving home… Far down the road – wet with rain and with the spare trees on either side running through the meadows – the grey sky above it all was mirrored in the pools." This early letter displays one of Van Gogh's greatest strengths in both letter-writing and art – the vividness of his memory, combined with the ability to lock together a particular physical and mental experience into a single resonant image.

Vincent remained at the school for two years before moving on to a state-run boarding school at Tilburg. At both establishments he showed his flair for languages, becoming proficient in French, English and German. Interestingly, an important part of the school curriculum was drawing. Just before his 15th birthday, in March 1868, for reasons that are still unclear, although they were most probably financial, Vincent was withdrawn from school midway through the second year of his studies and his formal education was at an end.

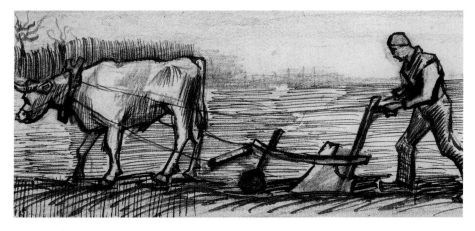

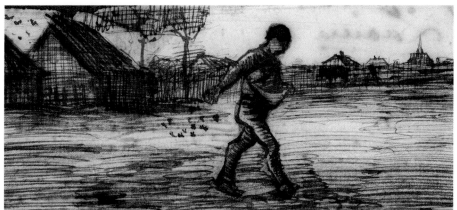

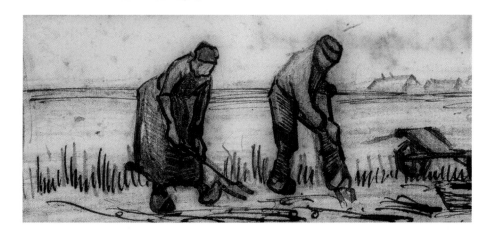

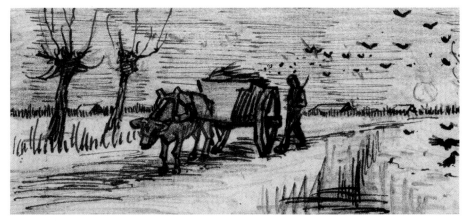

Above (from top): Ploughman; Sower; Potato Harvest with Two Figures; Oxcart in the Snow, *Nuenen, all August 1884. Despite some awkwardness of drawing, Van Gogh perfectly expresses the backbreaking reality of the hard labour of wresting food from the recalcitrant earth.*

THE YOUNG APPRENTICE

Van Gogh eventually followed in his three uncles' footsteps, rising through the ranks as an art dealer. He began work at Goupil's in 1869, and with the invaluable emotional support of his younger brother, he thrived, and was soon promoted to the firm's London office.

After leaving school, Van Gogh remained at home for a year doing nothing very much before his paternal uncle, and godfather, Cent stepped in. Although for generations, members of the Van Gogh family had followed a career in the church, it was decided that Van Gogh should take the example of his three uncles and enter the art trade.

GOUPIL AND CO.

This decision may have been influenced by Van Gogh's apparent promise as a draughtsman. It is ironic, however, that someone who was to become one of the world's most popular and expensive artists, and who sold so few works in his lifetime, was to spend the first four years of his professional life as a salesman in a commercial gallery.

Uncle Cent arranged an apprenticeship in what was almost the family business, Goupil and Co. in The Hague, and Van Gogh began work in July 1869. Goupil's was

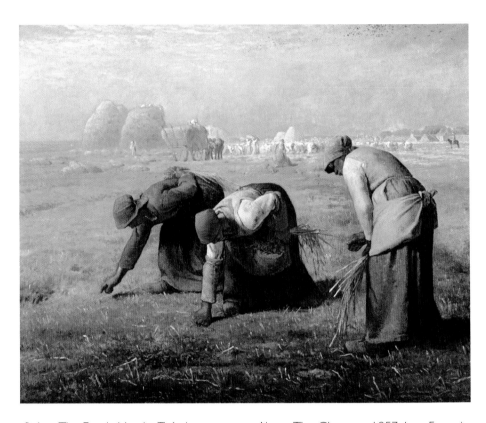

Below: The Footbridge *by Théodore Rousseau, 1855. He was one of the French Barbizon painters represented at Goupil's, where Van Gogh worked for several years.*

Above: The Gleaners, *1857. Jean-François Millet's work shocked his contemporaries by revealing the harshness of rural life. Women collect the wheat left unharvested.*

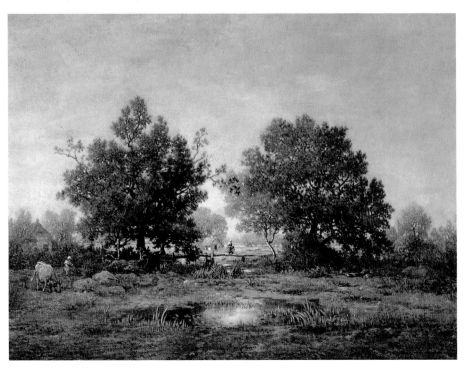

a French firm that specialized in making and selling high quality fine art photographic reproductions, etchings, engravings and photographs. Represented artists included the popular and sentimental painters of the day, including successful Salon artists. The Salon was an annual exhibition of contemporary works of art chosen by a jury of elected members. It became increasingly conservative as the century progressed, excluding from its walls many artists, such as the Impressionists, whose work is regarded so highly today. Goupil's also sold works by the French Barbizon painters, such as Jean-François Millet (1814–75), Théodore Rousseau (1812–67),

and their Dutch counterparts, known as the Hague School. The Hague School painters specialized in low-toned, richly painted images of everyday life. The most successful of these were the three Maris brothers and Anton Mauve (1838–88) who, in 1874, would marry Van Gogh's cousin Jet Carbentus.

The paintings of Rousseau and Millet struck a profound chord in Van Gogh's consciousness. Both artists painted the landscape around Fontainebleau (about 40km/25 miles south of Paris), imbuing it with a profoundly religious sensibility. Rousseau's painting *The Footbridge*, 1855, carries many of the elements that in Van Gogh's work would be transposed into a higher expressive key. Here, nature is presented as a friend to man, made safe and fertile – a place of comfort and peace. The bridge links the two halves of the composition while the figures and cattle reinforce the human aspect. Van Gogh would drop the picturesque romantic qualities to create an art of much greater expressive power.

THE LETTERS

Over 600 letters survive from Van Gogh alone and his last letter to his brother Theo was found, unfinished, in his pocket at his death. Although Van Gogh also corresponded with his parents and with his sister Wilhelmina, it was only to Theo that he felt he could unburden himself fully and achieve an intimacy that he found difficult to sustain in person.

His surviving letters show him to be one of the greatest letter writers of all time, expressing his deepest and most private feelings in a language that is simple and direct. His descriptions of colours, landscapes and his own paintings are vividly brought to life. Most touching of all is his practice of signing off his letters to Theo, "Always your loving brother, Vincent".

Above: Self-portrait, *by Hague School painter Anton Mauve, c.1884. Mauve married Van Gogh's cousin in 1874.*

Van Gogh seems to have thrived in the years he spent working at Goupil's; he was a well-liked member of staff, enjoying a close relationship with the manager, Herman Tersteeg, for whose daughter he made small books full of drawings of animals, birds and insects.

For almost four years, Van Gogh worked hard, learning a great deal about art, and his prospects seemed good. He enlivened the tedium of his dull social life by making scrapbooks of reproductions and engravings, and by occasional contact with Mauve and other artists of the region.

A BROTHERS' PACT

In the summer of 1872 Van Gogh went to stay at the new family home at Helvoirt, where his father had been given a new parish. His brother Theo, who had broken up from school, came to join them and they spent a lot of time together. One day, while walking together in the countryside, the two brothers made an important pact – always to support each other and write

Above: Van Gogh visited his family in Helvoirt where his father was minister at this church.

to each other on a regular basis, a practice that was to continue until Vincent's death 18 years later.

THE MOVE TO LONDON

In 1873, at his uncle's instigation, Van Gogh found himself promoted to the more prestigious London branch of Goupil's. Founded in 1867, and situated in the heart of London's prosperous West End, just a few minutes from the National Gallery, it was expanding into selling original works of contemporary art, albeit of a highly conservative kind. Van Gogh's primary responsibilities were to be the handling and selling of reproductions and engravings and he was very excited at the prospect: "I am looking forward very much to seeing London," he wrote to Theo, "It will be splendid for my English." In the meantime, Theo had followed him into the art business, accepting a position at Goupil's branch in Brussels before transferring to take over Van Gogh's vacated position at The Hague a few months later.

THE YOUNG PROFESSIONAL

Van Gogh remembered his first year in London as the happiest time in his life. London proved an inspiration in more ways than one. He was moved by its grandeur and squalor, and by the artists who had captured the realities of urban life.

To all outward appearances the young Van Gogh was every inch the ambitious young businessman, even down to his top hat; "You cannot be in London without one," he wrote to Theo.

LONDON LIFE
Van Gogh's three years in The Hague office had earned him a reputation as a hard-working, amiable and well-connected employee and he now enjoyed a respectable salary of £90 a year, four times that of the average working man in London. The address of Van Gogh's first lodgings is not known, but he described them as "quiet, pleasant and fresh".

His work was not particularly arduous, the hours were good and he had plenty of opportunity to enjoy the spectacle of the great capital: one of his most vivid experiences was of seeing "Rotten Row in Hyde Park, where hundreds of ladies and gentlemen ride on horseback".

A friend remarked of him how, while apparently looking at nothing, he "seemed to take in everything". The list of his favourite artists at the Royal Academy Summer Exhibition reveals his taste to have been quite conventional – he loved detail, sentiment and a strong narrative. He singled out paintings by John Millais (1829–96) for particular praise, and was impressed by John Constable (1776–1837) and William Turner (1775–1851). He was improving his English by reading John Keats (1795–1821), "who…is not very well known in Holland," he wrote, "[but] is the favourite of all the painters here".

Van Gogh also became an admirer of the English Social Realists: a group of loosely associated painters including Luke Fildes (1843–1927), Frank Holl (1845–88) and the Austrian, Hubert von Herkomer (1849–1914), who painted works replete with sick children, abandoned women, old men and women awaiting death and other such images that related to a sense of social concern.

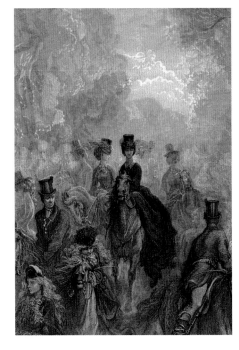

Above: Van Gogh began collecting the engravings that were published in magazines and books, such as this one, The Ladies' Mile, *by Gustave Doré.*

A DIFFERENT VIEW OF THE CITY
Van Gogh also became familiar with another bank of images relating to the life of the city. A year before his arrival, the book *London: A Pilgrimage* appeared. It is an intensely melodramatic verbal and visual mapping of the sprawling metropolis. Written by journalist Blanchard Jerrold (1826–84), it is best known for its illustrations by the virtuoso French illustrator, Gustave Doré (1832–83). These capture the chaotic energy of the capital, making effective use of stark oppositions of light and dark to evoke the vistas that made up the public aspect of the West End and the dark, claustrophobic

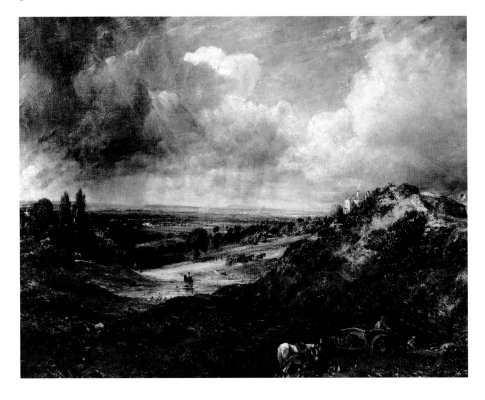

Left: Branch Hill Pond, Hampstead Heath, *by John Constable, 1828. Van Gogh admired Constable's work at the RA Summer Exhibition in London.*

Right: Eventide: A Scene in the Westminster Union, *by Sir Hubert von Herkomer, 1878. Herkomer was one of the English Social Realists greatly admired by the young Van Gogh.*

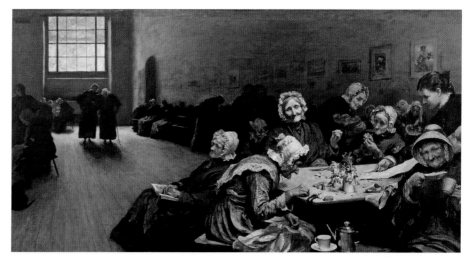

character of the forbidding alleyways that formed the city's underbelly, the East End.

One of Van Gogh's keenest pleasures was collecting the engravings found in the illustrated magazines that were so much part of mid- to late 19th-century English life. His favourites were the *Illustrated London News* (founded 1842), and its younger rival, *The Graphic* (1869). Their artists drew their work directly on to the woodblock and from these the engravers cut the image, resulting in engravings with a superior sharpness and directness. Van Gogh was a connoisseur and prided himself on buying the early editions of the magazine, when the blocks were still sharp and fresh: "The impressions I got on the spot were so strong that…the drawings are clear in my mind…my enthusiasm for those things is rather stronger than it was even then." The significance of these works on Van Gogh's imagination would only be revealed when he began to paint seriously. "To me, one of the highest and noblest expressions of art will always be that of the English, for instance, Millais and Herkomer."

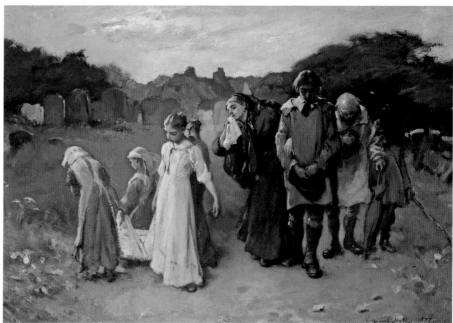

Below: Ophelia, *1852. John Millais' painting skills fascinated Van Gogh, as did the image of Shakespeare's drowned heroine.*

Above: Death of Her First Born, *by Frank Holl, 1877. A poignant scene that affected Van Gogh powerfully.*

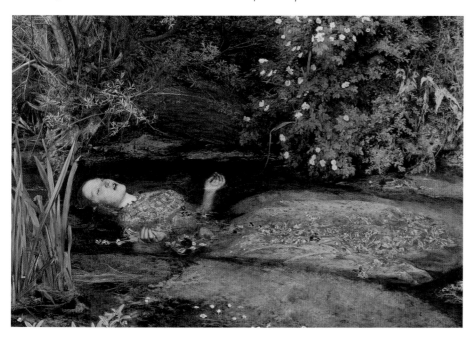

A GROWING SOCIAL CONSCIENCE

Van Gogh valued the popular engravings which he saw in magazines as much as the most revered masterpieces of Western art, seeing in their starkly realized images works of great moral urgency. He wrote, "An artist needn't be a clergyman or a church warden, but he certainly must have a warm heart for his fellow men. I think it very noble, for instance, that no winter passed without The Graphic doing something to arouse sympathy for the poor."

AN UNHAPPY LOVE AFFAIR

A turning point came in Van Gogh's life during a time when he was living in Brixton in south London. His unrequited love for his landlady's daughter led to a devastating upheaval in his life and set the pattern for the years to come.

In August 1873, Van Gogh moved to cheaper lodgings at 87 Hackford Road in the pleasant suburb of Brixton, south London.

THE LOYERS

Van Gogh's new landlady, Ursula Loyer, had moved to London from the south of France on the death of her clergyman husband and was running a small school with the help of her red-haired daughter, Eugenie. Van Gogh saw them as self-imposed exiles like himself and he confided in a letter to his brother how he was profoundly moved by the closeness of the relationship between the two women: "I never saw or dreamed of anything like the love between her and her mother."

Over the months, his silent admiration for Eugenie turned to passionate love and at last he declared himself, unaware that she was already engaged to a previous lodger. Undeterred, he persisted in his suit, but to no avail.

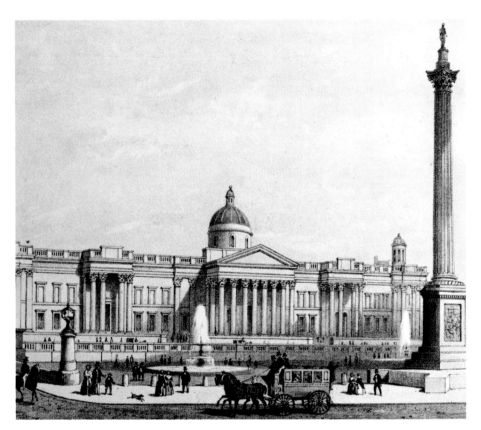

In June 1874, Van Gogh returned to Holland for the holidays, a changed man. He revealed nothing of his circumstances to his family, but spent most of his time reading and drawing. His mother wrote, "Vincent made many nice drawings… it is a delightful talent which can be of great use to him." Toward the end of the summer, he returned to London, and the Loyers, with his elder sister Anna, who wished to find a position as a teacher or governess in the city. However, almost immediately after their return, on the August Bank Holiday, Van Gogh persisted so fiercely with his courtship of Eugenie that remaining at the lodgings became

Left: Gardener near a Gnarled Apple Tree, *1883. When he visited his family in Holland, Van Gogh would spend his time drawing, capturing the Dutch countryside.*

Above: Van Gogh worked at Goupil's in Covent Garden, not far from the National Gallery in Trafalgar Square, which now houses several of his paintings.

impossible. The Van Goghs moved out and found new lodgings on Kennington Road. Soon after, Anna found a position in a school in Welwyn, about 40km (25 miles) north of London, and Van Gogh was left once more on his own.

Despite everything that had happened with the Loyers, Van Gogh wrote to his brother, over-optimistically, that he and Eugenie had agreed to "consider ourselves each other's brother and sister". This rejection of his love was to prove an extremely significant and devastating episode in his life, a turning point which, as he wrote later, caused him "many years of humiliation".

Right: Two Lovers (Fragment), *March 1888. This small section of a larger work shows the companionship Van Gogh desired his whole life, but never actually attained.*

Although Van Gogh rarely corresponded with his parents, his father nonetheless realized that something was not right. "Living at the Loyers' with all those secrets has done him no good... I am glad he left there, but not realizing his hopes must have been a bitter disappointment to him." His mother wrote sympathetically to Theo, "Poor boy, he does not take life easily."

A GROWING DISCONTENT

Van Gogh was never able to keep his personal life separate from his professional responsibilities and his infatuation with Eugenie and its consequences had a dramatic effect on his work at the gallery. He lost interest in selling reproductions and began to find solace in his religion and in books.

A letter to Theo written at this time includes veiled references to Vincent's emotional troubles and ends with the following quotation from the French philosopher and writer Ernest Renan (1823–92): "To act well in this world one must sacrifice all personal desires. Man is not on the earth merely to be happy or even to be simply honest. He is there to realize great things for humanity, to attain nobility and to surmount the vulgarity of almost everybody."

Van Gogh's choice to include this quotation from Ernest Renan, who was famous at the time for his controversial yet popular study *Vie de Jésus (Life of Jesus)*, published in 1863, reveals the complexity of Van Gogh's troubled personality and the extent, if not the direction, of his ambitions.

Right: Ernest Renan was the author of the controversial religious text Life of Jesus, *which influenced Van Gogh and enraged the Catholic Church.*

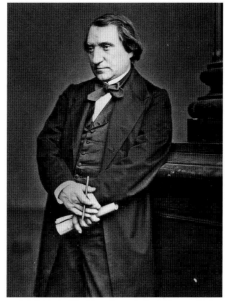

INNER LIFE

An artist's life does not explain away his art, nor can an artist's work be used as some kind of mirror that reflects his inner life. The relationship between an artist and the work he produces is complex and will always remain elusive. However, from what we know of Van Gogh's personal life, it is clear that it was always closely connected with his art – yet we should also remember that the real nature of his inner life must remain unknowable to us.

PARIS

A move to Paris offered Van Gogh the opportunity to discover a new, inspiring world of art. But it also led to a deepening of his troubles and the onset of a religious obsession. He was asked to leave his job at Goupil's, after almost seven years' service.

Van Gogh's family were so concerned about him that in October 1874, his Uncle Cent engineered a transfer to the gallery's head office in Paris. Van Gogh resented his uncle's interference and did not write to his family again until January the following year when he returned to London. Van Gogh's depression continued to affect his professional life and he seemed to be allowing his personal preferences to interfere with the professional need to accommodate the clients' desires. Once again he was re-called to Paris, arriving there at the end of May, and once again his attitude caused continuing concern.

A NEW CITY

Van Gogh's initial dislike of the city mellowed as he explored it at greater length. He spent his free time visiting the Louvre and the Musée du Luxembourg, which held celebrated contemporary works. He especially admired Charles Gleyre's (1806–74) *Lost Illusions*, and in his eyes, much more

Above: Van Gogh sketched the view from the window of his "little cabin" in Montmartre, Paris.

Below: Spring, *by Charles-François Daubigny, 1857. Blossoming trees became one of Van Gogh's favourite motifs.*

Below: Jean-Baptiste-Camille Corot. Van Gogh visited an exhibition of Corot's work.

Above: Lost Illusions, *by Charles Gleyre, 1843. An aging poet watches as his youthful dreams and ambitions glide past on a strange vessel.*

significant paintings, such as the Rembrandtesque landscape by Georges Michel (1763–1843) that had just been transferred to the Louvre, and *Spring* of 1857 by Charles-François Daubigny (1817–78). Above all, however, it was the spiritually charged *Supper at Emmaus* of 1648 by Rembrandt (1606–69) which held a special place in his heart. His letters are full of matters concerning painters and paintings, but he shows no awareness of the activities of the Impressionists who had held their first exhibition in Paris just before his arrival. He visited an exhibition of the work of Jean-Baptiste-Camille Corot (1796–1875), particularly admiring his *Garden of Olives*. Like everybody else,

he visited the Salon, the great annual exhibition of contemporary painters, where he singled out a work by the popular painter of sentimental peasant scenes, Jules Breton (1827–1906). Toward the end of his stay he visited a sale of drawings by his hero, Jean-François Millet. "When I entered the hall…where they were exhibited," he wrote to Theo, "I felt like saying, 'Take off your shoes, for the place where you are standing is Holy Ground.'"

RELIGIOUS FERVOUR

Van Gogh referred to his lodgings in Montmartre as a "little cabin". He lived an ascetic life, denying himself meat and depriving himself of what he regarded as unnecessary pleasures. He shared this cabin with an Englishman, Harry Gladwell, a fellow employee who encouraged his interest in religious matters. At the end of the working

day they would meet to read and discuss the works of Charles Dickens, George Eliot and, above all else, the Bible.

A SHAMEFUL ENDING

His depression continued and, determined to spend Christmas with his family in their new home at Etten, he took leave at the very busiest time of year. On his return Léon Boussod, the founder's son-in-law and soon to be director, called him in for an interview in which it seems Van Gogh, after having worked for the company for almost seven years, was coerced into giving his notice. Uncle Cent wrote of his "bitter sorrow", and his father wrote to Theo describing Van Gogh's continuing difficult behaviour as "a shame and a scandal".

Below: The Reapers, *by Jules Breton, 1860. Van Gogh hugely admired Breton's sentimentalized images of rural life.*

EVANGELISM

Van Gogh's interest in evangelical Christianity soon developed into an obsession. Everything was seen through the filter of his religious beliefs to the extent that his letters became almost unreadable, over-burdened with Biblical quotes and references. He turned against the critically engaged writers who had once sustained him through difficult times, to the extent of bullying Theo: "Did you do as I advised you," he asks, "and get rid of the works of Michelet, Renan, etc.?"

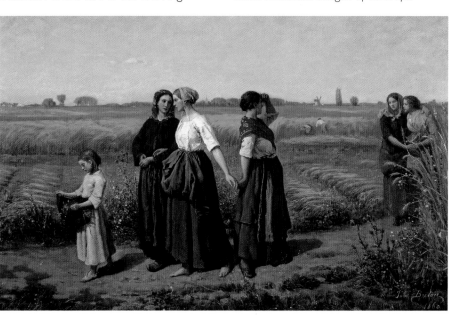

A RETURN TO ENGLAND

Religion was now playing a greater and greater role in Van Gogh's life. A kind twist of fortune brought him back to England, where he taught in schools in Kent and London, but he never managed to become fully settled.

On his return to Etten, Van Gogh was met with a family council. Everyone had an opinion on what he should do next. His father suggested the possibility of his opening his own gallery and Theo thought that he might train as an artist, but Van Gogh ignored all advice. He applied unsuccessfully for a position as an evangelist among the coal mining communities of northern England and even considered the idea of working as a missionary in South America.

RAMSGATE AND LONDON
Fortunately, just before the period of his notice came to an end, Van Gogh was offered a teaching position in a school in Ramsgate on the south coast of England, where his sister Anna was living at the time. He left Paris on 1 April 1876, and one of his last actions in the capital was to buy three etchings after Millet from the

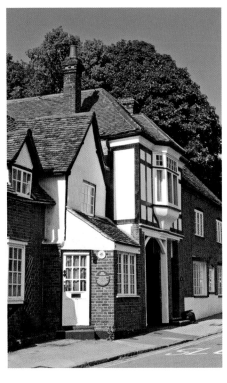

Above: Van Gogh's sister lived in Rose Cottage in Ramsgate.

Above: Van Gogh taught in this house in Royal Road, Ramsgate, Kent.

DRAWING AS THERAPY

As Van Gogh travelled through South-east England he noted the similarity of the Kentish country-side to the Dutch landscape of his home. The school in Ramsgate overlooked the sea and, judging from his letters, he spent a lot of time enjoying the drama of the coastal view.

Van Gogh found drawing a therapeutic activity, helping to keep his depressive tendencies at bay, and, as was his habit, he made a number of charming, but amateurish sketches, which he sent to his family to give them an idea of his surroundings and the places he visited.

gallery of Paul Durand-Ruel, the dealer who had supported the Impressionists throughout the 1870s. It seems impossible that Van Gogh could have been unaware of their activities – but there is no indication in his letters that they interested him at the time.

Initially Van Gogh was given a month's unpaid probation at the school. He was responsible for 24 pupils to whom he taught arithmetic, French and German, and dictation. In July 1876, the school was moved to London and it became increasingly clear that there would be no future for him there and so once more Van Gogh was forced to seek another position. He soon found one – as an assistant in a Methodist boys' school at Isleworth, on the outskirts of London, run by the Reverend Jones.

Van Gogh received a salary of £15 per annum and, as part of his duties, collected school fees from the boys' families, many of whom lived in the East End of London, "that very poor part which you have read about in Dickens," he wrote to Theo. Such experiences reinforced his empathy with the poor and the oppressed.

Some idea of the impact the city of London would have made on Van Gogh might be gathered from looking at the illustrations by Gustave Doré in Blanchard Jerrold's *London: A Pilgrimage*, published in 1872. Doré's illustrations create an unforgettable image of a fantastical city. Van Gogh valued the book highly, and its Dante-esque portrayal of the city in all its aspects. The preciseness of observation, the sense of compassion and the dramatic shifts of black and white would all find resonance in his own later work.

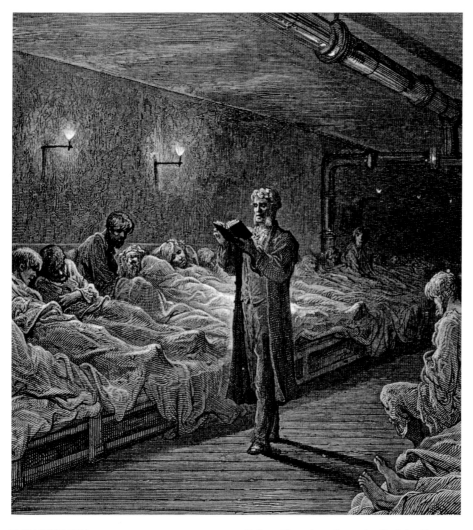

Left: Scripture Reader in a Night Refuge, *by Gustave Doré from* London: A Pilgrimage. *Van Gogh praised Doré's "noble sentiment" – given his family background he must have found images such as this very affecting.*

The ideas and feelings contained in his sermon would remain as the defining elements of his brief, turbulent and tragic life.

HOME AGAIN

It soon became evident that there would once more be no hope of professional advancement in Van Gogh's present position, and so again he returned home, fully determined to follow his calling to be a missionary or evangelist. His family remonstrated once again, Uncle Cent's judgement prevailed and Van Gogh began work as a clerk in a bookshop in Dortrecht.

For Van Gogh books were almost as important as pictures. "I have a more or less irresistible passion for books, and I want to continually instruct myself, to study, if you like, just as much as I want to eat bread." It was largely through literature that Van Gogh learned about other people.

EVANGELISM

Van Gogh remained actively involved in various churches, but he never felt constrained by any one denomination. He was overjoyed at being given the opportunity to preach a sermon at the Congregational Church at Turnham Green in west London. The text, from Psalm 119, was apposite to his situation: "I am a stranger on the earth; hide not Thy commandments from me." He wrote to Theo, that as he spoke he felt "like somebody who was emerging from a dark cave underground". His sermon contains the following lines: "…our life is a pilgrim's progress… we are strangers on the earth, but though this be so, yet we are not alone for our Father is with us." In line with his Christian thinking, Van Gogh accepts grief, sorrow, loneliness and death as the means through which redemption and joy may finally be realized.

Below: Over London – by Rail, *by Gustave Doré. A view that reveals the underbelly of the capital of the British Empire.*

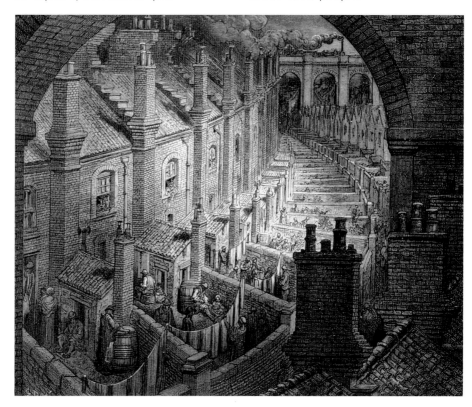

A PRACTICAL CHRISTIAN

Chastising himself, and depriving himself of food and even sleep, Van Gogh was "out of his mind" and perturbed by a deep, religious unhappiness. His family decided that the only solution was to send him to study theology.

Van Gogh led a largely solitary life in Dortrecht and was deeply unhappy there. He would turn up late for work, moody and irascible. Rather than applying himself to the business of selling books, he seems to have spent most of his time reading.

A SOLITARY EXISTENCE

As was his practice, he explored the city's art galleries, museums and churches. The tedium of existence was enlivened on one occasion by a fleeting visit from Theo. Van Gogh's increasingly odd behaviour, his lengthy prayers at table, his fasting, his apparent insomnia and his habit of reading late into the night contributed to his landlord's opinion that his lodger was "out of his mind". Van Gogh regarded his

work at the bookshop as a temporary measure at best. He was determined that he would follow the family tradition and the example of his father and find some way to preach the Gospel and do good works. His letters began to express an open disdain for the art trade and especially what he considered to be the bourgeois values of the Van Gogh family – he would "rather end up having to eke out a living," he wrote, "than fall into the hands of Messrs. Van Gogh." The situation became impossible. Three months after beginning work at the bookshop, a schoolteacher friend passed on his feelings to the family and, after the usual consultation, it was agreed that Van Gogh should go to Amsterdam to gain the necessary qualifications to follow his ambition.

A STUDENT IN AMSTERDAM

Van Gogh was 24 years old and now had the financial and emotional security he needed, living with his Uncle Johannes, the vice-admiral, who had a large house overlooking the docks in Amsterdam. Before he could study theology at the university, he had to learn Greek and Latin, a necessary requirement for entry. But Van Gogh was not at all suited to academic work. "My head sometimes feels heavy," he wrote, "and often it burns and my thoughts are confused." His tutor, a brilliant

Below: A Vanitas Still Life, *by Simon Renard de Saint-André (1613–77), showing the first chapter of Thomas à Kempis',* The Imitation of Christ *and Warning Against Vanity.*

THE GOOD CHRISTIAN

While in Dortrecht, Van Gogh translated extracts from the Bible into four languages and copying out the entirety of Saint Thomas à Kempis' 15th-century classic of spiritual teaching, *The Imitation of Christ*. He kept a drawing of the saint in his room and the text played a crucial role in his physical and spiritual life. "Never be entirely idle but either be reading, or writing, or praying or meditating or endeavouring something for the public good." Such words supported Van Gogh's own idea of what it meant to be a Christian – the need to be humble, and to sacrifice personal desires and ambitions for the greater good. He must have felt immense frustration, reading about Christ's mission rather than being able to actively follow it.

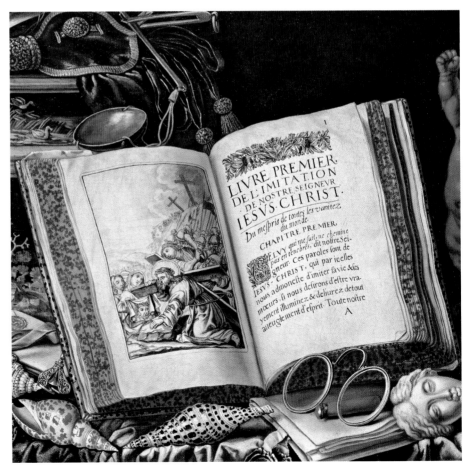

Jewish academic, Mendes de Costa, who was about Van Gogh's own age, has left a poignant memory of his charge. Van Gogh would beat himself when he felt that he had inadequately prepared for his classes. "I can still see him stepping across the square…without an overcoat as an additional self-chastisement, his head thrust forward a little to the right, and on his face, because of the way his mouth drooped at the corners, a pervading expression of indescribable sadness and despair. And when he had come upstairs, there would sound again that singular, profoundly melancholy, deep voice: 'Don't be mad at me, Mendes; I have bought you some little flowers again because you are so good to me.'"

Drawing was still important to him, and his room, as ever, was decorated with prints, including a sheet from Charles Bargue's

Below: The Reformed Church of Amsterdam which Van Gogh would have visited during his time there.

Above and left: Plates from Cours de Dessin Volume 1, *c. 1886. Van Gogh decorated his rooms with sheets from the art manual by Charles Bargue.*

Cours de Dessin, a self-help art manual that he copied from intermittently throughout his life, right up to his last days in Auvers.

VISITING THE RIJKSMUSEUM

In Amsterdam, Van Gogh visited the newly opened Rijksmuseum. There he would have seen the works of Rembrandt and Frans Hals. "What struck me most on seeing the old

Dutch pictures again is that most of them were painted quickly, and that these great masters, such as Frans Hals, Rembrandt, [Jacob] Ruysdael and so many others – dashed off a thing from the first stroke and did not retouch it very much." This was something Van Gogh would take to heart. It was a quality that he also saw in the Japanese prints that he began to collect around this time.

THE BORINAGE

Van Gogh eventually found contentment preaching the Gospel to a community of miners in Belgium, but it was not to last. His eccentric habits led to his rejection by the Church, and it was this that prompted him to seek a different salvation, in art.

Van Gogh was in turmoil. Madame Bonte, the wife of a pastor who knew him, remembered him saying at this time, "Nobody has understood me. They think I'm a madman because I wanted to be a true Christian. They turned me out like a dog, saying that I was causing a scandal, because I tried to relieve the misery of the wretched. I don't know what I'm going to do."

LIFE IN THE COALFIELDS

By the summer of 1878, it became apparent that Van Gogh was not going to gain entrance to the university, so he abandoned his studies and, helped by the Reverend Jones, was granted a place on a three-month training course for evangelists in Brussels. His mother had no illusions about his prospects. "Wherever Vincent may be or whatever he may do, he will spoil everything by his eccentricity, his queer ideas and views on life." His nomination was refused, but as recompense in January 1879, he was permitted to start work as a missionary in the coal-mining district of the Borinage in southern Belgium.

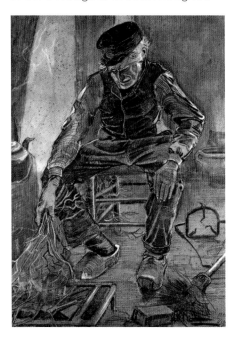

AN OUTCAST ONCE MORE

Van Gogh found a certain contentment here, for though life was hard he was at last preaching and living in accordance with his beliefs. He tried to follow Christ's teaching literally; "I shall have to suffer much," he wrote to Theo, "especially from those peculiarities which I *cannot* change, first, my appearance, my way of speaking, and my clothes." He dirtied his face to emulate the grimed faces of the miners and took to wearing "an old army jacket and a shoddy cap". He helped the sick and the needy, gave away his few possessions, slept on straw in an outhouse and as a result was regarded by the very people he wished to help as a madman. He lasted six months before the Church Council Committee withdrew their financial and moral support – due to his "almost scandalous excess of zeal".

Left: Farmer Sitting at the Fireplace, *1881. Van Gogh depicts the body of this old man as if it has been broken by a lifetime of hard labour.*

Above: Evening, *1860. Jules Breton's melancholic image of a well-fed peasant contrasts markedly with Van Gogh's stark representation in* Farmer Sitting at the Fireplace, *below.*

A SALVATION IN ART

Bereft of official support, Van Gogh decided in July 1879 to transfer his activities to the village of Cuesmes. He wrote to Theo, "To the family, I have…become a more or less objectionable and shady character… I am inclined to think the best and most sensible solution all round would be for me to go away…to cease to be, as it were."

At Cuesmes he drew and painted in earnest, while living with a miner's family in very cramped conditions. In the middle of the brutally cold winter of 1880, when he was at his lowest ebb, Van Gogh decided to make a pilgrimage to the home of Jules Breton, the renowned painter of peasant life, who lived in northern France in the village of Courrières. The journey on foot took

THE BORINAGE

It was the largest and the most dangerous coalfield in Europe; living conditions were appalling, wages were below subsistence level, many of the mines were dilapidated, and accidents and landslides common. Van Gogh perversely described it as "picturesque [because] everything… *speaks*, and is full of character." All around him he could see images as memorable as any evoked by the writings of Dickens and Zola or as envisaged in the drawings of Gustave Doré. In these difficult circumstances he began to draw and to paint with a box of watercolours sent to him by his friend Tersteeg, of Goupil's.

him almost a week. As he drew near, instead of an old farmstead, he came upon Breton's newly constructed brick studio. Dismayed by its "stone-cold and forbidding aspect", Van Gogh lost his nerve, turned away and made his difficult way back to the Borinage, surviving only by trading drawings for food and board. "Yet it was in these depths of misery, that I felt that I shall get over it somehow. I shall set to work again with my pencil, which I had cast aside in dejection, and I shall draw again, and from that moment I have had the feeling that everything has changed for me."

This was the moment, it seems, that at the age of 27, Van Gogh decided to dedicate himself absolutely to becoming

Above: Van Gogh lived in this miner's cottage in Cuesmes.

an artist – and a very particular kind of artist, one who would use his art to preach a gospel, an evangelist in paint. As Émile Zola writes of the harsh reality of life and the stoical heroism of those who survive it, so Van Gogh reveals the impact of the environment – *le milieu* – upon ordinary people. This would remain a constant in his art: just as the skies in Dutch landscape painting are locked into the land, so in all his art

Below: The Poor and Money, 1882. In the Borinage Van Gogh lived among the poor working-class people.

Van Gogh's people belong to the territory they inhabit. In *Germinal*, written 1884–85, Zola describes in graphic detail the misery of the miners and the families who toil in terrible conditions. Van Gogh shared with Zola, not his deep pessimistic fatalism, but his pantheistic outlook, his rootedness in reality and the author's belief that "this life of suffering…makes you love naked, living reality."

Below: Van Gogh shared Émile Zola's interest in representing life as it really was for the working classes.

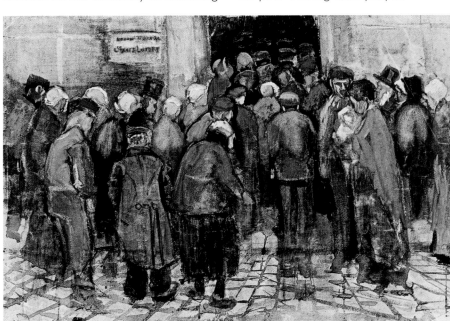

DESTITUTE BUT FREE

At last Van Gogh seemed to be on his chosen path. The experience of the last few years had ruined his health; he was destitute, but free to draw and paint, which he began to do seriously and almost compulsively.

In October 1880 Van Gogh decided that in order to improve his art, he would have to move to Brussels, where he could take lessons in perspective and anatomy.

LIFE IN BRUSSELS

Theo was now sending him money on a regular basis and Van Gogh now fully acknowledged the fact that he was totally dependent his brother's financial and emotional support – as he would continue to be until his death nearly ten years later. Theo had followed in Vincent's footsteps and succeeded in the art trade where his elder brother had not. Van Gogh's unease with this situation and his reliance upon the sympathy, understanding and financial support of his brother is a running motif throughout their correspondence.

Below: Theo van Gogh regularly sent his brother money as well as offering emotional support through his correspondence.

Two letters from January 1881 bear witness to this state of affairs; one complains bitterly about Theo's apparent lack of commitment to Vincent's needs, the second, posted immediately afterwards, apologizes for his selfishness. It would seem that at this time Van Gogh was trying to start afresh and, recognizing the need to re-establish contact with his family, was prepared to behave himself in order to do so. He made up his mind and left Brussels to spend the summer at Etten.

A NEW FRIEND

Van Gogh's dearest wish was to travel to France and to study in Paris or in the forest of Fontainebleau, home to the Barbizon painters. However, lacking the necessary funds to make the journey and being

uncertain of his proficiency as an artist, he travelled instead to Brussels to put this right. On arrival, he immediately set himself a programme of self-education, visiting galleries, reading and studying books on anatomy, phrenology and perspective. He also worked by copying from his ever-growing collection of prints and reproductions, looking especially at the work of Rubens, many of whose greatest works hung in the churches and art galleries of the capital. Through Theo's offices he met and made friends with another artist, a young aristocrat, Anthon Van Rappard. Although wary of each other at first, they soon

Below: The second half of the 19th century was a time of unprecedented artistic activity in Brussels.

became close friends. Van Rappard invited his new friend to share a studio and, as was his habit, Van Gogh worked hard, producing some very powerful drawings, such as *The Lamp Bearers* and *Miners' Women Carrying Sacks* (or *The Bearers of the Burden*), which owed much to his recent experiences in the Borinage and to his deep knowledge and sensitive assimilation of the work of the English illustrators. Then, in April 1881, Van Rappard had to leave the city and, although they remained in touch through correspondence, without the immediate presence and support of his friend, Van Gogh felt unable to remain in Brussels; he decided to move back to Etten, to his family and the familiar countryside of the district. He left Brussels on 12 April.

STUDYING THE MASTERS

Van Gogh's study of Rubens helped him to develop his confidence in using the material means of his art – line, form and colour – to express feeling rather than merely describing form. A little later he wrote how he

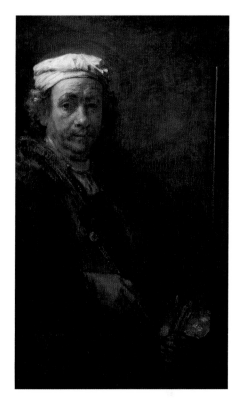

Right: Portrait of the Artist at his Easel, *by Rembrandt van Rijn, 1660. Van Gogh was a great admirer of Rembrandt's work and studied it in depth.*

saw in the Flemish master's work, "his way of drawing the lines in a face with streaks of pure red."

Over the next few years Van Gogh never missed a chance to study the work of the great Dutch masters. He especially admired the paintings of Frans Hals, whose dynamic virtuoso brushwork appealed to him, and of course the work of his beloved Rembrandt. He relished the old master's ability to express his inner feelings as well as his deeply religious attitude towards people and life in general and his expressive use of light and shade.

These encounters with the masters kept alive Van Gogh's sense of sympathy and the deep affinity he felt he shared with these great painters of the human condition. Repeated encounters with their work presented him with the challenge to create a modern equivalent to their great achievements. Van Gogh was still very much a student, but the seeds

were sown, and his own greatness would soon reveal itself. He studied the portraits of Rembrandt and Hals and found his own commitment to portraiture strengthened. He came to see that, for him, portraiture could act as a form of modern history painting for his own time.

'VINCENT'

Van Gogh's experiences had not only shaken him physically, but had also destroyed any surviving faith he may have had in the established Church. He was a new man whose total commitment was to his art. To mark this transformation he dropped the surname Van Gogh, a name always difficult for foreigners to pronounce correctly, and began to sign his work simply "Vincent". This act signalled, intentionally or otherwise, a further rejection of the family Van Gogh and an attempt, perhaps, to forge a bond with Rembrandt, who had also signed his work with only his Christian name.

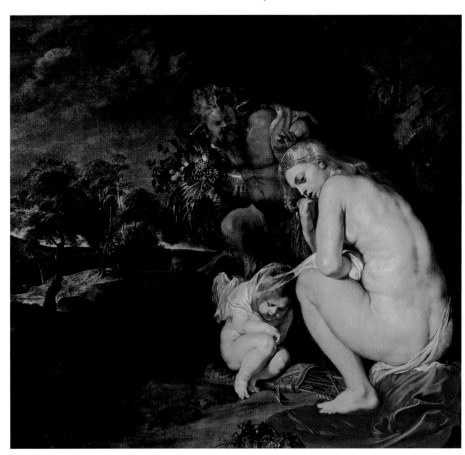

Left: Venus Frigida, *by Peter Paul Rubens, 1614. Van Gogh honed his drawing skills by copying works by other artists.*

THE RETURN TO ETTEN

With his confidence as a painter growing, Van Gogh continued to move around in search of subjects and inspiration. While staying at his family home in Etten, he fell in love once again, and once again, it ended tragically.

While Van Gogh was living at home with his family, his health improved and through drawing and painting out of doors, his work developed a new confidence.

THE PEASANT LIFE

Van Gogh had now fully turned his back on the city to embrace the commonly held notion that "real" values – however brutal – were only to be found enshrined in the life of agricultural and rural communities. "When I say that I am a painter of peasant life, that is a fact…it was not for nothing that I spent so many evenings…in their homes with the miners and the peat cutters and the weavers and the peasants." He found support for such ideas and feelings in the work of those artists whose work gave a quasi-mystical status to peasant experience: artists

such as Millet, Breton, Lhermitte and those of his own country, Rembrandt, Hals, Israëls and Mauve. Nevertheless, he was determined to find strength from within himself alone. As he wrote bitterly to Theo in December 1881, he found "their whole system of religion horrible".

ANOTHER UNHAPPY AFFAIR

However much he valued his own intellectual and spiritual independence, Van Gogh longed for female companionship. His past history had shown that he was attracted to, and to some extent preyed upon, vulnerable suffering women. During his stay at Etten during the summer of 1881,

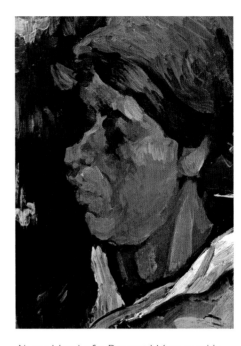

Above: Head of a Peasant Woman with Dark Cap, *1885. In such studies it is possible to see Van Gogh's powerful, even clumsy use of distortion for emotional effect.*

Below: The Frugal Meal, *by Josef Israëls, date unknown. Van Gogh considered Israëls as an artist worthy of the company of Rembrandt and Millet.*

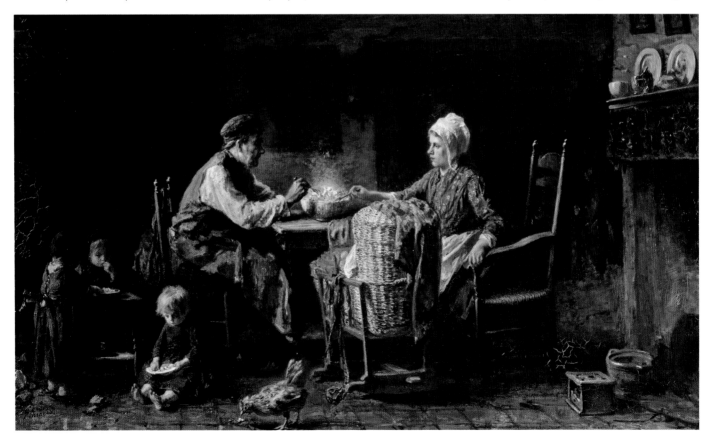

Right: Churning Butter, *1866–8. Jean-François Millet's paintings are powerful in composition and effect, with a sentimental edge that appealed to Van Gogh.*

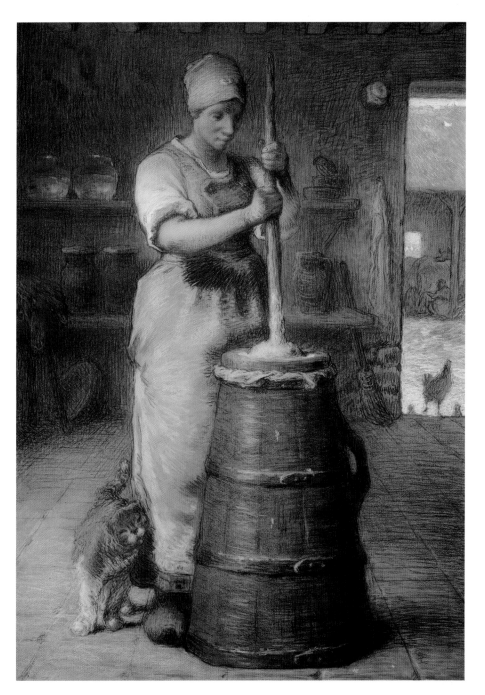

he met and fell in love with his recently widowed cousin, Kee Vos-Stricker, who was visiting for a few months with her four-year-old son. She immediately and resolutely rejected his advances, but Van Gogh, as was his nature, persisted and his continuous and misdirected efforts to win her affections resulted in her fleeing back to her family home in Amsterdam. Van Gogh attempted to visit her there, only to be driven out of the house by her father after an extraordinary incident which Van Gogh recounted: "I put my hand in the flame and said: 'Let me see her for as long as I can keep my hand in the flame…' But they blew out the lamp…and said, 'You shall not see her'." His mother took Kee's side and Van Gogh never forgave her. From this time, as he wrote, "they were strangers" to each other. She is hardly ever again mentioned in his letters.

PAINTING BEGINS IN EARNEST

Unable to continue living at the family home, Van Gogh returned to The Hague, living independently in poverty in the industrial district on the outskirts of the city, where he lived for the next 18 months. Determined to pursue his ambition to become an artist, he continued to visit and learn from Mauve.

Right: Snow Storm. *A beautifully sensitive composition by Anton Mauve who had respect for Van Gogh's nascent talent.*

PÈRE MILLET

Millet was Van Gogh's model, his 'god'. The French artist was renowned as the 'peasant-painter', a role Van Gogh wished to inherit: "Millet is *father* Millet, that is, counsellor and mentor in *everything* to the younger painters." Van Gogh's religious sensibility and evangelical zeal were now sublimated into his new understanding of art.

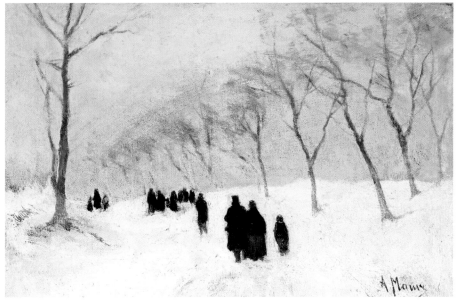

THE HAGUE

Van Gogh was still learning the conventions of painting. With the help of instructional books, and lessons from his cousin Mauve, he began to produce works with a unique style, which he would maintain throughout his career.

Despite, or perhaps because of, the complexities of his personal life, this was the moment when Van Gogh began to produce drawings and paintings of a powerful and stark originality.

WORKING IN EARNEST
By this time Van Gogh had accumulated around 1,500 engravings, mostly from the English periodicals, and his study of them prompted him to work during this period mainly with pen and ink, chalk and litho crayon. He also experimented with lithography. The vital energy of his work was fuelled by his powers of direct observation and his empathy with his chosen subjects. He seriously considered the possibility of applying for a position as a graphic artist on one of the illustrated journals he admired so much, but seems not to have taken the idea any further.

Van Gogh took some informal lessons with his cousin Mauve and under his guidance he produced some very creditable still-life paintings. Despite his lack of a formal art

education, Van Gogh was growing increasingly confident in the awkwardly expressive style that he had developed over these few years; he was keenly aware of his problems with perspective, a necessary convention, he believed, for any artist to master if they were going to attempt to paint the flat landscape of Holland and the Low Countries. "They are landscapes with complicated perspective, very difficult to draw, but for that reason there is a real Dutch character and sentiment in them." Such concerns prompted him to make use of self-help books such as Cassagne's *Guide de l'ABC du Dessin*. In the winter of 1882 he had a simple drawing frame constructed, using as a model those employed by Albrecht Dürer and the Dutch masters. This allowed him to instantly translate a scene into a simple perspectival pattern, in which the diagonals "shoot away into the distance like arrows from a bow", effectively dispensing with the complications of establishing a coherent foreground.

Below: Corner of Leidsche Square, Amsterdam, *date unknown. George Hendrik Breitner called himself the 'people's painter'. The title also belongs to Van Gogh.*

Above: The Bookseller Blok, *November 1882. Jozef Blok was a well-known bookseller in The Hague. Van Gogh was keen to represent all kinds of people.*

This simple tool was a radical discovery and it revolutionized his art. Previously he had thought that "getting depth and the right perspective into a drawing was witchcraft or pure chance." Now, along with his idiosyncratic and effective use of line and tone, perspective became part of his expressive armoury.

PAINTING THE WORKING CLASSES

At this time Van Gogh became friendly with talented artist George Hendrik Breitner (1857–1923) who, in common with many artists of the time, was attracted to working-class subjects. Together, they walked the poorer districts of The Hague and its surrounding areas looking for likely subjects to paint and draw, just as the English Social Realist artists had done in London and, before them, Rembrandt had done in Amsterdam. Breitner later went on to work on the famous *Panorama Mesdag*.

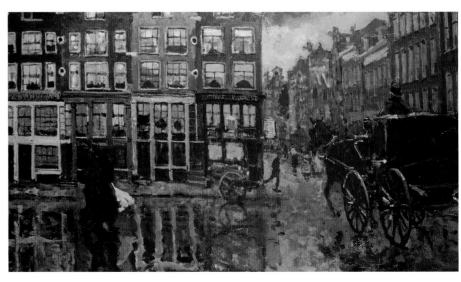

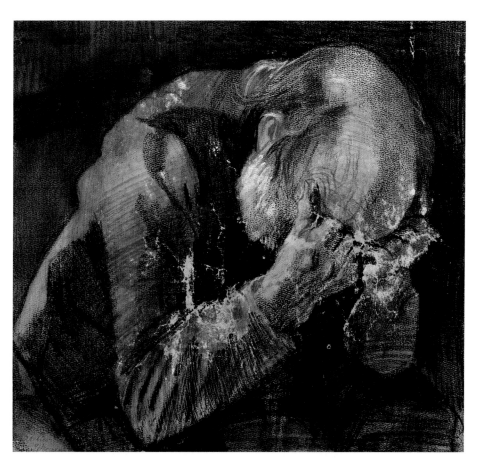

Left: Old Man with his Head in his Hands,
*1882. Van Gogh's own vulnerability to
attacks of overwhelming despair would have
helped him find the means to represent
such extreme emotional states.*

life, is very much dependent on the
magazine and book illustrations upon
which so many were based. Van Gogh
was evidently attracted to the single
figure, making character studies of great
power and insight. However, for all the
individual characteristics that he captures,
these drawings are 'types' of people –
even though drawn with a powerful
empathy, they show neither sympathy
nor sentimentality. The strong chiselled
line, the dramatic use of tone and the
precision of his characterization make
the drawings of this period the first
unique works of his career and the basis
of all that was to follow.

"You ask about my health," he
wrote to Theo in December 1882,
"– last summer's trouble is really quite
gone, but I feel rather depressed at the
present, whereas at other moments,
when my work progresses well, I am
quite cheerful…"

Below: Still Life with Pots, Jar and Bottles,
*1884. A simple study of ordinary objects
given a timeless dignity by a sombre
palette and restrained composition.*

THE START OF A UNIQUE STYLE

Van Gogh's Uncle Cor (Cornelius)
commissioned him to make a series
of drawings that would record the
changing face of the city, its buildings and
people. Van Gogh's resulting pen and ink
drawings are radically different from the
conventionally picturesque interpretations
of the urban space; they give a dramatic
and immediate sense of the reality of the
city. Rather than choosing the obvious
tourist sites, Van Gogh was drawn
toward "the poor quarters, the suburbs,
the road-works, the people etc." – trying,
as he wrote, to capture "full reality". The
realization of these works, drawn from

*Below: Van Gogh used a drawing frame like
this one, pictured in the* Painters' Manual
by Albrecht Dürer, published in 1525.

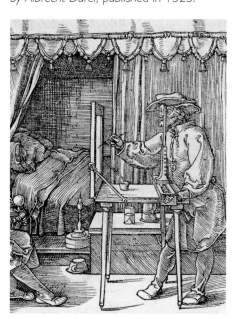

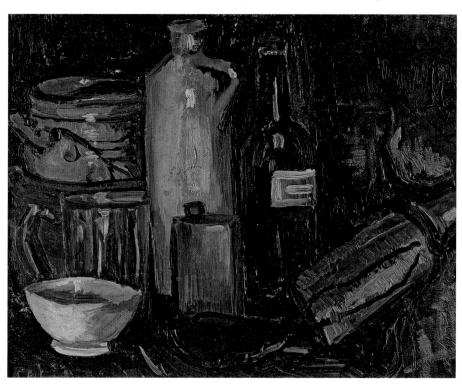

SIEN AND THE HAGUE

As previous encounters with the opposite sex had revealed, Van Gogh was a passionate man. At some stage early in his time in The Hague, Van Gogh met Clasina Maria Hoornik, whom he called Christine or Sien.

"I need a woman," Van Gogh declared to Theo, "I cannot, I may not live without love. I am a man and a man with passions: I must go to a woman, otherwise I will be turned to stone." Now he had found one. A seamstress, artist's model and prostitute by profession, Sien was 32 years old with a 5-year-old daughter. She was also pregnant, with serious mental and physical health problems.

A FALLEN WOMAN

Van Gogh shared with many middle-class people a fascination with the 'fallen woman' who had fallen foul of the moral codes of the day – a victim of the harsh economic realities of modern society.

Some time in the late spring she moved in with him and Van Gogh gained a model, a lover and a surrogate family. His religious and artistic impulses helped him justify his behaviour to his brother: "It is wonderful how pure she is,

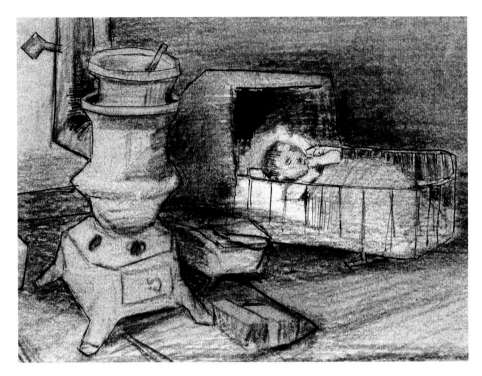

notwithstanding her depravity. Something far deep in the ruin of her soul, heart and mind, has been saved. And in these rare moments her expression is like that of a 'Mater Dolorosa' by Delacroix." His relationship was a carefully guarded secret – from his immediate family at least. But, as the year progressed, his money problems became ever more acute and, with some money from Theo, he made his way home alone for Christmas. The tensions within the household were unbearable. On Christmas Day 1882, Van Gogh refused to go to church and during the resulting argument, his father demanded that he leave the family home. Van Gogh took him at his word and left immediately to return to The Hague and Sien.

Left: Sien, Peeling Potatoes, *1883. Van Gogh loved to draw from life. Here he captures the quiet concentrated performance of a simple domestic act.*

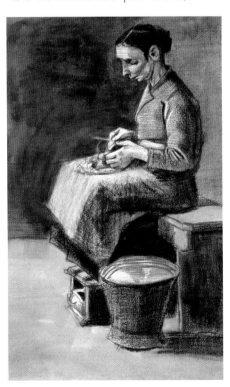

Above: Cradle, *July 1882. Crude but touching, the contrast between the angularity of the cast iron stove and the vulnerable sleeping baby is highly effective.*

SORROW

Mauve and Theo tried unsuccessfully to intervene with the family. Tersteeg, who had been so supportive, withdrew his friendship. Mauve also ended his relationship with Van Gogh, calling him a "vicious character" and turning

VAN GOGH THE PATRIARCH

Van Gogh enjoyed periods of real happiness playing the patriarch with his surrogate family. "How often, that child has comforted me…when I'm home he can't leave me alone for a moment; when I am at work, he pulls at my coat or climbs against my leg till I take him on my knees…the child is always happy."

Right: "Sorrow", *April 1882. A lithograph from a number of drawings made of the subject. He sent one to Theo referring to it as "the best figure I have drawn yet."*

him out of the studio, refusing to see him ever again. Van Gogh had a lot to worry about. His relationship with Sien was now common knowledge and was the cause of many of his troubles. Worse, in June 1882, he suffered a severe attack of gonorrhoea, which put him in hospital for several weeks; Sien looked after him and a month later her second child was born.

Van Gogh's relationship with Sien was complicated and its true nature will never be fully revealed. She was important to him as a companion, lover, mother-figure and muse. He clearly locked into the sadness and resignation her worn face reveals. He also, it would seem, valued and celebrated her role as homemaker. In taking her and her child into his care, Van Gogh was acting according to his religious and moral principles; he saw it as an act of charity, but he was imposing his desires upon her in a way that could not be sustained. Despite all the pressures, Van Gogh refused to give her up. His drawings of his companion are deeply felt, but she is never shown as the happy contented mother common in so many 19th-century depictions. One

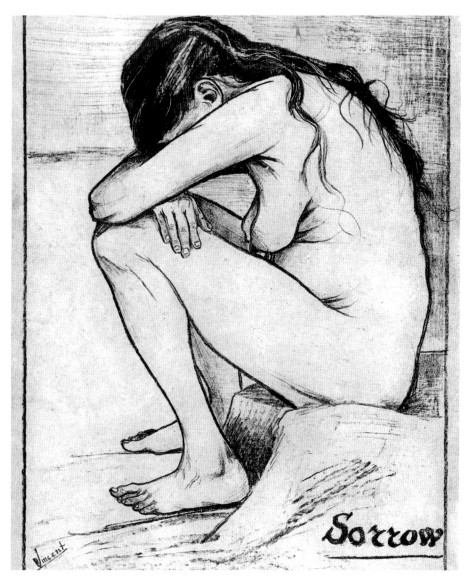

drawing stands out as being emblematic of her suffering; it bears the simple title, inscribed on the page: "Sorrow". It was drawn shortly before she had moved in with Van Gogh and is at once an image of particular and universal appeal – the impact of that single word set against the forlorn anonymous figure is one of the most unforgettable in Western art; it looks back to medieval woodcuts and forward to the expressive work of artists as various as Edvard Munch, Käthe Kollwitz and Pablo Picasso.

FAMILY PRESSURE

None of these familial feelings could completely allay Van Gogh's continuing depression, and his sense of desperation

Left: Sien Facing Left, *1883. The artist's confident use of interlocking diagonals anticipates the energy and power of his later portraits.*

worsened as winter approached. He talked to Theo of how he felt "more and more a kind of void" within him that could not be filled.

Driven by family pressure Van Gogh returned home to Nuenen (where his parents were now living) to face disgrace and suspicion. His claim that he was not the father of Sien's child was probably not believed. How the relationship ended is unclear. Presumably Van Gogh washed his hands of the affair, but whatever happened, in the autumn of 1883, just a year and a half after they had first met, Sien resumed her former life.

Many years later, her body was recovered from the waters of the docks at Rotterdam. Like so many tragic heroines of 19th-century art and literature she had acted out her role to the full.

NUENEN

In the countryside of Drenthe in Holland, Van Gogh briefly sought the solitude of the bleak landscapes. Returning to the family home in Nuenen and embracing a modern style, he entered one of his most prolific periods.

In September 1883, having lived and worked in The Hague for 18 months, Van Gogh moved to the remote Drenthe province on the north-east coast of Holland. There were various possible reasons for the move: living was cheaper in the countryside and it offered an escape from his recent troubles at home and in The Hague.

A RETURN TO RURAL LIFE

Like so many romantically inclined artists, Van Gogh saw in the solitude of nature something of the eternal. He read into the seasonal activities of sowing, growing and harvesting an analogy for life, death and creativity. The flat marshy landscape with its low thatched cottages and distant vistas appealed to him, and in the beginning he was hopeful that he could find there a visual counterpart to his emotional and artistic ambitions. Initially he worked with his friends Breitner and Van Rappard, who had been there for some time, but they soon moved on and Van Gogh was left on his own. His paintings of this period

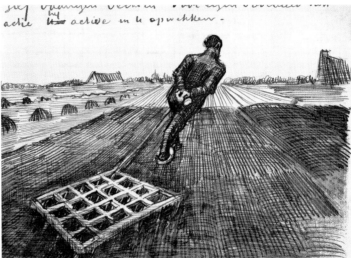

are heavy melancholy documents of isolation that, despite their unremitting bleakness, offer some kind of spiritual consolation. The solitude, however, became too debilitating and after two months he decided to bring his period of self-imposed isolation from his family to an end by returning once again to the family home. "A thing… I was loath to do," he confided to Theo. His father was now pastor in the parish of Nuenen. His welcome was

Above: Man Pulling a Harrow, *a sketch from a letter Van Gogh wrote to Theo from Drenthe, 28 October 1883.*

guarded, but he soon settled down to work, using the laundry room as a studio. A new beginning beckoned.

HOME AGAIN

This period, from December 1883 to November 1885, saw the production of an immense amount of work, about one-quarter of Van Gogh's surviving output. It is characterized by his need to find a "coarse and rough technique" suitable for his ambition to create a modern "rural" art. "This is who I am, as authentic and real as the people and landscape I paint." Accordingly, he needed an art that signalled that same authenticity – he used thick sticks of graphite, rather than expensive pastels, and drew on rough paper, rather than the smooth paper associated with academic drawing. As he was not a

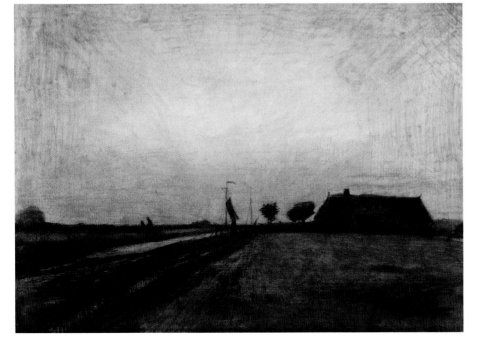

Left: Landscape in Drenthe, *autumn 1883. The powerful brooding melancholy of the low-lying landscape is perfectly expressed in this work and contrasts with the cosiness of Jean-François Millet's composition in* The Church at Greville *(right).*

Above: The Protestant church in Nuenen where Van Gogh's father was minister.

Right: Congregation Leaving the Reformed Church in Nuenen, *1884.*

"nice person," he continued, he would "avoid 'nice colours'." The works of this time could be read as emblematic of his own sense of isolation, loss of faith and the growing distance between him and his father. Such ideas and feelings are found throughout his art, but are especially evident in his series of paintings of the old church tower of Nuenen and the cemetery paintings such as *Funeral in the Snow near the Old Tower* or *Churchyard in Winter*, both painted in early December 1883.

Right: The Church at Greville, *1871–4, by French Realist Jean-François Millet.*

THE FRENCH REALISTS

In terms of his own art practice, Van Gogh was, in effect, turning his back on the idea of painting the modern developing city in favour of using the landscape as a means of creating a modern art. He actively sought out likely subjects that he could paint and draw in the spirit of the French Realist artists Gustave Courbet (1819–77) and Jean-François Millet.

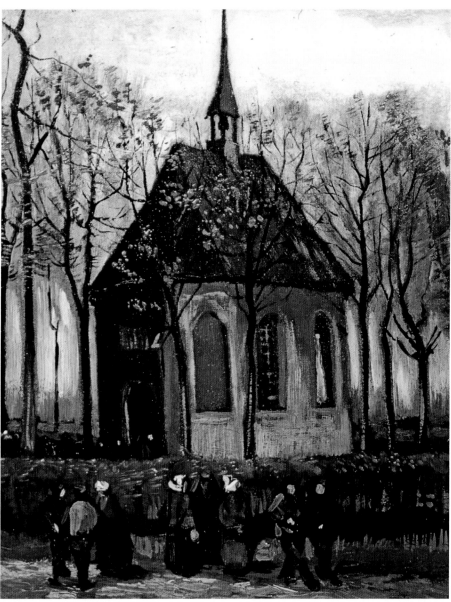

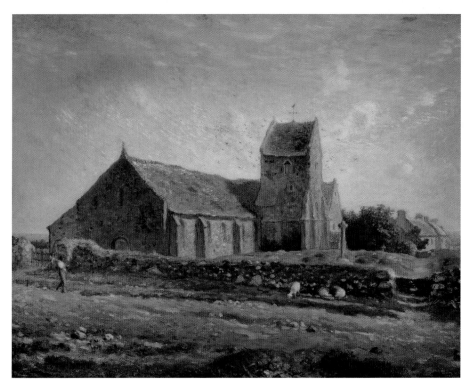

PROGRESS AND DESPAIR

Van Gogh's anxiety about his lack of technical skill was a constant throughout his life, and served as both his weakness and his strength. Although Van Gogh wrote, "I have no technique", eventually he would recognize his lack of academic skills as a liberating force.

"How I manage to paint a scene," Van Gogh wrote, "I simply don't know." Despite all the uncertainty and anguish over his artistic shortcomings, Van Gogh was always rigorously clear-headed and astute in the critical assessment of his own progress.

THE DEVELOPING ARTIST

He continued, "I sit down with my blank canvas before the scene I have chosen, I look at the scene, and I tell myself that my blank canvas must become that scene. I come home disappointed, put the canvas away for a time, and then gingerly take another look at it. I'm still dissatisfied… I can still see the wonderful scene I sat before, and look what I've made of it! And yet, I don't know, I look again at the canvas – perhaps there is an echo of the scene there… Nature has reproduced herself through me in a kind of shorthand." "My belief is that we must get far beyond technique – so far that people declare we haven't any. Let our work be so clever that it seems naïve."

FURTHER TRAGEDIES

In the autumn of 1884, Van Gogh fell victim to a prolonged state of depression. He antagonized everyone – even Theo. "You haven't yet sold a thing I have done," he wrote, "whether for a little or a lot. In fact, you haven't even tried." As Van Gogh was only beginning to produce paintings of a saleable nature, such criticisms, however hastily made (and equally hastily retracted), seem unfair, but they mark his increasing confidence in his art.

His situation was made worse at this time by an inappropriate relationship with an older woman called Margot, who fell in love with him. It seems that she was mentally unstable, and Van Gogh, possibly out of pity, entered into a complex emotional entanglement with her. Margot somehow was led to believe that an engagement was imminent and when it did not materialize she drank strychnine and was taken away to a mental institution. Further tragedy was to follow.

On 27 March 1885, Van Gogh's father died unexpectedly. Despite their differences, this solemn, gentle man had never stopped supporting his wayward son, although he had never been able to understand him. Two days before he died he wrote of his son, "If only he succeeds in some way or other, no matter which."

Van Gogh was deeply upset by his father's death. His mother was given a year's grace before having to leave the parsonage, but in the meantime Van Gogh had quarrelled with his sister Anna and had moved out of the family home to take lodgings with the sexton of the local Catholic church. Despite his difficult circumstances, Van Gogh was working well and began to think, as he had done on several previous occasions, about the possibility of forming an artists' co-operative, although this came to nothing in the end.

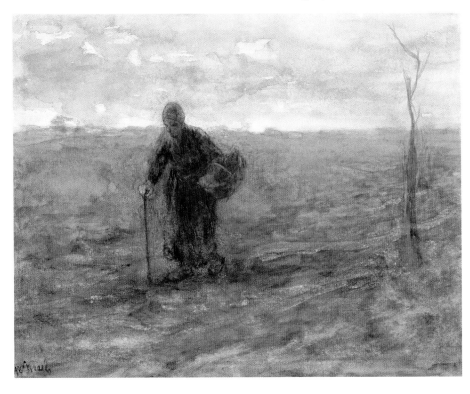

Left: Old Woman on the Heath, *by Josef Israëls. An evocative study that compared with Van Gogh's close-focused, chiselled drawing opposite reveals the originality and power of Van Gogh's vision.*

INFLUENCES

Van Gogh's oil paintings reveal his love for Rembrandt as well as the Dutch artist Jozef Israëls, who was a member of the Barbizon group. The sharp outlines of his drawing are modulated by the dramatic distribution of lights and darks to create an almost sculptural style of painting. Figures seem not so much painted or drawn as carved or modelled, their forms emerging from the darkness into the light.

Below: Peasant Woman Stooping and Gleaning, *July 1885.*

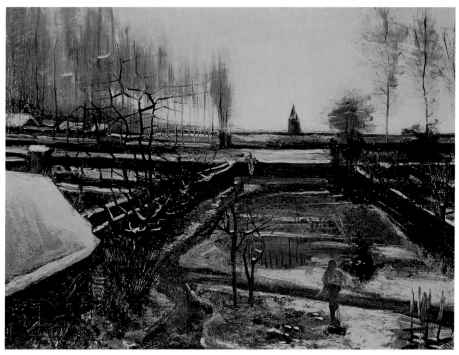

THE WEAVERS

Inspired by his friend Van Rappard and such novels as George Eliot's *Felix Holt, the Radical* (1866), Van Gogh embarked upon a campaign of drawing and painting the working people of the district, peasants and weavers. Weaving was the main cottage industry of the area. Van Gogh's letters show

Below: Landscape with a Church and Houses, Nuenen, *1885.*

how he was drawn to the dramatic visual possibilities of their activities. He described one of the looms as "a monstrous black thing of grimed oak – like some fabled instrument of torture, a prison…"

His images of the workers in the field are developed from the monumentalized figures of Millet, but are even more sculptural in effect, their bodies made awkward, distorted and broken by their

Above: The Parsonage Garden at Nuenen in the Snow, *1885. Note the significance of the horizon and the use of perspective to enhance the emotional impact of the composition.*

labours. There is no relief, no joy in their activities – just hard animal effort – and yet Van Gogh manages to endow these figures with a dignity that is far removed from Millet's fatalistic romanticism.

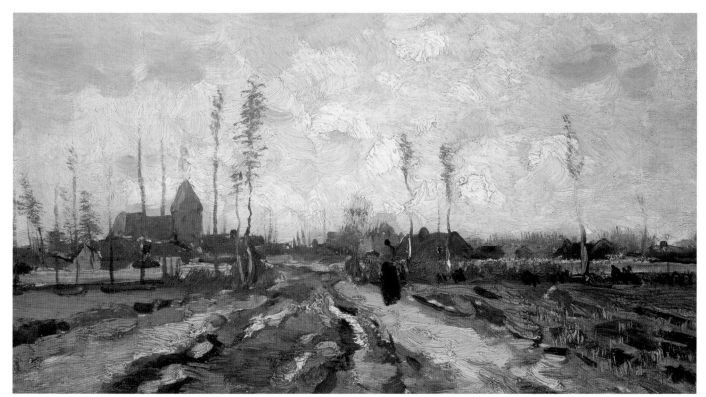

A MODERN MASTERPIECE

Van Gogh's first deliberate masterpiece was created in the summer of 1885. A secular version of the *Last Supper*, he would call it *The Potato Eaters*. The response, though mixed, inspired Van Gogh to see himself as a great artist.

At this time Van Gogh was enthusiastically reading the writings of the French Romantic artist, Eugène Delacroix (1798–1863) and absorbing his ideas on the effects of colour. "While painting recently, I have felt a certain power of colour awakening in me, stronger and different than what I have felt till now."

A FIRST MASTERPIECE

In May, Van Gogh's friend Van Rappard came for a two-week visit. He was openly impressed by Van Gogh's progress and gave particular praise to his drawings. After his departure, Van Gogh felt encouraged to begin on the production of a major work, his first deliberate masterpiece. He set to work on this painting immediately after his

father's death and decided upon the subject. It would be a secular version of the *Last Supper*, a Rembrandt's *The Supper at Emmaus* for modern times – he would call it *The Potato Eaters*. Following standard academic procedures, he built up to the final work, making sketches, drawings and oil studies of the individuals who would feature in the final painting. He had become acquainted with the de Groot family, and they agreed to pose for him for a small payment. Once again, complications made Van Gogh's life difficult, for the daughter of the family, Gordina de Groot, became pregnant and Van Gogh was thought to be responsible. Although he strenuously denied any involvement, the local priest forbade any Catholics to pose for him.

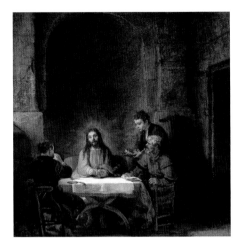

Above: Rembrandt's The Supper at Emmaus, *1648.*

Below: The Potato Eaters, *1885. Van Gogh makes the simple sharing of food into an act of profound religious significance.*

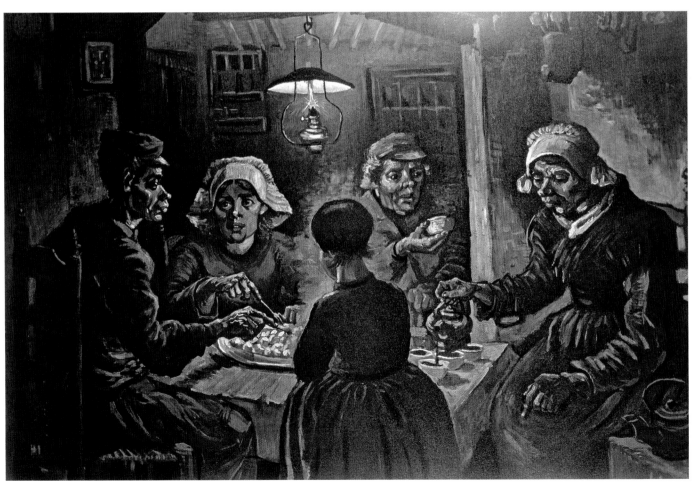

Despite such troubles, the painting was finished. He sent his friend Van Rappard a lithographic version of the work and was devastated by his friend's negative response – he thought it "a violence [to] nature". Van Gogh was so hurt that he broke off their five-year friendship and never spoke to Van Rappard again. Theo, however, immediately understood its iconic force: "Some see beauty in it," he wrote, "precisely because the characters are so genuine." To which Van Gogh responded, "I feel a power within me to do something; I see that my work holds its own against other work."

TRUTH IN ART

To escape the complications of the situation at Nuenen, Van Gogh decided to cut his losses and make his way by foot to one of the greatest European ports, Antwerp. Just before he left, he painted *Still Life with Bible*. It is at once a looking forward and a looking back: Van Gogh has painted the family Bible open at Isaiah, "He is despised", and next to it, an unremittingly bleak novel by Émile Zola (1840–1902), ironically titled

Below: Still Life with Bible, *1885. This work reveals the artist's deep regard for the Bible and contemporary French literature.*

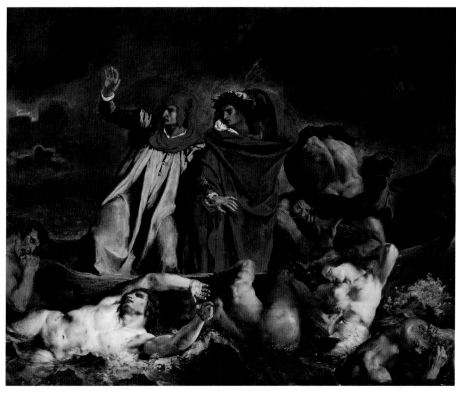

La Joie de Vivre (*The Joy of Living*, 1884). The contemporary French novelists were vitally important to Van Gogh. Later he would write to his sister of their importance: "If, on the other hand, one wants the truth, life as it is, then there are, for instance, de Goncourt in *Germinie Lacerteux*, *La Fille Eliza*, Zola in *La Joie de Vivre* and *L'Assommoire*, and so many other masterpieces, all portraying life as we feel it themselves, thus satisfying our need for being told the truth."

Above: Dante and Virgil in the Underworld, *by Eugène Delacroix, 1822. Delacroix's dramatic subject matter and vibrant brushwork made a deep impact upon Van Gogh.*

COLOUR AND MUSIC

Delacroix's ideas led Van Gogh to ponder on the relationship and emotional effects of colour and music. Although both the painting and drawings of this period are sombre, he recalled how, even at this time, he "was aware of the relationship between colour and Wagner's music". He wrote to Theo of the "enormous variety of moods in symphonies of colour" in Delacroix's work, but the full impact of such ideas would only come into force later in his career. Van Gogh had begun to take piano lessons from the organist of the local church, although these did not last long: Van Gogh, uninterested in conventional ways of learning, would strike the keyboard and sing out "Prussian blue", "bright cadmium" or "dark ochre", depending on the notes he struck.

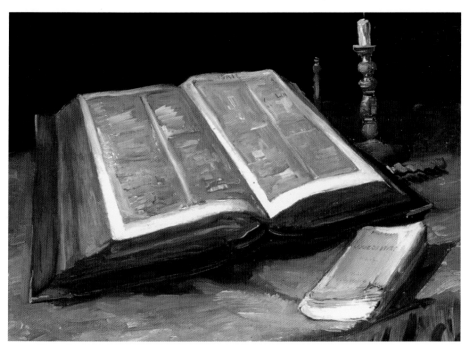

ANTWERP AND THE ACADEMY

Moving to Antwerp, a prosperous port with a rich historical and cultural tradition, Van Gogh enrolled in the prestigious Royal Academy of Fine Arts. Van Gogh was somewhat ambivalent about the Academy, but the experience had a positive impact on his painting.

Van Gogh arrived in Antwerp on 27 November 1885, having broken definitively with his family: never one to avoid self-pity he wrote that he was "more estranged from them than if they were strangers." He would never see his mother or return to Holland again.

THE ROYAL ACADEMY

Perhaps with the death of his father, Van Gogh could finally be himself. He rented a small, cheap room above a paint merchant's shop on Beeldekensstraat and enjoyed the thrill of being mistaken for a sailor. He had prepared himself for what he knew would be a period of intense study and severe privation. Theo could be relied upon to send what he could but Van Gogh found it almost impossible to survive – his letters are full of complaints to his brother: "It is hard, terribly hard to keep on working when one does not sell, and when one has to literally pay for one's colours out of what would not be too much for eating, drinking, and lodgings, however strictly calculated."

He needed to be successful and one of the major reasons for moving to Antwerp was to enter the highly prestigious Royal Academy of Fine Arts. The Academy attracted students from all over Europe who wished to undergo a rigorous academic training. It was at this august institution that Van Gogh arrived on 8 January 1886, dressed in his blue cattle-driver's smock and his favourite fur hat. "An unpolished man," a student remembered, "who crashed like a bombshell into the Antwerp Academy." "How flat, how dead, and how dry-balled the results of that system are," Van Gogh wrote,

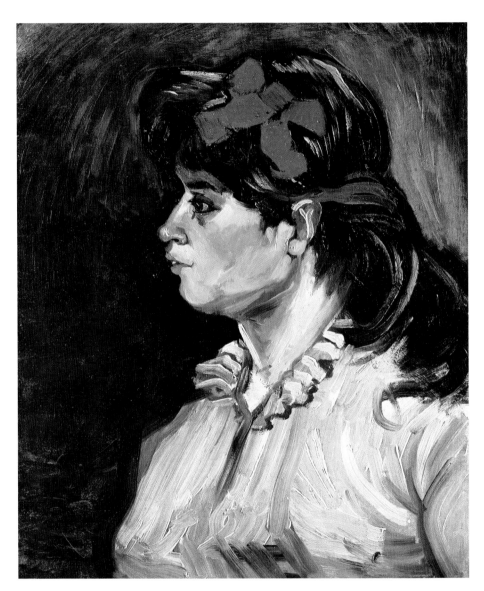

"…it is correct, it is whatever you like, but it is dead." As there were no female models at the Academy, Van Gogh enrolled in outside classes and here his direct, powerful drawings began to attract attention. "God damn it!," he once declared, "A woman must have hips, buttocks, a pelvis in which she can carry a baby!" Despite limited recognition from his fellow students, he was already willing himself into a sense of despair, certain that his time in Antwerp would "probably prove to be like everything, everywhere, namely disillusioning…"

Above: Portrait of a Woman with Red Ribbon, *December 1885. The most evidently Rubensian of Van Gogh's works.*

REMBRANDT AND RUBENS

As a Dutchman, Van Gogh remained intensely proud of his national heritage throughout his life. Although he learned much from his encounters with Peter Paul Rubens (1577–1640) he felt him to be merely "superficial" when compared to Rembrandt, who he thought of as the "great and universal master portrait painter of the Dutch Republic."

Right: The Cathedral of Our Lady, Antwerp.

Rubens was the acknowledged master of Baroque painting and his work played a part in directing Van Gogh toward the sensual and dramatic possibilities of vivid colour and dynamic form. The few of Van Gogh's paintings that survive from his period in Antwerp owe much to Rubens' extraordinary ability to bring warmth and vitality to human flesh. In Van Gogh's painting of a singer from a cabaret, *Portrait of a Woman with Red Ribbon* (1885), we can see the broad handling and rich creamy tones associated with Rembrandt. Equally evident is the influence of Rubens in the vivid touches of red and green that help to suggest the woman's vibrant sexuality. The energy that will spill out later in Van Gogh's work is seen here – restrained, but very much present.

In the Cathedral of Our Lady in Antwerp, Van Gogh would have studied two of Rubens' most renowned works, the dramatic *The Raising of the Cross* (1610–11), with its freshly realized female heads and rippling form of the horse with its exuberant mane (right panel, not shown), and the slightly later *The Descent from the Cross* (1614). In both of these works Van Gogh could study the decisive brushwork and the vibrant luminosity of the Flemish master. "Colour," wrote Van Gogh, "is not everything in a picture, [but] it is what gives it life." His study of Rubens confirmed his reading of Delacroix – "true drawing," he paraphrased, "is modelling in colour." This simple phrase would remain the essential defining element of his art. Van Gogh wrote to Theo that as a result of his studies, his palette was "thawing" and his paintings becoming brighter.

Although Van Gogh admired and learned much from works such as Rubens' large-scale masterpieces he found himself drawn more and more to thinking about the possibilities of portraiture. In his paintings of this time a new expressive potential can be seen being unleashed.

Below: The Raising of the Cross, *by Peter Paul Rubens, 1610–11 (central panel).*

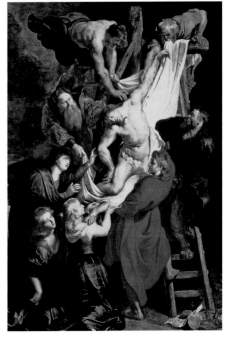

Below: The Descent from the Cross, *by Rubens, 1611–14 (central panel).*

JAPAN AND JAPANESE PRINTS

Japanese art was a great influence on many artists of Van Gogh's era, including Monet, Degas and Whistler. Van Gogh himself became a collector of Japanese prints and considered himself a connoisseur of the new 'Japonisme'.

It was while living and working in Antwerp that Van Gogh acquired his first Japanese *ukiyo-e* (literally 'pictures of the floating world') woodblock prints. These prints were inexpensive to buy and later, when Van Gogh moved to Paris, he and his brother Theo built up a substantial collection, buying from the popular oriental emporium of Siegfried 'Samuel' Bing (1838–1905) in the Rue de Provence, which was close to their lodgings.

JAPONISME

Japanese prints had taken the European avant-garde by storm in the 1860s and by the end of the decade all things Japanese had become common intellectual property.

A whole generation of artists, including Claude Monet (1840–1926), Edgar Degas (1834–1917) and James Abbott McNeill Whistler (1834–1903), exploited to varying degrees the novel

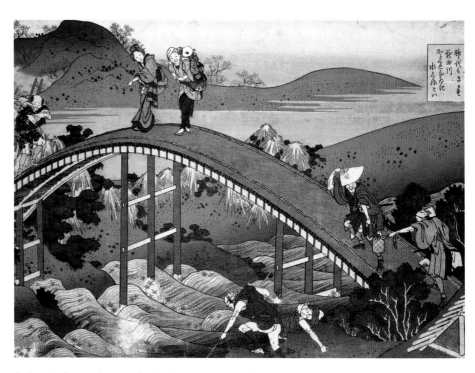

Below: La Japonaise, *by Claude Monet, 1876. A deliberate and splendidly vulgar example of Monet's commercial exploitation of the fashion for all things Japanese.*

Above: Hand-coloured woodblock print, Autumn Maple Leaves on the Tsutaya River, *by Japanese artist Katsushika Hokusai, c. 1839.*

EUROPEAN INVENTION

Japonisme had little to do with real Japanese life and culture. It was in fact very much an invention of the European imagination: an exotic 'other' where naïve, simple people lived in harmony and wonder within a landscape characterized by blue skies and apple blossom, inhabited by fabulous warriors, beautiful courtesans or old men lost in contemplation. "If we study Japanese art," wrote Van Gogh, "we see a man who is undoubtedly wise, philosophic and intelligent, who spends his time how? In studying the distance between the earth and the moon? No. In studying the policy of Bismarck? No. He studies a single blade of grass."

peculiarities that they found in this work. In very different ways, all these artists found in Japanese prints a means of introducing a new way of seeing and a new sensibility into European art and culture. This considered aesthetic and critical understanding was referred to as 'Japonisme' to distinguish it from the more superficial appropriation of Japanese culture referred to as 'Japonaiserie'. In a very short space of time Van Gogh moved from an exponent of 'Japonaiserie' to a master of 'Japonisme'.

The craze for all things Japanese was further promoted by books such as *Manette Salomon*, by Edmond (1822–96) and Jules de Goncourt (1830–70). Published in 1867, this work, a novel about artistic life in Paris, was an essential text for any would-be artist, especially one, like Van Gogh, who had any ambitions to study in Paris.

Above: Sudden Shower over Shin-Ohashi Bridge and Atake, *by Utagawa Hiroshige, from* One Hundred Famous Views of Edo.

Right: Van Gogh's The Bridge in the Rain *(after Hiroshige), 1887.*

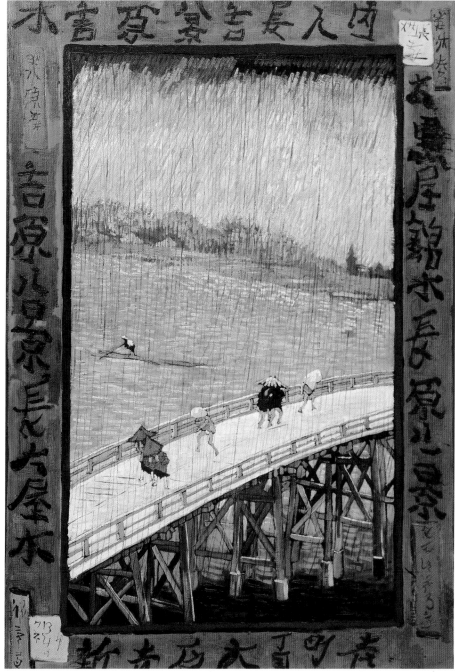

THE PRINTS

Katsushika Hokusai (1760–1849) became the most well-known of the Japanese masters, followed by Utagawa Hiroshige (1797–1858). Most of the prints coming into Europe in the 1860s were near-contemporary, and brightly-coloured (Japanese inks were fugitive and their sharp colours would fade if exposed to too much light). Sophisticated amateurs admired earlier prints that used fewer colours whereas Van Gogh preferred the healthy vulgarity of the 'decadent' masters such as Utagawa Kuniyoshi (1798–1861) and Utagawa Kunisada (1798–1865).

Avant-garde artists valued the high decorative content of Japanese prints and the very different means the makers used to picture the world – they enjoyed the arbitrary use of colour and strong asymmetrical compositions, often cropped as a result of a single sheet being part of a diptych and triptych. Compared with traditional notions of European perspective, artists found the Japanese use of multiple viewpoints and their expressive use of scale and proportion intensely exciting. Also, the interest in the landscape, urban subjects and caricature, together with the often overt or covert sexual nature of content to be found in the prints, helped to liberate the imaginations of these European artists, and to nurture and confirm much of their experimental activity.

By the 1880s Japanese art and design was no longer the novelty it had been during the previous two decades and artists both young and old were reassessing its significance. A whole new generation, including Émile Bernard (1868–1941), Paul Gauguin (1848–1903), Georges Seurat (1859–91), Henri de Toulouse-Lautrec (1864–1901) and of course Van Gogh himself, would find in the subject matter and formal characteristics of Japanese prints a rich resource from which to adapt, adopt, appropriate and subvert.

In his free adaptation of Hiroshige's *A Sudden Shower*, Van Gogh's unease with the traditional conventions of European art can be seen. He has transposed the flat, linear aspects of the Japanese artist's composition into a richly textured weave of heavily worked paint.

BACK IN PARIS

"I am not an adventurer by choice but by fate and feeling nowhere so much a stranger as in my own family and country." Having exhausted the opportunities available to him in Antwerp, Van Gogh returned to the artistic capital of the world at that time – Paris.

After three months in Antwerp, Paris called. Van Gogh's work and ambitions were moving beyond the bounds of provincial art schools, however prestigious they might be. Theo, who had already moved to Paris, had been singing the praises of the French capital, its museums and galleries, the excitement of the new painting. Here, Van Gogh would be able to meet other like-minded painters, find conducive models and more opportunities to sell pictures. If he moved to Paris, Van Gogh assumed, he would live with Theo in relative comfort and security in the liveliest capital of Europe.

VINCENT ARRIVES

Theo was aware that impressive though Van Gogh's development as an artist was, his essentially tonal work would look distinctly old-fashioned against the work being done by the Impressionists. Theo also realized that having his tempestuous brother in the capital would bring its own

problems and so was wary of setting an exact date for his arrival. Van Gogh, however, was not to be put off. Without warning, some time in March, Van Gogh left Antwerp on

Above: Studio at Batignolles, *by Henri Fantin-Latour, 1870. Pictured: Scholderer, Manet, Renoir, Astruc, Zola, Maître, Bazille and Monet. Van Gogh heard about this group and wanted to see their work himself.*

Left: The Galerie d'Apollon in the Louvre, Paris. Van Gogh spent a lot of his time in Paris visiting galleries and museums and admiring the work of other artists.

a sudden impulse and, arriving at the Gare du Nord, scribbled this note to his brother:

"Dear Theo, Do not be cross with me for having come all at once like this. I have thought about it so much, and I believe that in this way we shall save time. Shall be at the Louvre from midday or sooner if you like."

One can only imagine Theo's consternation at this news. He realized, even if his brother did not, the incompatible nature of their personalities and needs. He had wanted Vincent to remain in the country, to recover from

the privations of the last few months and in doing so, support their recently widowed mother. Instead, his nervous, over-excited brother was in Paris and expecting to move into Theo's small apartment, situated just a few streets away from the gallery of Boussod, Valadon and Co. (formerly Goupil's), where he was manager.

Theo had earlier confided in his sister that if their brother did come to Paris, then he would have to live in separate lodgings, for he himself was not well and was embroiled in a complex relationship with a woman whom we only know as 'S'. All arguments failed, for as Van Gogh had earlier written, "There is no chance, absolutely none, of making money with my work in the country, and there is such a chance in the city…going to the country would end in stagnation."

FURTHER EDUCATION

From Van Gogh's point of view, Paris was the next logical step in his self-education as an artist. He had long abandoned the idea of working

Above: Boulevard des Capucines, *by Claude Monet, 1873–4. It is hard today to realize the radical nature of the sketch-like paintings of Monet and his associates.*

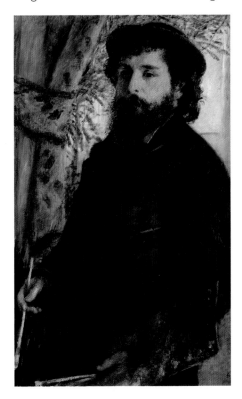

Above: Portrait of Claude Monet, *1875. Pierre-Auguste Renoir's depiction of his fellow Impressionist Monet exudes an air of self-confidence, even self-complacency that Van Gogh could never attain.*

in England and his love of Millet's work was now tempered by his enthusiasm for Rubens and Japanese prints. In Paris he knew that he could study at first hand and in detail the works of Delacroix and the new radical painters he had heard about, such as Claude Monet, "a landscape painter cum colourist", and the group known as the Impressionists, none of whose work he had actually seen prior to his arrival in Paris – he had a lot of catching up to do. He also hoped that he would at last have a measure of emotional and financial security and the opportunity to make the most of his brother's contacts in the art world. In a letter to a friend, the now forgotten English artist, Aloysius Livens, whom he had

met in Antwerp, he wrote, "Paris is Paris, there is but one Paris and however hard living may be here… the French air clears up the brain and does good – a world of good."

Van Gogh had known about the Impressionists at second hand from his brother, but one can imagine the shock at his first encounter with their works, in which a freedom of colour and handling was allied with startling original compositions of everyday subject matter. It seemed so obvious to them that a new age needed a new, technically audacious art to record it.

MONTMARTRE: LA VIE BOHÈME

Van Gogh found himself quite at home in the bohemian surroundings of Montmartre.
He began studying at the studio of Fernand Cormon, where he came into contact with the
radically minded avant-garde painters who would inspire him so much.

Situated to the north of central Paris, Montmartre is set around a hill, '*la butte Montmartre*'. Even today, the quarter still preserves something of its bohemian character and village-like charm.

AN ARTISTIC HUB

In Van Gogh's time, a few windmills still survived in Montmartre, reminding the artist of his homeland. In between the buildings were quarries, walled vineyards, allotments, smallholdings and workshops. Montmartre had become a centre for entertainment, famous for its cheap wine. The narrow streets that wound to the top of the hill were picturesque by day, dark and dangerous at night. The great basilica of Sacré-Coeur that still dominates the city landscape was then a building in progress, begun in expiation of the violence that befell the city in the

Below: Fernand Cormon's Cain, 1880. Van Gogh studied under Cormon, whose studio was close to the Van Goghs' lodgings.

Above: The lodgings at 54 Rue Lepic in Montmartre, where Theo and Vincent van Gogh lived together.

Above: The Boulevard Montmartre, Paris, c. 1900, where Theo van Gogh was manager at Boussod, Valadon and Co.

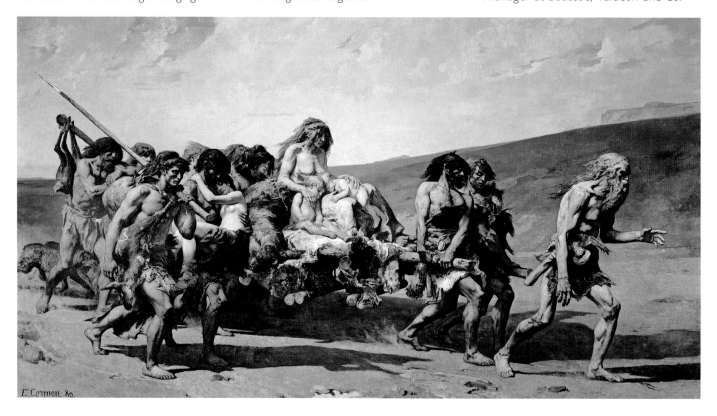

Right: Vegetable Gardens in Montmartre: La Butte Montmartre, *1887.*

aftermath of the French Commune in 1871. Theo and Van Gogh originally lived on Rue Laval, in a tiny apartment one block to the south of the Place Pigalle which marked the boundary of Montmartre and the rest of Paris. Theo must have lived under considerable strain, for Van Gogh was incredibly untidy, but things improved when, a couple of months later, they moved to new lodgings at 54 Rue Lepic. This apartment enjoyed views across the whole of the city, a living room, two bedrooms and a small studio for Van Gogh.

BOUSSOD, VALADON AND CO.

Just down the hill was the district of Batignolles which had been the centre of radical artistic activity in the previous decade. Since 1881, Theo had been the gallery manager of Boussod, Valadon and Co. at 19 Boulevard Montmartre. He had used his position to persuade the firm to allow him not only to sell the more conservative works associated with the firm but to try to develop a market for the Impressionists as well, but so far he had met with only limited success. During the 1880s, the artists associated with Impressionism, although so well-known today, were neither well-regarded nor widely known.

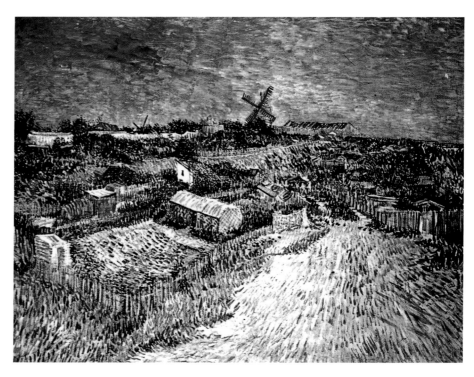

CORMON'S STUDIO

Van Gogh, still very much unsure of himself as an artist, joined the studio of the respected academic painter, Fernand Cormon (1845–1924), whose studio was a few blocks away from Theo's apartment. Such studios, or *ateliers libres*, were undertaken by successful Salon painters as commercial enterprises to prepare would-be artists for entry into the official state-controlled art school, the École Nationale des Beaux-Arts. The teaching varied in intensity from studio to studio and, as Van Gogh would have known from his friend Breitner who had studied there, Cormon's atelier was one of the most liberal. It was at Cormon's studio that Van Gogh became friendly with a group of radically minded young artists who would serve to inspire him and introduce him to the various communities of avant-garde painters.

Above: The purpose of the ateliers libres *was to prepare artists for entry into the École Nationale des Beaux-Arts.*

FERNAND CORMON

Cormon was an academic painter who had just completed a cycle of highly-coloured decorative paintings for the newly rebuilt Hôtel de Ville, but his fame rested upon his meticulously finished canvases of historic and prehistoric subjects. His most celebrated picture was *Cain*, which had enjoyed tremendous popular and critical acclaim at the 1880 Salon. Cormon was often criticized for his lack of imagination as an artist, but he was nevertheless a sympathetic man who encouraged his students not just to draw the model in the academic fashion, but to study and paint in the open air.

AT CORMON'S STUDIO

Paris continued to provide Van Gogh with inspiration. Through Cormon's studio he made friends with fellow painters. He worked hard at his painting and continued to study the great works in the Louvre.

Van Gogh enrolled at Cormon's studio just as it re-opened. It had been closed as a result of a student prank played by the precocious and ambitious Émile Bernard, who had already been suspended from the École des Beaux-Arts for "showing expressive tendencies in his paintings".

NEW FRIENDS

Bernard had continued his rebellious ways by daubing the studio's dark-coloured backdrop, against which the naked model posed, with streaks of brilliant colour. He was excluded from the studio and left Paris for a walking tour of Brittany. When the studio re-opened he would drop by from time to time and it was on one of these occasions that he met Van Gogh. Already at the studio were two other students with whom Van Gogh had become acquainted; one was the rising star, Louis Anquetin, (1861–1932) and the other, Henri Marie Raymond de Toulouse-Lautrec (1864–1901), whose personal and artistic fascination with the disreputable side of Parisian life was already beginning to reveal itself in a series of sensitive, delicately realized portraits of working-class women.

A PERSONAL PORTRAIT

This vivid account of Van Gogh has been left by Archibald Hartrick, an English artist who was also at Cormon's: "Red-haired with a goatee, rough moustache, shaven skull, eagle eye and incisive mouth, as if he were about to speak; medium height, stocky without being in the least fat, lively gestures, jerky step, such was Van Gogh, with his eternal pipe, canvas, engraving or sketch. He was vehement in speech, interminable in explaining and developing his ideas, but not very ready to argue – except with his brother, it seems. Theo was nearly driven mad by Van Gogh's passionate

Left: Portrait of Vincent van Gogh, *by Henri de Toulouse-Lautrec, 1887. Before Van Gogh stands a glass of absinthe. Alcohol would wreak tragic consequences on Toulouse-Lautrec's own short life.*

Below: Outrageous and charismatic, Toulouse-Lautrec was a true friend to Van Gogh and his work reveals a similar sympathy to those damaged by life.

Right: View of Meaux, *by Georges Michel. Van Gogh admired Michel's landscapes, which he saw in the Louvre.*

enthusiasms. He had an extraordinary way of pouring out sentences in Dutch, English and French, then glancing back over his shoulder and hissing through his teeth. In fact when he was thus excited he looked more than a little mad; at other times he was apt to be morose, as if suspicious…. But in some aspects Van Gogh was personally as simple as a child, expressing pleasure and pain loudly in a childlike manner. The direct way he showed his likes and dislikes was sometimes very disconcerting, but without malice or conscious knowledge that he was giving offence." One must be wary of such accounts as, like so many witness reports, this one was written long after the events recorded – and yet, for all that, it rings true.

A TIME OF STUDY

At Cormon's, Van Gogh would spend four hours a day drawing the nude and making studies after casts taken from antique and Renaissance sculpture. His afternoons were mostly spent re-acquainting himself with the Louvre and the Musée du Luxembourg, which

Below: Street Scene, at Five in the Afternoon, *by Louis Anquetin, 1887. Anquetin studied at Cormon's studio.*

had been established in 1818 to show the work purchased by the state of those artists who had achieved national success at the annual Salon. On an artist's death, their work would then enter the collection of the Louvre. Van Gogh could study works by landscapists such as Georges Michel (1763–1843), whom he rated alongside Rembrandt, and Daubigny, whose painting *Spring*, painted in 1874, was now hanging in the Louvre. Daubigny was a painter much admired by Van Gogh – one of his last

completed works would be an exuberant rendering of Daubigny's house and garden at Auvers-sur-Oise. Van Gogh never lost faith with the painters he studied during this period, writing in the last year of his life of "the eternal youth of the school of Delacroix, Millet, Rousseau and [Jules] Dupré."

Below: The Caryatids' room in the Louvre. Like Monet, but unlike Degas, Seurat and Gauguin, Van Gogh had little regard for the stylized nature of classical art.

COLOUR IN NATURE AND ART

Paris afforded Van Gogh the opportunity to view the works of two of his greatest influences: Delacroix and Monticelli. Following their example, he painted endless studies of flowers, seeking to render their colours and contrasts.

Van Gogh would already have known Eugène Delacroix's work – but now, nourished by his recent reading of the artist's writings, it is likely that he was keen to see the works again. Visiting the churches and galleries of Paris allowed him to do this.

DELACROIX

One can only imagine Van Gogh's response to Delacroix's *Pietà* (1844) in the Church of St Denis du St Sacrement, and to the great murals in the Chapelle des Anges at Saint Sulpice, completed in 1861 just before the artist's death in 1863. He, like so many artists, would have stood in front of Delacroix's monumental *Jacob Wrestling with the Angel* and studied the power of its colour, the drama of interlocked figures, the vigour of the landscape and, above all, the magisterial fusion of colour and line in the still life at the lower edge of the painting whose influence is clearly seen in Van Gogh's future work.

MONTICELLI

Van Gogh also adored the work of Adolphe Monticelli (1824–86), an eccentric painter from the south of France who had enjoyed a period of renown in the previous decade, but had since fallen into obscurity. Monticelli, who was also admired by Cézanne, came from a humble family. An alcoholic, he lived a bohemian life, dedicated to his painting. Influenced by Delacroix and the Barbizon painters, he produced romantic and fantastical canvases built up in richly encrusted and highly coloured surfaces. The prismatic colour and the weight of impasto often rendered his canvases almost completely unintelligible. Van Gogh was struck by his freedom of technique and what he saw as his visionary power. "I sometimes think," he wrote later in life, "I am really continuing

Left: Jacob Wrestling with the Angel, *by Eugène Delacroix, 1849–61. The archetypal struggle between opposites, man and god.*

Below: Harvesting, *by Adolphe Monticelli. Reminiscences of Watteau, Millet and the baroque mingle together in Monticelli's highly idiosyncratic style.*

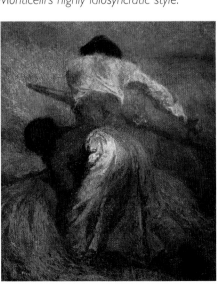

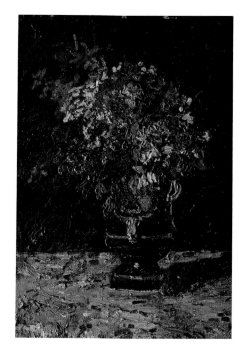

Above: Vase of Flowers, by *Monticelli. The rich colour and heavy impasto appealed both to Van Gogh and to Cézanne.*

Above: Delacroix's Flowers, *1848. Delacroix wrote that a painting should be first and foremost a "feast for the eyes".*

Below: Bowl with Sunflowers, Roses and other Flowers, *1886. Van Gogh has learned his lessons well.*

that man," and he encouraged his brother to promote his work. The high regard he held for this now forgotten artist was one of the major reasons for his decision to travel south to Provence.

PAINTING FLOWERS

Like Rubens, both Delacroix and Monticelli were consummate painters of flowers. Following their practice, in the summer of 1886, Van Gogh began a programme of flower painting that resulted in over 30 surviving canvases, each startlingly different in form, content and coloration. As when painting self-portraits, painting flowers does not involve the expense of hiring a model. Choosing his blooms and their setting, Van Gogh found he could explore the effects of radical colour contrasts and harmonies and develop his drawing without having to concern himself with the vagaries of personality or perspective. He wrote of Monticelli's flower pieces that they were merely "an excuse for gathering together in a single panel the whole range of his richest and most perfectly balanced tones."

His descriptions of these paintings are deeply lyrical, but the lyricism is never employed for its own sake; at the base of these endlessly inventive variations is a sustained exploration

of colour, texture and composition. "I have made a series of colour studies in painting," he told Levens, "simply flowers, red poppies, blue cornflowers and myosotis, white and red roses, yellow chrysanthemums – seeking oppositions of blue with orange, red and green, yellow and violet, seeking *les tons rompus et neutres* to harmonize brutal extremes. Trying to render intense colour and not a grey harmony."

One can almost sense Van Gogh's excitement as he makes one discovery after another. Fired by all he was experiencing he was working furiously, painting his pictures directly on to the canvas with no underdrawing or preparatory sketches, his brushes loaded with paint. His frenetic activity was further fuelled by the impact of seeing the eighth Impressionist exhibition, which had opened in May 1886.

IMPRESSIONIST EXHIBITION, 1886

The Impressionist exhibitions had begun in 1874, and in May 1886, the long-delayed eighth exhibition took place in Paris. The inclusion of a masterpiece by Georges Seurat heralded the end of Impressionism and the beginning of a new avant-garde scene.

Many of the works shown at the exhibition by younger artists such as Georges Seurat, Paul Signac and Paul Gauguin revealed dissatisfaction with the ocular approach evident in the earlier exhibitions.

THE IMPRESSIONISTS

Of those who had shown in the original exhibition in 1874 only Edgar Degas (1834–1917), Berthe Morisot (1841–95) and Camille Pissarro (1830–1903) were represented here; Monet, who was regarded as the leader of the group, Pierre-Auguste Renoir (1841–1919) and Alfred Sisley (1839–99) did not exhibit. Van Gogh had by now become a great admirer of some of the Impressionists, although at this stage his letters did not mention the work of an ex-stockbroker who for the

last three years had been trying to earn his living as an avant-garde artist – Paul Gauguin. Gauguin was hungry to create an art that would appeal not just to the eye, but that would strike a chord in the viewer's imagination and stir the soul.

The 1886 exhibition was dominated by an extraordinary work by an enigmatic and brilliantly gifted 26-year-old painter named Georges Seurat. His canvas, *Un dimanche après-midi à l'ile de la Grande Jatte* (Sunday Afternoon on the Island of the Grande Jatte), was monumental in size (2 x 3m/7 x 10ft) and so original that new names were needed to characterize it: pointillism, divisionism and Neo-Impressionism. The painting's surface was composed of tiny dabs of pure colour which, when seen from a distance, mixed in the eye to create a shimmering, tapestry-like effect.

This work seemed to many to be a welcome and necessary corrective to the highly subjective and intuitive painting of Monet and his associates. A new generation of writers and artists wanted an art that was more evocative, more centred upon ideas than mere sensation. As Gauguin said, "the ceiling of Impressionism is too low."

The avant-garde in Paris was a notoriously fractious community, with groups constantly forming and re-forming, each suspicious of the others as they tried to build

Below: Sunday Afternoon on the Island of La Grande Jatte, 1884–6. Georges Seurat's monumental composition of an ordinary Sunday afternoon combines the hierarchic power of Egyptian and Renaissance art with an audacious use of colour.

Right: Camille Pissarro. Van Gogh wrote, "What Pissarro says is true, you must boldly exaggerate the effects of either harmony or discord which colours produce."

upon the seemingly outdated experiments of the previous decade. Seurat became the authoritative figure on the scene and Pissarro, a founder of the original Impressionist group, began to adopt his 'ultra-modern' style. Pissarro also became friendly with Van Gogh, and as he had done with the unruly Cézanne in the 1870s, took him under his wing.

However difficult Van Gogh may have been, the various factions were careful not to fall out with him if they could help it, for Theo had managed to use his position at Bossoud, Valladon and Co. to secure a room on the third floor of the gallery, where he was allowed to show and sell the work of artists

Below: Apple Pickers, by Camille Pissarro, 1886. A respect for working people, and a fascination with artistic experimentation, characterize Pissarro's art.

he believed in, such as Monet and Pissarro. Unfortunately, for obvious reasons, Theo could not show his brother's work. Van Gogh, undeterred, found other venues, such as the shop and gallery of Julien 'Père' Tanguy on Rue Clauzel.

Tanguy's shop was also a rendezvous point for artists and it was here that Van Gogh met the wealthy Paul Signac (1863–1935). Signac was the self-styled apostle of

Above: Père Tanguy, 1887–8. Rodin owned a version of this painting. It is painted in clean colour straight from the tube, with Japanese prints in the background.

pointillism, desperate to find other adherents. By the summer of 1887, Van Gogh had taken the new style on board and, as was his nature, was wresting it from its punctilious exactitude and in doing so creating from it the seeds of his future.

'PÈRE' TANGUY

The 60-year-old Tanguy was an eccentric and generous spirited shopkeeper, colour merchant and small-time picture dealer who often exchanged his colours for paintings. In the process, much to his wife's annoyance, he had built up a large collection of paintings by Paul Cézanne, Van Gogh, Émile Bernard and others. He sold work when he could – Cézanne's for 50 francs, the occasional Van Gogh for a derisory 20 francs. Such was their mutual regard that Van Gogh painted three portraits of Père Tanguy, *à la Japonaise*, settled in the centre of a wall decorated with Japanese prints, Tanguy's hands folded in his lap in emulation of the Buddha. Tanguy did not forget the strange Dutch artist; four years later, he was one of the few mourners at Van Gogh's funeral.

FRIENDSHIPS

Van Gogh was happy in Paris: "We are working at the French Renaissance," he wrote to Theo, who at his persuasion had exhibited Monet at Boussod's. "I feel more French than ever in this task; we are in a homeland here."

Living with Van Gogh was proving to be a great trial to Theo. His elder brother's ceaseless conversations, general untidiness and bohemian lifestyle were driving him to illness.

THE LONG-SUFFERING THEO

Shortly before moving to the larger apartment on Rue Lepic, Theo wrote a desperate letter to his sister Wil, complaining, "My home life is almost unbearable! No one wants to come and see me any more because it ends in quarrels, besides he is so untidy that the place looks far from attractive. I wish he would go away and live by himself." In response his sister advised him to ask Van Gogh to move out, but Theo could not. "It is quite certain that he is an artist, and while what he is doing now may sometimes not be beautiful, it is sure to be of use to him later on, and then it will be sublime, and it would be a shame if it were impossible for him to go on studying. No matter how impractical he may be, if he only improves himself he is sure to start selling one day. I am fully determined to go on acting as I have done until now."

In late December 1886 Theo suffered "a serious nervous disorder" – probably exacerbated by living with his brother. As a result Van Gogh seems to have spent less time at the apartment and more and more time wandering the city.

PÈRE TANGUY

At Père Tanguy's shop Van Gogh met briefly with Paul Cézanne who had no time for Van Gogh's canvases, thinking them the work of a madman. He received a more sympathetic response from Paul Signac and a close

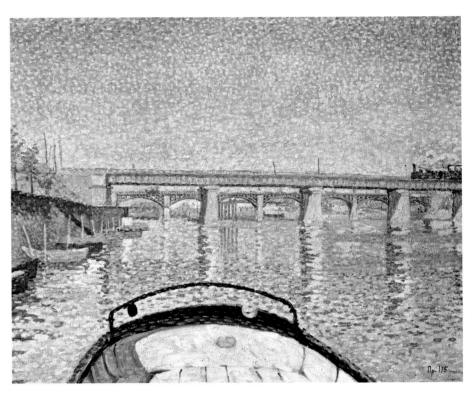

Above: The Bridge at Asnières *by Paul Signac, 1888. Painted in the pointillist or divisionist technique adopted by Van Gogh in some of his works.*

Below: Self-portrait, *by Paul Cézanne, 1887. In his* L'Oeuvre, *Émile Zola revealed his disappointment with Impressionist art; even that of his friend, Cézanne.*

Right: Paul Signac c. 1900. A wealthy man, Signac befriended and supported many avant-garde artists less fortunate than himself.

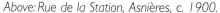

Above: Rue de la Station, Asnières, c. 1900. *Above: Detail of* The Night Café in Arles.

POINTILLISM

Georges Seurat had studied scientific research on colour by Charles Blanc (1813–82) and Eugène Chevreuil (1786–1889), writers who revealed how a colour placed on a canvas will engender in the viewer's eye a halo of its complementary colour. Paul Signac would have discussed the work and ideas of his good friend Georges Seurat with Van Gogh, who was happy to experiment with pointillist effects. Many of his paintings of this time use variations on the technique and are clearly inspired by their commitment to urban themes.

However, Van Gogh could never really accept the 'scientific' tenets that Signac insisted underpinned and justified their practice. He found their ideas on colour the most intriguing, especially their use of small non-descriptive touches of complementary colours – a technique that he would have known from studying the work of Rubens and Delacroix, both acknowledged sources of the new process. When Van Gogh experimented with the style he could not adopt the cool, objective approach favoured by his friends.

This process became part of his standard practice and can be seen in some of his some of his most well-known canvases, for example *Interior of a Restaurant* of 1887, and in a suitably modified way for a greater emotional effect in other canvases, such as *The Night Café in Arles.* "I often think of his [Seurat's] method," he wrote from Arles, "though I do not follow it at all, but he is an original colourist, and Signac likewise, though to a different degree; the pointillists have found something new, and I like them well, after all."

friendship developed between the two. Signac was always on the lookout for new converts to pointillism and would go with Van Gogh to paint not the boulevards at the centre of Paris, but the suburban and industrial areas on the periphery of the city, such as Asnières (the setting for Georges Seurat's masterpiece *Bathers at Asnières* of 1883–4, retouched in 1887). "Sticking close to me," Signac remembered, he "shouted and gesticulated, brandishing his large, freshly covered canvas, and with it he polychromed himself as well as

Above: Bathers at Asnières, *by Georges Seurat, 1883–4. This magisterial painting, epic in scale, was retouched in 1887 – the artist adding dots of orange and blue to the boy's hat.*

passers-by." Van Gogh would meet Émile Bernard there too, as his family lived in the vicinity. The three artists never worked together as Bernard, only 19, although initially attracted to pointillism and taken up by Signac, had soon rejected pointillism in favour of working with Gauguin. Signac never forgave him.

THE 'PETIT BOULEVARD'

"What is required in art nowadays," Van Gogh wrote, "is something very much alive, very strong in colour, very much intensified." Like so many artists of his generation Van Gogh was determined to find a public to enjoy and purchase their new, experimental art.

The friendship between the young Bernard and Van Gogh remained strong. It would last until Van Gogh's death.

ÉMILE BERNARD

The two friends painted together through the summer and into the winter of 1887, and Van Gogh's determination to paint directly from his subject matter was noted by Bernard: "Rain or snow, he braved them all. He put himself to work no matter what time of day or night whether to paint a starry sky or noon sun."

Van Gogh and Bernard celebrated their friendship with two exchanges of the same subject, the railway bridge at Asnières. Later, when Van Gogh moved to the south of France, the relationship continued through their correspondence. Bernard was to publish excerpts from Van Gogh's letters in 1893 (followed by a full collection in 1911), and this was a formative event in establishing Van Gogh's posthumous reputation both as an artist and a consummate letter-writer.

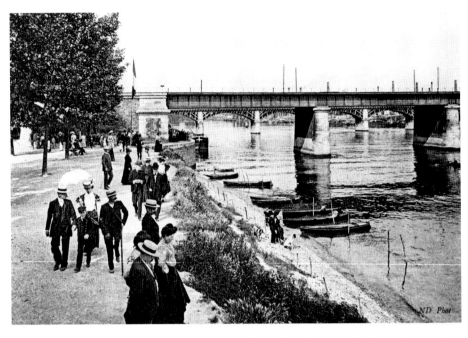

PARIS EXHIBITIONS

Van Gogh and Bernard were not the only avant-garde artists who struggled to create a viable response to the Impressionist experiments of the previous decade, although Van Gogh had no illusions about the nature of that struggle. He was dismayed by the

Above: The bridge at Asnières. A scene that attracted many of Van Gogh's friends and acquaintances – and one that he would paint in different locations many times.

"disastrous squabbles among the various cliques of the new painters, each member getting at each other's throats with a passion worthy of a nobler and better aim." Perhaps in an attempt to reconcile the disparate factions and bring them to the attention of a largely inattentive public, Van Gogh used his gallery experience to organize a number of exhibitions in cafés and restaurants.

In the spring of 1887, he exhibited a collection of his own Japanese prints in a popular restaurant, Le Tambourin, where he had been able to negotiate free meals in exchange for his otherwise unsaleable paintings. The restaurant was run by an ex-artist's model, Agostina Segatori, with whom he had some kind of relationship – which, as ever, ended badly.

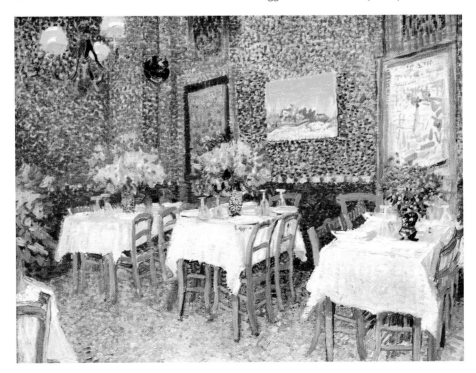

Left: Interior of a Restaurant, 1887. Van Gogh's espousal of the latest theories can be clearly seen in this painting.

Right: Van Gogh's portrait of restaurant owner Segatori, December 1887.

In November Van Gogh organized an exhibition of the work of his new associates, the "painters of the petit boulevard", at La Fourche, a large, popular and inexpensive restaurant in the avenue de Clichy, patronized by artists and writers. Works on view included those by his friends Toulouse-Lautrec, Bernard and Louis Anquetin – artists who painted the unfashionable suburbs and the streets and café culture of Montmartre. Their name set them apart from the radical painters of the previous generation – Monet, Renoir and the other, now successful, Impressionists whose work was sold in expensive galleries on the 'grands boulevards' in the city centre. There were a few sales, which delighted Van Gogh, but unfortunately none of his own works were sold. According to Bernard, Van Gogh's work, which included a portrait of Tanguy and some paintings of factories, made a significant impact. "The general impression," he wrote, "was that the hall was dominated by him; it was a joyful, vibrant, harmonious impression."

Bernard would not allow Van Gogh to invite Signac and his friends to exhibit and so any hope that

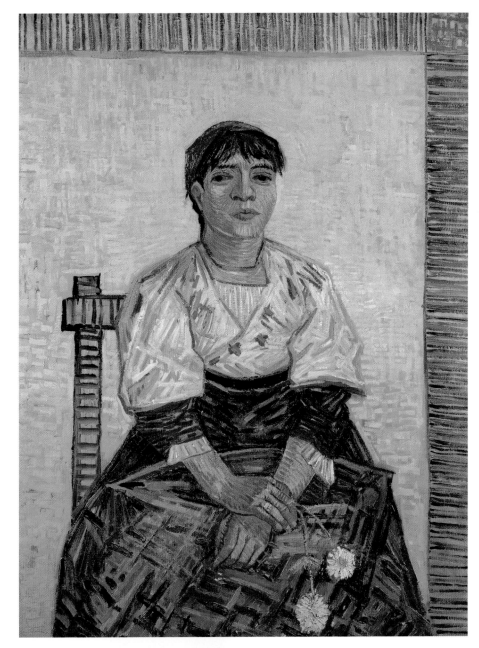

Van Gogh may have had of reconciling the various warring parties failed. Van Gogh was never one to take sides, though, and he happily showed with Bernard's enemies, Seurat and Signac, in the lobby of the newly opened Théâtre Libre, on Rue Pigalle. This was a prestigious event for him, but one that resulted in no real recognition or sales.

Nevertheless, these activities reveal the extent of Van Gogh's ambitions and his awareness of the need to exhibit in order to secure a recognized position as a major player in the avant-garde.

Left: La Fourche, Avenue de Clichy, Paris.

THE CALL OF THE SOUTH

Van Gogh now found himself drawn to the south of France. His attitude now was more ambitious and professional than ever, as was Theo's, who was now investing seriously in his talented older brother.

In Paris, however hard a time he may have had of it personally, Van Gogh had proved himself to be a dedicated, professional and ambitious artist, furthering his career by making best use of all the possibilities available to him. He had exhibited his work, made friends and acquaintances, developed contacts and absorbed many of the dizzying possibilities that the avant-garde scene had to offer.

A RETURN TO THE COUNTRYSIDE

Van Gogh expended much energy attempting to convince Theo of the sound business sense of becoming an independent dealer and marketing the work of the Impressionists and their friends. He was overjoyed when Theo signed a contract with Monet and sold some work by Degas. However, in autumn 1887, with the prospect of another cold winter looming, he grew depressed and weary. His friend Gauguin was away in South America, apparently painting the exotic splendour of the tropics, but in reality working as a navvy

Below: Self-portrait with Straw Hat, 1887, painted with flecks of contrasting colours and cursive strokes of paint.

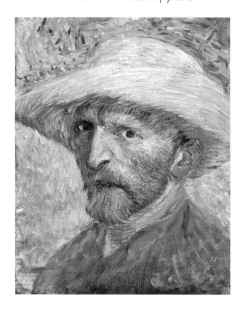

Above: Martinique Landscape, 1887. Painted just a few years before an earthquake, Gauguin represents the exotic island of Martinique as a earthly paradise.

on the Panama Canal. Van Gogh longed to imitate his friend's search for some earthly paradise and decided to travel to the south of France in order to recuperate and to bring the confusion of the last few years into order. He hoped to revisit and build upon the work he had done at Nuenen, which was still, he thought, the best he had ever done, and use his experience in Paris to recreate it in more vigorous form. Accordingly, he made plans to go south to Marseilles, stopping off briefly at Arles to paint the

landscape familiar to him from the paintings of his beloved Monticelli and the mysterious and solitary Cézanne.

Theo was relieved to see him go and agreed to send him a monthly remittance – not as a charitable act, but as an investment in his elder brother's future. In return, Van Gogh agreed to

Above: Wheat Field with a Lark, *1887. The directional brushstrokes and broken colour suggest the invisible action of the wind.*

DEVELOPING A NEW STYLE

In a systematic, workman-like way Van Gogh greedily absorbed the new tendencies demonstrated in the work of Lautrec, Bernard, Signac and Seurat. He put them through the boot camp of his own practice, re-inventing them, and in the process strengthened and further defined his own ambitions. His paintings of this time are built up of a modified pointillist dot and dash – Van Gogh never used the methodical technique of Signac, but always worked in an open, intuitive fashion. From his friends Anquetin and Bernard, he adopted and adapted their innovative use of flat areas of colour and the strong enclosing line. Slowly the possibility of a new art suggested itself – one in which line and colour would act as sympathetic and expressive partners combined to make a single visual utterance of remarkable power.

give Theo ownership of all his output. Before setting off, Theo took him to Seurat's studio where he saw the painter at work on his latest painting, *La Parade.* Seurat's precise and measured manner, impressive though it was, was at odds with Van Gogh's newly adopted way of working. He had now acquired the distinctive approach to painting and drawing that he would use and develop for the rest of his short life – the short, hatched, rhythmic touches of pigment that lock the entire surface of paper or canvas into one expressive unit.

Below: The Parade, *by Seurat, 1887.*

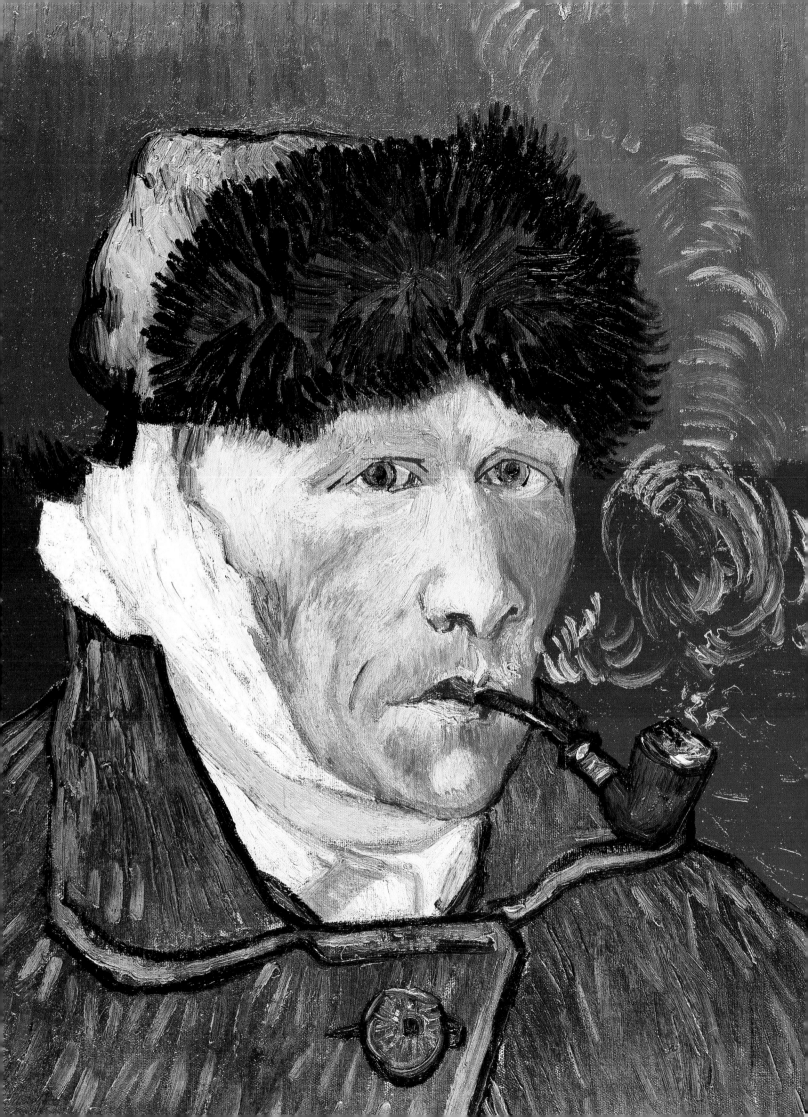

THE SOUTH: ARLES, ST-RÉMY AND AUVERS-SUR-OISE

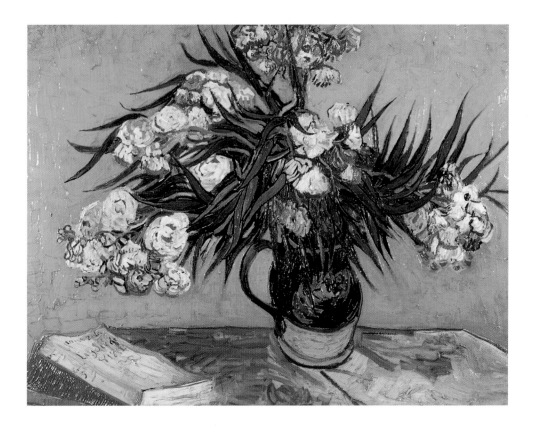

Van Gogh moved to Arles for a variety of related reasons, not least to
attempt to recover his failing health and to continue to develop his art.
He was buoyed up by his dream to establish a 'Studio of the South' in the
Yellow House ('*la petite maison jaune*') where he and his friends and
colleagues could work and exhibit together, creating in the process – far
from the hectic rush of the capital – a new art for the future. Theo's letters
reveal just how close they had become over the two years he had been
in Paris and the letters between the two brothers give a unique account
of the rest of Van Gogh's short life.

Above: Still Life: Vase with Oleanders and Books, *August 1888. Left:* Self-portrait with
Bandaged Ear and Pipe, *January 1889. Reds and oranges clash with greens and blues, and
the break in the background behind Van Gogh's head cuts right through his eyes.*

ARLES: SPRING AND NEW LIFE

Arles did not seem to interest Van Gogh much as a city. Instead he looked to the immediate vicinity, and taking the landscape and the people of Arles as his inspiration, he produced some profoundly beautiful work, while his personal life continued to be chaotic and difficult.

Van Gogh's two years in the capital had exhausted him. He had produced an astonishing variety of paintings and assimilated much that the Paris art world had to offer. Now separated from his brother, colleagues and acquaintances and far removed from the city, Van Gogh took up his correspondence again.

ARRIVAL IN ARLES

On 20 February 1888, after a long and arduous train journey, Van Gogh arrived in Arles to find the landscape covered in a rare fall of thick snow. He saw the town and the vast plain stretching out toward the distant mountains "white against a sky as luminous as snow…just like the winter landscapes that the Japanese have painted."

Above: Van Gogh saw his new surroundings imbued with memories of his northern homeland and looked out for motifs that suggested the landscape of Holland.

ARLES

A working town, Arles also supported a military barracks housing a company of Zouaves, composed mainly of conscripts from French settlers in Algeria and Tunisia, and their resplendent uniforms gave the town an added sense of the exotic. Van Gogh was uninterested the legacy of the town's past history. It had been one of the most important ports in Roman and medieval times, but had since slipped into a slow decline. Van Gogh never mentioned the almost intact Roman amphitheatre that dominates the centre of the town, although he would visit for the local bullfights, and he referred to the carvings on the façade of the Romanesque cathedral of Saint-Trophime, one of the most beautiful buildings in France, as a "Chinese nightmare".

Arles is situated on the right bank of the River Rhône as it breaks into the Camargue delta; to the east and north lie the flat plain of La Crau that stretches out to the foothills of the Alpilles Mountains. Though impressed by the surrounding landscape, Van Gogh was less pleased with Arles itself, dismissing it as "a filthy town". He found the people generally unhelpful, but he recognized and appreciated the much-vaunted beauty of the Arlésiennes – the young women of Arles, with their colourful shawls and black headdresses – and wondered what Seurat would have done with such material.

TREES IN BLOSSOM

The inclement weather ruled out any immediate excursions into the countryside and so he contented himself with painting still lifes and generally settling in. However, in less than a month, the trees were in blossom and he began to paint them. Between 24 March and 20 April he completed nine paintings of peach trees in blossom. Beautifully observed, they are frankly decorative and reminiscent of Japanese prints in their subject matter and delicacy of touch and colour. With consummate ease, Van Gogh fuses the natural with the symbolic; without any allegorical awkwardness they speak of the beginnings of new life after the darkness of winter. He described the works as being "done in open air in an orchard" and "probably the best landscape I have done."

As he was in the middle of painting this series, he heard of the death of his relative and sometime teacher, Anton Mauve. "Something – I can't say what – took hold of me and brought a lump to my throat", and he inscribed one of the canvases with "Souvenir de Mauve, Vincent",

to be given to Mauve's widow (Van Gogh's cousin). Later, he would send another, more modest, image of blossoms to his brother Theo in honour of the birth of his son: life and death. So much of Van Gogh's art is preoccupied by the cycles of birth, life, death and regeneration, whether in human experience or the natural world.

REMINDERS OF HOME

Coming south to find echoes of Japanese prints, he was surprised everywhere he looked by reminders of Dutch 17th-century landscape painting. One of his first completed oils of this time, painted with the aid of his trusted perspective frame, was of a wooden lifting-bridge at Langlois, which had been designed by a Dutch engineer and was similar to one he had made a drawing of at Drenthe.

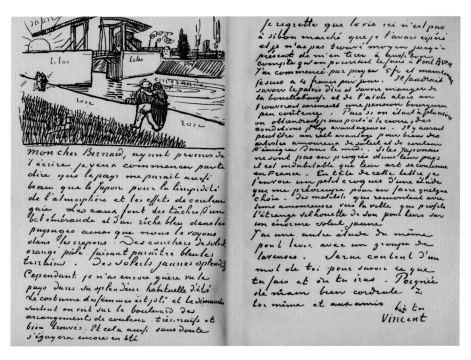

Above: Van Gogh's letters are precious documents of his inner life and his work: this drawing reveals that The Lovers of 1888 were once part of this composition.

Below: The Langlois Bridge at Arles with Road Alongside the Canal, *March 1888. Van Gogh painted this picture soon after his arrival in Arles.*

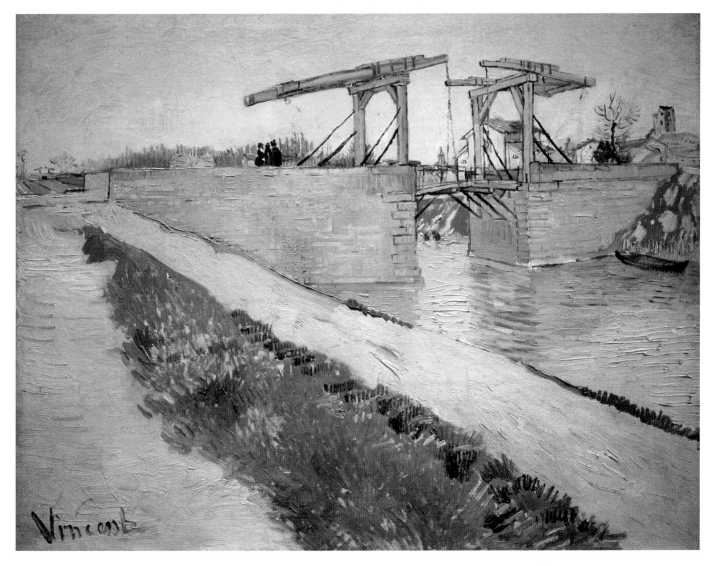

THE SHOCK OF THE SUN

Van Gogh was filled with confidence and optimism. His painting, he felt, was better than ever, and encouraged by the good weather and a somewhat healthier lifestyle, he continued to make new artistic discoveries, creating in the process some of his most popular works.

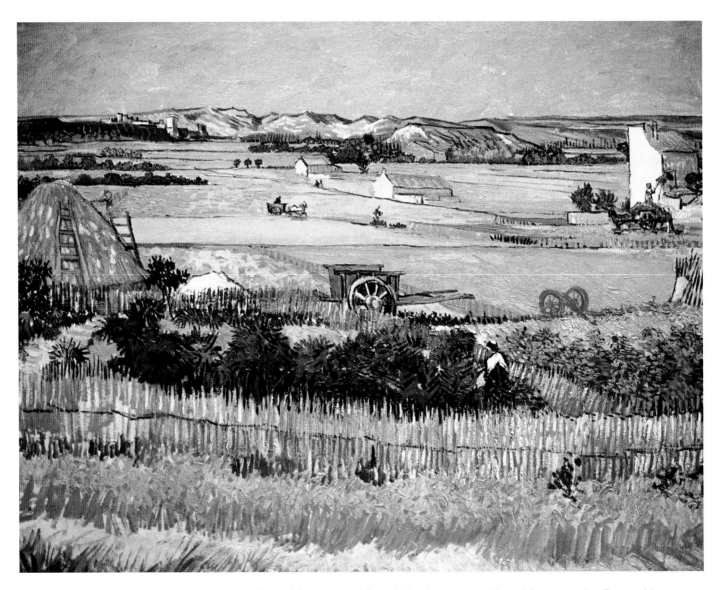

Van Gogh continued his practice of painting directly from nature, without the need for preparatory studies. He revelled in the exoticism of the region's many attractions: the rocky outcrop of Montmajour, the patchwork quilt of La Crau, the mighty River Rhône and the Roman tombs that edged the Alyscamps. In the town he enjoyed the cafés, the parks and the iron bridge at Trinquetaille.

A NEW OPTIMISM

Van Gogh painted the flowers and vegetation as they came into season, in the full heat of the sun, when the mistral

allowed (a strong, cold wind blowing down from the north). He painted still lifes such as a beautiful "cup with orange and blue patterns" and a "handsome barbotine or majolica jug." He recognized this work as a major achievement and in its simplicity and boldness it looks forward to the works of Henri Matisse.

In June he painted *Harvest at La Crau,* which he considered to be his best work to date. The months passed and as the summer heat intensified, Van Gogh relished the life-restoring radiance of the Mediterranean sun, "a light that for want of a better word I shall call

Above: Harvest at La Crau, with Montmajour in the Background, *1888.*

yellow, pale sulphur yellow, pale golden citron! How lovely yellow is! And how much better I shall see the North!" Despite the mistral, and the occasional downpour of rain, he could hardly keep up with his own production, "nature here being so *extraordinarily* beautiful." There is a new warmth and intimacy between the two brothers evident in these letters; they were on a joint venture, with Theo's financing of his brother being a step on the road to him

Below: Van Gogh lived in this house during the time he spent in Arles.

Above: Rocks with Oak Tree, *July 1888. The powerful graphic structure of his drawings is paralleled in his paintings.*

becoming an independent dealer, ready to champion and profit from his support of avant-garde art.

Van Gogh was growing increasingly optimistic about the future of his art and that of his friends, Émile Bernard and Paul Gauguin, who at that time were working together in Brittany. He considered the three of them as potential harbingers of a new art: "A new Renaissance, this green shoot springing from the roots of the old felled trunk."

SEEKING THE LIGHT

His painting and drawing are miracles of re-invention as the complexity of sensual experience, the sight, smell and feel of the landscape is distilled into pictorial fact. In emulation of Rembrandt and the Japanese, he became a master of the simplest of media – the reed pen. Cheaper than paints, he could use this when the mistral made painting impossible. Like Cézanne, a "fellow painter of the south" who had returned to his native Aix-en-Provence a decade earlier, Van Gogh was not so much interested in capturing the fleeting effects of light that had captivated so many of the Impressionists in the 1870s, as in the business of finding an equivalent for the *éclat* (the 'shock' of light) itself.

Below: Van Gogh enjoyed visiting the Roman tombs at Alyscamps.

WORK AND HEALTH

If his letters are to be believed, Van Gogh was now taking active steps to improve his health, and to keep to a modest intake of alcohol, being, as he wrote, "aware of Monticelli's ruinous addiction to absinthe". However, he continues, "from the mental labour of balancing six essential colours, red – blue – yellow – orange – lilac – green…with one's mind strained to the utmost…the only thing to do to bring ease and distraction…is to stun oneself with a lot of drinking or heavy smoking." He was eating properly when he could, though the food in the café where he was staying was almost inedible, and he was making use of the local brothel for what he termed necessary "hygienic" purposes.

PAINTING LANDSCAPES

"What I learned in Paris is leaving me, and I am returning to the ideas I had in the country before I knew the Impressionists." More and more interested in the scenery around him, Van Gogh made painting expeditions to the sea, as well as painting the landscape around Arles.

Keen to experience new surroundings, Van Gogh made a visit to the picturesque town of Saintes-Maries-de-la-Mer, a small community on the Mediterranean coast where Monticelli had painted some years before.

A TRIP TO THE SEA

As there was no train to the town from Arles, Van Gogh made the five-hour journey across the wild beauty of the Camargue in a horse-drawn coach and stayed five days. In a landscape dominated by lavender fields and overlooked by a fortified church, Van Gogh was able to use a wide range of his favourite colour contrasts and to return to familiar motifs of rural labour. Like his Dutch forebears, Van Gogh uses a series of horizontal bands made up of distinct colours that allow the full panoramic sweep and nature of the landscape to be appreciated. "The south should be represented by *contraste simultané* of colours and their derivations and harmonies and not by forms and lines in themselves."

At the coast he was struck by the look of the cottages, finding them similar to the dwelling he had painted a few years before at Drenthe. But it was the sight of the sea itself that inspired him to write one of the most descriptive passages in his letters: "The Mediterranean has the colours of mackerel, you don't always know if it is

Below: Seascape at Saintes-Maries, *1888. A subject familiar to Van Gogh from the Dutch coast and Japanese prints, but now invested with a new energy.*

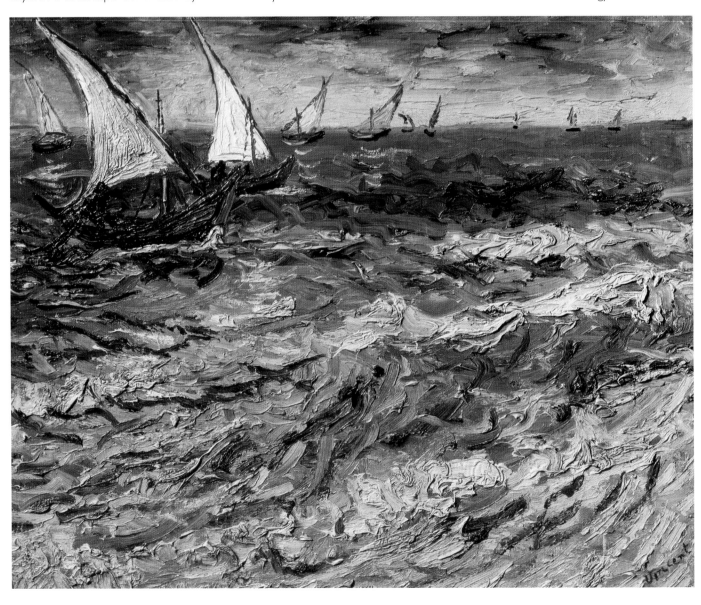

Right: The harbour at Saintes-Maries-de-la-Mer, in southern France. Heavy development has all but obliterated many of the motifs Van Gogh painted.

green or violet, you can't even say it's blue, because the next moment the changing light has taken on a tinge of pink or grey." The audacious colouristic experiments of his time in Paris enabled him to use vibrant harmonies to capture not just the look of the landscape, baking beneath the hot Mediterranean sun and the hard blue of the sky, but also its feel.

Such was his growing confidence in his art that he amazed himself by making a drawing of the complex forms of the fishing boats in less than an hour without resorting to the use of his perspectival frame. For Van Gogh, drawing, while being part of a process, becomes increasingly a thing in itself and his drawings are as inventive and extraordinary as his paintings.

THE SIMPLE LIFE

Like so many other 19th-century artists, Van Gogh was looking to the countryside to seek out subjects that would celebrate the apparently

Below: The Café de la Gare in Arles.

simpler lives of those who lived there, 'uncorrupted' by the complexities of modern urban living. In moving away from Paris, as Gauguin and Cézanne had done, Van Gogh was not escaping from reality. As an ex-art dealer he would have known that rural subject matter, if handled correctly, was highly bankable – in 1885 Millet's *Angelus* had sold to an American buyer for the astronomical sum of 800,000 francs.

For Van Gogh, however, any such ideas were overshadowed by his deep need to relate and connect to the world. He always came back to the human dimension, even to the extent of denigrating the very art to which he had dedicated his life. "It's more worthwhile to make children than pictures or carry on business… it's what people have in their hearts that matters…"

THE CAFÉ DE LA GARE

The downstairs room of the café in Arles remained open all night and Van Gogh became friendly with the owners; he managed to persuade Madame Ginoux to pose for him on a number of occasions. Van Gogh made the café the subject of one of his most compelling canvases, *The Night Café*. He also painted the café early in the morning; it is a hellish equivalent to the sacramental atmosphere of his first masterpiece, *The Potato Eaters*. Its composition also creates a curious parallel to his painting *Vincent's Bedroom in Arles*, which he produced in anticipation of Gauguin's imminent arrival.

PAINTING PORTRAITS

However much Van Gogh loved painting the landscape around him, he loved and needed people more. His portraits of the ordinary people he met, like all the greatest portraits, seem to truly take on a life of their own.

There is a huge variety in Van Gogh's portraits, but they exhibit the same precision of draughtsmanship and sensitivity to individual characters. He frequently makes use of emblems to suggest something of the sitter's personality and uses a strikingly coloured background to counterpoint or harmonize with their complexion and clothing.

FINDING MODELS

As he had done in Nuenen, Antwerp and Paris, Van Gogh chose to eschew the traditional clients of portraiture, preferring to portray friends and the ordinary people of the community. As ever, though, the difficulty was finding compliant models. He could persuade men easily enough with a drink perhaps, or by striking up a friendship, but women were a different matter. However, Van Gogh always worked quickly – a useful strategy as it stopped the sitters from changing their minds.

THE ROULIN FAMILY

Van Gogh's greatest friend at this time was Joseph Roulin, who was in charge of sorting mail at the Arles railway station. He was a staunch Republican, whose golden hair, beard and florid complexion contrasted with his uniform. He and his family lived a few doors away from the Yellow House, which Van Gogh was having decorated prior to moving in. "I am now at work with another model," Van Gogh wrote, "a postman in a blue uniform trimmed with gold." He painted the postman at least six times. Roulin and his family became very important to Van Gogh; he was welcomed into their

home and they took a real interest in his welfare. His friendship with Roulin gave him entry into a family, and a real sustaining friendship. Van Gogh also painted important portraits of his wife and family and, when the postman left Arles for a post in Marseilles, Van Gogh gave him one of the many portraits he had painted of him as a parting gift.

As he painted the father, so he painted the mother, their baby Marcelle and their sons, Armand, aged 16, and the younger Camille, who was 11 years old.

AN INSPIRED PORTRAITIST

In Arles Van Gogh also met and painted a portrait of the Belgian artist Eugène Boch. This is no naturalistic

Right: Portrait of Eugène Boch, *September 1888. Van Gogh's portraits are masterly conjunctions of the decorative and the real.*

portrait, but a symbolic representation of his sensibility – echoing the subject's yellow ochre jacket, set against a night sky of the intensest blue, a bright star shines forth.

We do not know the name or the circumstances that led to Van Gogh's painting of a young woman in a stunning red and black dress. He entitled the painting *La Mousmé* – a Japanese term for a young girl, taken from Pierre Loti's recently published novel *Madame Chrysanthème*. In these paintings and others like them, such as the radically realized portrait of the aged gardener, Patience Escalier, in a blue smock and yellow straw hat, one realizes the profound significance of Van Gogh's achievement. Like his hero Rembrandt, Van Gogh was able to give a completely convincing record of an ordinary individual and endow it with a sense of ultimate value. As he wrote to Theo, "it is the only thing in painting that excites me to the depths of my soul, and makes me feel the infinite."

Right: Portrait of the Postman Joseph Roulin, *August 1888. Drawing and colour work together to make an unforgettable portrait.*

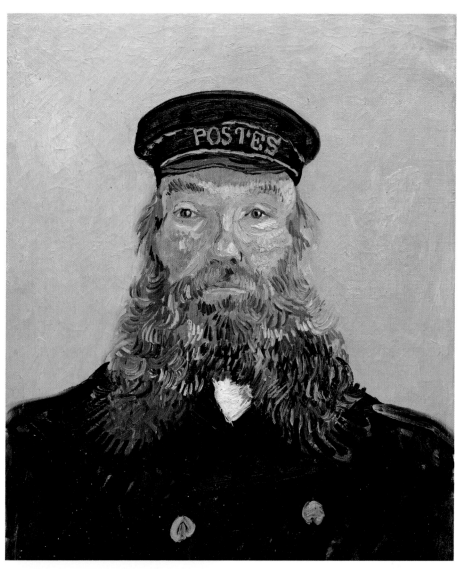

Above: Portrait of a One-eyed Man, *December 1888. Brush marks weave together to hold the composition in place.*

Above: Portrait of Milliet, *September 1888. Many of Van Gogh's portraits are based on oppositions of contrasting colours.*

THE ZOUAVE

Among Van Gogh's many portraits of ordinary people are a few of Lieutenant Paul-Eugène Milliet, an officer in the Zouave regiment who was also interested in drawing and sometimes took lessons from Van Gogh. They often went on sketching expeditions together, although as an old man Milliet admitted that while he admired Van Gogh's drawings, he had never had a particularly high opinion of his friend's paintings!

Lieutenant Milliet is shown in these portraits as a striking young man, with swarthy skin that makes a perfect foil for the deep blues and vermilion of his uniform.

WAITING FOR GAUGUIN

"The painter of the future will be *a colourist the like of which has never yet been seen….*
But I'm sure I am right to think that it will come in a later generation, and it is up to us to do
all we can to encourage it, without question or complaint." Van Gogh to Theo, May 1888.

Van Gogh's letters kept him in touch with family, friends and associates and allowed him to keep alive his hope of founding a 'studio in the south', an artists' commune, just as the Pre-Raphaelites had done in England in the late 1840s. Above all, he wished to join forces with Gauguin and Bernard.

GAUGUIN

Bernard and Gauguin were at that time working together in Brittany, producing deliberately avant-garde paintings based upon religious themes and coloured by their interest in Breton folk culture. Bernard's recent conscription into the French army meant that he would be unavailable, but Gauguin was another matter. He was in dire straits, he had been ill, his pictures were not selling and he had been living on credit at his hotel in Pont-Aven for the last two months. Theo, who had just received an inheritance from Uncle Cent

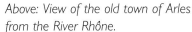

(unlike Vincent, who received nothing), was supporting him and planning to invest in his future.

Van Gogh argued that even though living expenses in Arles were high, if Gauguin and he lived together, Theo would, in effect, be consolidating his outgoings. He was captivated by the idea of founding an 'Impressionist

Above: View of the old town of Arles from the River Rhône.

Society in France' in Arles with Theo as director and, if necessary, with Gauguin at the helm. "We all like Japanese painting," he wrote, "we have felt its influence, all the Impressionists have that in common; then why not go to Japan, that is to say the equivalent of Japan, the South?" Gauguin prevaricated but by the end of the summer his circumstances forced him to agree in principle to joining Van Gogh in Arles. This news spurred Van Gogh into a furious period of activity, painting works to impress his friend and in the process producing some of the most iconic paintings of all time.

SUNFLOWERS

Van Gogh had now negotiated the rent of a ramshackle, yellow-painted building that fronted the nearby Place Lamartine and called

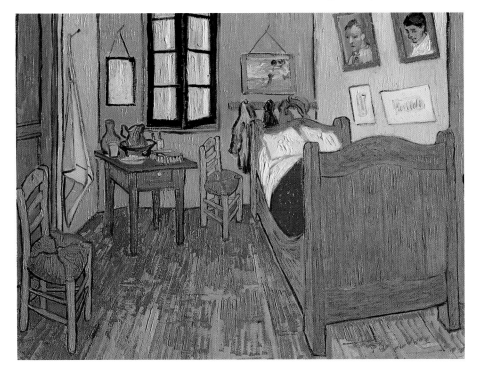

Left: Vincent's Bedroom in Arles, September 1889. Exaggerated perspective and heightened colour create an atmosphere of warmth and welcome.

it the 'Yellow House'. He stayed with his friends, the Ginoux family, at the Café de la Gare during the time it took to make the place habitable. He took delight in furnishing and decorating it to his own requirements and gathered a number of his canvases together to hang in his friend's bedroom: *The Poet's Garden*, (actually the nearby public park), *Starry Night*, a vineyard, a furrowed field and a painting of the Yellow House itself.

Every morning he arose early to work on a projected series of 12 sunflower paintings, each one featuring a simple earthenware Provençal vase signed with 'Vincent' on its side, as if suggesting that the flowers, all shown at various stages of development and decay, were in some way a representation of himself.

Right: Self-portrait Dedicated to Vincent van Gogh (Les Misérables), *by Paul Gauguin, 1888. Gauguin acknowledged the intellectual centre of Van Gogh's art.*

Below: Self-portrait Dedicated to Vincent van Gogh, *1888, by Émile Bernard. As in Gauguin's self-portrait, a secondary portrait within the painting marks it as a document of friendship and, for a while at least, shared ambitions.*

SELF-PORTRAITS

As a "Japanese gesture of brotherhood", Gauguin and Bernard would paint their own portraits and send them to Van Gogh. Gauguin painted a portrait of himself as Jean Valjean, the anti-hero of Victor Hugo's novel, *Les Misérables*, including a profile sketch of Bernard in the background. He wrote to Van Gogh in his typically arrogant fashion that it was "so abstract as to be absolutely incomprehensible". Bernard produced a self-portrait with a sketch of Van Gogh in the background as if tacked on to the wall behind him. Van Gogh praised Gauguin's work and underplayed his own contribution, a stunning self-portrait as a *bonze*, a Zen monk. He has shown himself half-length, with his familiar blue-trimmed jacket, set against a pale malachite-green background, bare of any emblems. His expression is tense, apprehensive even. Head shaved, beard trimmed, Van Gogh has painted himself as an acolyte awaiting his master.

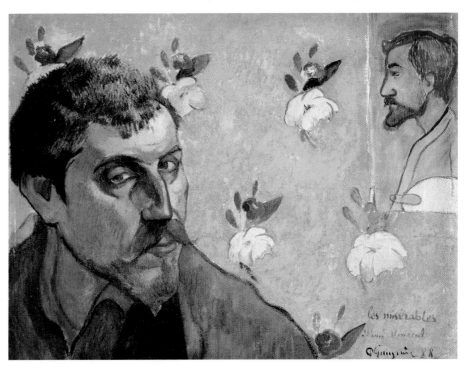

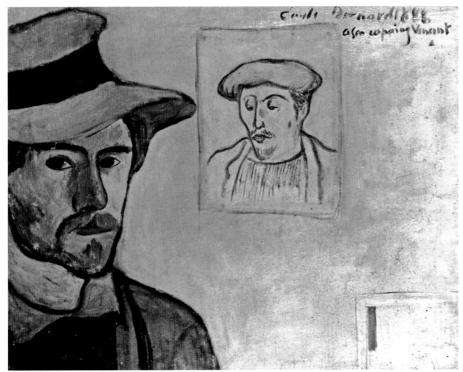

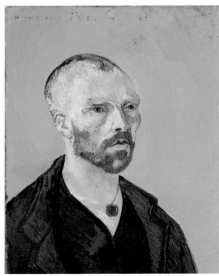

Above: Self-portrait Dedicated to Paul Gauguin, *1888, by Van Gogh. Van Gogh wrote that this self-portrait was painted as "the portrait of a Bonze, humbly worshipping the eternal Buddha".*

A MEETING OF OPPOSITES

Van Gogh and Gauguin became an artistic odd couple: the one passionate, organized and a good cook, the other vague, disorganized and undomesticated. Inevitably, their personalities clashed, as they discovered their differences ran deep.

While waiting for Gauguin to arrive, Van Gogh attempted a self-conscious exercise in his friend's manner. "I must not do figures of that importance without models," he wrote to Theo. "I painted a figure of Christ in blue and orange – and an angel in yellow. Red earth, hills green and blue, olive trees with violet and carmine trunks, and green-grey and blue foliage. A citron yellow sky." It was a complete disaster and he destroyed the painting.

GAUGUIN'S ARRIVAL

In the early hours of 23 October 1888 Gauguin arrived at Arles having travelled from Pont-Aven in Brittany. He went straight to the Café de la Gare, where he was recognized from the self-portrait that he had done for Van Gogh, and settled down to wait until late morning before calling on his friend.

Their arrangement was clear: in return for sending one painting a month to Theo, Gauguin would receive 250 francs a month. The two artists decided

to pool their resources. Gauguin, a former sailor, was appalled at Van Gogh's untidy nature and his complete inability to manage money and so took over the household management, impressing Van Gogh with his skills as a cook. The two men's characters could not have been more different. Gauguin, like Van Gogh, was a complex individual, characterizing himself as a half-savage, half-civilized man. Van Gogh put it even more bluntly: "With Gauguin sex and blood will prevail."

PROFESSIONAL DIFFERENCES

Professionally, too, they were at odds. Van Gogh's way of working was so completely different from Gauguin's that tensions between the two were inevitable. Gauguin had planned to stay for six months, which, given the situation, was optimistic; he was a man of the world and it had only been his dire financial problems that had induced him

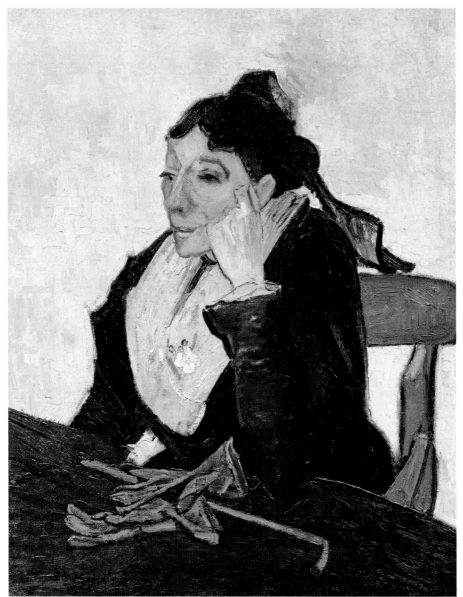

Left: L'Arlésienne: Madame Ginoux with Gloves and Umbrella, *1888. The proprietress of the Café de la Gare in Arles, she posed several times for both artists and was a good friend to Van Gogh.*

Below: Café at Arles, *by Gauguin, 1888. The setting is that of Van Gogh's* The Night Café, *but Gauguin's painting exudes a completely different atmosphere. Van Gogh's friend Joseph Roulin may be glimpsed in the background.*

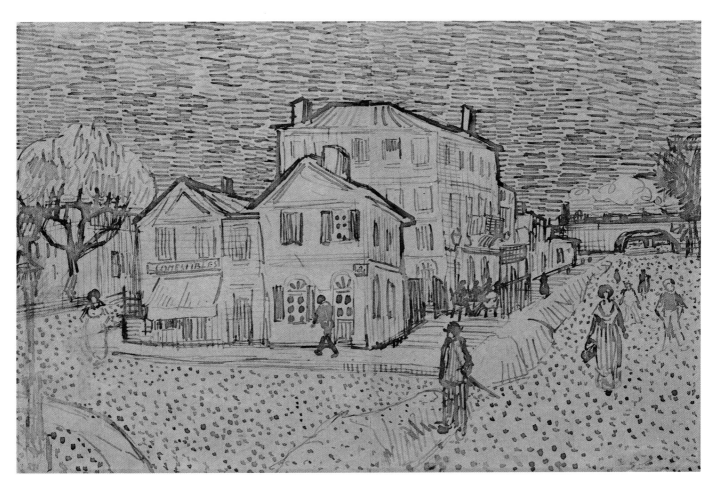

Above: Vincent's House in Arles (The Yellow House), *September 1888. Van Gogh rented four rooms. His bedroom is behind the window with one shutter closed.*

to leave Brittany where his work had been going well. Van Gogh's reputation as a difficult and unpredictable character was also well established. However, for the first few weeks at least, each man was on his best behaviour. As Van Gogh feared, Gauguin's first impressions of Arles were not positive – he later referred to it as "the dirtiest hole in the south" and compared it unfavourably with the rich verdant landscape of Pont-Aven. Their first outing together was to Les Alyscamps, a little distance beyond the walls of the town. Once a large Roman necropolis, it was now used as a park and the two men made it the subject of their first painting expedition. Neither artist showed any interest in the antique remains; they concentrated on the landscape and the picturesque nature of the townsfolk who promenaded there. Although they shared the same subject-matter, their response to it was very different.

A PRODUCTIVE PERIOD

Gauguin was in a positive, buoyant mood as Theo had managed to sell one of his paintings for 500 francs and other sales seemed likely – including one to Degas – and there was serious talk of a future exhibition in Paris. Van Gogh, as was his practice, was prepared to play the acolyte and in the two months they were together they worked hard.

Gauguin painted about seventeen canvases and Van Gogh about twenty-five. Gauguin was a measured, considered painter who liked to take time to plan his canvases and produced preparatory drawings and sketches before carefully executing the final painting. He preferred to work on rough-woven canvases into which the paint sank to produce a dull matt surface; Van Gogh, on the other hand, was happy

Right: Paul Gauguin. The artist's pensive pose is in keeping with his belief that art should be made from memory or drawings and be an invitation to dream and imagination.

with manufactured canvases with a fine weave. For Gauguin painting was very much a studio-based activity, allowing memory to filter out the inessentials; his distortions were carefully calculated to suggest evocative images, replete with nuance and mystery.

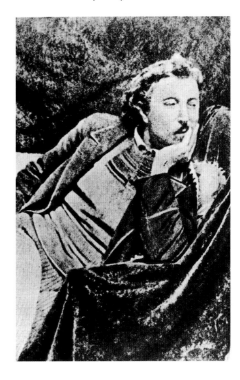

GROWING APART

Tensions grew between the two painters. The conflict between them was as clear in their opinions on the works of other artists as it was in their opinions on each other as people, and how they thought art should be made.

After an initial lapse of confidence, and attempts at some experimental canvases under Gauguin's tutelage, Van Gogh, independent and stubborn as ever, began to re-assert himself. "I cannot work without a model…. I exaggerate, sometimes I make changes in a motif; but for all that, I do not invent the whole picture; on the contrary, I find it already in nature, only it must be disentangled."

GROWING CONFLICT
Of all Van Gogh's paintings, Gauguin most admired the *Sunflowers*. The distance between the two men can be seen in Gauguin's portrait of his colleague painting them. "It's me," said Van Gogh, "yes, but me gone mad." The portrait shows Van Gogh intent on painting directly from nature, with a palette upon which Gauguin has imposed his sense of orderliness, perhaps finding Van Gogh's messy palette distasteful. Van Gogh continued to wrestle

Below: Old Women of Arles, *by Gauguin, 1888. A painting from memory; the cornstooks belong to Brittany, not Arles.*

Above: Van Gogh's Memory of the Garden at Etten, *1888. Gauguin's painting was a response to this work.*

with his friend's belief in the necessity for abstraction and produced a number of exploratory works in good faith; they are interesting, but compared with his other canvases, ultimately unconvincing.

DIFFERING OPINIONS
As winter drew on the two friends found it less conducive to work outside. Short of funds, they were forced to spend a lot more time together and as a result, as Van Gogh put it, the atmosphere grew "electric". Both men were opinionated and volatile, Gauguin possibly becoming aware that the man he thought was going to be his disciple was in fact proving himself to be the stronger painter. Although they were united by their love of art, their ideas could not have been more at odds,

Right: Still Life: Vase with Fifteen Sunflowers, *1889. Painted by Van Gogh as part of a series of paintings of sunflowers to celebrate Gauguin's arrival in Arles.*

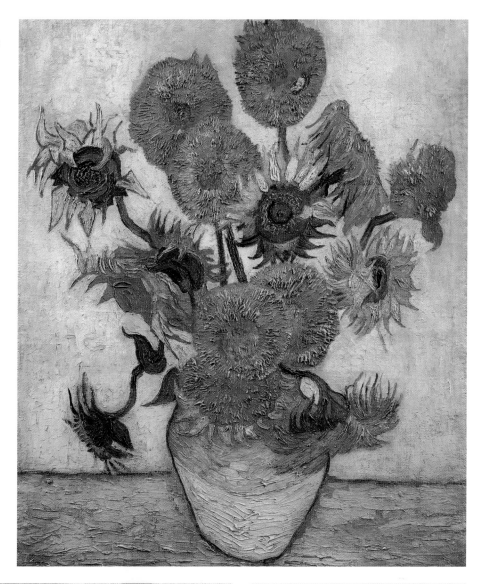

as a visit to the Musée Fabre in Montpellier on 13 December revealed. Gauguin admired works by Raphael, Ingres and Degas, whereas Van Gogh admired Delacroix, Daubigny, Rousseau and Daumier. In 19th-century thinking, Gauguin had named artists who were renowned as draughtsmen, masters of line, whereas Van Gogh's chosen favourites were known for their emotive use of colour.

The result of all this was that Gauguin began to think of moving on. The experiment was over and with things apparently beginning to go well for him in Paris, he could see no further reason to stay. Van Gogh, for his part, had now realized that Gauguin had little more to teach him. It is not surprising that sooner or later they were going to reach a crisis.

Below: Van Gogh Painting Sunflowers, *1888. This is Gauguin's only portrait of Van Gogh; the strain between the two men is starting to show.*

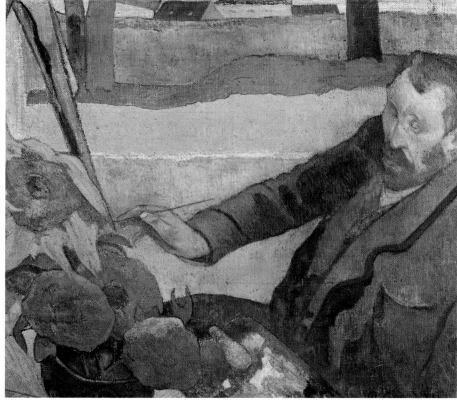

THE EXPRESSIVE PAINTER

Van Gogh's distortions stemmed from his emotional relationship with the objects he was painting and the physicality of the medium, be it paint, chalk, charcoal or ink. Once he knew what he was doing he worked, as he liked to think the Japanese did – fast. Art should be expressive: "the real painter," Van Gogh had written in 1885, "does not paint things as they are, after a dry and learned analysis. They paint them as *they themselves* feel them to be. My great wish is to learn to change and re-make reality. I want my paintings to be inaccurate and anomalous in such a way that they become lies, if you like, but lies that are more truthful than literal truth."

THE DEBACLE

Tension gave way to violent turmoil between the two men. In a now legendary incident, Van Gogh is said to have sliced his own ear with a razor blade, though the truth about what happened may never be known.

Unfortunately, Gauguin's later, and highly doctored, account of what happened over that fateful Christmas is the only one that exists. Some historians believe that this account contains inconsistencies and that it may have been Gauguin himself who cut off Van Gogh's ear.

BREAKDOWN

The tragedy began on 10 December 1889. According to Gauguin's version of events, during an alcohol-fuelled argument, Van Gogh threw a glass of absinthe at his companion and then collapsed. Gauguin took him home but was disturbed in the night by Van Gogh wandering into his bedroom. Although in the morning Van Gogh apologized, Gauguin worried that if a similar incident occurred in the future, he might not be able to control his response. He decided to leave, but did not do so immediately.

On 23 December, Van Gogh may have received news of his brother's engagement, which may have had some bearing on his subsequent actions, but we shall never know. That evening as Gauguin was taking a late night stroll, he

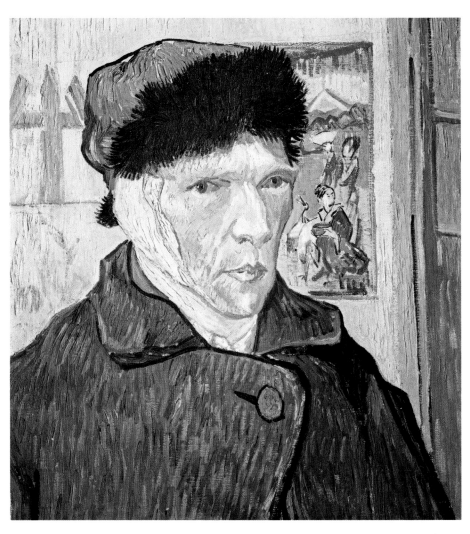

Above: Self-Portrait with Bandaged Ear, 1889. Like some martyred saint, Van Gogh displays his wound to the world.

A RELIABLE WITNESS?

Gauguin's account was included in his memoir, *Avant et Après*, which was written in 1903, only a few months before his own death, and it is impossible to ascertain just how accurate it might be. Clearly he had good reason to present himself in the best light he could, given the subsequent tragic events of Van Gogh's life. Gauguin claimed to have found the following lines written on the wall of Van Gogh's bedroom:

> Je suis Saint Esprit.
> Je suis sain d'esprit.
> I am the Holy Spirit.
> I am of sane mind.

heard footsteps behind him and turned to see Van Gogh standing close by, threatening him with an open razor. Gauguin tells how he calmed him down with a single "powerful look", causing Van Gogh to turn and flee. Fearful of the consequences if he returned to the Yellow House, Gauguin booked himself into a hotel, intending to gather his things and leave the following day.

The next morning, as he approached the house, he saw a crowd milling around its entrance. He went in and entered Van Gogh's bedroom. There he saw his friend lying apparently lifeless on the bed, surrounded by bloodstained towels. Van Gogh had turned the razor on himself and sliced away the lower

portion of his left ear. Gauguin later claimed that he was the only one to realize that Van Gogh was not dead and, after informing the assembled company of this fact, turned to leave, saying, "if he asks for me tell him that I have gone to Paris. The sight of me could be fatal to him." Theo was alerted and immediately made his way down to Arles. Van Gogh was taken away to hospital. It later transpired that after he had severed the lower part of his ear, he wrapped it in a piece of paper, took it to the local brothel where he asked for a woman

Right: The Courtyard of the Hospital at Arles, *April 1889. The natural forms of trees, bushes and flowers set against the architecture create a powerful composition.*

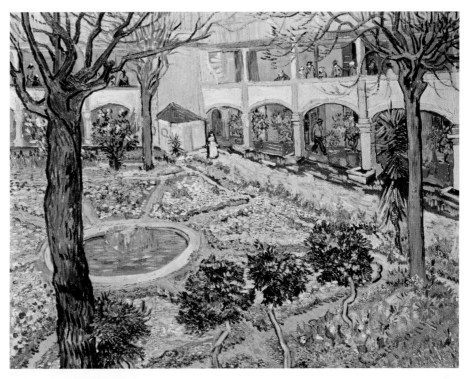

Right: The Courtyard of the Hospital at Arles, *April 1889. The natural forms of trees, bushes and flowers set against the architecture create a powerful composition.*

named Rachel, and giving it to her, said, "Look after this object carefully", or as another account tells it, "Take this in memory of me".

RECOVERY AND PAINTING

Van Gogh recovered surprisingly quickly. Theo had stayed with him for only a short time, returning to spend Christmas with his new fiancée, and Van Gogh was looked after by his friend Joseph Roulin. One of Van Gogh's first canvases of 1889 is a still life of a table top upon which are placed Van Gogh's pipe, some tobacco and a couple of sprouting onions – all emblems of the artist himself. Though it

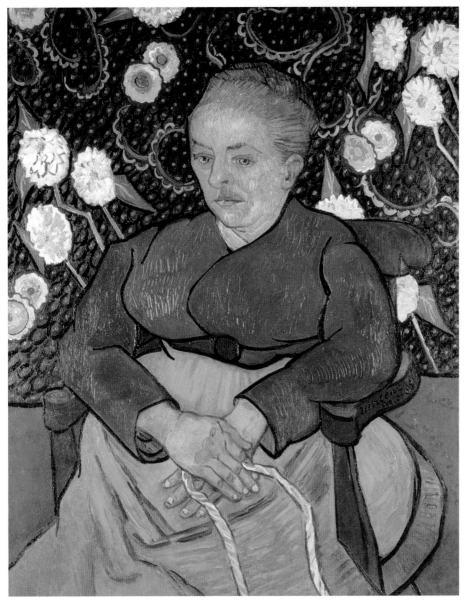

Above: The hospital Maison de Santé in *Arles where Van Gogh was a patient.*

is daylight, a candle burns as if to illuminate an opened letter, presumably from Theo, and a popular medical text, *Annuaire de la Santé.* Van Gogh was fully aware that painting was deeply therapeutic for him, as many of the paintings of this difficult period reveal. None more so than the five canvases he painted of Madame Roulin.

Van Gogh seemed to recover, but suffered another bout of mental illness in late March and returned to the hospital at Arles. During his stay here he was well cared for and was visited by his friend, Signac.

Left: La Berceuse (Augustine Roulin), *January 1889. Painted as Van Gogh recovered in Arles; the rope she holds in her hand is attached to a cradle.*

WITHIN THE WALLS AT ST-RÉMY

A voluntary stay in a mental institution, funded by his brother Theo, gave Van Gogh an improbable kind of contentment. With the very basic treatment which was on offer there, he was free to paint and draw, and his work flourished.

Once released from the hospital, Van Gogh could not return to the Yellow House – a petition from the townspeople had been lodged against him. Fearing further outbreaks of his illness he realized in April 1889 that he could no longer cope on his own. "At the end of the month I should like to go to the hospital in St-Rémy, or another institution of this kind…. Forgive me if I don't go into details and argue the pros and cons of such a step. Talking about it would be mental torture."

ST PAUL'S

Theo agreed to pay the modest fees necessary for Van Gogh to be housed at the mental hospital of Saint-Paul-de-Mausole in the foothills of the Alpilles. St-Rémy was 32km (20 miles) away from Arles and the hospital was just over a mile out of the town. It had originally been a monastery, but had been a mental institution since the 17th century. Its picturesque exterior belied a drab and depressing interior that Van Gogh described as being like a "third-class waiting room in some stagnant village." The asylum had certainly seen better days. There were only ten other male inmates and so there was plenty of space for Van Gogh to be given two rooms – a bedroom and a room in which he could paint. The barred window of his bedroom looked out over a field of wheat bounded by a simple stone wall and "the morning sun in all its glory". From his painting room he could see the garden, with its fringe of flowers, stone benches and circular fountain shaded by a number of tall pine trees. Van Gogh was restricted to the building for a month, but by early June was allowed to wander around the garden and then, accompanied by an escort, into the surrounding countryside.

TREATMENT

Van Gogh found the other inmates "more discreet and polite" than the people of Arles. Here, away from the bad memories, prying eyes and malicious rumours of the town, he could relax and recuperate. His regime was hardly taxing. The superintendent Dr Théophile Peyron, a navy doctor, seems to have taken little interest in his charges. Nevertheless his diagnosis of Van Gogh's epilepsy was probably essentially correct. Add to this

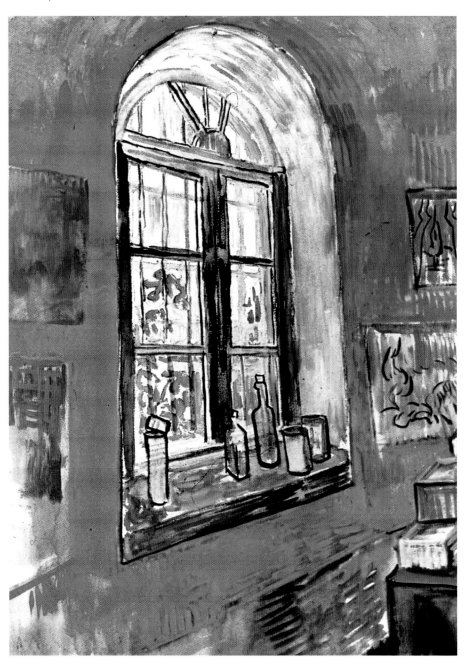

Left: Window of Vincent's Studio at the Asylum, *October 1889. A poignant picturing of inner and outer worlds.*

Right: Enclosed Field with Rising Sun, *1889. Such compositions reveal Van Gogh's uncanny ability to convey the all-encompassing energy of light and space.*

Van Gogh's sense of general anxiety, depression and complications brought on by his misuse of alcohol together with his syphilitic infection and we are probably as close as we are ever going to get to the nature of his condition. Treatment was basic: total immersion in a cold bath of water twice a week, rest and the opportunity to paint and draw. Despite the appalling food (mostly lentils and beans) and the inertia of fellow patients and staff, Van Gogh, in the first few months of his stay at least, was relatively content.

A KIND OF CONTENTMENT

The year Van Gogh remained at St Paul's was deeply productive. In between his breakdowns and periods of depression, he devoted himself to painting and drawing with complete lucidity and was in perfect control of his creative ability. He painted the views from his window and images of the hospital grounds and building. When he was well enough to venture outside he produced a series of paintings of the cypress trees, olive orchards and surrounding mountains. When unable to venture beyond the confines of the institution he could pass the time reading his favourite novels and making some astounding recreations of works by those artists that meant the most to him. The relative isolation imposed by the institution suited him – freed from the responsibilities of existence, he could enjoy a curious dark freedom as his art continued to flower in these straitened circumstances.

Below: The landscape in the immediate vicinity of the asylum became the subject of some of Van Gogh's most revealing works.

Below: Van Gogh was able to recover in the peace and quiet of the cool, light-filled meditative space of the converted 12th-century Franciscan convent.

LANDSCAPE TRANSFIGURED

Some obscure event triggered a sudden deterioration in Van Gogh's mental health.
Subsequently, he vacillated between periods of clarity and attacks of madness and paranoia,
spurring him on to paint compulsively.

One day on a visit to the town of St-Rémy, Van Gogh fell into what he described as some kind of "faint" and returned to the asylum shaken and distraught. Then, five days after writing to congratulate Theo on his wife's pregnancy, Van Gogh suffered his worst fit to date while painting in the open landscape. "You can imagine that I am terribly distressed because the attacks have come back, when I was already beginning to hope that it would not return…. Presumably the attacks will come back again in the future, it is *abominable*." It has often been suggested that Van Gogh's attacks were possibly psychosomatic – brought on by news or circumstances that threatened his fragile sense of security; but such readings remain highly speculative.

Below: Looking out from the cloisters, a scene Van Gogh drew and painted often.

A BROKEN PITCHER

He now fell into a paranoid state of mind, becoming fearful of his fellow patients and intimidated by the open landscape that lay beyond the asylum walls. It was six weeks before he could bring himself to leave the building at all – let alone walk in the courtyard garden.

It seems that Van Gogh was under no illusions as to the nature of his own mental health: toward the end of his time at St Paul's asylum he wrote to his brother, "Don't forget that a broken pitcher is a broken pitcher, and therefore in no way do I have any pretensions."

When he was well enough to venture outside again, accompanied by an attendant, he was overwhelmed by the otherworldly qualities of the

Below: The Stone Bench in the Garden of Saint-Paul Hospital, *November 1889.*

landscape. In his heightened state of mind, he seems to have experienced a prolonged and ecstatic identification with the natural world. This is evidenced by his many letters, drawings and paintings of this time, which are of a visionary intensity that has been equalled, perhaps, but never surpassed.

COMPULSION TO WORK

Van Gogh sent his work to his brother on a regular basis, using their correspondence to elucidate his own feelings about his painting and his state of health. During this time, there is no trace of self-pity in the letters, but rather they are expressions of deep lucidity and clear thinking. "As far as I can judge I am not…a madman. You will see the canvases I have done in the intervals are steady and not inferior to the others."

A VERY REAL LANDSCAPE

Van Gogh's paintings should be understood within the context of the landscape in which he worked. In an age when light pollution was unheard of, the brilliance and wonder of the night sky, together with the transforming force of the Mediterranean sun, inspired Van Gogh to work ever more urgently. The landscape of the region is one of abrupt transitions; the tall verticals of the cypress trees standing proud against the gold of the wheatfields, the knotted forms of the olive groves edging the foothills of the Alpilles. These barren limestone hills, pitted with caverns and ravines, have been worn into fantastical forms by time and weather. In the full glare of the summer sun it is a landscape where searing light alternates with deepest shadow, black, blue and lilac. Van Gogh's apparently hallucinatory landscapes of this period are firmly rooted in the real.

Picasso explained, "Painters no longer live within a tradition and so each one of us must recreate an entire language... Painting isn't a question of sensibility; it's a matter of seizing power, taking over from nature, not expecting her to supply you with information and good advice... Van Gogh was the first one to find the key to that tension."

Above: The lower slopes of these small limestone mountains are home to olive and almond trees. Alphonse Daudet, one of Van Gogh's favourite novelists, based his 1885 novel Tartarin sur les Alpes *in this region.*

Right: Les Peiroulets Ravine, *October 1889. Beneath this painting lies another, probably because Van Gogh had temporarily run out of canvas.*

Another time he confessed, "I am feeling well just now.... I am not strictly speaking mad, for my mind is absolutely normal in the intervals, and even more so than before. But during the attacks it is terrible – and then I lose consciousness of everything. But that spurs me on to work and to seriousness, like a miner who is always in danger..."

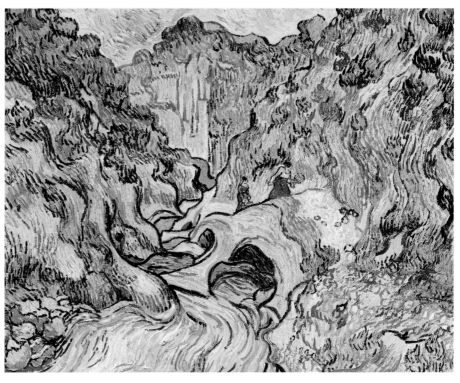

LEAVING THE SOUTH

A year after the debacle with Gauguin, Van Gogh's health remained unstable. A yearning grew in him to return north, which shifted his artistic focus, and apparently seemed to bring about a recovery. He found inspiration in studying the works of artists he admired.

Throughout his life Van Gogh had difficulty sustaining close relationships. Late in 1889, Van Gogh, for whom friendships were so important, was to fall out with another old friend, Émile Bernard.

A QUARREL WITH BERNARD

In November, Van Gogh received a letter from Bernard, which included photographs of two of his recent works – *Christ in the Garden of Olives* and *Christ Carrying His Cross*. Van Gogh found them "false", "appalling" and "spurious". He saw in them the pernicious influence of his friend Gauguin, an influence he himself had rejected. "I considered abstraction an attractive method," Van Gogh wrote, "but that was delusion." Van Gogh disliked painting from memory or the imagination and was angered by Bernard's pseudo-religious pretentions. In Van Gogh's eyes, memory could be no substitute for observation. "Come now," he wrote, "make up for it by painting your garden just as it is, or any way you like."

ILL HEALTH

Van Gogh continued to suffer intermittent attacks; when he was well he painted, when ill he did not. He made a two day visit to Arles, without suffering any ill effects. On 23 December (ominously, exactly a year after the razor debacle), there was a paint-swallowing incident which may have been a suicide attempt or call for help. This was followed by another distressing episode as he attempted to drink the kerosene used to fill the oil lamps.

As before, Van Gogh seemed to recover quickly. On 31 January, he received news that Theo's wife Johanna had given birth to a baby boy, who was to be named Vincent Willem Van Gogh after him. Van Gogh was

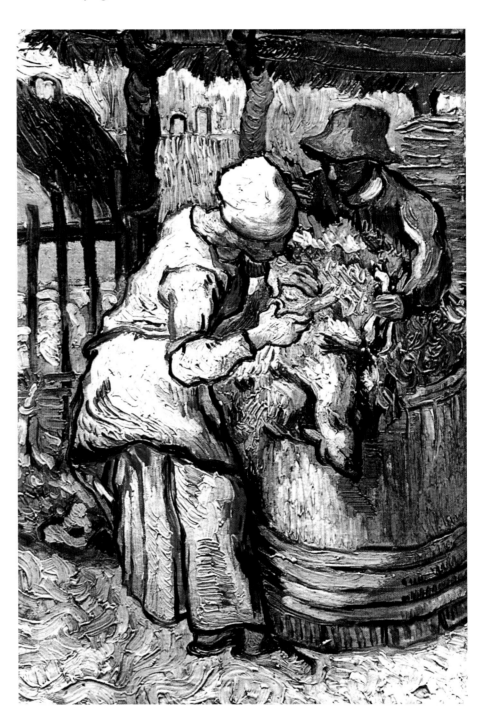

overjoyed and to celebrate he painted a sprig of almond blossom in a vase. Three weeks later he was considered well enough to visit Madame Ginoux, proprietor of the Café de la Gare, who was ill and confined to bed. Van Gogh set out with one of three versions of the portrait he had painted

Above: The Sheep Shearers *(after Millet),* Van Gogh, September 1889.

from a drawing of her by Gauguin. Something happened: Van Gogh never made it to Arles, but was found the next day, without the painting, and brought back to the hospital.

Right: Prisoners Exercising *(after Doré), February 1890. Although there is a surprising range of colour in Van Gogh's interpretation of Doré's print, the effect is almost monochrome. He uses directional brushstrokes to express his increasing frustration with his own confinement.*

YEARNING FOR THE NORTH

This was the third attack in as many weeks and this time recovery was slow. Van Gogh was in a state of numbed depression, beyond active suffering, just stupefied. In the two months it took him to recuperate, he grew ever more nostalgic for the north. A couple of weeks before his departure, he wrote: "While I was ill I nevertheless did some little canvases from memory which you will see later, memories of the North." The implications of this simple sentence speak volumes. He wanted to come home – wherever home might be. He wrote to Theo of his wish to journey north, away from Arles and all the sad memories of the last two years, and to see his baby nephew.

REVISITING THE MASTERS

When recovered sufficiently to paint, but not yet certain enough of himself to move beyond the asylum, Van Gogh produced flower pieces and made copies of his work. This was a habitual

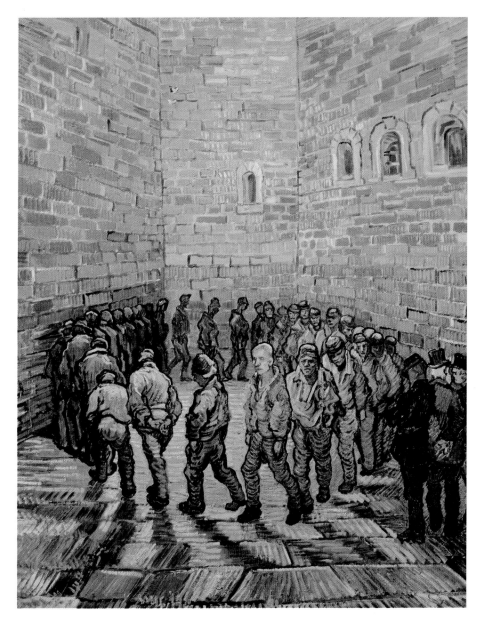

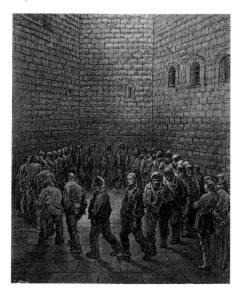

Above: The Exercise Yard, Newgate Prison, *by Doré, 1872. In his version, Van Gogh emphasizes the individual who looks out from the trudging figures.*

practice for him, perhaps instigated to keep a record of works that, when given away, might well be lost or destroyed by their indifferent owners. He also worked on imaginative interpretations of works by Rembrandt, Millet (who had become increasingly important to him), Delacroix and Daumier. One of these homages was a stark interpretation of *The Exercise Yard, Newgate Prison* by Gustave Doré, developed from an engraving in the publication, *London: A Pilgrimage*, which he had first brought to Theo's attention in 1877. All the artists he chose share a common thread: accessibility, humanity and technical virtuosity. The subjects Van Gogh chose, all taken from prints in his own collection, are deeply revealing of his anxieties and desires. Such works continue his abiding

ambition to use colour, line, texture and subject matter to create works that whether taken from nature or from secondary sources use a symbolic language that, he hoped, would express spiritual and emotional truths. Like those artists he most admired, Rembrandt, Delacroix and Millet, he used allegory instinctively and on occasion deliberately to create an art that always points to something beyond itself.

On 16 May 1890, Van Gogh was released from St Paul's, leaving the asylum unescorted. He telegraphed Theo from nearby Tarascon and arrived in Paris at 10 a.m. the next day. If the judgement expressed by the single word Dr Peyron inscribed on his records next to the detailed account of Van Gogh's attacks is to be believed, then he was "cured".

SUCCESS

While Van Gogh was still in the south, he achieved his first and only major sale.
In the heated artistic climate, his work was controversial enough to lead two fellow
artists to challenge each other to a duel.

Van Gogh had an ambivalent attitude toward the promotion of his own work. In Paris he had organized exhibitions of his paintings and those of his friends but these had achieved only minimal success. He had also placed paintings with a handful of independent dealers, like Père Tanguy, but despite this, few outside his own circle were aware of his work.

LES VINGT

The Salon des Indépendants was flourishing, providing an exhibition space where, for a small payment, artists could show their work without having to place it before a jury. Accordingly, in March 1888, Theo had sent three of Van Gogh's works there. Van Gogh reiterated that he should be referred to only as "Vincent, not Van Gogh".
The following year, two further works were shown – *Irises* and *Starry Night over the River Rhône*. These attracted a certain degree of interest and as a result Van Gogh was invited to show with the prestigious Belgian-based avant-garde group *Les Vingt* (or *Les XX*). He sent six canvases to their January 1890 exhibition, including two versions of the *Sunflowers, Flowering Orchard at Arles*, *The Red Vineyard* and his recently completed *Wheat Field at Sunrise*. He was showing in good company – alongside Cézanne, Lautrec, Renoir and Sisley. It was at this exhibition that he achieved his only major sale. Anna Boch, the wife of the artist Eugène Boch whom Van Gogh had befriended and painted in

Below: Irises, May 1889. The dense rhythmic patterning of the flowers seen at such close quarters emphasizes the power and energy of natural growth.

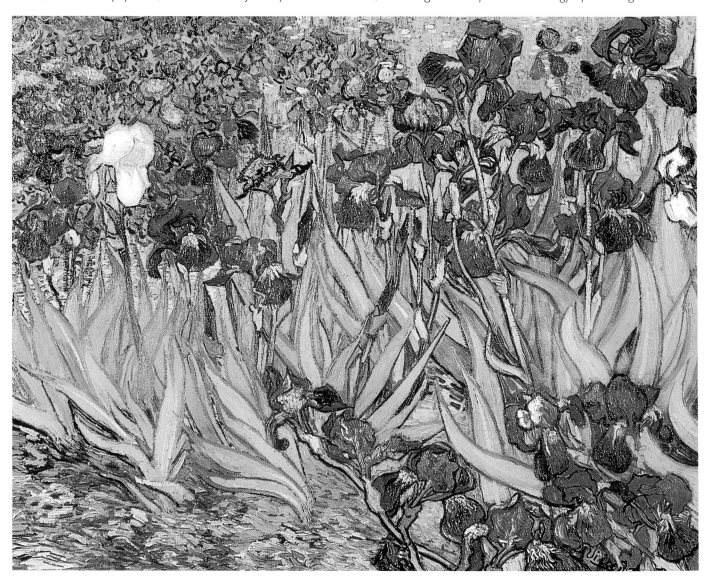

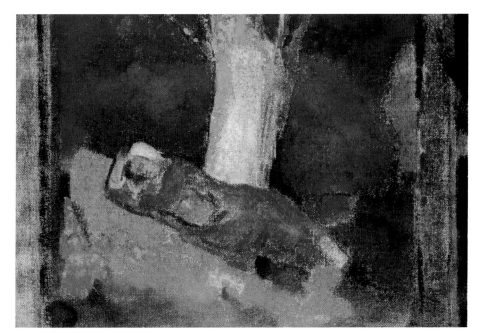

Left: Woman Sleeping Under a Tree, *by Odilon Redon (1840–1916), 1900–1. Van Gogh's example helped artists such as Redon to have the courage to extend the boundaries of French avant-garde practice.*

who referred to him as a "unique pioneer". Van Gogh responded to this by asking him never to write anything else about his work; he seemed to fear that, as he wrote to his mother and Wil, "success is about the worst thing that can happen".

In January 1890, a young writer, Albert Aurier, published an article in one of the leading Parisian periodicals, the *Mercure de France*, entitled *Les Isolés* (The Isolated Ones): *Vincent van Gogh*. This significant article referenced the work of such controversial and then little-known artists as Cézanne, Bernard, Guillaumin, Degas, Pissarro and Gauguin, almost all of whom are now household names. Van Gogh wrote to Aurier, embarrassed, telling the young man that his prose was more effective than the paintings he was writing about. However embarrassed he may have been, it did not stop him sending copies to his Uncle Cor, Tersteeg and Alexander Reid, a successful Scottish dealer he had known from his days at Goupil's.

1888, bought *The Red Vineyard* for 400 francs. One of the exhibitors, Henri de Groux (1866–1930), a member of *Les XX*, refused to exhibit his work in the same gallery as Van Gogh, and as a result de Groux was expelled from the group, but not before being challenged to a duel by Toulouse-Lautrec, an action actively supported by Signac.

CRITICAL RECOGNITION

Theo, although actively promoting the work of Gauguin and the Impressionists, could not, given his brother's dire employment record at the gallery, do the same for his brother. However, by 1889 Van Gogh's work was beginning to attract serious critical attention – a notable achievement for an artist who had only been working with full confidence for around two years and at a complete remove from any significant spheres of artistic influence. Van Gogh's ambivalence to success became apparent in his dealings with those critics who began to mention his name. One of the first to do so was a Dutch journalist, J. J. Isaacson,

SYMBOLISM

The 1880s had seen an expansion of avant-garde journals in Paris, many with a tiny audience. In the cafés and salons, artists, poets and writers argued and formulated their theories. The heyday of Impressionism was over. What was desired above all was art of mystery and evocation and, although the manifestations of such an idea were various, the word most frequently associated with them was the ambiguous term 'Symbolism'.

Right: The Red Vineyard, *1888. The only one of Van Gogh's paintings sold by him in his lifetime.*

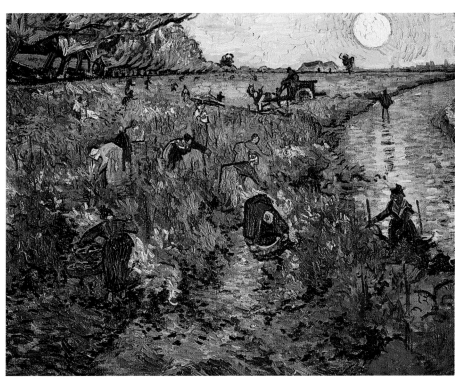

WITH DOCTOR GACHET

An incredibly productive period followed Van Gogh's discharge from the asylum. He took up lodgings at a café in Auvers, a town not far from Paris, under the supervision of a Dr Gachet. He soon discovered that Gachet was as sick and melancholy as he was.

"I must make a change – even if it's for the worse," Van Gogh had written from St-Rémy and on 17 May 1890, this time fully expected, he arrived in Paris, meeting his brother at the station. Theo took him to his apartment on Cité Pigalle, not far from their former lodgings on Rue Laval. Theo's wife, Johanna, was struck by Van Gogh's robust presence which contrasted markedly with that of the frail Theo. After two days, as agreed, Van Gogh moved to Auvers-sur-Oise, north-west of Paris. It was an area favoured throughout the 19th century by artists, including Cézanne, Daubigny, Pissarro and Corot. Camille Pissarro and Theo had arranged for Van Gogh to live in lodgings under the supervision of Dr Paul Gachet. This supervision proved to be somewhat lax, however.

DR GACHET'S TREATMENT
The doctor was a widower with two teenage children, Marguerite and Paul. He was somewhat eccentric with an interest in homeopathy and,

perhaps, a bit of a quack. Van Gogh remarked that "Dr Gachet…is sicker than I am." Like Van Gogh, Gachet suffered from depression and his treatment for the artist consisted of their lunching together twice a week and gentle sociability. An amateur artist himself, Gachet encouraged Van Gogh in his work, and was, as the artist recorded, "absolutely *fanatical*" about it. Gachet had a fine collection which included works by Pissarro, Cézanne, Renoir and Monticelli.

AN OUTPOURING OF WORK
During his time at Auvers, Van Gogh worked with tremendous energy; he had, as it turned out, only two months to live, yet within that period he completed around eighty canvases. He lodged at the Café Ravoux on the Place de la Mairie for 3 francs 50 a day and became friendly with the family, painting their daughter, Adeline Ravoux. On a typical day he would begin painting early in the morning,

Above: Portrait of Adeline Ravoux, *June 1890. The 13-year-old daughter of Van Gogh's landlord; the profile view gives this study the air of a Renaissance portrait.*

around 5 a.m., and work through until the evening, the day broken only by a brief lunch and dinner. He was usually in bed by 9 p.m.

Right: The Auberge Ravoux in Auvers today. Van Gogh rented a room here and was on very good terms with the whole Ravoux family.

AUVERS-SUR-OISE

The picturesque town of Auvers is situated some 30km (20 miles) north of Paris. Set in the undulating landscape of the Oise Valley, its gentle qualities had previously attracted painters such as Corot, Daumier, Pissarro and the Romantic Realist painter Daubigny, who had settled there and lived in the town until his death in 1878.

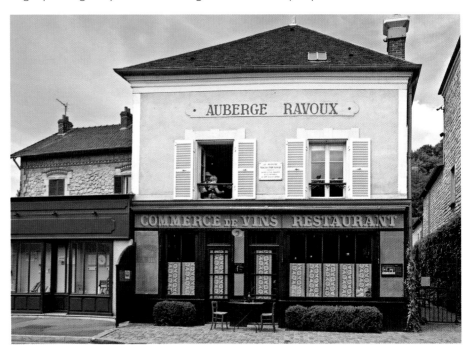

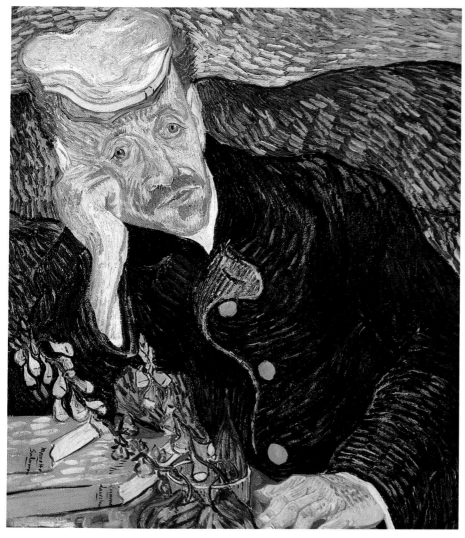

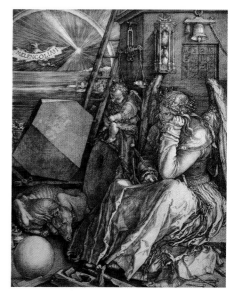

Above: Melancholia, *by Albrecht Dürer, 1514. The classic image of melancholia – the spiritual sickness of modern man.*

Left: Portrait of Dr Gachet, *June 1890. The doctor is shown in the pose of Dürer's angel, holding a foxglove to indicate his hidden sickness.*

Below: The House of Doctor Gachet at Auvers, *by Paul Cézanne, 1872–3. The town of Auvers-sur-Oise was popular with many artists, including Cézanne.*

PORTRAITS OF GACHET

Van Gogh painted two canvases of his doctor friend in Auvers. He was intrigued by one whose profession was the curing of others, but who could not cure himself. Van Gogh depicted Gachet as an archetypal "modern man" marked by melancholia – "sad and yet gentle" as he himself wrote. While Van Gogh thought of this portrait as being specifically modern, he also saw in it resonances of the metaphysical – seeing it as a secular parallel to Gauguin's *Christ in the Garden of Olives*.

Gachet's pose derives from Van Gogh's portraits of Madame Ginoux, but more than anything, it recalls the fallen angel in Albrecht Dürer's engraving, *Melancholia*, of 1514. The foxglove in Gachet's hand and vermilion table top that seems to cut into his body reference his heart condition; the novels introduce a sharp note of yellow, and may suggest the presence of the artist, who loved and identified so strongly with them.

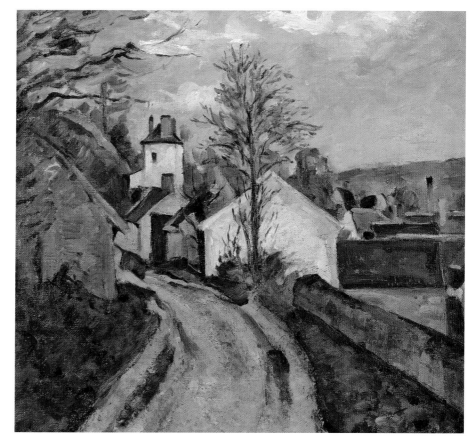

TURBULENCE AND PEACE

Van Gogh began to see the world "through a glass, darkly". Signs of his unhappy state were to be found in his behaviour, in his writings and in the series of paintings which were to become his very last works.

No one seemed to realize the true nature of Van Gogh's condition. Dr Gachet spent three days a week away in Paris attending to his private practice and seems to have felt that rest and relaxation were enough to keep Van Gogh on the straight and narrow. Up until early June 1890, everything seemed fine but, as the days passed, Van Gogh's behaviour, in retrospect at least, gave out signals that all was not well. As ever, there are warning signs in his correspondence.

DEEP DEPRESSION

He wrote to Theo of his enduring sense of isolation, even while in the company of friends and relatives. He experienced things, he wrote, as if "through a glass, darkly", using the famous phrase from St Paul's epistle to the Corinthians. Three weeks before his suicide, Van Gogh went for dinner at Theo's apartment. There he met his friends Albert Aurier and Toulouse-Lautrec, both of whom were good company and shared a real admiration for him and his work.

Before the fourth guest arrived, however, Van Gogh left the party, returning to Auvers without eating.

We do not know why he left, but increasingly it seems that he felt himself to be a growing burden to Theo. His own lack of an immediate family had also always saddened him. Painting could not always put paid to such anxieties and sometimes seemed a poor substitute for a full life. Van Gogh wrote, "The prospect grows darker, I see no happy future at all." Theo and Johanna had their own problems – a sickly child, Theo's recurrent health problems and his continuing professional uncertainties. However, Johanna replied sympathetically to Van Gogh and her letter clearly reassured the artist. Just

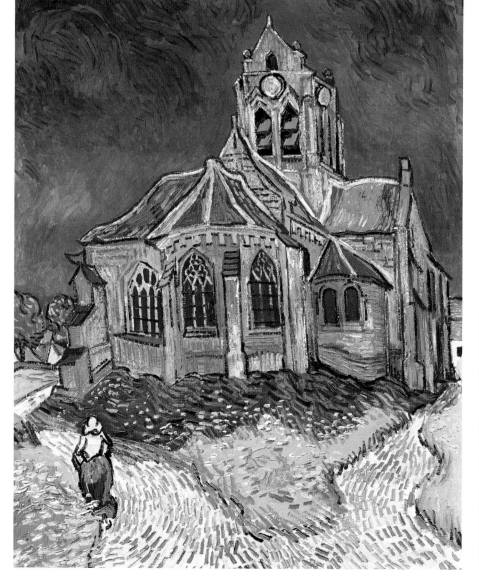

Left: The Church at Auvers, *June 1890. The combined energies of line and colour create a compelling image. Van Gogh's favoured motif of the forked path gives a singular tension to the work.*

Below: A photographic image such as this reminds us of how the artist transforms the reality of a rather modest church into something truly spectacular.

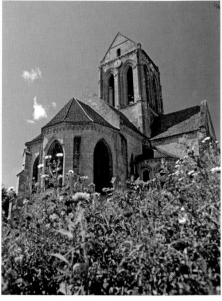

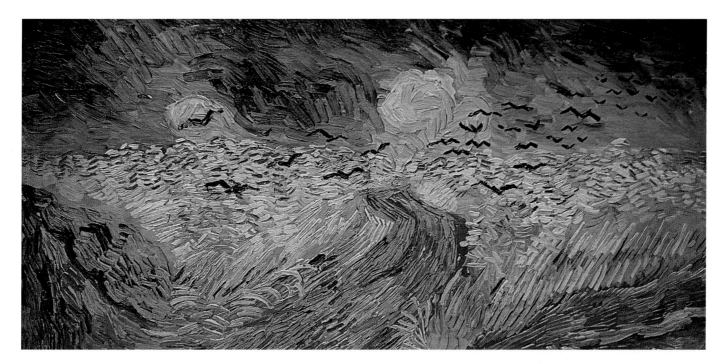

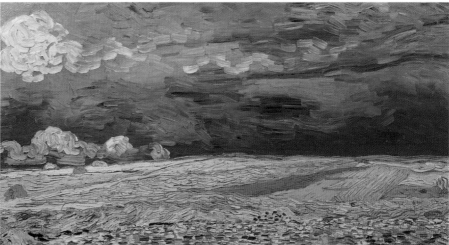

Above: Wheat Field with Crows, *July 1890. One of the most celebrated paintings of Western art – not Van Gogh's last, but one that powerfully suggests the fusion of the inner and outer worlds of the artist.*

Right: Wheat Field Under Clouded Sky, *July 1890. Van Gogh uses a 'double-square' proportioned canvas which gives his landscape a startling sense of actuality.*

when he clearly felt his life "threatened at the very root," he told her, her letter had read "like a gospel". In a letter of 15 July, Van Gogh complained about their plans to take a brief vacation to Holland and he tried, unreasonably and to no avail, to persuade them to come to Auvers instead.

FINAL PAINTINGS

No painting evokes the complexity, and crucially, the essential 'unknowability' of Van Gogh's state of mind like his magisterial *The Church at Auvers*. It is a simple, almost prosaic local church, but in Van Gogh's painting it becomes charged with life and warps and buckles under its own pressure. As in *Wheat Field with Crows*, a diverging path leads the viewer into the image only to come to an abrupt closure on either side of the church. There is no escape – not around the church or into it, for the doors are closed, the windows dark. However, other works

painted at this time are hugely exuberant, expressive canvases that seem to burst from their frames. Among them is a group of 13 narrow horizontal canvases, which, following the example of Millet, were probably intended as a decorative ensemble. "I'm fairly sure that these canvases will tell you what I cannot say in words," wrote Van Gogh about some of these landscapes, "…how healthy and invigorating I find the countryside." One of these, *Wheat Field with Crows*, is often mistakenly considered to be the artist's last work. It is undeniably a threatening painting but Van Gogh intended it to be considered as only one image of the countryside transformed by the dramatic effects of light and weather. Seen together these works may well

create a larger message, but seen on its own, with crows flailed by the wind, the forked path and the contrasting horizontal bands of colour and agitated rhythms of the broken brushwork, the painting seems freighted with a heavy, ominous atmosphere.

AN ARTIST OF HIS TIME

The majority of the paintings of this period are filled with light, with swirling, looping forms, which should remind the viewer that this was the decade of Art Nouveau and that, although Van Gogh was a unique artist in many ways, he was still operating with the broader cultural preoccupations of his time.

SUICIDE

Van Gogh's death was mysterious. His funeral was small and constrained by the ignominy of suicide. The effect of his brother's passing on Theo was immense, and his grief and despair brought even more tragedy.

The final tragic episode of Van Gogh's life is shrouded in mystery and speculation. The simple facts, as far as they are known, are as follows.

AN UNFINISHED LETTER
On 23 July 1890, Van Gogh received a letter containing 50 francs from Theo who had just returned to Paris from Holland. Van Gogh started a reply, but abandoned it, putting it unfinished into his jacket pocket. Then he wrote another letter, which he sent. It contained an order for some paints and a vivid description of his ambitious painting of *Daubigny's Garden*.

Four days later, on Sunday 27 July, after finishing lunch at Ravoux's café in Auvers, Van Gogh set off to paint the surrounding landscape, taking with him a revolver. Some time soon after, he shot himself in the chest, but managed to make his way back to his room without causing any suspicion. Later, one of the Ravoux family called on him and, seeing his terrible condition, immediately fetched the local doctor. Van Gogh's friend Dr Gachet arrived soon after.

DEATH AND FUNERAL
Van Gogh seemed to be in a comfortable condition. The blood flow was slight and it was decided not to take him to hospital. No attempt was made to remove the bullet. Van Gogh refused to reveal Theo's Paris address and, because it was a Sunday, they could not contact him though his gallery office. He was contacted the following day, and came immediately to sit at his brother's bedside. Van Gogh was conscious and alert; they conversed not in French but in Dutch, the language of their family and childhood. Van Gogh grew weaker as the day progressed. Just before he died, he whispered the words, "The sorrow will last forever."

Van Gogh died in his brother's arms on 29 July at one o'clock in the morning. Some time before the funeral the next day, Dr Gachet made a quick pencil sketch of Van Gogh on his deathbed. The local

Above: Dr Paul Gachet, *by Norbert Goeneutte, 1891. Dr Gachet was with Van Gogh at the time of his death.*

Right: Portrait of Vincent van Gogh on His Deathbed, *by Dr Paul Gachet, 29 July 1890. Van Gogh died at the age of 37, having achieved in less than ten years a body of work that would transform our idea of what art can be.*

priest refused to allow his hearse to be used for the funeral of a suicide, so his body was taken, to be buried, in a hearse borrowed from a neighbouring town.

A small gathering including Bernard, Père Tanguy, Lucien Pissarro and Dr Gachet followed the cortège, which was strewn with yellow flowers: there was no religious ceremony and Van Gogh was buried in the cemetery above the town adjacent to the wheat fields he had painted. Theo was a broken man. It was left to Dr Gachet to deliver the funeral oration. His simple words stand as a fitting tribute to Van Gogh: "an honest man and a great artist; he had only two aims: humanity and art. It was art, which he cherished above everything, that will make his name live."

THEO'S GRIEF

Later, looking through his brother's jacket pockets, Theo came across the unfinished letter Van Gogh

had started to write to him on 23 July. In it Van Gogh acknowledges his brother's formative role in his art before continuing, "Well, my work… I risk my life on it, and my reason has half foundered." Utterly distraught, Theo attempted

Above: After his death in 1891, Theo van Gogh was buried next to his brother Vincent in the cemetery at Auvers.

unsuccessfully to organize a memorial exhibition of his dead brother's work. He himself was not well and Van Gogh's death can only have aggravated his already delicate physical and mental health. He suffered some kind of nervous collapse, gave in his notice at Bossoud's and, perhaps in readiness for setting up as an independent dealer, he offered help to Paul Gauguin who was preparing to return to Tahiti.

Theo's behaviour became increasingly erratic and unpredictable and Johanna took him back to Holland where tragically he died in an asylum in Utrecht on 25 January 1891. Johanna brought his body back to France and the two brothers were together once again, side by side, their two graves set against the wall of the graveyard at Auvers, just feet away from the wheat fields Van Gogh had loved so much.

Left: Daubigny's Garden, June 1890. All his career Van Gogh wished not merely to paint the likeness of things but to capture something much more fundamental: a pictorial equivalent of the energy of life itself.

POSTHUMOUS REPUTATION

The canonization of Van Gogh as secular saint of the avant-garde began almost before he died; his rise to the status of an international megastar – one of the most popular and best-loved artists in the world – took a little longer.

Starting in 1893, Émile Bernard began to publish the 21 letters that he had received from Van Gogh. Johanna, Theo's widow, became the guardian of the estate and managed its affairs with great care and judgement. However, Van Gogh's work was only known to a relatively small group of people until the first major exhibition of his work.

THE BERNHEIM-JEUNE EXHIBITION

This exhibition was to take place at the prestigious Bernheim-Jeune Gallery, Paris, in 1901. Various critical articles and reviews had set the scene, the most important being Albert Aurier's article of 1889, published just months before the artist's suicide, and an 1891 article by Octave Mirbeau. These two texts set the tone for all subsequent commentaries on the artist until relatively recently: Van Gogh as an *artiste maudite*, the cursed artist, a failure, who died a "painful and

tragic death", but whose "mystical soul" and "predisposition to lunacy" meant he "dreamed the impossible". This image suggested a raw, naïve, instinctive painter whose "strong personality", "love of nature" and "loathing of intellectualism" made him a "great and pure artist".

The timing of the exhibition was perfect. A whole new generation of young ambitious artists were waiting impatiently in the wings, ready to build on the achievements of their forebears. In the years following, retrospective exhibitions of Seurat, Gauguin and Cézanne took place, as well as further Van Gogh shows. These exhibitions gave young artists, in Gauguin's words, "the right to dare anything". Picasso, newly arrived in Paris, saw the Bernheim-Jeune exhibition, as did Matisse, who already owned two Van Gogh drawings. It was at this exhibition that Matisse's friend, André Derain (1880–1954), introduced the work of Van Gogh to Maurice de

Above: The Green Line, Madame Matisse *by Henri Matisse, 1905. Van Gogh's work was massively important to the radical experimentation that was the hallmark of Parisian avant-garde art in the 1900s.*

Vlaminck (1876–1958), who later exclaimed: "I loved Van Gogh that day more than my own father."

These and subsequent exhibitions in Paris, the Netherlands and Germany initiated the arrival of Van Gogh as a major figure. His life and work became the touchstone for those artists who wished to create an art that would be expressive and authentic – using line and colour in an intensely subjective and direct manner – any crudeness or awkwardness being evidence of the urgency and intensity of the artist's feelings.

ARTISTIC INFLUENCE

In France, the appropriation of aspects of Van Gogh's work by Matisse, Derain and Vlaminck helped to earn them earn the nickname,

Left: Barges on the Seine Near Le Pecq, *by Maurice de Vlaminck, 1906.*

people's lives for the better. Although his life was marked by physical and mental troubles, his art is eminently sane. He lived a life totally dedicated to his art, his early interest in Christianity subsumed totally into a belief that art itself was some kind of sacred activity. His paintings and his letters are visionary, revealing the sacredness of human life. Van Gogh's suicide has nothing to do with his art – the work stands alone.

Van Gogh's art is life-affirming in every aspect; it transcends the personal details of his own existence, and yet, as the letters reveal, it is enriched by it at the same time. These paintings are gifts to us from a man who has since passed into legend, an inspirational artist of great energy and originality, whose work shines like a beacon, illuminating the fundamental creative nature of humanity.

Below: The Van Gogh Museum in the Netherlands attracts over one million Van Gogh enthusiasts every year, from all over the world.

Les Fauves (the Wild Beasts – the first major 20th-century art movement), while in Germany knowledge of his work was crucial to the formation of the Expressionist group, *Die Brücke*. By World War I, Van Gogh's paintings had become expensive and his position in the art market secure, but it was in 1956 with Vincent Minelli's film *Lust for Life* that his worldwide reputation as an artistic genius reliant upon his supposed 'madness' became set in stone.

So how true is this image? Van Gogh remained rooted in the Realist tradition, and continued the heritage of the artists he loved – Rembrandt, Delacroix and Millet. He believed that painting should be accessible to a wide audience and that it should change

THE VAN GOGH MUSEUM, AMSTERDAM

Opened in 1973, the museum holds the largest collection of paintings by Van Gogh in the world, attracting well over a million international visitors each year. The permanent collection includes over 200 of Van Gogh's paintings, plus many of his drawings and letters. Artworks by Van Gogh's contemporaries are also on display. The museum funds and carries out a great deal of research into the work and life of Van Gogh, its mission being to make the "life and work of Vincent van Gogh and the art of his time accessible to as many people as possible in order to enrich and inspire them."

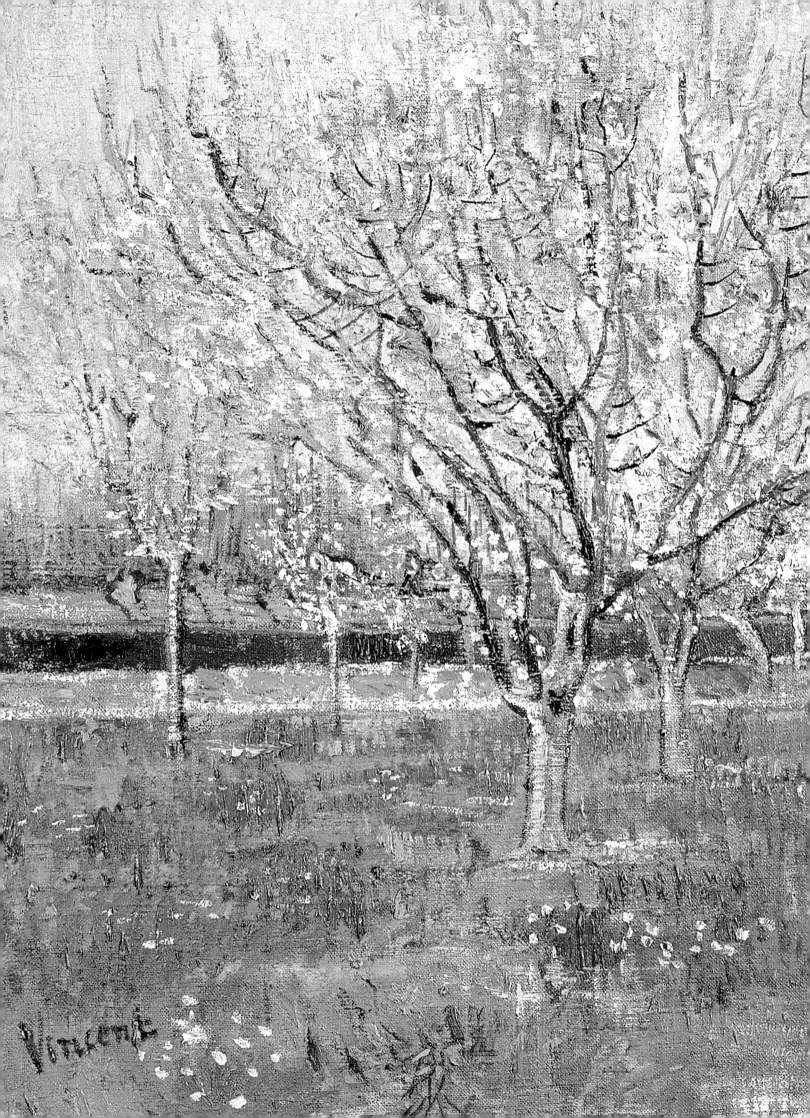

THE GALLERY

The image of Van Gogh as a painter who worked in a frenzy of impassioned creativity is an insistent one, but one that has little basis in fact. In reality, Van Gogh was an extremely self-conscious artist both in the subjects he chose to paint and in the way he painted them. Even the most superficial glance at his work reveals just how reflective and precise a painter he was. On closer examination, the energy, strength and precision of his brushwork and the freshness, vibrancy and clarity of his colour become ever more apparent. Van Gogh wished above all to create a distinctly modern art that would be accessible to everyone. Looking through this gallery, we can follow him as he returns again and again to the motifs that were important to him, the individual and the larger community, the landscape and the simple objects with which we surround ourselves: chairs, beds, flowers and vegetables. He wished to make an art that would depict the extraordinary nature of ordinary things and above all that would serve as an equivalent to the great religious works of the past.

Left: Orchard in Blossom (Plum Trees), *April 1888. In the spring of 1888, Van Gogh painted 14 canvases of the blossoming fruit trees around Arles.*

ENGLAND AND NORTHERN EUROPE

Van Gogh was driven to paint what he saw, but he did so with a deep awareness of the great reservoir of images that he had seen in the popular art journals of the day and in the collections and museums he visited. Like Picasso, Van Gogh had the ability to assimilate a huge variety of visual stimuli and to recreate it as his own. In this section we see him struggling to forge an independent language of painting, equivalent to the great masters he loved so much, but also one that would do justice to his chosen subject matter – the ordinary people he came across in his travels.

Above: Lane with Trees and One Figure, *March 1884. Van Gogh was constantly sketching the things he saw around him. Left:* Head of a Woman with Her Hair Loose, *December 1885. Always preferring to paint the real people around him, Van Gogh produced a large number of portraits throughout his career.*

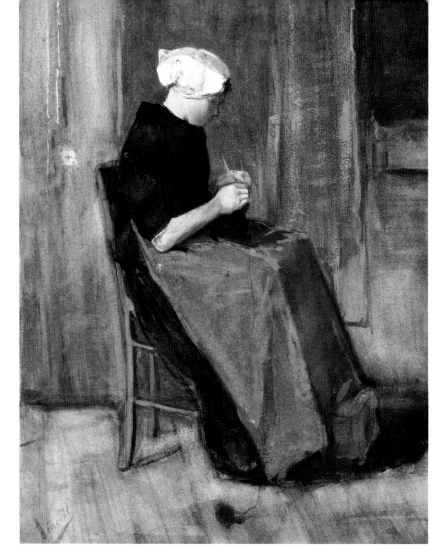

Scheveningen Woman, Knitting, December 1881, watercolour, private collection

This sharply observed study of a woman at work is enlivened by the unusual combination of blue, black and white, which contrasts markedly with the drab colours of the bare interior. It is as close as Van Gogh ever came to the sentimentality that is characteristic of so much 19th-century genre painting.

Sower, September 1881, pencil, pen and brown ink, private collection, 60 x 45cm (23.5 x 17.5in)

This early drawing of a peasant sowing seed is an image that Van Gogh would have known from his reading of the Bible, and from the day-to-day activities that went on around him in the countryside surrounding his home in Holland. Even this simple study, stiff and awkward, carries clear intimations of the cycle of life and the need for nurture.

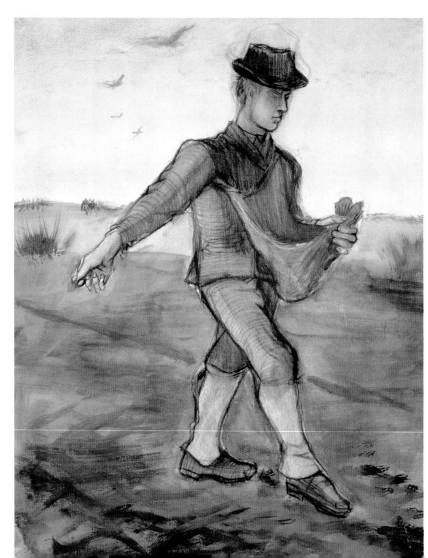

Still Life with Cabbage and Clogs, November–December 1881, oil on canvas, Van Gogh Museum, Amsterdam, the Netherlands, 34 x 55cm (13.4 x 21.7in)

Still life can serve several purposes; as here, it can be used as an exercise and a means to perfect one's technique, but it can also suggest the moral or spiritual significance of ordinary things, and how they can be meditated upon and valued in and for themselves. Still life painting became popular in the 19th century and was raised to the level of great art by artists such as Van Gogh, Manet and Cézanne.

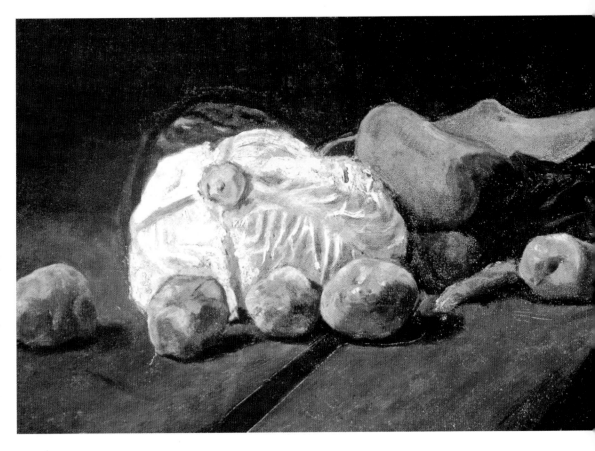

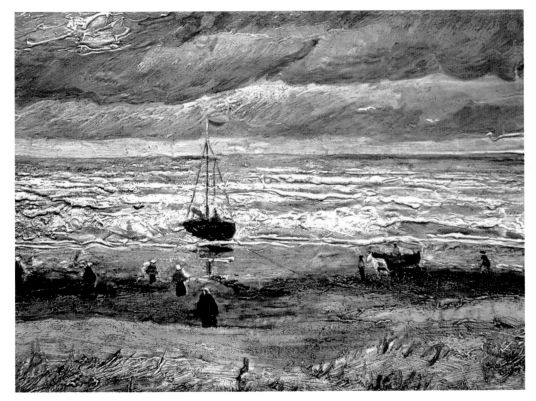

View of the Sea at Scheveningen, August 1882, oil on canvas, Van Gogh Museum, Amsterdam, the Netherlands, 34.5 x 51cm (13.6 x 20in)

Living in the lowlands, Van Gogh could not help but be aware of the power of the sea, and the idea of its mystery and endless movement impressed him all his life. Equally significant was the understanding of the dangers faced by those whose livelihood depended upon the harvesting of its bounties.

Scheveningen Women and Other People Under Umbrellas, July 1882, watercolour heightened with white on vellum, Gemeentemuseum, The Hague, the Netherlands, 28.5 x 21cm (11 x 8in)

This charming sketch seems to be saturated with moisture, the medium of watercolour perfectly echoing the subject matter. In this simple composition there is no sentimentality or anecdotal detail – it is simply an effective piece of visual reportage caught with minimal means.

Potato Market, 1882, watercolour on paper, private collection, 36 x 44cm (14 x 17.5in)

Although Van Gogh cared greatly for ordinary people, he was never politically engaged, choosing to express his sympathy through his work instead. His feelings are especially evident here in this watercolour of farmers of the Brabant region unloading their wares. Colour is kept to a minimum and there is a strong sense of immediacy and social interaction.

Beach with People Walking and Boats, September 1882, gouache, watercolour and charcoal on paper, private collection, 27.8 x 46cm (11 x 18in)

Many of Van Gogh's paintings and drawings show his strong tendency toward organizing compositions into a series of horizontal bands, each characterized by rhythmical and agitated brushwork. This relatively restrained study is a convincing evocation of the dull wetness of the couple's seaside stroll.

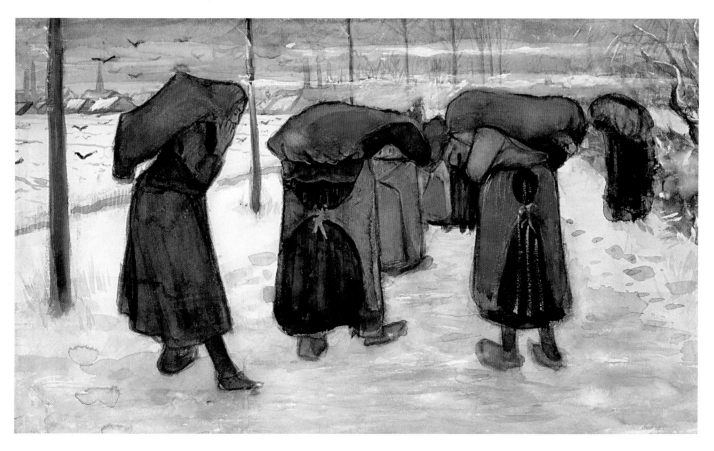

Women Miners, November 1882, watercolour on paper, Kröller-Müller Museum, Otterlo, the Netherlands, 32 x 50cm (12.5 x 19.5in)

Van Gogh was above all a Realist. His art descends from the socially engaged work of Rembrandt, Courbet and Millet. However, at the time of this painting he was still very much engaged with Christianity, though one represented not by the church, but by Christ, "the greatest of all artists". He hoped that such works as this would play their part in changing the world for the better. In this powerfully realized painting, he shows how the necessity of earning a living has reduced these women to the level of beasts of burden. There is no political agenda at work, just a profound sense of human empathy. The high horizon brings the viewer's eye-level down to that of the women. Although from 1874 women no longer worked down the mines, children of 12 still worked a 12-hour day until the 1890s.

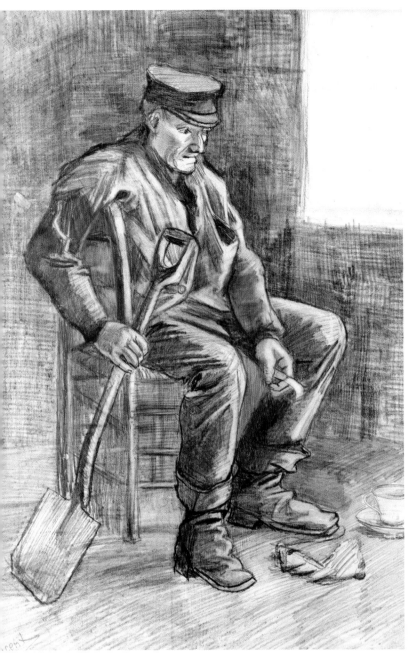

Workman with Spade, Sitting near the Window, March 1883, pencil and chalk, Arkansas Arts Centre, Little Rock, AR, USA, 58.5 x 40.7cm (23 x 16in)

Van Gogh did not receive a formal art education and this drawing demonstrates his lack of knowledge of human anatomy, although this very lack becomes a strength in drawings such as this. Crude though it may be, it shows Van Gogh's attraction to drawing simple working people, which would remain a constant throughout his short life, and the way in which he was able to endow such people with dignity and gravitas without falling into sentimentality.

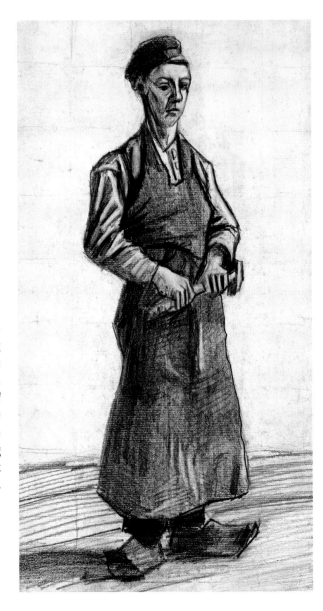

A Carpenter with Apron, September 1882, black chalk and pencil on paper, private collection, 45.1 x 24.2cm (18 x 9.5in)

Van Gogh's drawings of ordinary people celebrate their resilience and quiet dignity. His choice of subject and the sharp graphic lines of this drawing are reminiscent of the engravings in publications, such as the *Illustrated London News* and *The Graphic*, both English magazines with a strong social conscience that Van Gogh admired.

Bakery, March 1882, pencil and charcoal on vellum, Gemeentemuseum, The Hague, the Netherlands, 20.4 x 33.6cm (8 x 13in)

Van Gogh often made modest drawings such as this to record the places and neighbourhoods in which he lived. He would include such sketches in letters home to his family.

Fish-drying Barn, June 1882, pencil on paper, private collection

Meticulously observed and minutely rendered drawings such as this show Van Gogh's dedication to mastering the skills necessary for his future career. The horizontal banding structure gives a sense of order to the composition without losing the scene's ordinariness. Comparing this carefully rendered topographical study with the later paintings of Auvers shows the extent of Van Gogh's artistic journey.

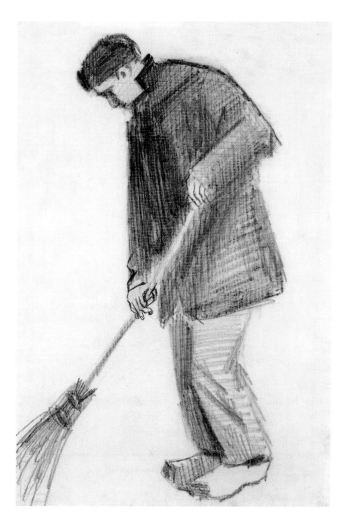

Young Man with a Broom, autumn 1882, charcoal on paper, Gemeentemuseum, The Hague, the Netherlands

In this early drawing we again see Van Gogh's interest in depicting the actions of working people. The draughtsmanship is awkward and stiff as he attempts to capture the simple act of a man sweeping the street. His later representations of working people show how, as in so many other instances, Van Gogh moved rapidly from the uncertainty of the beginner to someone who could harness his technical skills and put them to extraordinary emotional ends.

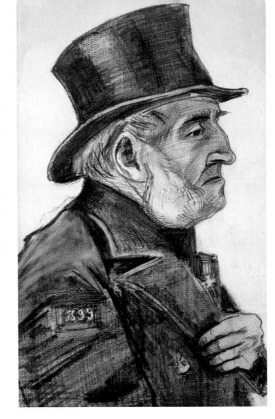

Orphan Man with Top Hat, December 1882, charcoal and crayon on paper, Worcester Art Museum, MA, USA, 40 x 24.5 cm (15.7 x 9.6in)

Perhaps because of his evangelical leanings and reading of the gospels, Van Gogh had immense sympathy for humble people. Here we see an elderly man, who, despite a life of hard work, is now dependent on the charity of others. In tracing the careworn features, Van Gogh evokes a profound sense of empathy.

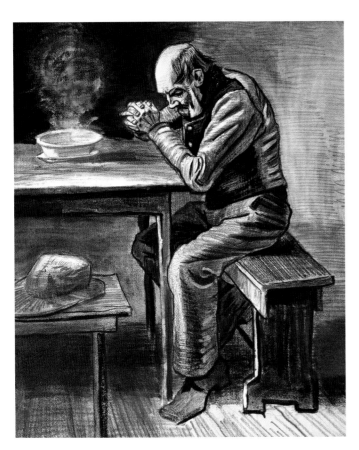

Prayer Before the Meal, December 1882, pencil, black chalk, ink, heightened with white, private collection

The influence of the English illustrators is very evident in this sharp-angled drawing of a man at prayer before his frugal meal. This could easily be an illustration to one of the Social Realist novels Van Gogh loved to read – mixing his concern for the plight of ordinary people together with his evangelical piety.

Orphan Man, Sitting with a Girl, September–October 1882, black chalk and pencil on paper, private collection, 48.9 x 26cm (19 x 10in)

Van Gogh never married and had no children, but all his life he looked on those who did with special regard. This stark representation of family life is shot through with understated sentiment; as the old man looks at the young child we see a simple image that tells of the inevitable progress of time.

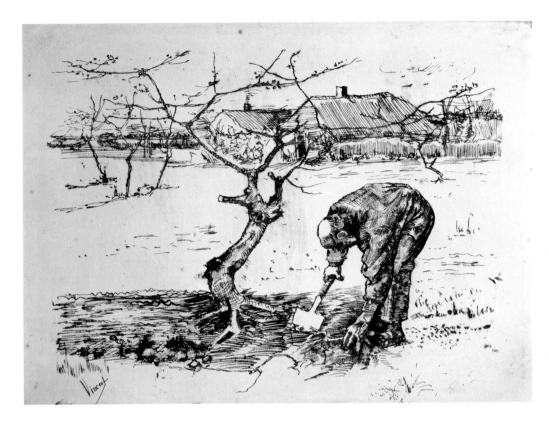

Gardener near a Gnarled Apple Tree, July 1883, pen transferred to lithograph with pen and ink, location unknown

This sketch has all the immediacy of the object seen. Van Gogh has concentrated the weight of his lines upon both the figure of the man and the echoing form of the tree that he is tending. Between the open branches the roofs of distant cottages can be seen. This apparently illustrative sketch has an allegorical undercurrent, suggesting the need to nurture and the security of the home.

Peasant Burning Weeds, October 1883, oil on panel, private collection, 30.5 x 39.5cm (12 x 15.5in)

In such brooding, dramatic works, narrative is sacrificed in favour of the evocation of mood. Using thick, creamy paint and a limited palette of browns, yellows and deep greens enlivened by two touches of red, Van Gogh is working within a well-established tradition of painting the peasant lives of the Dutch people.

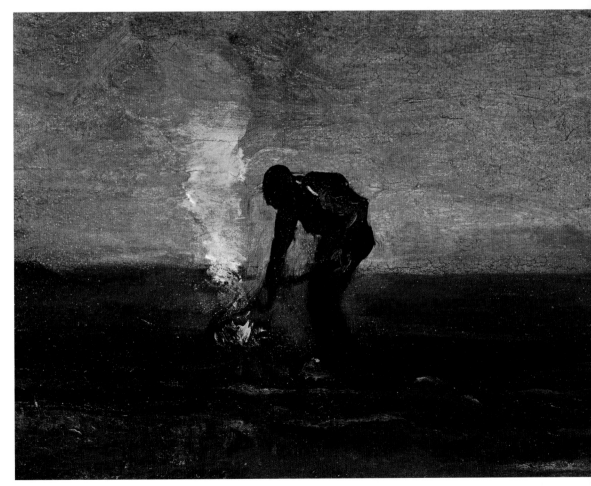

Girl Kneeling by a Cradle, March 1883, pencil and charcoal, heightened with white, on paper, Van Gogh Museum, Amsterdam, the Netherlands

Many of Van Gogh's secular images are suggestive of religious motifs. In this intimate study Sien's daughter is pictured kneeling to look at her young baby brother, Willem. The drawing is simple, but effective: by showing only the back of the young girl Van Gogh avoids any overtly sentimental gloss to give a more effective and reverential image.

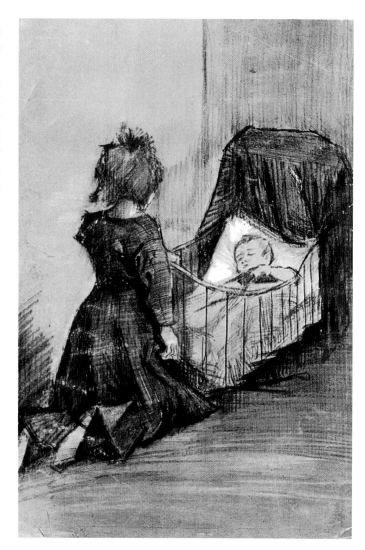

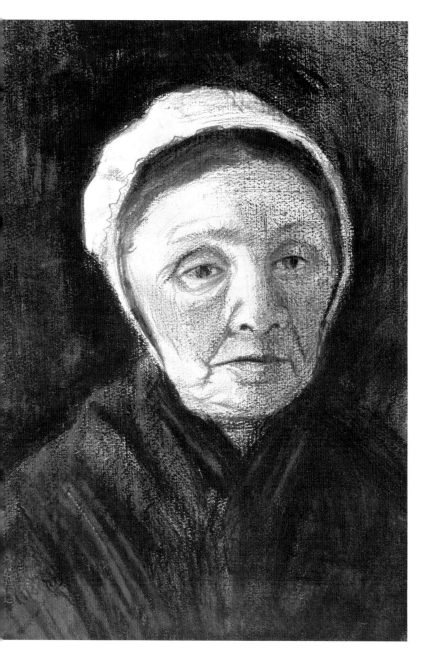

Woman with White Bonnet (Sien's Mother), Head, March 1882, charcoal, black and brown chalk on paper, Gemeentemuseum, The Hague, the Netherlands

A simple study of an unknown individual, possibly Sien's mother. Van Gogh has created a carefully structured tonal drawing using black and brown chalk, strengthening those lines on the woman's careworn face to create an image not just of a physiognomy or type, but of someone consumed by memories and marked by experience. The drawing's subtle, yet marked, asymmetrical composition gives it a sense of the intimate, the contingent, the real.

Sien's Mother's House, Closer View, May 1882, pencil and pen, heightened with white, Norton Simon Museum of Modern Art, Pasadena, CA, USA

Van Gogh's unease with perspective gave him an opportunity that he exploited, consciously or otherwise, to create strong, simple pictorial designs. Here the low viewpoint and extremely basic perspectival system gives a powerful and effective sense of an experiential space. The lines of the fence and the house make a strong horizontal pattern that is set against the diagonals of the two fences edging the pathway.

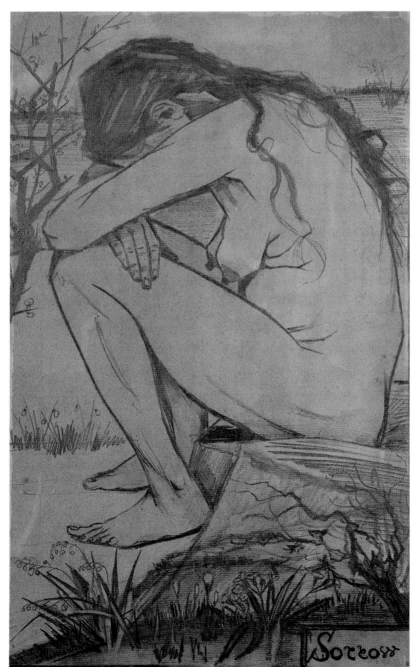

Sorrow, 1882, pencil, pen and ink, New Art Gallery Walsall, UK, 44.5 x 27cm (17.5 x 10.5in)

This unforgettable depiction of Sien is one of complete despair. Here, Van Gogh's companion, a woman of the streets, appears like Eve in the Bible, locked inside her own misery. This is one of Van Gogh's few studies of the nude and in this drawing (subsequently made into a lithograph) we can see his growing mastery in reducing the complexity of experience, both visual and emotional, into a single, compelling image.

Peat Boat with Two Figures, October 1883, oil on canvas on panel, Drents Museum, Assen, the Netherlands, 37 x 55.5cm (14.6 x 21.9in)

A dull heaviness pervades this work – the colours and composition are simple, pared down to a minimum. The two figures, each bent on the jobs in hand, are connected by the diagonal of the path and plank. The influence of Millet and Daumier can clearly be felt in the generalized forms and in the deep respect that Van Gogh has awarded these toiling people. The figures share a lack of distinguishing features which suggests not the particular, but the generic – the arduous struggle to survive in a difficult world.

Landscape in Drenthe, September–October 1883, pencil, pen and brush in brown ink, opaque white watercolour, on laid paper, Van Gogh Museum, Amsterdam, the Netherlands

The brightness that lights up the sky reduces the signs of human habitation into a series of sparse silhouettes. The low horizon, close tones and the pervasive emptiness of the composition suggest something of the melancholy that Van Gogh expresses in his letters of the time. However, low-toned landscapes were popular in Holland and one must not read too much of Van Gogh's own personal feelings into such works.

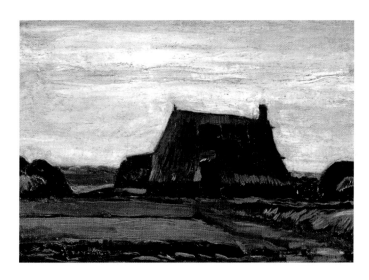

Farm with Stacks of Peat, November 1883, oil on canvas, Van Gogh Museum, Amsterdam, the Netherlands, 37.5 x 55cm (14.8 x 21.7in)

Van Gogh's pictures of houses are particularly touching. He thought of himself as a "stranger in the world" and in this painting, as in so many of his others, the dwelling as a place of shelter, warmth and comfort – in a word domesticity – seems forever beyond his grasp. Throughout his short life he struggled to find acceptance in various communities and in every case he failed. This image of a house gives little sense of the life that is lived within its walls and contrasts vividly with the intimate nature of his *Potato Eaters* of 1885.

Weaver Facing Right, February 1884, oil on canvas on panel, private collection, 37 x 45cm (14.5 x 17.7in)

Van Gogh had read and much admired George Eliot's novel, *Felix Holt, the Radical*. Published in 1866, it tells of a young man who casts off his comfortable middle-class existence, choosing instead a life of poverty. Van Gogh described in a letter how he had set the weaver into the wooden structure of the loom, "as if he were a prisoner in some terrible instrument of torture".

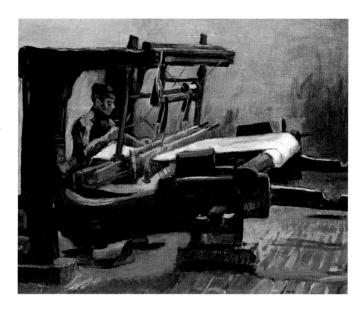

Potato Planting, September 1884, oil on canvas, Von der Heydt Museum, Wuppertal, Germany, 70.5 x 170cm (28 x 67in)

Simple, direct and unpicturesque. The low, flat landscape stretches behind the labouring figures and their stolid cow, whose white-and-tan hide provides a simple contrast with the blue-green of the sky and field. Van Gogh painted a community absorbed in the daily round of activities necessary for their survival: digging and planting, spinning and sewing.

Two Rats, November 1884, oil on panel, private collection, 29.1 x 41.3cm (11.5 x 16in)

This intimate study of two rats conjures up the poverty-stricken nature of Van Gogh's life at this time; perhaps it also reveals his empathy with creatures universally despised as vermin. In painting the rats he reminds the viewer that even these, the lowest of the low, are living creatures – and part of the grander scheme of things.

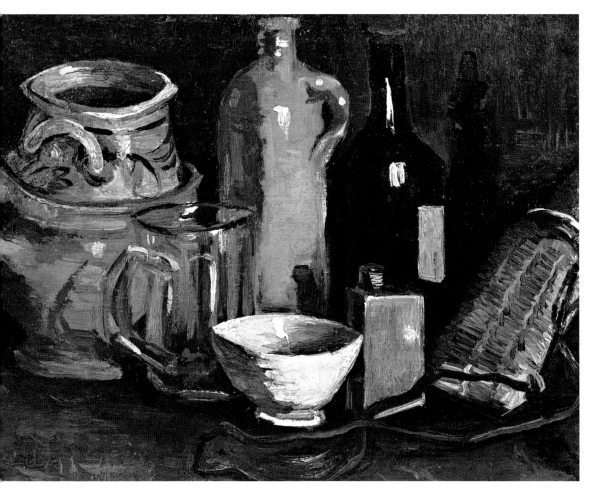

Still Life with Pottery, Beer Glass and Bottle, November 1884, oil on canvas, private collection, 30.6 x 41cm (12 x 16in)

Van Gogh's respect for the simple objects that sustain life finds expression in many of his paintings. This painting is very much a learning exercise in the Chardin-esque tradition that was still fashionable at the time, but the worth it gives to these simple utilitarian objects asserts their right to be valued for themselves.

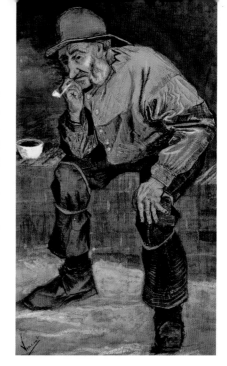

Old Man with a Pipe, 1883, pen and ink and charcoal, Gemeentemuseum, The Hague, the Netherlands, 46 x 26cm (18 x 10in)

In drawings such as this it becomes evident that Van Gogh closely modelled his drawings of the working people on the work of the British-based Bavarian artist, Hubert von Herkomer. This figure fills the entire surface of the paper; it is of a real man, lost in contemplation, rather than a picturesque, sanitized image made for the popular market.

Peasant Woman by the Fireplace, June 1885, oil on canvas laid on board, Musée d'Orsay, Paris, France, 29 x 40cm (11.5 x 15.5in)

This strong, crudely realized depiction of a peasant woman sitting by the hearth, lit by the fire, is the opposite of the picturesque. To one side is a simple kitchen chair of the kind that will reappear many times in Van Gogh's art, often as a sign for the authentic nature of basic human values.

Woman Reeling Yarn, June 1884, gouache on paper laid down on board, Kuboso Memorial Museum of Modern Art, Izumi, Japan, 35 x 42cm (14 x 16.5in)

Van Gogh made many drawings and paintings of men and women absorbed in the various aspects of their work. He wrote: "Their life is hard. A weaver who stays hard at work makes a piece of about 60 yards a week while his wife has to sit before him, winding – so there are two of them who work and have to make a living from it."

Head of a Peasant Woman with Dark Cap, December 1884, oil on canvas on panel, private collection, 35 x 26cm (13.8 x 10.2in)

Late in 1884, Van Gogh began working toward a large, ambitious oil painting, *The Potato Eaters* – a canvas that would, he hoped, reveal him as the worthy successor of Millet. This is one of the many studies for the painting.

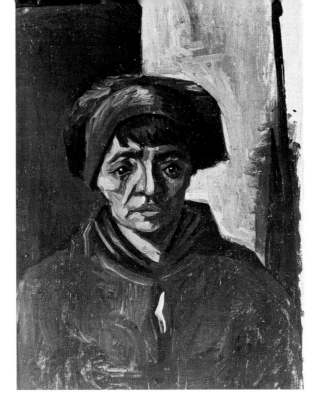

Head of a Peasant with Cap, December 1884, oil on canvas, Art Gallery of New South Wales, Sydney, Australia, 39.4 x 30.2cm (15.5 x 12in)

Another study for *The Potato Eaters*. Van Gogh painted in a manner that, to him, corresponded with the peasant way of life – using dark, earthy colours that suggest the earth they sowed and tilled to gain the food they ate.

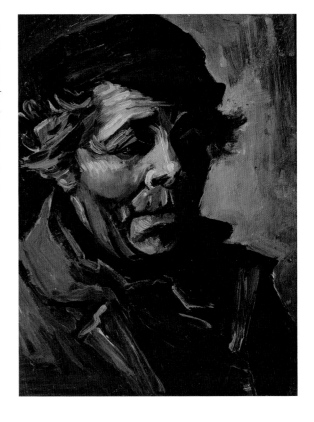

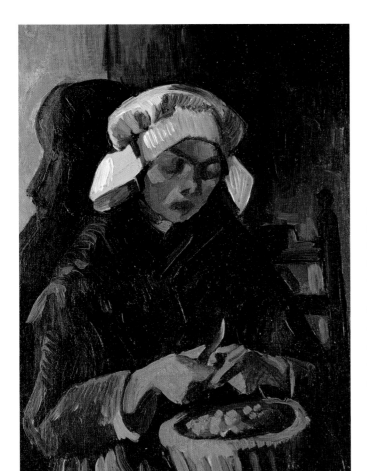

Peasant Woman Peeling Potatoes, February 1885, oil on canvas, private collection, 41.3 x 30.2cm (16 x 12in)

Van Gogh got to know the families around Nuenen when he lived there, and would sit and study their daily lives. Following the example of the French artist Jean-François Millet, he acted the 'peasant-painter' and his letters and behaviour made it very clear that he felt more at home with these people than with his own middle-class family, with whom he had recently broken.

Peasant and Peasant Woman Planting Potatoes, April 1885, oil on canvas, Kunsthaus Zürich, Switzerland, 33 x 41cm (13 x 16in)

Van Gogh looked closely at the real world but also plundered the huge collection of black and white prints and illustrations that he had amassed over the years. His use of the stark contrasts of these images is evident in the restricted colour and light and shade of his work at this time. This particular composition is a re-working, conscious or otherwise, of Millet's celebrated painting *The Angelus* of 1857–9.

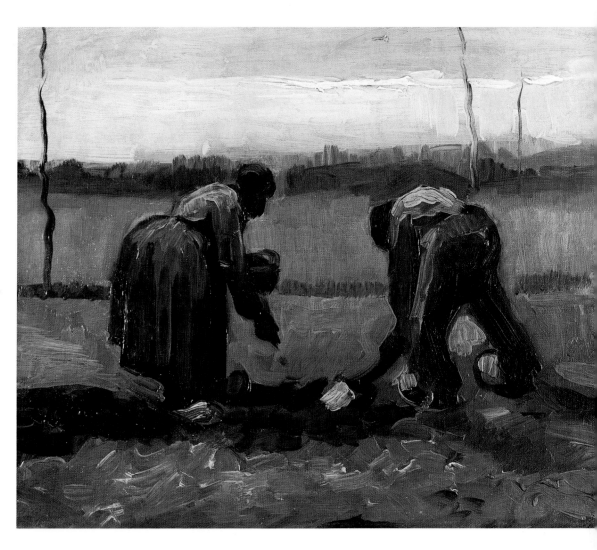

Head of a Peasant Woman with White Cap, March–April 1885, oil on canvas, National Gallery of Scotland, Edinburgh, UK, 47.5 x 35.5cm (18.7 x 14in)

Van Gogh's works of this period reveal the awkwardness and determination of a beginner. The power of his lack of facility as he struggles with his medium to give form to his vision. He eschews the facile and the superficial for a sense of 'the authentic'. As he wrote, "I like so much better to paint the eyes of people than to paint cathedrals."

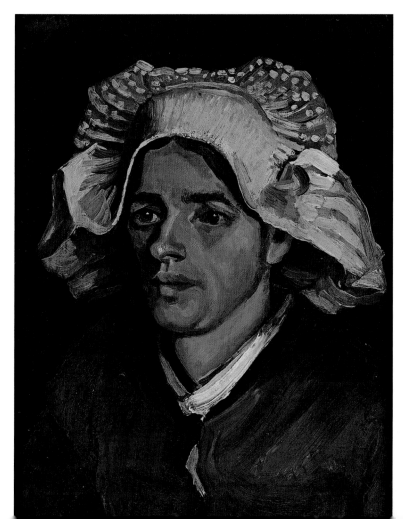

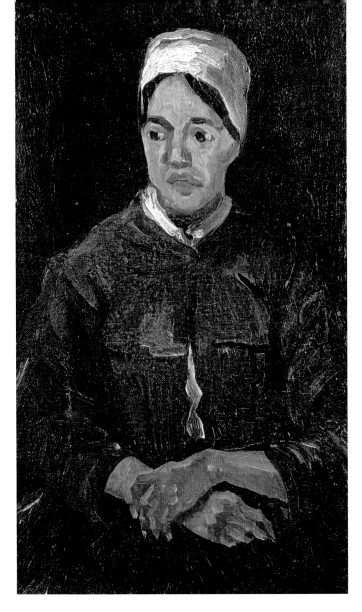

Peasant Woman,
Seated (Half-figure),
February–March 1885,
oil on canvas on panel,
private collection,
46 x 27cm (18 x 10.5in)

Here, Van Gogh has used a
sombre and limited palette,
applying the dark tones with
a fully charged brush in
luscious, slabby marks.
Simple juxtapositions of
darks, highlights and mid-
tones are subtly employed to
give an almost sculptural
presence to the sitter.

Portrait of a Woman (Head of
a Peasant Woman with
Bonnet), c.1885, chalk on
paper, private collection,
29.5 x 20cm (11.5 x 8in)

This is another of the
character studies that formed
the building blocks of what
was to become Van Gogh's
first major masterpiece,
The Potato Eaters. He
had been looking closely at
the Dutch artists Rembrandt
and Frans Hals and has
captured, as those great
17th-century artists had
done, the humanity and
physicality of ordinary
people, bestowing upon
them a dignity often
denied in real life.

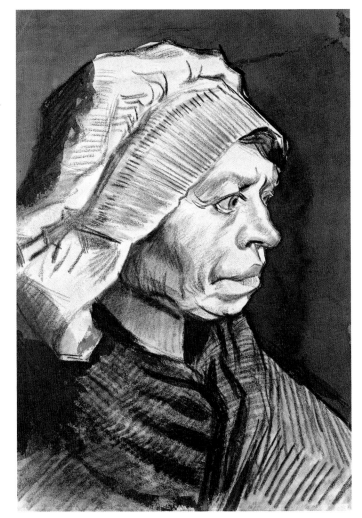

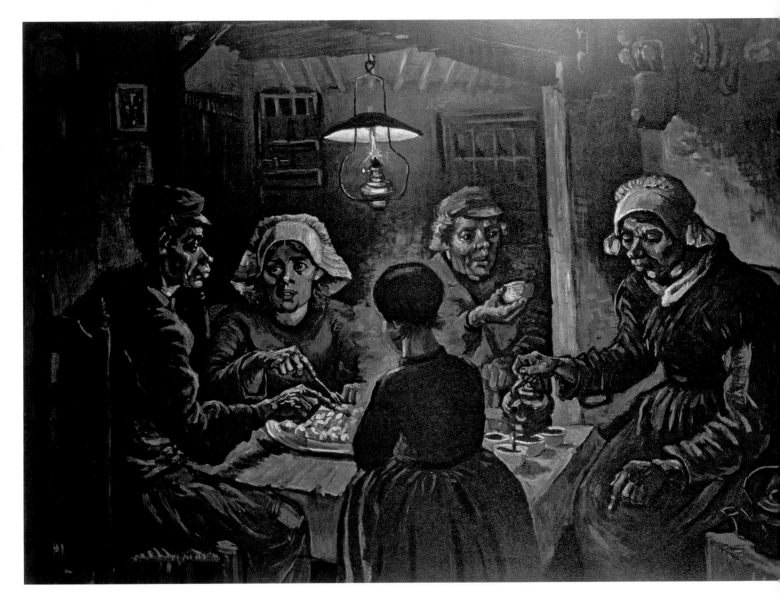

The Potato Eaters, April–May 1885, oil on canvas, Van Gogh Museum, Amsterdam, the Netherlands, 82 x 114cm (32 x 45in)

Van Gogh has invested an ordinary peasant meal with a mystical, religious aura in an attempt to use the rural (as opposed to the urban) as the foundation stone of a new, socially committed, humanitarian art. It is the culmination of his artistic, religious, literary and personal concerns; resonances of Leonardo's *Last Supper*, Rembrandt, Courbet, Millet and the contemporary Dutch artists, with whom he was so familiar, are all here. Whatever Van Gogh's intellectual or mystical ambitions, his artistic agenda was always to be rooted firmly in the real.

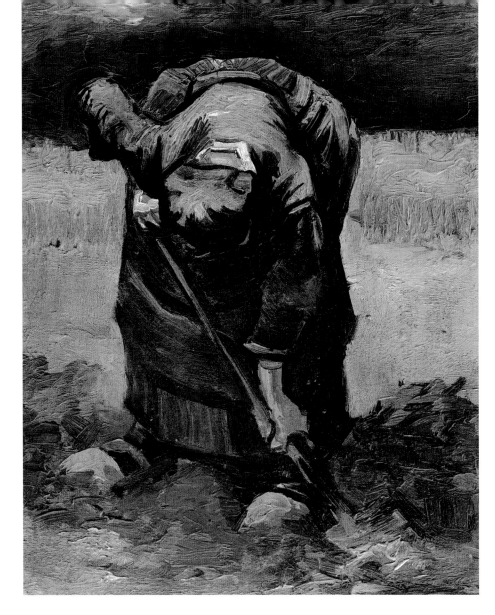

Peasant Woman Digging, August 1885, oil on canvas, The Barber Institute of Fine Arts, University of Birmingham, UK, 42 x 32cm (16.5 x 12.5in)

This painting translates into thick slabs of pigment the power of Van Gogh's incisive draughtsmanship. Each stroke of the brush, like a chisel blow, plays its part in constructing the sculptural mass of this bulky figure, who is bent in a pose that would never have been taken up by a professional model in an art academy.

Cottage with Peasant Woman Digging, June 1885, oil on canvas, private collection, 30.5 x 40cm (12 x 15.5in)

Van Gogh was very much an artist who thought in terms of programmes and campaigns. In the works of this period he can be seen methodically cataloguing the lives of his subjects, their hard work and sustained efforts to stay alive; subjects who, despite the privations they endure, display a sense of simple human dignity.

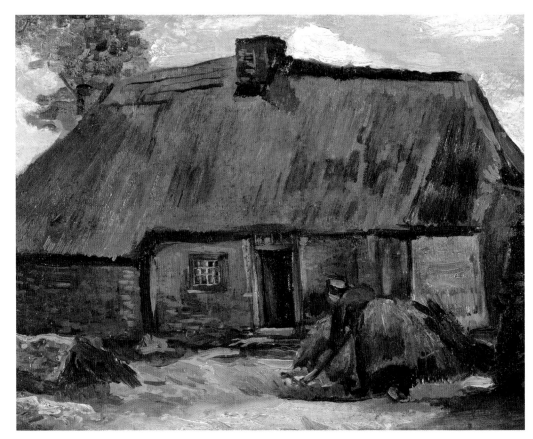

Still Life with Bible, 1885, oil on canvas, Van Gogh Museum, Amsterdam, the Netherlands, 65.7 x 78.5cm (26 x 31in)

Van Gogh's most significant painting of the period introduces a theme that he was to repeat many times throughout his career. The family Bible, open at the Book of Isaiah, is placed next to a candlestick to emphasize the brevity of life. The inclusion of a French novel sets up a dynamic relationship between the word of God, transmitted through the text of the Bible, and contemporary French literary culture. Once again we see that Van Gogh's palette is dominated by earth colours, but in this painting yellow has made its dramatic appearance.

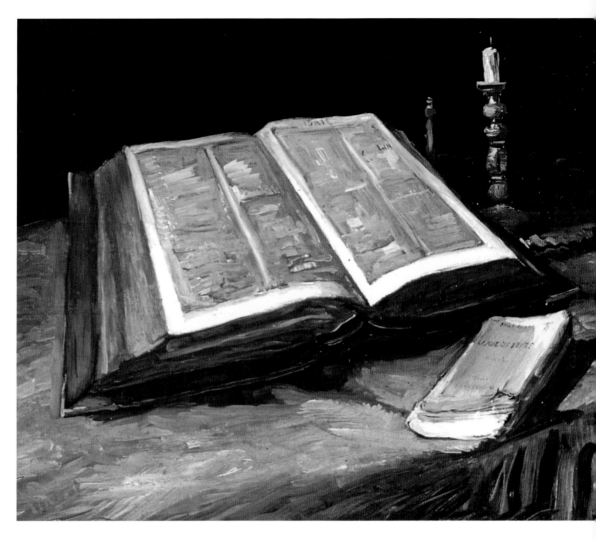

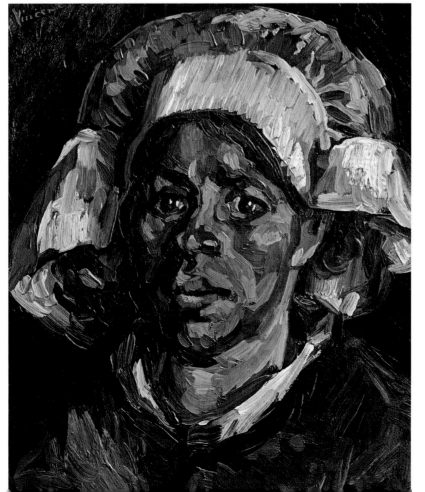

Gordina de Groot, Head, May 1885, oil on canvas, private collection, 47 x 34.5cm (18.5 x 13.5in)

This work was painted in Nuenen, just after Van Gogh completed *The Potato Eaters*. The experience of producing a major painting gave him much more confidence, as can be seen in this powerfully realized portrait. Each brush mark is considered as a single dynamic unit that plays its role to create a rhythmical ensemble in which the brilliant red (in the eyes, the mouth and Van Gogh's signature) makes a vivid contrast with the short staccato stabbings of green and blue pigment.

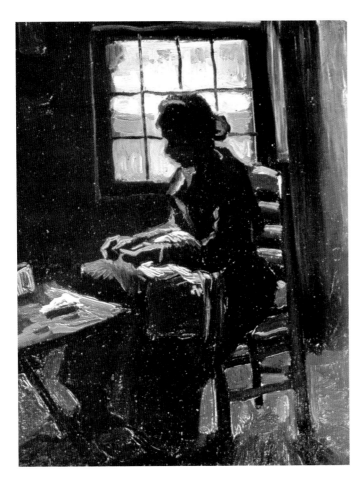

Woman Sewing, March 1885, oil on canvas, Van Gogh Museum, Amsterdam, the Netherlands, 43.2 x 34.2cm (17 x 13.5in)

This interior of a woman seen against a window is painted in a direct and deliberately clumsy fashion. Van Gogh has built up his image in slabs of opaque paint that retain the action of his brush as the stiff paint gradually locks the figure into her constrained surroundings. It is as if Van Gogh is consciously disregarding academic conventions of anatomical exactitude in order to paint in a direct and immediate way the metaphysical significance of 'humble' work.

The Cottage, May 1885, oil on canvas, Van Gogh Museum, Amsterdam, the Netherlands, 65.7 x 97.3cm (26 x 38.3in)

In the landscape around Nuenen, Van Gogh found images familiar to him from childhood, but also images similar to those found in the work of Millet and his Dutch followers. Possibly aware of the commercial opportunities such subjects offered, he painted a series of such works, often depicting the changing seasons. The sturdy form of the dwelling contrasts with the spiky trees silhouetted against the lurid sky. The visitor, seen from behind and dressed in peasant costume, strikes a picturesque note.

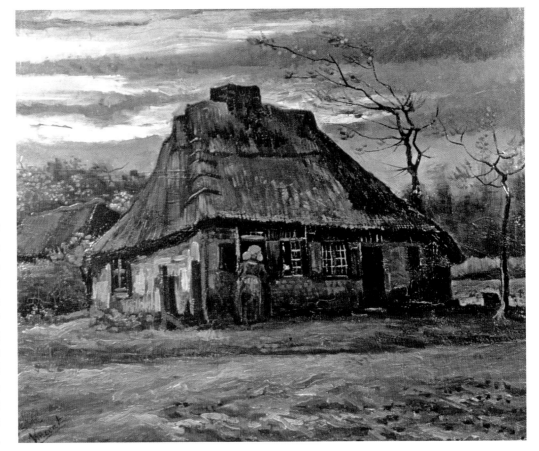

Autumn Landscape, October 1885, oil on canvas laid down on panel, Fitzwilliam Museum, University of Cambridge, UK, 64.8 x 86.4cm (25.5 x 34in)

Van Gogh considered this painting to be one of his best to date. We know that he was reading the writings of the French artist Eugène Delacroix and that he was attempting to introduce colour in a more dynamic way into his art. Using the nuanced tones of autumn foliage set against broken cloud, Van Gogh has begun to introduce light and colour into his painting.

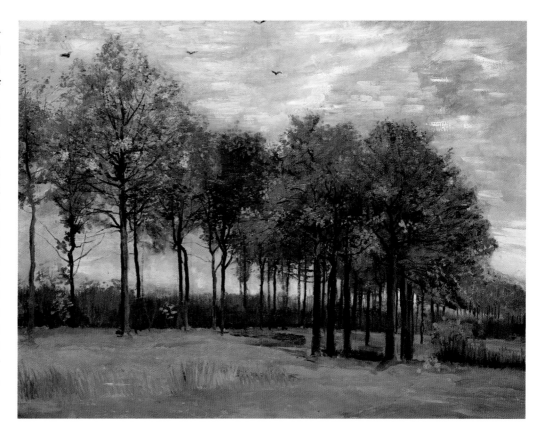

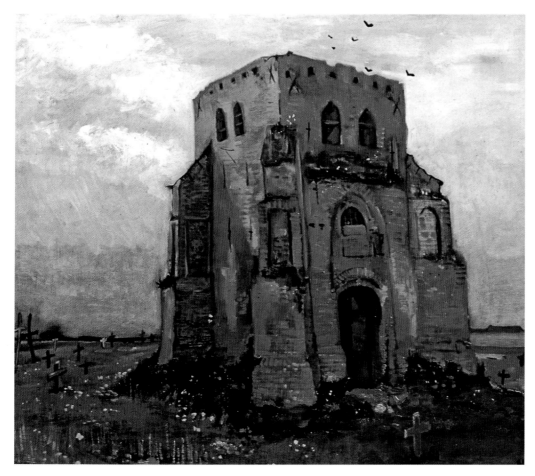

The Old Church Tower at Nuenen ('The Peasants' Churchyard'), June 1885, oil on canvas, Van Gogh Museum, Amsterdam, the Netherlands, 65 x 88cm (25.6 x 34.6in)

Van Gogh knew his Bible intimately and the use of ordinary things to convey spiritual truths was second nature to him. Here everything, the low horizon, the few birds skirting the top of the tower, the block-like presence of the ruined church all suggest that this is no mere topographical sketch. He wrote how he hoped this work would suggest the decline of the power and authority of the church in the modern world.

Reaper, 1885, pencil on paper, private collection, 30 x 23.7 cm (11.8 x 9in)

The image of the reaper is a powerful one in Western culture, suggestive of life and death. However, this ungainly sketch captures little of the allegorical possibilities of the subject that Van Gogh will develop to great effect in much of his later work.

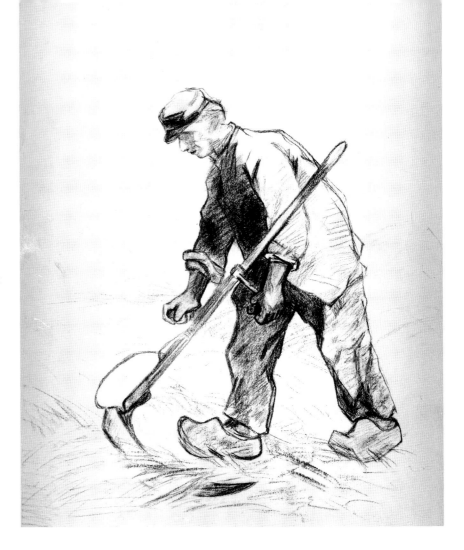

Still Life with Birds' Nests, October 1885, oil on canvas, Van Gogh Museum, Amsterdam, the Netherlands, 39.3 x 46.5cm (15.5 x 18.3in)

Van Gogh delighted in the large and small aspects of the natural world; in this painting the poignancy of these birds' nests, empty or abandoned, suggests a sense of wretched loneliness. A study in browns, oranges and lilacs, the thick brush work emphasizes the tactile character of these prosaic objects made strange by the artist's intense scrutiny.

The Vicarage at Nuenen,
October 1885,
oil on canvas, Van Gogh
Museum, Amsterdam,
the Netherlands,
33 x 43cm (13 x 17in)

The family home; six
months before this
picture was painted Van
Gogh's father had died
unexpectedly. The artist
worked in the laundry room,
which he had asked to be
turned into a makeshift
studio. The contrast
between the solid bourgeois
home and the pictorial
charm of the peasants'
cottages is unmistakable.
Despite the presence of the
figures that stand before
the gate, everything in the
composition suggests a
sense of exclusion.

Sale of Building Scrap, May
1885, watercolour on paper,
Van Gogh Museum,
Amsterdam, the Netherlands

Like a scene from a novel
by Zola, the contents of
The Peasants' Churchyard
are being sold for scrap.
The building itself was
demolished shortly after
this watercolour was
completed. There is
a somewhat ghoulish
touch in the inclusion of
two peasants, who are
gathering together the
discarded wooden crosses
that once marked the
graves of their forebears.
Van Gogh's concern about
the dwindling influence of
Christianity on the lives
of ordinary people is
here made evident.

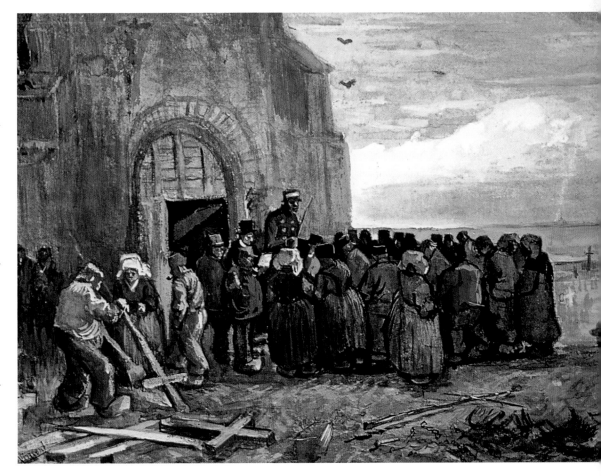

Portrait of an Old Man with Beard, December 1885, oil on canvas, Van Gogh Museum, Amsterdam, the Netherlands, 44.5 x 33.5cm (17.5 x 13.2in)

Van Gogh's growing certainty of touch can be felt here. This character study has the power and energy of an early Cézanne painting. Each separate brush stroke is made to count as they lock together to form an almost sculptural realization of this old man. The restricted colours make a moving harmony of silvers, greys, browns and blacks that complement the meditative aura of the painting.

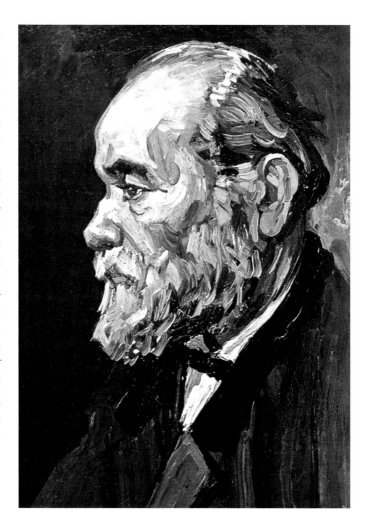

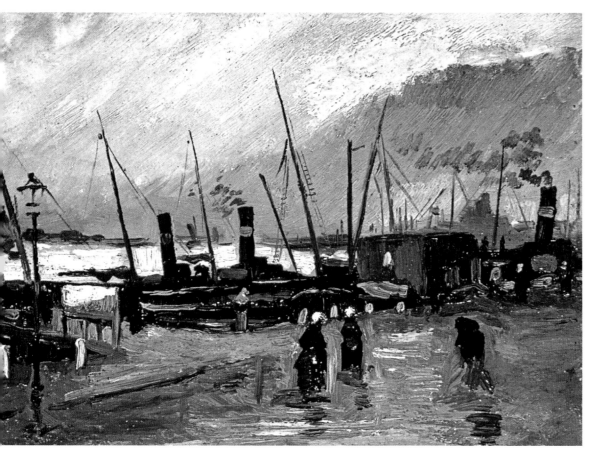

The De Ruijterkade in Amsterdam, October 1885, oil on panel, Van Gogh Museum, Amsterdam, the Netherlands, 20.3 x 27cm (8 x 10.7in)

At this time Van Gogh was hoping to produce works that would be attractive to the local art market. This is a perfect evocation of a wet and gloomy evening. Painted with minimal means, the smoke stacks and masts counterpoint each other, creating a lively pattern against the dark luminosity of the sky. It is an image that he would return to in the South of France, where sailboats would replace the steamboats and the sun the rain-filled sky.

Backyards of Old Houses in Antwerp in the Snow, December 1885, oil on canvas, Van Gogh Museum, Amsterdam, the Netherlands, 44 x 33.5cm (17.3 x 13.2in)

The heavy snow-laden sky casts an oppressive presence over the ragged geometry of the backyards. The fallen snow gives an atmosphere of stillness and quiet to the scene. However, Van Gogh's vision is very different from the intimate cityscapes of Vermeer or de Hooch, whose paintings endow the urban with an air of community and security. In Van Gogh's painting we look out not over the public prospect of house frontages but over a chaotic tumble of windows and roofs.

Skull of a Skeleton with Burning Cigarette, winter 1885–6, oil on canvas, Van Gogh Museum, Amsterdam, the Netherlands, 32 x 24.5cm (12.6 x 9.7in)

Van Gogh had a reputation as a rebel during his brief time studying at the Antwerp Académie des Beaux-Arts. Although a grimly humorous take on the rigours of academic training, this is nevertheless a well-observed and carefully crafted tonal study. Van Gogh has boldly simplified the complex forms of the skeleton and overlaid the tonal divisions with strong graphic strokes of his brush.

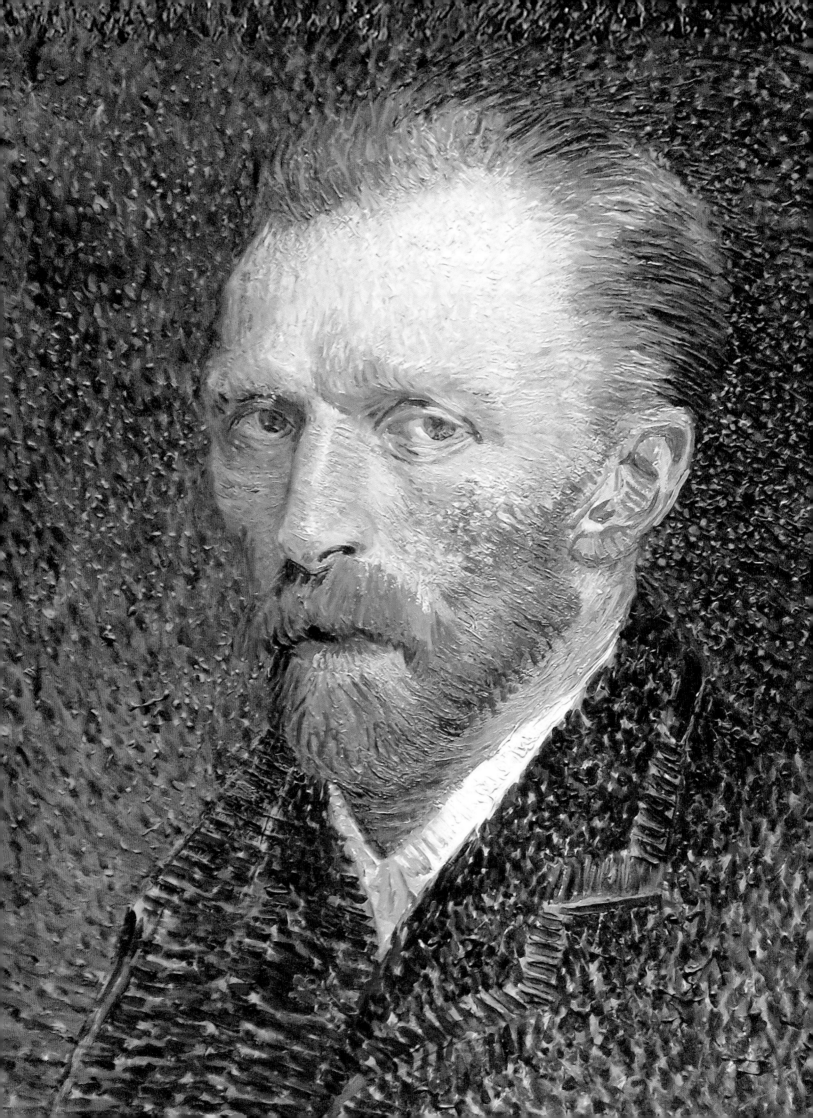

PARIS

In the mid- to late 19th century, Paris was the self-proclaimed centre of
the art world. Many artists of different nationalities flocked to France's
capital to follow their fine art studies. Van Gogh arrived just as the
Impressionists were beginning to become generally accepted. Younger
artists were challenging their apparent dedication to *plein air* painting.
With his brother Theo being involved in the gallery world and actively
trying to promote the Impressionists' work, Van Gogh was in a perfect
position to take advantage of all that was happening. His cool,
self-appraising self-portraits of this period, painted with short flecks
of colour, document the liberation experienced by the artist in the
two years he remained in the French capital.

Above: The Restaurant de la Sirène at Asnières, *1887.*
Left: Self-portrait, *spring 1887. Van Gogh painted this not long after his arrival in Paris.*
He is ready to learn and determined to succeed, whatever the odds.

View of Montmartre, 1886,
charcoal and feather,
Stedelijk Museum
Amsterdam/Snark Archives,
the Netherlands

Van Gogh is looking up at
the windmills of Montmartre
that give this French
landscape a touch of
Holland. It is a carefully
observed drawing that is
sensitive to detail and to the
complexities of light and
shade. The irregularity of
the smallholdings and the
neighbouring structures have
been generalized into simple
blocky forms, which gives a
certain gravitas to the scene.

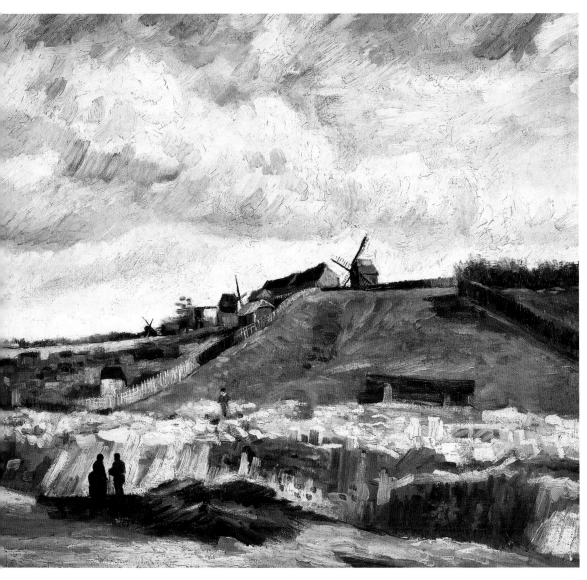

*The Hill of Montmartre with
Quarry*, 1886, oil on canvas,
Van Gogh Museum,
Amsterdam, the
Netherlands, 56 x 62.5cm
(22 x 24.6in)

Already Van Gogh's style
is lightening and increasing
note is being taken of
broken touches of pure
colour. A blustery day –
the pink and violet of the
broken clouds are also found
in the block-like strokes that
describe the white cut of
the quarry. The eye is led
up past the clutter of
smallholdings, towards
Paris itself, which lies hidden
behind the ridge. The rolling
rhythms of the clouds
contrast with the block-like
forms of the white stone and
the dark silhouettes of the
two iconic figures.

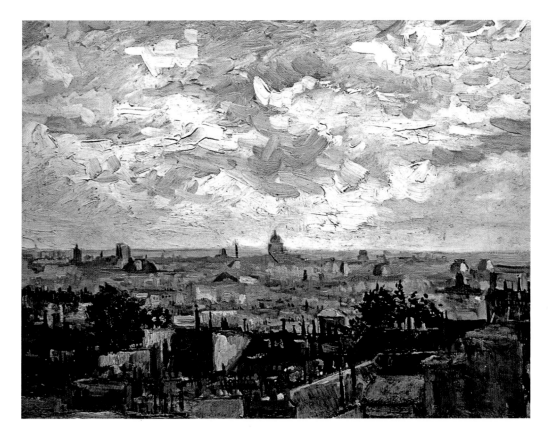

View of the Roofs of Paris, summer 1886, oil on canvas, Van Gogh Museum, Amsterdam, the Netherlands, 54 x 72.5cm (21.3 x 28.5in)

Painting the modern city in a suitably modern way had been one of the primary ambitions of the Impressionist circle of painters. In these works Van Gogh can be seen following that agenda. Looking down from the heights of Montmartre across the city, the imposing bulk of Notre Dame and the distinctive dome of the Pantheon are clearly visible. The agitated brush work of the sky suggests something of the explosion that is to come.

Lane at the Jardin du Luxembourg, June–July 1886, oil on canvas, Sterling and Francine Clark Art Institute, Williamsburg, MA, USA, 27.5 x 46cm (10.8 x 18.1in)

A simple, fresh, naturalistic study of the gardens of the Luxembourg Palace in Paris. Van Gogh would have visited the museum of French contemporary art that was housed here many times. He registers what he sees with a direct and confident application of paint; two touches of red serve to hold the composition in place and counterpoint the green of the foliage.

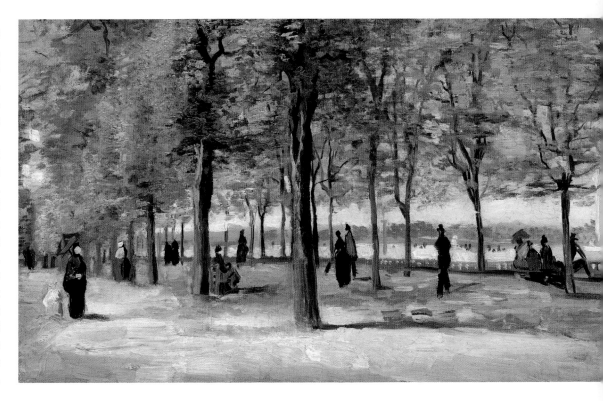

Outskirts of Paris, 1886, oil on canvas on cardboard, private collection, 45.7 x 54.6cm (18 x 21.5in)

Van Gogh lived in Montmartre on the outskirts of Paris and many of his paintings feature not the *ville éclaré* of the inner boulevards – the great stores, churches and public monuments – but rather 'the zone', an awkward space where the city encroaches upon the countryside. This painting shows none of the glamour of the great art capital of Europe, creating instead a poetic image of uncertainty and contingency.

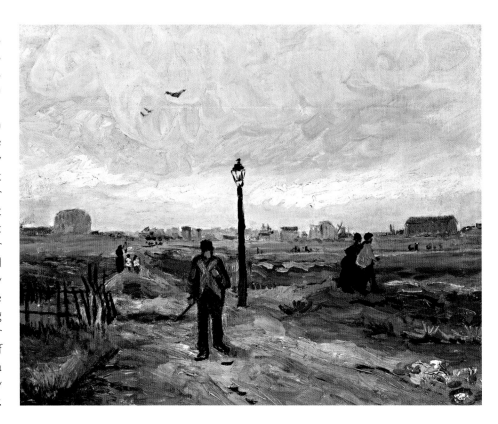

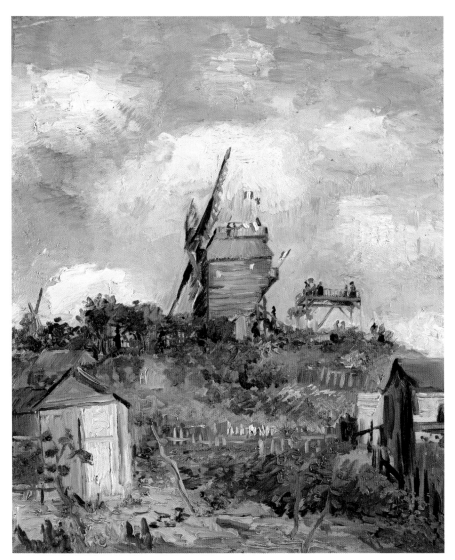

Le Moulin de la Galette, summer 1886, oil on canvas, Kelvingrove Art Gallery and Museum, Glasgow, Scotland, 46 x 38cm (18.1 x 15in)

Van Gogh carried a nostalgic yearning for his homeland wherever he went, and he must have been comforted to see the familiar form of a windmill standing alert on the flanks of '*la butte Montmartre*'. Though his colours were becoming lighter, he was still very much engaged in working within the Dutch tradition of tonal painting.

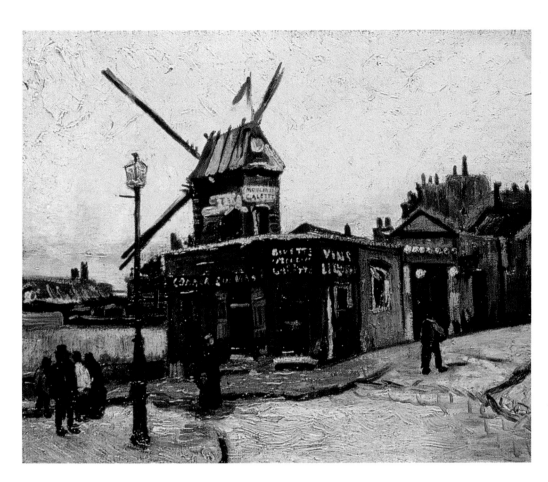

Le Moulin de la Galette,
autumn 1886, oil on canvas,
Kröller-Müller Museum,
Otterlo, the Netherlands,
38 x 46cm (15 x 18in)

In the earlier part of the
19th century a French
painter, Georges Michel,
had lived in Montmartre
and painted its windmills
in a manner reminiscent
of Rembrandt. Van Gogh's
initial Parisian canvases are
very much in his manner,
but, within a very short
space of time, his style
of painting changes
dramatically as he becomes
aware of the light-infused
canvases of Monet and
the Impressionists.

*Terrace of a Cafe on
Montmartre (La Guinguette),*
1886, oil on canvas, Musée
d'Orsay, Paris, France,
49.5 x 64.5cm
(19.5 x 25.5in)

Though part of Paris,
Montmartre had kept much
of its original picturesque
village charm. It was a place
where people from the
city could lose themselves
in bars, bistros and
restaurants, where the
classes and sexes mingled
and enjoyed their leisure. It
was cheap and full of
students, artists, writers
and musicians. Van Gogh
lived at the heart of this
exciting milieu and took
advantage of it, meeting
people, talking, drinking
and painting.

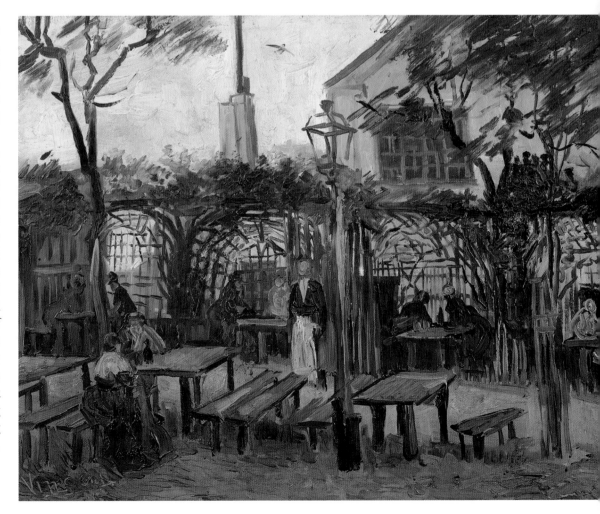

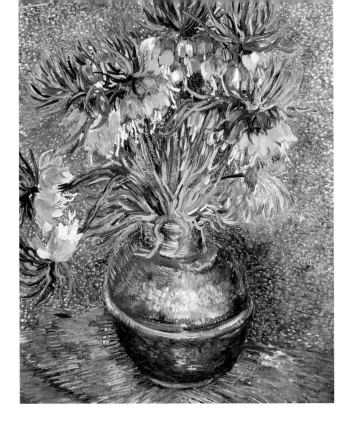

Fritillaries in a Copper Vase, April–May 1887, oil on canvas, Musée d'Orsay, Paris, France, 73 x 60.5cm (28.5 x 24in)

Van Gogh produced a large number of still lifes of flowers in which heavily encrusted paint surfaces show the influence of Adolphe Monticelli (1824–86). The richly worked background of variegated blue contrasts with the vividness of the copper vase and reddish yellow of the flowers.

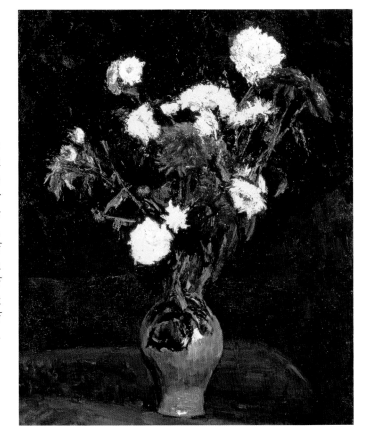

Vase with Carnations and Zinnias, summer 1886, oil on canvas, private collection, 61 x 50.3cm (24 x 19.8in)

In the summer and autumn of 1886 Van Gogh embarked upon a campaign of painting still lifes of flowers. He found it difficult to gain access to models, and flowers, like his self-portraits, gave him free rein to experiment with colour, texture and the fall of light. This particular example is relatively traditional in approach, following the example of Fantin-Latour, but there is a liveliness in the handling of the flower-heads that suggests the shape of things to come.

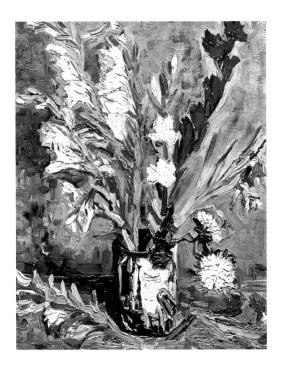

Vase with Gladioli, summer 1886, oil on canvas, Van Gogh Museum, Amsterdam, the Netherlands, 46.5 x 38.5 cm (18.3 x 15.2 in)

An extraordinarily vigorous composition, full of contrasts. The brushwork is constructed of regularly placed blocks of thick colour laid on with a square brush that contrast with the freely painted forms of the exuberant blooms.

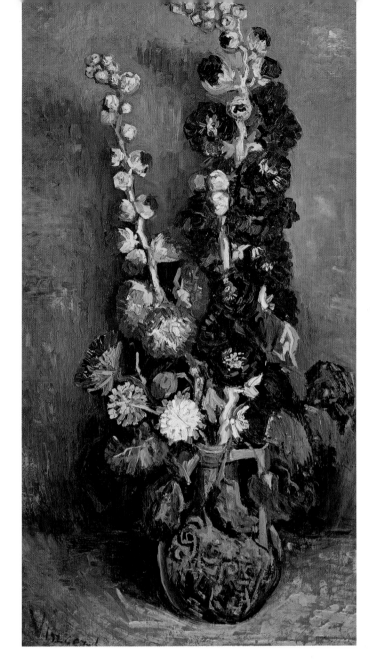

Vase with Hollyhocks, August–September 1886, oil on canvas, Kunsthaus Zürich, Switzerland, 91 x 50.5cm (36 x 20in)

Van Gogh's encounter with Delacroix and the artists associated with Impressionism allowed him to develop a broken, rhythmic application of paint and to break free from the tonal sobriety and broad painterly handling that had characterized his Dutch period. Supported by his brother Theo and the paint seller Père Tanguy, Van Gogh began to paint a number of flower pieces on which he could experiment with touches of pure colour.

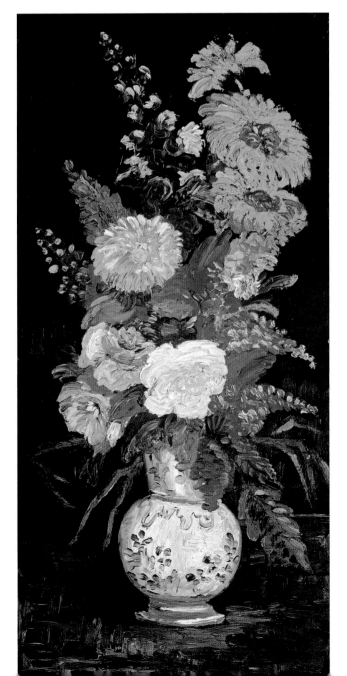

Vase with Asters, Salvia and other Flowers, summer 1886, oil on canvas, Gemeentemuseum, The Hague, the Netherlands, 70.5 x 34cm (27.8 x 13.4in)

The latter part of the 19th century saw a revival of still life painting. It allowed artists such as Manet and Cézanne, as well as Van Gogh, to concentrate on the formal aspects of picture making without having to consider the ethical or moral issues normally associated with art. Van Gogh's delight in the painterly virtues is evident in the relish of the formal rhythms of this rather ungainly vase of flowers.

Portrait of the Art Dealer Alexander Reid, Sitting in an Easy Chair, winter 1886–7, oil on panel, Fred Jones Jr. Museum of Art, University of Oklahoma, Norman, OK, USA, 41 x 33cm (16.1 x 12in)

The sitter here was a Scottish colleague of Van Gogh's at Goupil's who became a highly successful dealer. He was friendly with Van Gogh until, it is said, Van Gogh (himself depressed by his dependency on Theo's goodwill) suggested a joint suicide pact as a simple means of resolving a temporary problem in his friend's complicated emotional life.

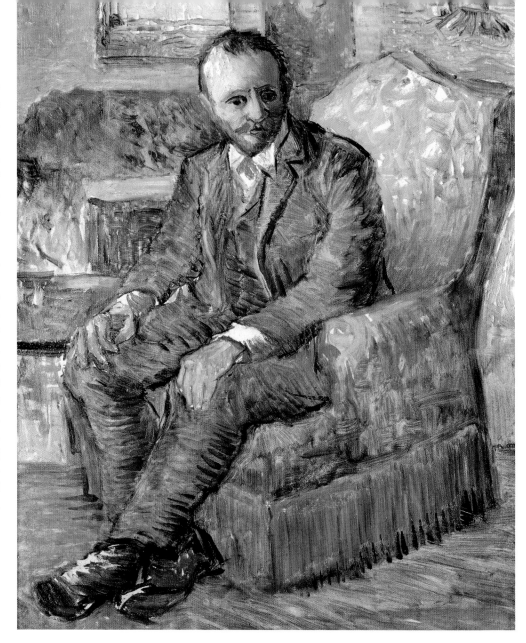

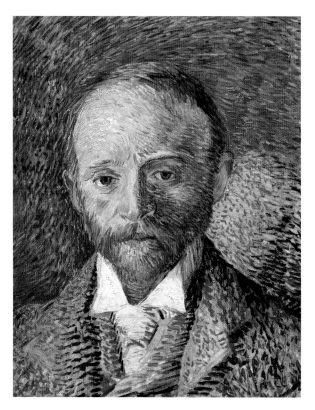

Portrait of the Art Dealer Alexander Reid, spring 1887, oil on cardboard, Glasgow Art Gallery and Museum, Scotland, 41.5 x 33.5cm (16.3 x 13.2in)

Reid shared Vincent and Theo's enthusiasm for Monticelli's painting. This work, completed when they were still close, is characterized by an indefinable sense of melancholy. The green/orange colour harmony is exquisitely balanced, as is the unexpected presence of the back of the chair, which gives the painting a quirky dynamic.

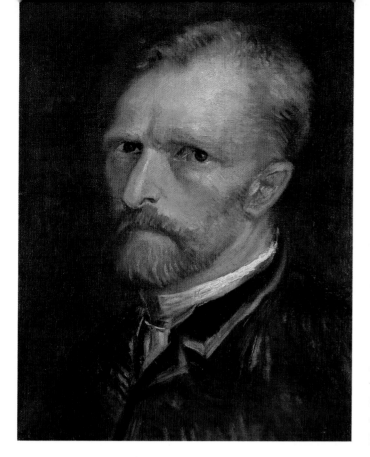

Self-portrait, autumn 1886, oil on canvas, Gemeentemuseum, The Hague, the Netherlands, 39.5 x 29.5cm (15.5 x 11.5in)

More than 24 self-portraits survive from Van Gogh's two-year stay in Paris. He painted this using the earthy range of colours that typified his Antwerp paintings. Only his piercing blue eyes are accentuated in this otherwise rather muted self-portrait; he looks anxious, but determined, his beard is well-trimmed and the handling of his jacket (recognizable from other self-portraits of the period) is restrained.

Woman Sitting by a Cradle, spring 1887, oil on canvas, Van Gogh Museum, Amsterdam, the Netherlands, 61 x 45.5cm (24 x 18in)

Van Gogh's ceaseless experimentation and risk-taking can be seen in his adoption of a tentative, nervous style of painting using delicate broken dabs of relatively dilute oil paint. For a while both he and Toulouse-Lautrec employed this manner to create a number of highly sensitive, psychologically charged portraits. The sitter is Léonie-Rose Davy-Charbury, niece of an art-dealer friend of Theo's. Van Gogh's determination to find a highly personalized style is almost palpable.

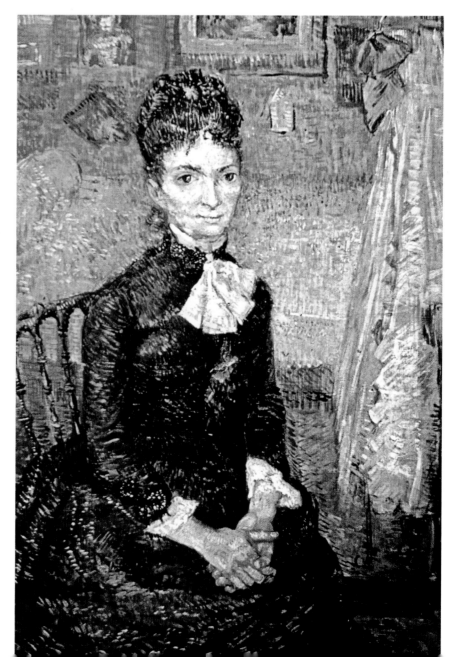

Still Life with Absinthe, spring 1887, oil on canvas, Van Gogh Museum, Amsterdam, the Netherlands, 46.5 x 33cm (18.3 x 13in)

This is no still-life of humble domestic objects given gravitas by years of sustained use, but the table top of a Parisian café on which is placed the ubiquitous absinthe and water – the 'green fairy'; a potent alcoholic drink, distilled from wormwood and aniseed. The drink became synonymous with alcoholism, and was often referred to as 'the ticket to the madhouse.'

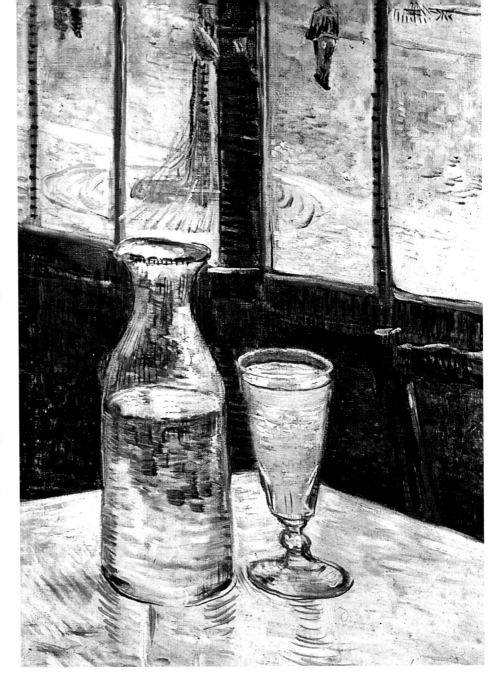

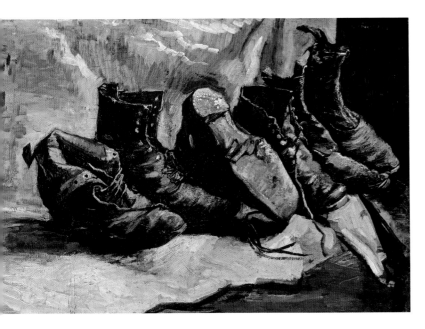

Three Pairs of Shoes, December 1886, oil on canvas, Fogg Art Museum, Harvard University Art Museums, Boston, MA, USA, 49 x 72cm (19.3 x 28.3in)

Van Gogh produced a number of paintings of worn out shoes, all of which had a special resonance for him. As a youth he had read John Bunyan's *Pilgrim's Progress*, a book he continued to read all his life. It is known that he bought these shoes specifically with the intention of painting them, using them as a symbol of the journey through life. As he did so often, Van Gogh has found a simple way of illustrating a profound truth without slipping into pretentiousness or triviality – these boots are as much an image of the artist as any of his self-portraits.

Nude Woman Reclining, Seen from the Back, early 1887, oil on canvas, private collection, 38 x 61cm (15 x 24in)

Painting the nude was a rite of passage for any significant artist in the 19th century and the challenge of approaching this time-honoured subject in a radical, modern way had captured the energies of some of the most talented and intelligent painters of the day. Directional brushwork and a subdued palette create a sense of intimacy and restraint. The humanity of this work suggests the nudes of Rembrandt or Corot.

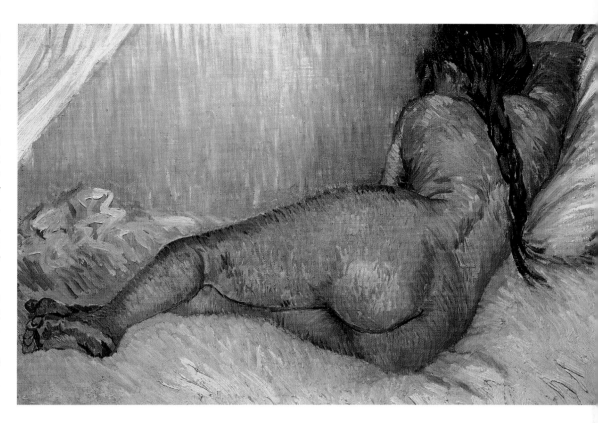

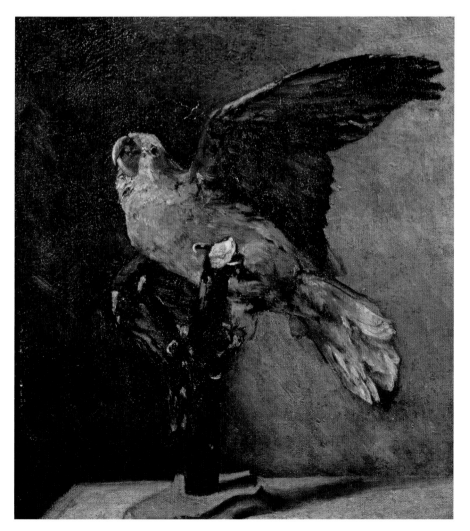

The Green Parrot, autumn 1886, oil on canvas on panel, private collection, 48 x 43cm (19 x 17in)

This painting belongs to Van Gogh's first few months in Paris and its subject, a stuffed parrot, is painted with a real sense of assurance – the brushwork is lively and the colours of the parrot's gaudy plumage give the artist the excuse to set the contrasting colours of green and red against the russet browns and ochres of the background.

View from Vincent's Room in the Rue Lepic, 1887, oil on pasteboard, private collection, 46 x 38cm (18 x 15in)

This view is from the apartment that Theo and Vincent van Gogh had moved into from their cramped quarters on the Rue Laval. The work reveals a tentative and idiosyncratic use of certain aspects of pointillism; the image is formed by short strokes and dabs and dashes of pure colour which dance across the surface of the painting, while tense lines hold the architectural details in place. Close scrutiny of the work reveals Van Gogh's use of an underlying geometric framework to help him create a convincing perspectival structure.

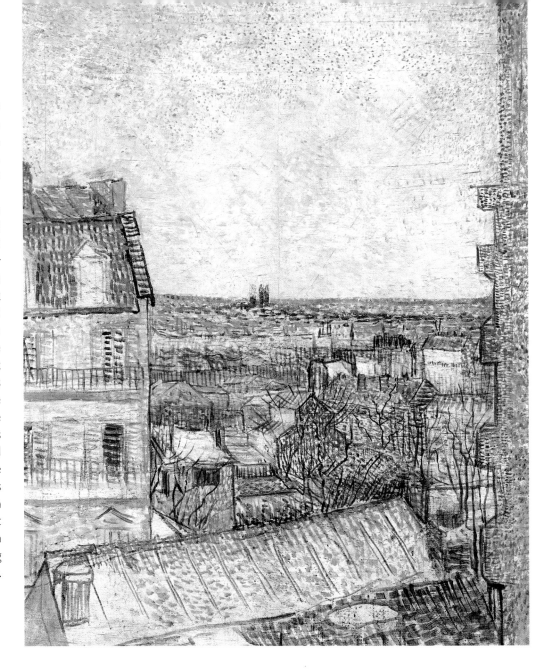

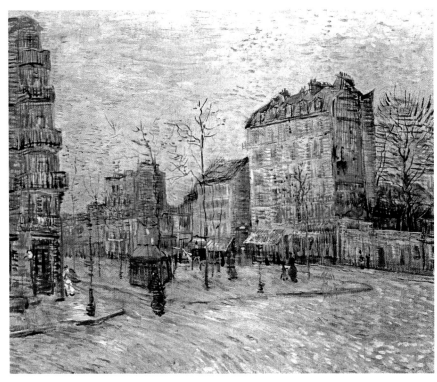

Boulevard de Clichy, February–March 1887, oil on canvas, Van Gogh Museum, Amsterdam, the Netherlands, 45.5 x 55cm (16.7 x 21.7in)

This is as close as Van Gogh gets to the great cityscapes that were painted in the previous decade. The lightness of the brushwork flickers across the surface of the canvas; horizontal and vertical marks create the structure and architectural forms of the building, while dancing touches of colour suggest the ever-changing play of light.

Self-portrait, spring 1887, oil on paper, Kröller-Müller Museum, Otterlo, the Netherlands, 32 x 23cm (12.5 x 9in)

Like Rembrandt, Van Gogh painted many self-portraits. They catalogue his steady experimentation with the new techniques with which he was coming into contact, but they are also psychological documents, as each seems to represent a different persona. As he did so many times, Van Gogh has made great play with colour contrast, using his own red colouring against the cool tones of the greens and blues of his necktie and background. The light green used to describe his left eye gives this portrait a very powerful sense of presence.

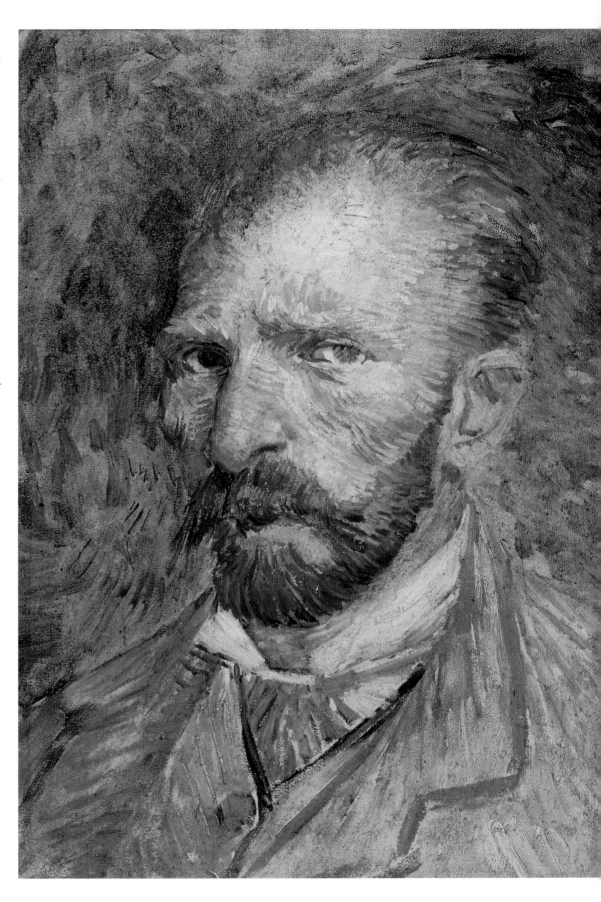

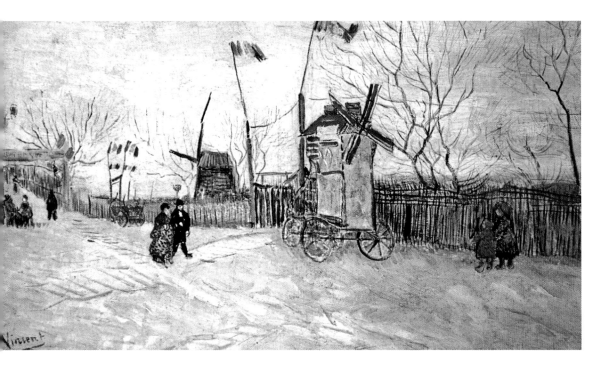

Street Scene in Montmartre: Le Moulin à Poivre, February–March 1887, oil on canvas, Van Gogh Museum, Amsterdam, the Netherlands, 34.5 x 64.5cm (13.6 x 25.4in)

The horizontal format is striking and the composition, banded across the middle section of the canvas in an ungainly sprawling fashion, suggests a sense of informality and movement. It is as if the countryside has somehow made a tentative encroachment into the sprawling city, which remains hidden, just out of view.

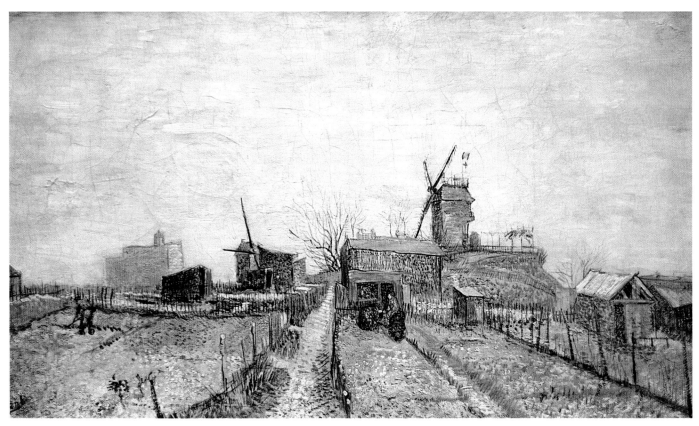

Vegetable Garden in Montmartre, 1887, oil on canvas, Van Gogh Museum, Amsterdam, the Netherlands, 44.8 x 81cm (17.5 x 32in)

Suddenly, in the space of a few weeks, Van Gogh began to make use of his re-encounter with the work of Delacroix, Rubens and the great colourists whose work he could see in Paris. This painting gives little sense of the fact that just a few hundred yards away is the bustling activity of a modern city; it is a deliberate homage to the work of Georges Michel, who had painted this area a few years earlier and for whom Van Gogh had the highest regard.

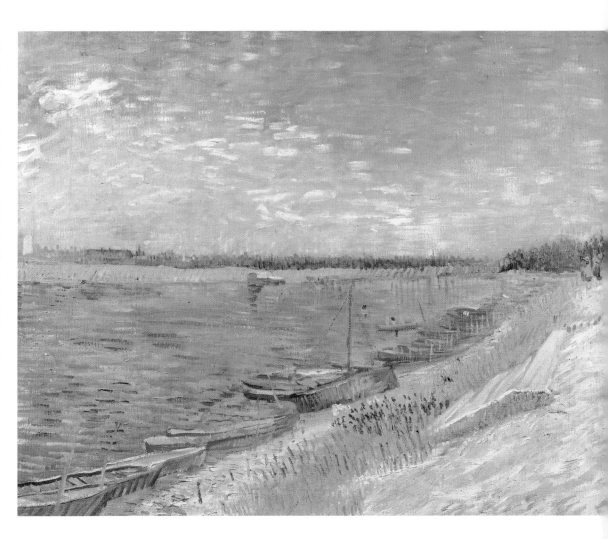

View of a River with Rowing Boats, 1887, oil on canvas, private collection, 52 x 65cm (20.5 x 25.5in)

Van Gogh has taken a sharp-angled view of the river and the boats that are moored to its bank. The painting shows a growing mastery of drawing and composition, and although there are notes of strong colour, the effect is of a tapestry-like softness. Every element of the painting is constructed with the power that would become one of the hallmarks of Van Gogh's future work.

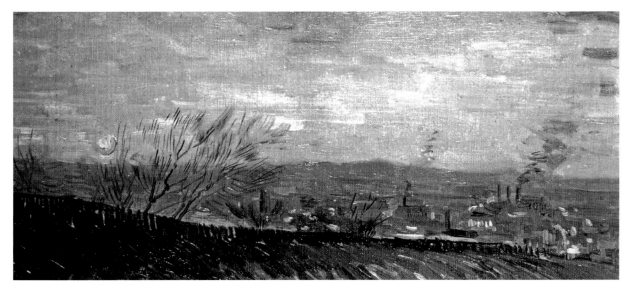

Factories Seen from a Hillside in Moonlight, 1887, oil on canvas, Van Gogh Museum, Amsterdam, the Netherlands, 21 x 46.5cm (8.3 x 18.3in)

The evening light and the setting sun veils this industrial landscape with mystery and brings a harmonious beauty to what would otherwise be a nondescript scene. Once again Van Gogh's ability to create poetry out of the most mundane of subjects is evident. Subtle tones are laid down with broken directional brushwork, the bare silhouettes of the leafless trees brushed in with delicate feathered strokes.

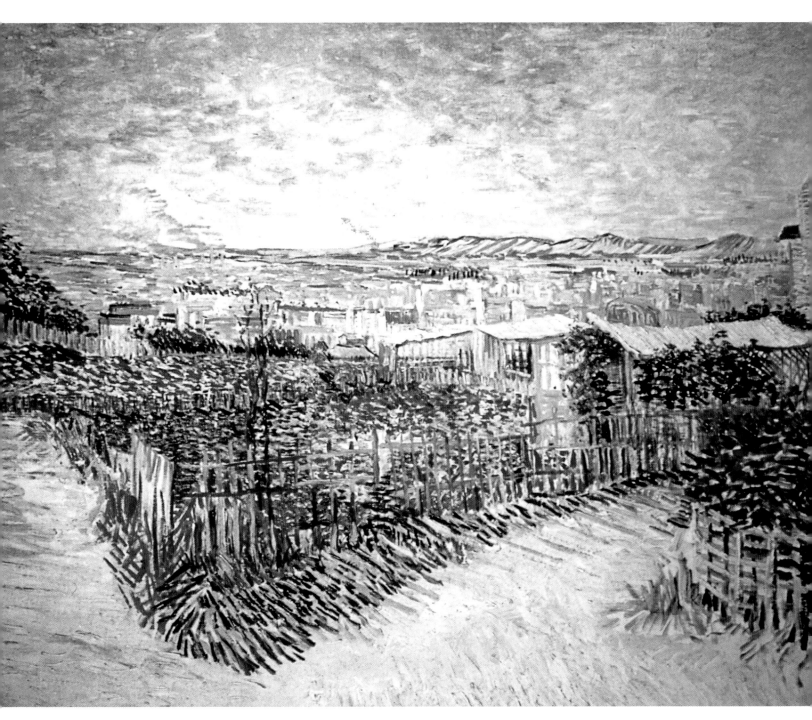

Vegetable Gardens at Montmartre, summer 1887, oil on canvas, Van Gogh Museum, Amsterdam, the Netherlands, 81 x 100cm (32 x 39.4in)

Another daringly experimental piece in its touch, colour and composition and brushwork. A sharp diagonal cuts into the foreground of the picture creating one of Van Gogh's favourite compositional motifs: the bifurcated pathway. The raggle-taggle of allotments, vegetable plots and smallholdings create a kaleidoscopic display of variegated colour. Greens and ochres, lilacs and pinks have been gently stroked on to the canvas in his own version of the pointillist style developed by Seurat and Signac and taken up with such enthusiasm by his friend Pissarro. Like Pissarro and Rembrandt, Van Gogh was always attracted to a landscape that showed the marks of human intervention.

Restaurant de la Sirène at Asnières, summer 1887, oil on canvas, Musée d'Orsay, Paris, France, 54.5 x 65.5cm (21.5 x 26in)

Van Gogh worked with Bernard and Signac at Asnières, a working-class suburb on the western edge of Paris. His depictions of the area reveal his growing interest in experimentation and the increasing lightness of his palette. Here, the high colour and broken brushwork reveal the influence of Signac – a disciple of Seurat, the instigator of pointillism.

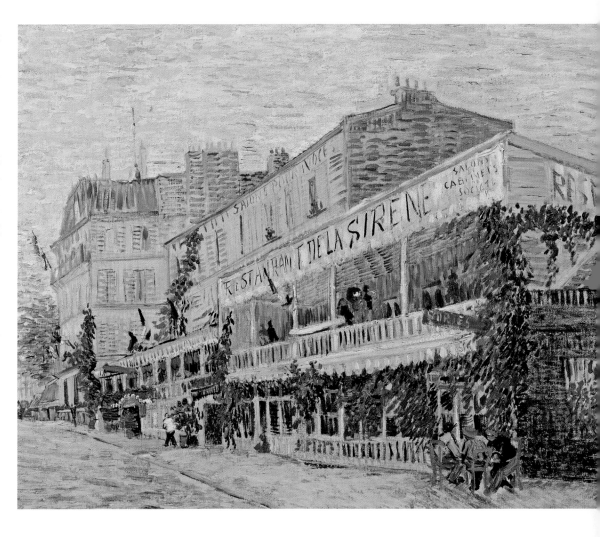

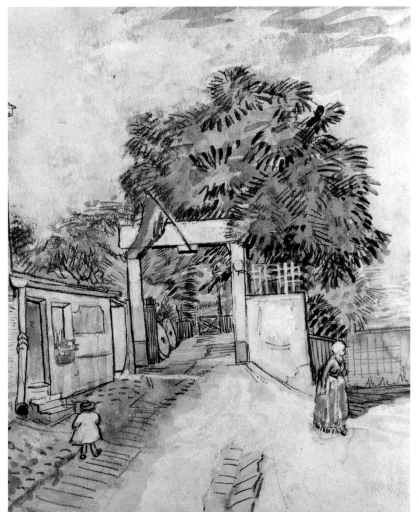

Entrance to the Moulin de la Galette, June–September 1887, watercolour on paper, Van Gogh Museum, Amsterdam, the Netherlands, 31.5 x 24cm (12.5 x 9.5in)

Here the architecture creates a dynamic and unusual compositional structure, which unites Van Gogh's interest in traditional Dutch painting with his newfound admiration for Japanese prints. Like so many French artists, Van Gogh has made use of the tricolour to introduce notes of pure colour into his painting.

Vase with Flowers, Coffeepot and Fruit, spring 1887, oil on canvas, Von der Heydt Museum, Wuppertal, Germany, 41 x 38cm (16 x 15in)

A straightforward study of simple everyday objects, allowing the particular characteristics of each to quietly state its individual presence and to work together with others to create a harmonious ensemble of line, colour and texture.

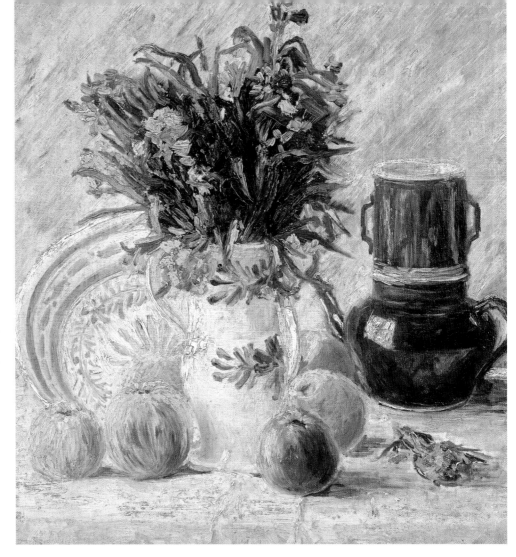

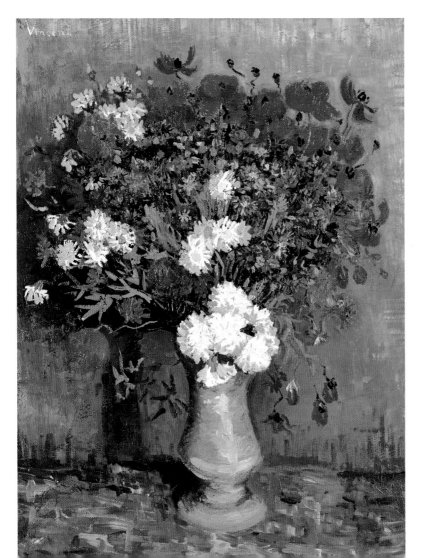

Vase with Cornflowers and Poppies, summer 1887, oil on canvas, private collection, 80 x 67cm (31.5 x 26.5in)

This exuberant painting is built upon the simple contrast of two basic colours – blue and red, which together with the white of the chrysanthemums make up the colours of the French tricolour. The table upon which the blue vase stands is made up of an interweaving pattern of broken brushstrokes.

Vase with Lilacs, Daisies and Anemones, summer 1887, oil on canvas, Musée d'Art et d'Histoire, Geneva, Switzerland, 46 x 38cm (18 x 15in)

Compare this with *Vase with Cornflowers and Poppies*. Here the same blue vase, table and backdrop play to an informal grouping of wild flowers – the colours in the bouquet are echoed in subdued form by the rest of the composition. Van Gogh is clearly experimenting with a smaller, dab-like application of paint.

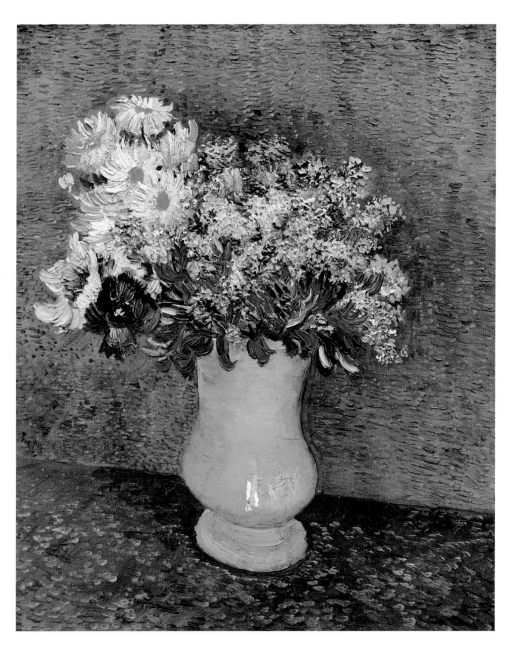

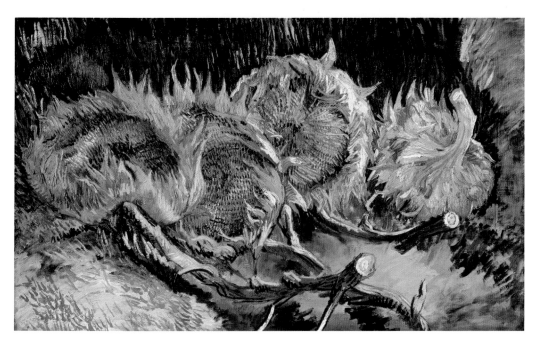

Four Cut Sunflowers, 1887, oil on canvas, Kröller-Müller Museum, Otterlo, the Netherlands, 60 x 100cm (23.5 x 39.5in)

These decaying sunflower heads are more than a study in colour and form. Van Gogh will make yellow his colour, the colour of life and regeneration, and one cannot help but read into these closely observed forms his own unease and his need to leave the cold of the dreary north for the heat and light of the south.

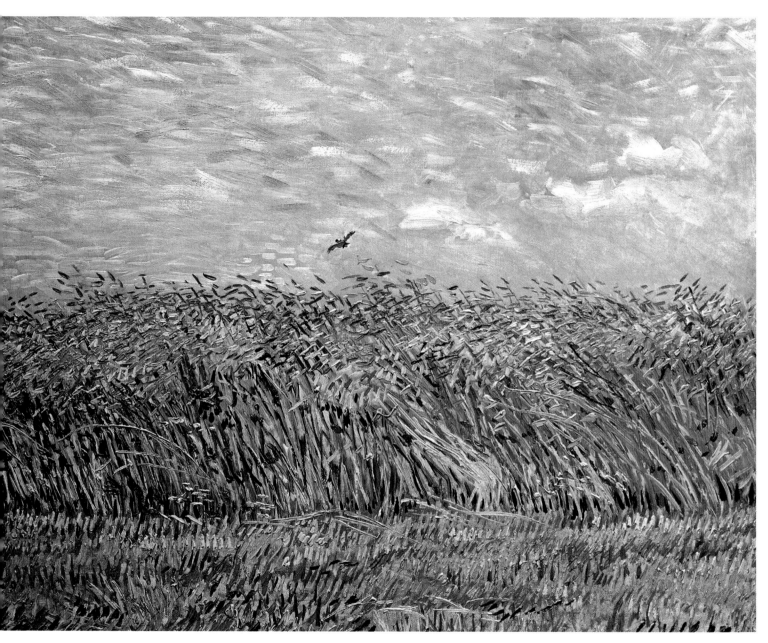

Wheat Field with a Lark, summer 1887, oil on canvas, Van Gogh Museum, Amsterdam, the Netherlands, 54 x 65.5cm (21.5 x 26in)

The horizontal banding structure used here is typical of the artist. The rhythmical sequence of agitated brushmarks makes a convincing pictorial equivalent to the movement of the gust of wind as it blows through a wheat field and throws a bird off balance. Van Gogh would return to this motif in some of his final paintings, when the topographical immediacy of this painting would become electrified by a tense, emotional dynamic.

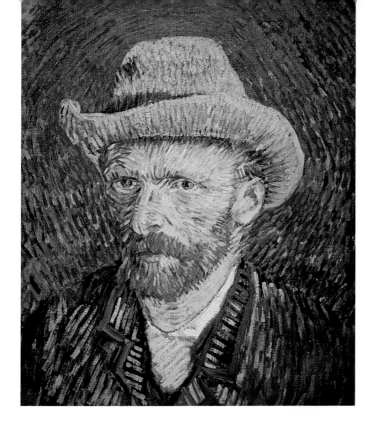

Self-portrait with Grey Felt Hat, January–March 1887, oil on canvas, Van Gogh Museum, Amsterdam, the Netherlands, 44 x 37.5cm (17.5 x 15in)

Van Gogh's self-portraits are all different, but all are united by the particular intensity he gives to his own gaze as it scrutinizes the face in the mirror. This portrait is tense, but reflective. The paint is applied in a series of directional marks that seem to spiral out from the very centre of the canvas, irradiating out from the artist in a field of energy.

Self-portrait with Straw Hat, summer 1887, oil on canvas, Van Gogh Museum, Amsterdam, the Netherlands, 40.5 x 32.5cm (16 x 12.8in)

This rapidly painted sketch depicts the artist sporting a straw hat as if in anticipation of finding the utopia he saw represented in Japanese prints. The unobtainable Orient is to be replaced by the relative accessibility of Provence, where he hoped to found a 'Studio of the South'.

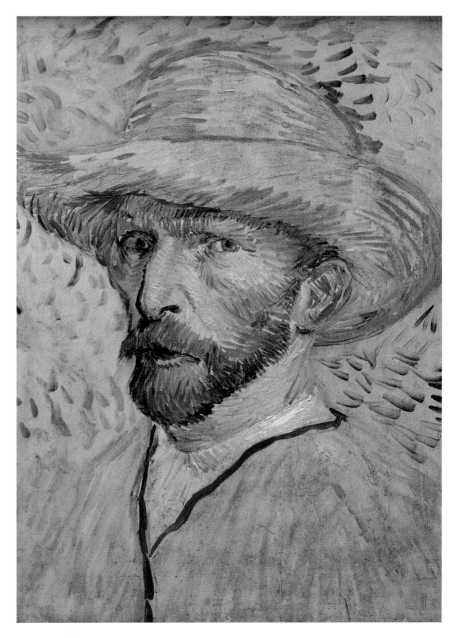

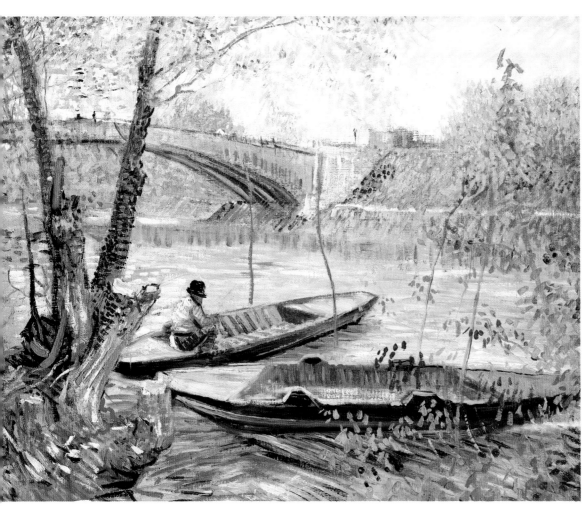

Fishing in Spring, spring 1887, oil on canvas, Art Institute of Chicago, IL, USA, 49 x 58cm (19.5 x 23in)

Van Gogh is now more confident in his use of the techniques associated with pointillist painting, mixing what he has learned from Impressionists such as Monet with the newer ideas of his friend, Paul Signac. Around the edge of the canvas he has painted a border of variegated touches of red pigment which serves to contain, contrast and counterpoint the cooler colours of the main composition. Paintings such as this show that Van Gogh is hard at work absorbing the lessons of the Parisian avant-garde, their subject matter and techniques.

The Seine with the Pont de la Grande-Jatte, summer 1887, oil on canvas, Van Gogh Museum, Amsterdam, the Netherlands, 32 x 40.5cm (12.6 x 16in)

In the summer of 1887, together with his young friend Émile Bernard and on occasion Paul Signac, Van Gogh spent time painting in Asnières, a spot familiar through Seurat's monumental paintings of *The Bathers at Asnières* and *Sunday Afternoon on the Île de la Grande-Jatte*. There is a delightful informality in both the technique and the subject matter that removes this work from the high seriousness of Seurat's modern day masterpieces of urban life.

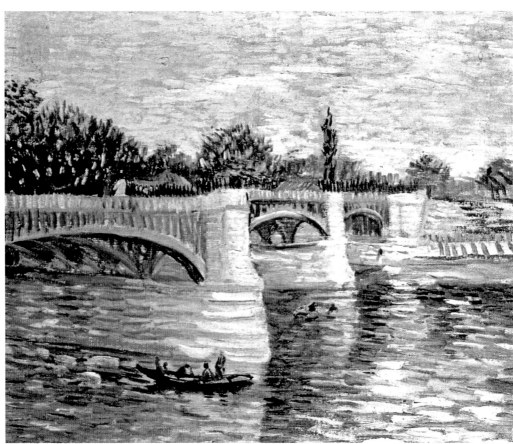

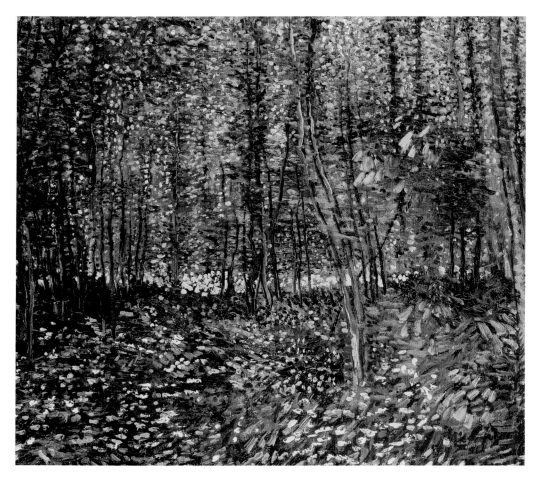

Trees and Undergrowth, Summer 1887, oil on canvas, Van Gogh Museum, Amsterdam, the Netherlands, 46.5 x 55.5cm (18.5 x 22in)

The flickering quality of light and movement here is matched by Van Gogh's own nervous technique. The thin tree trunks are masked in a loose network of short directional strokes that indicate leaves and undergrowth. Against the green, touches of yellow gather and disperse to suggest the fall of light within the shaded wood. Only a few years later, works such as this played a significant role in the development of the highly decorative landscapes of the great Austrian artist Gustave Klimt.

The Ramparts of Paris, summer 1887, pencil, chalk, watercolour and bodycolour, Whitworth Art Gallery, University of Manchester, UK, 39.5 x 53.5cm (15.5 x 21in)

The subject of this study is the fortifications that less than twenty years earlier had seen fierce fighting during the Paris commune. Here Van Gogh is using his brush to emulate the work of Rembrandt and the Japanese artists he loved so much. It seems as if this may have been an experimental piece, since the two figures in the foreground have been left unfinished.

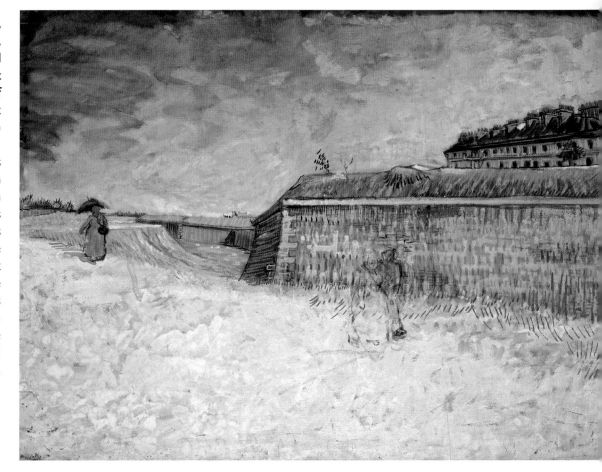

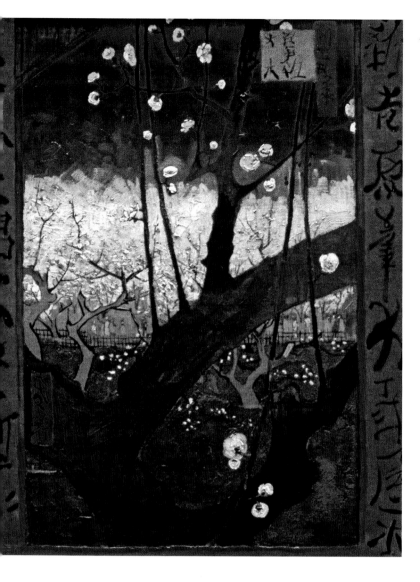

Japonaiserie: Flowering Plum Tree (after Hiroshige), September–October 1887, oil on canvas, Van Gogh Museum, Amsterdam, the Netherlands, 55 x 46cm (21.5 x 18in)

Van Gogh's powerful reinterpretation uses the rich coloration and striking asymmetrical composition of Hiroshige's print but completely ignores the flat washes of thin colour integral to the delicate charm of such images.

Japonaiserie: Oiran (after Kesaï Eisen) (Also known as 'The Courtesan'), September–October 1887, oil on canvas, Van Gogh Museum, Amsterdam, the Netherlands, 105.5 x 60.5cm (41.5 x 23.8in)

A free reworking of the original Japanese woodblock print, which was reproduced on the cover of *Paris illustré* in May 1886, the flat colours and sharp lines have been reinterpreted by the artist in thick ridges of impastoed paint. Through such paintings Van Gogh began to find the qualities that made his work entirely his own. Another version of the print appears in the background of one of his portraits of his friend Père Tanguy (1887).

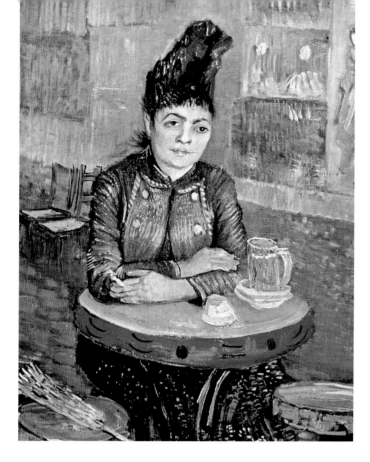

Agostina Segatori Sitting in the Café du Tambourin, February–March 1887, oil on canvas, Van Gogh Museum, Amsterdam, the Netherlands, 55.5 x 46.5cm (21.9 x 18.3in)

La Segatori was the Neapolitan proprietor of the restaurant in which Van Gogh traded paintings for meals. Some of Van Gogh's Japanese prints can be seen in the background. La Segatori, who may have had an affair with Van Gogh, looks out, lost in reverie, apparently unaware of the presence of the artist. This painting is characteristic of the work of Van Gogh and his friends. Degas, Lautrec, Manet and Renoir all painted similar portraits of modern women within the urban environment.

Plaster Statuette of a Female Torso, spring 1886, oil on canvas, Van Gogh Museum, Amsterdam, the Netherlands, 35 x 27cm (13.8 x 10.6in)

At Cormon's studio in Paris, Van Gogh tried to master anatomy, drawing from a life model and studying, in proper academic fashion, casts after classical sculpture.

Plaster Statuette of a Female Torso, winter 1887–8, oil on canvas, private collection, 73 x 54cm (28.7 x 21.3in)

This drawing is strongly realized and the contrasting colours of yellow and blue give a powerful effect – the line of the table top falling away echoes and contrasts with the dynamic movement of the broken torso.

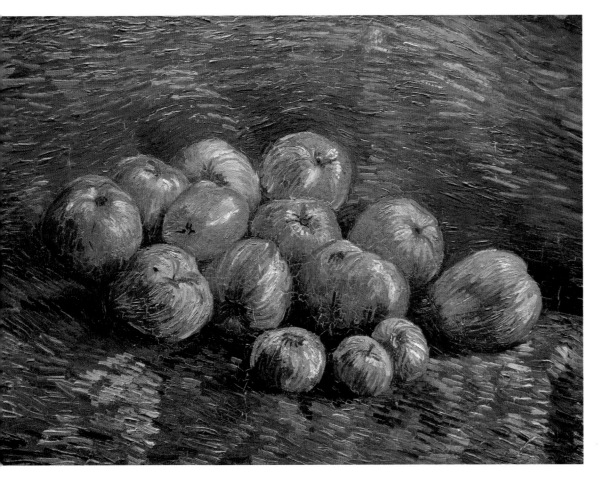

Still Life with Apples,
autumn–winter 1887–8,
oil on canvas, Van Gogh
Museum, Amsterdam, the
Netherlands, 46 x 61.5cm
(18 x 24in)

By the 1860s still life had
become a respected genre in
French painting. Artists such
as Cézanne, Monet and
Renoir would make this once
lowly genre the equal of the
traditionally more important
kinds of painting such as
landscape and particularly the
history and religious paintings
associated with the Salon and
the art of the establishment.

*Still Life with Red Cabbages
and Onions,* autumn 1887,
oil on canvas, Van Gogh
Museum, Amsterdam, the
Netherlands, 50 x 64.5cm
(19.7 x 25.4in)

Comparing the still lives
reproduced on this page,
one can really sense Van
Gogh's hunger to develop
an individual style worthy of
comparison with his fellow
avant-garde artists.

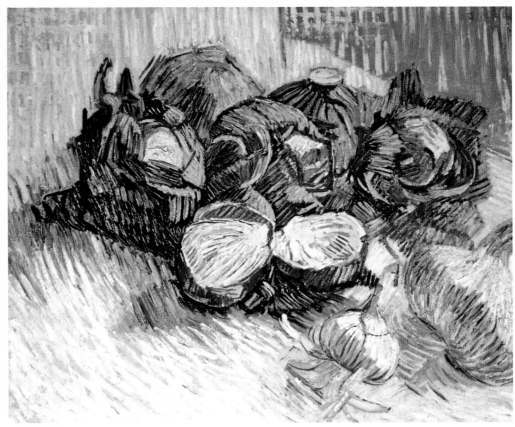

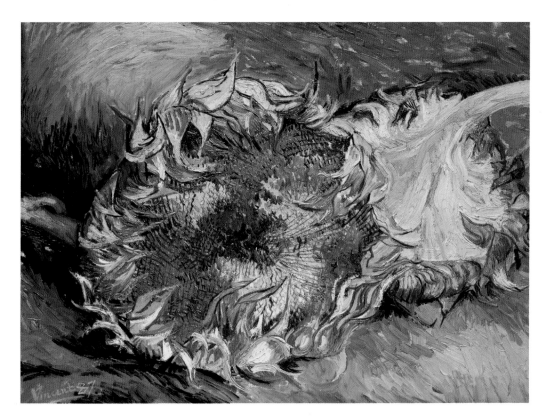

Two Cut Sunflowers,
August–September 1887,
oil on canvas, Metropolitan
Museum of Art, New York,
NY, USA, 43.2 x 61cm
(17 x 24in)

This study of two discarded
sunflowers is one of a
number Van Gogh did at
this time. They have a stark,
dramatic, almost human
presence, suggestive of loss
and sacrifice – the religious
connotations of such an
image are unmistakable.

Still Life with Quince Pears,
winter 1887–8, oil on
canvas, Gemäldegalerie
Neue Meister, Dresden,
Germany, 46 x 59.5cm
(18 x 23.5in)

A study in casual disorder.
Still life painting, like
self-portraiture, is a subject
matter readily available
to any artist – it is
undemanding, never moving,
uncomplaining and cheap. It
is also a genre that, because
of its simplicity, allows the
artist the space to test his
skills and create works that
are celebrations of the
ordinary – the beauty of
paint and the evident
beauty of the fruit.

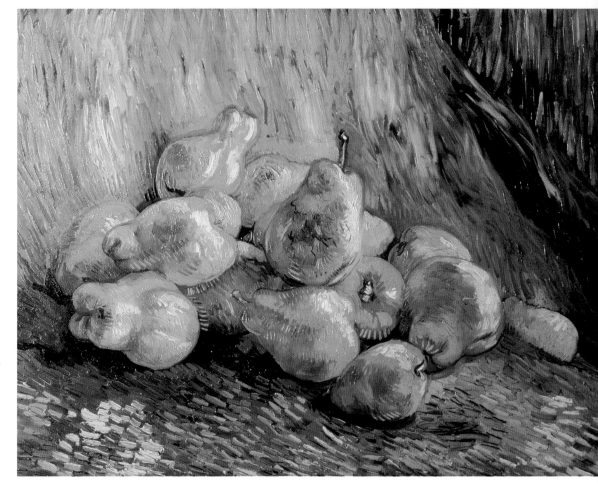

Self-portrait, autumn 1887, oil on canvas, Musée d'Orsay, Paris, France, 47 x 35cm (18.5 x 13.8in)

In this dishevelled portrait, Van Gogh has cast aside the reserve of some of his other self-portraits of the time. Van Gogh found it difficult to get models to pose for him and used self-portraiture as a means of experimenting with appearance and technique. This intense and concentrated painting demonstrates his conviction that form and meaning should be conveyed through the juxtaposition of bright colours, and reveals the influence of Neo-Impressionists such as Seurat and Signac.

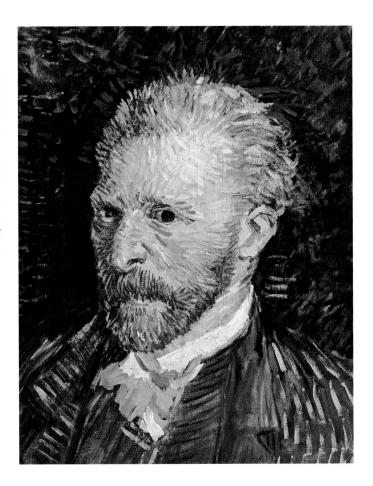

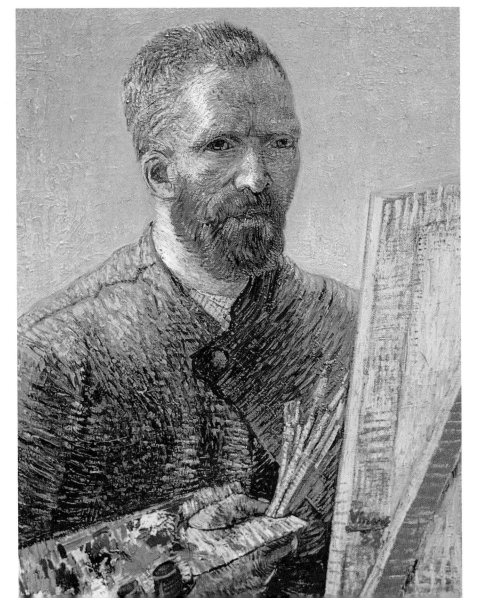

Self-portrait in front of the Easel, 1888, oil on canvas, Van Gogh Museum, Amsterdam, the Netherlands, 65.5 x 50.5cm (26 x 20in)

Van Gogh's prominent signature suggests that he was pleased with this image of himself. He has self-consciously shown himself as an artist. The painting is a summary of all he has learnt in the two years in Paris. The regular weave of short, dry strokes of complementary colours build up into a self-image that is confident and alert.

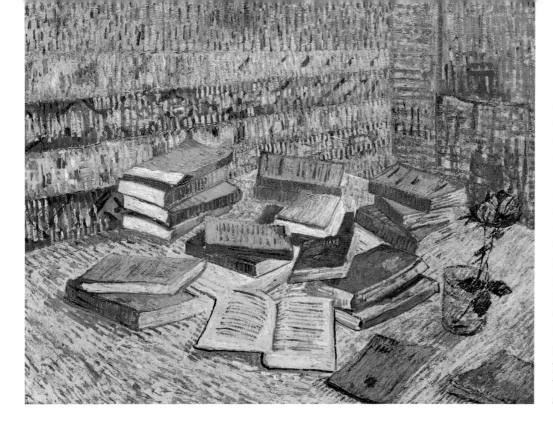

Still Life with French Novels and a Rose, autumn 1887, oil on canvas, private collection, 73 x 93cm (28.7 x 36.6in)

Books were an essential supporting and nurturing element in Van Gogh's life and in this, one of the last paintings of his Parisian period, he celebrates the power and forthrightness of the French school of Naturalist writers. The painting is saturated by yellow, the colour that for Van Gogh signified life and regeneration.

Portrait of Père Tanguy, autumn 1887, oil on canvas, Musée Rodin, Paris, France, 92 x 75cm (36 x 29.5in)

This work belonged to the great French sculptor, Rodin. Its subject was a colour merchant and great enthusiast of radical painting, Père Tanguy, who was prepared to accept works few wanted in exchange for paint. He exhibited Van Gogh's work and is shown here as a benign Buddha-like figure with a straw hat as a halo and the sacred presence of Mount Fujiama behind him signalling his almost spiritual aura. The colours of this portrait are simple, cool blues and yellows, brought together in the tones of Tanguy's face and hands and enriched by the accompanying bright colours of the Japanese prints that are hung, cheek by jowl, behind him.

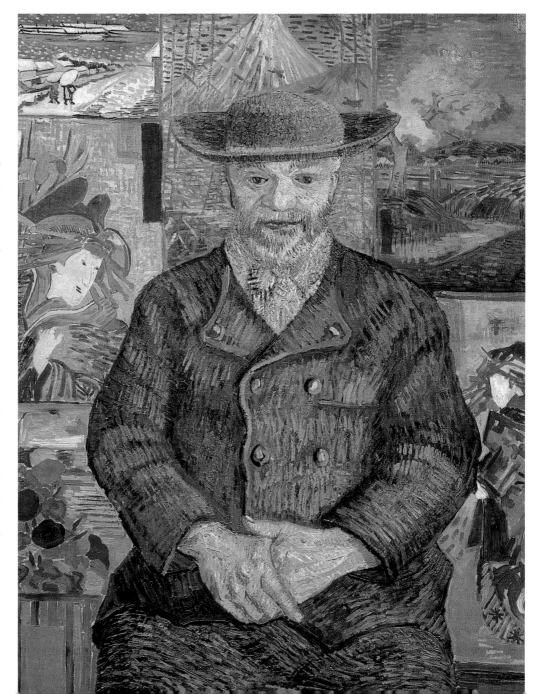

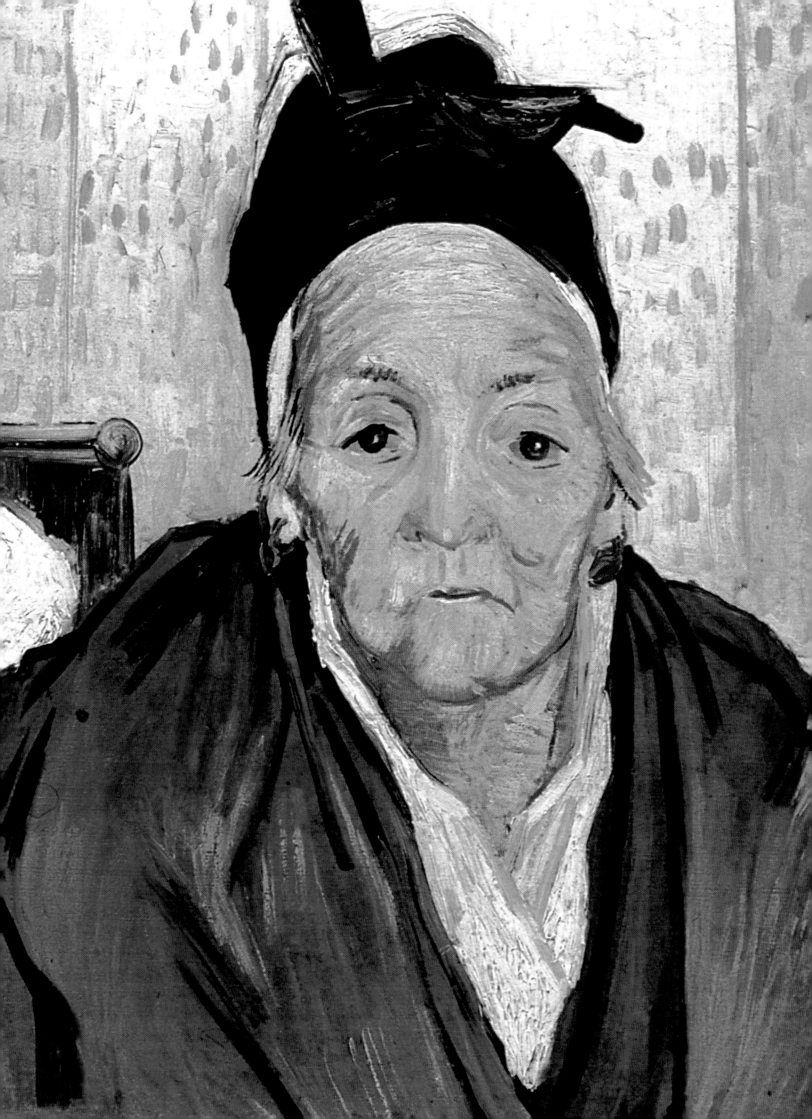

ARLES

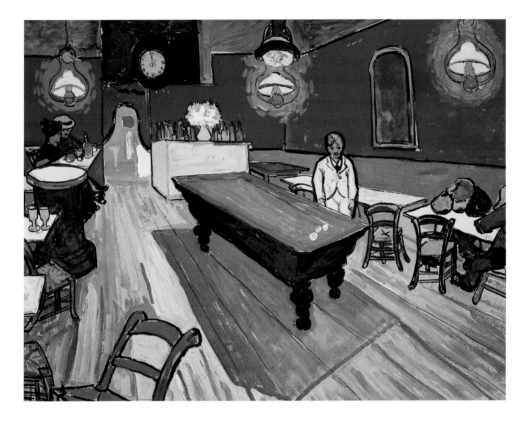

When Van Gogh arrived in Arles in February 1888, he had only another two years to live. Within that time, between bouts of incapacitating illness, he produced a body of work that includes what have become some of the most famous and best-loved paintings in the world. However, it is important not to over-romanticize his achievement through the benefit of hindsight, coloured by the massive industry that has grown up around his art and life. It is quite a challenge to see these works for what they are: attempts by a talented and dedicated artist to create a new kind of painting that would speak in an open and accessible way about what it is to be human.

Above: The Night Café in Arles, September 1888. Van Gogh became good friends with the Ginoux family, who ran the Café de la Gare, where he lived in Arles before he moved into the nearby Yellow House. Left: An Old Woman of Arles, February 1888.

Still Life: Potatoes in a Yellow Dish, March 1888, oil on canvas, Kröller-Müller Museum, Otterlo, the Netherlands, 39 x 47cm (15.3 x 18.5in)

Potatoes were the staple diet of the poor. Seen from above, the gnarled silhouettes of the potatoes lie within a simple earthenware bowl, the yellow of the bowl contrasting with the blue horizontal brushstrokes that describe its shadow.

Still Life: Bottle, Lemons and Oranges, May 1888, oil on canvas, Kröller-Müller Museum, Otterlo, the Netherlands, 53 x 63cm (20.8 x 24.8in)

Yellow and blue predominate to create a light-filled composition; the physical proximity of the bottle and fruit is emphasized by the sharp angular line that describes the tabletop. The variegated touches of colour give a scintillating effect to the painting.

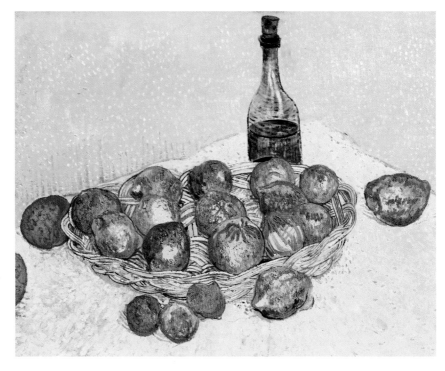

Blossoming Almond Branch in a Glass, March 1888, oil on canvas, Van Gogh Museum, Amsterdam, the Netherlands, 24 x 19cm (9.5 x 7.5in)

If bad weather made painting out of doors impossible, Van Gogh turned to still life and self-portraiture. In this painting a single sprig bursts into blossom – a sign of new life sustained in artificial surroundings. The blossom relates to Van Gogh's admiration for Japanese prints, and the love the Japanese felt for trees in blossom. Van Gogh has counterpointed the pleasing irregularity of the twig by setting its delicately nuanced form – with touches of pinks, lilacs, ochres and greens – against the simply stated presence of the red horizontal band of paint and his boldly stated signature. The visibility given to his own name surely suggests a reference to his own hopes of a physical and spiritual rebirth in his new home.

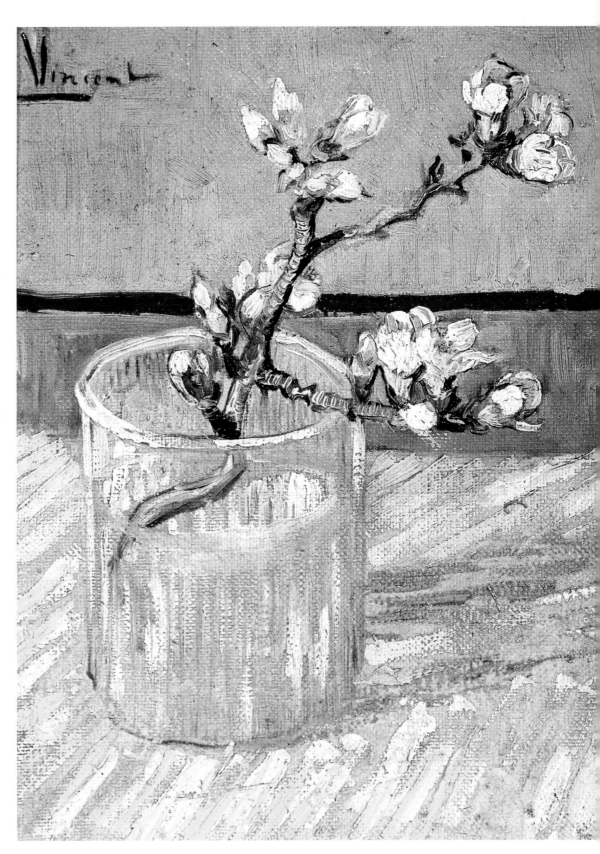

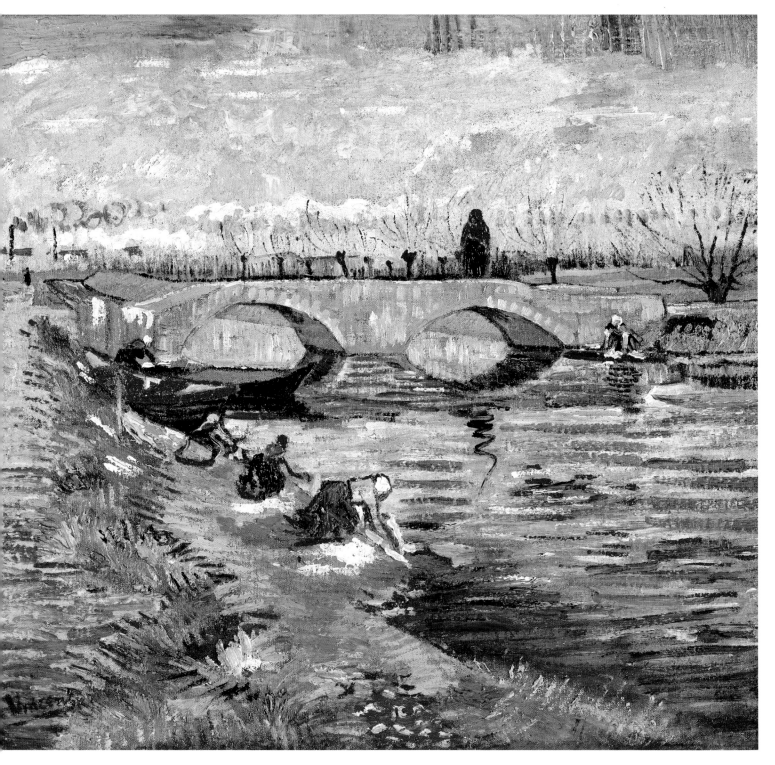

The Gleize Bridge over the Vigueirat Canal, March 1888, oil on canvas, private collection, 46 x 49cm (18.1 x 19.3in)

In this work the brilliance of light and colour is counterpointed by the drama of composition and evident brushwork. Red outlines make an effective foil for the greens, while the intense blue of the river, painted in short horizontal slabs of pigment, is matched by the cool yellows and muted oranges that describe the river bank and bridge.

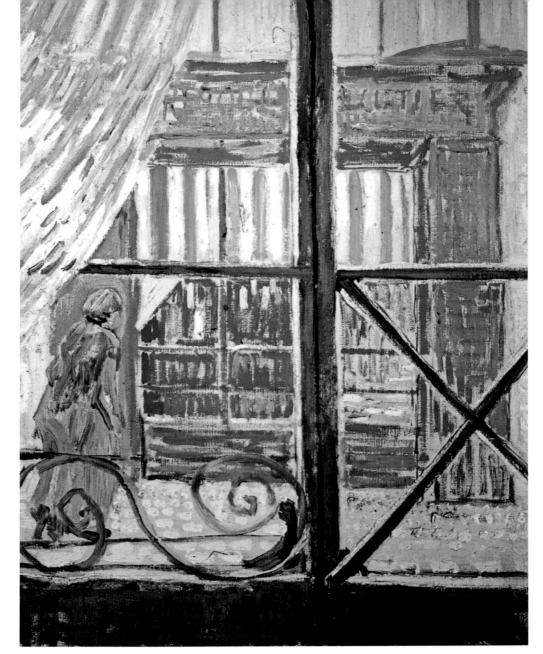

Pork-butcher's Shop seen from a Window, February 1888, oil on canvas on cardboard, Van Gogh Museum, Amsterdam, the Netherlands, 39.5 x 32.5 (15.5 x 12.8in)

A startling composition painted at high speed, brilliantly sketched in contrasting colours, oranges and blues, greens and reds. The geometric structures of window and shop are counterpointed by the arabesques describing the curtain, walking figure and wrought-iron work. As so often, Van Gogh has incorporated the distinctive visual vocabulary of Japanese prints into one of his own compositions.

The Langlois Bridge at Arles with Women Washing, March 1888, oil on canvas, Kröller-Müller Museum, Otterlo, the Netherlands, 54 x 65cm (21.5 x 25.5in)

Unlike Monet in his paintings of Rouen Cathedral, Van Gogh was uninterested in subtle nuances of light; instead he wished to capture the stunning quality of the heat and the light. An unexpected slab of blue describes the shadowed buttress of one of the stone piers supporting the wooden structure of the bridge. The heavy impasto marks and broad areas of clean colour enhance the fragile delicacy of the distant trees and the quirky carriage that makes its way across the bridge.

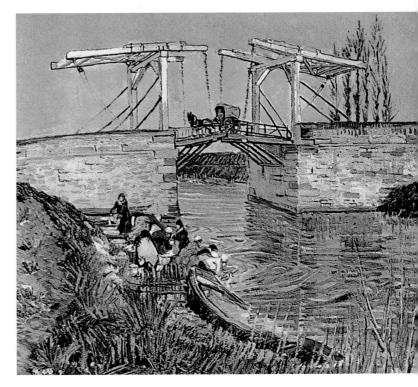

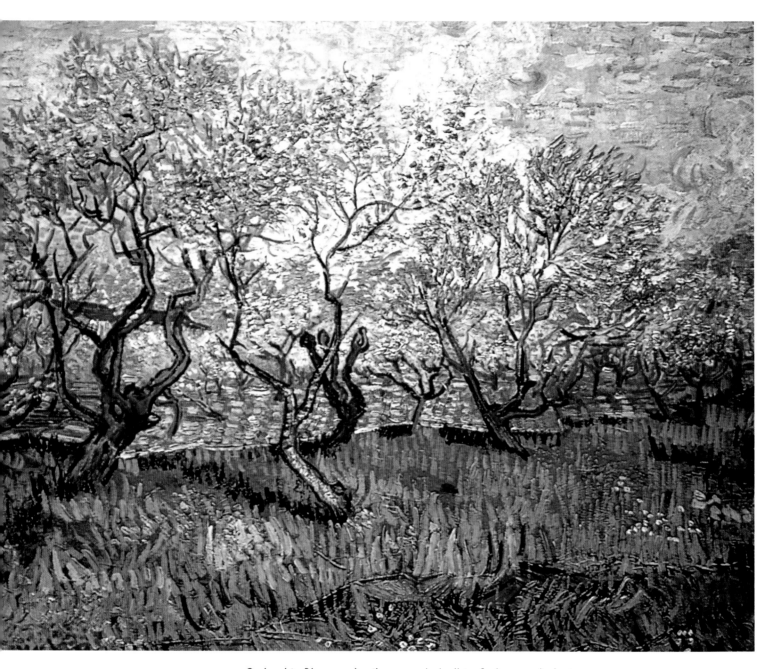

Orchard in Blossom, April 1888, oil on canvas, Van Gogh Museum, Amsterdam, the Netherlands, 72.5 x 92cm (28.5 x 36in)

Van Gogh arrived in Arles convinced of "the absolute necessity for a new art of colour and design" to find an equivalent to "the Japanese way of feeling and drawing". He saw in the blossoming trees the perfect vehicle for his enthusiasms. He produced 14 canvases of the subject, which he hoped would form a decorative scheme.

Blossoming Pear Tree, April 1888, oil on canvas, Van Gogh Museum, Amsterdam, the Netherlands, 73 x 46cm (28.7 x 18.1in)

A scene depicted many times in Japanese prints. Here the tree is seen from above, its fragile blossoms set against the angular forms of the branches.

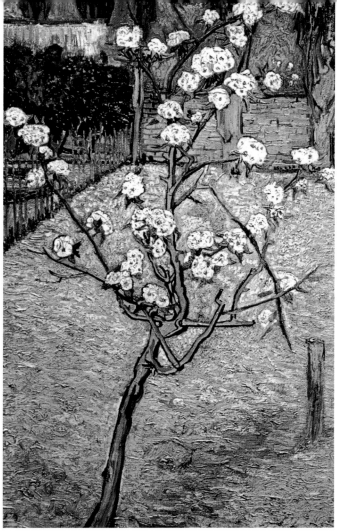

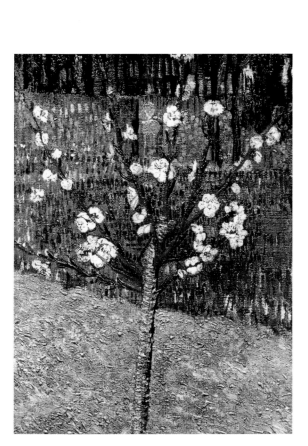

Almond Tree in Blossom, April 1888, oil on canvas, Van Gogh Museum, Amsterdam, the Netherlands, 48.5 x 36cm (19 x 14in)

Van Gogh considered these paintings, unique in themselves, as part of an ambitious decorative ensemble, suggestive of the optimism associated with the season. The butterfly seen in mid-flight between the blossoms may well suggest the transitory nature of life and, perhaps, hope itself.

Peach Tree in Blossom, April–May 1888, oil on canvas, Van Gogh Museum, Amsterdam, the Netherlands, 80.5 x 59.5cm (31.5 x 23.5in)

In a letter Van Gogh told his brother how he wanted his three orchard paintings to hang together. He hoped that they would be a commercial success, as he felt that they were a subject that "everyone enjoys".

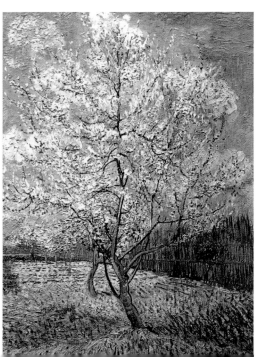

Farmhouse in a Wheat Field, May 1888, oil on canvas, Van Gogh Museum, Amsterdam, the Netherlands, 45 x 50cm (17.7 x 19.7in)

A relatively subdued image of a wheat field, but nevertheless a strong, dynamic and original composition. It is a subject upon which Van Gogh would expend much energy over the summer, often working in the full glare of the Mediterranean sun. The diagonals of trees take the viewer's eye from the foreground into the painting, a movement abruptly arrested by the strong horizontal line of building and horizon, a simple pictorial structure given life by the dynamics of the artist's brushwork.

Street in Saintes-Maries, June 1888, oil on canvas, private collection, 38.3 x 46.1cm (15 x 18in)

When Van Gogh visited the picturesque community of Saintes-Maries, he was surprised to find the houses reminding him of those of the landscapes of Holland. Once again, too, his memories were reformed through his awareness of Japanese prints. The startling colours and energetic, confident drawing set these dwellings firmly in their environment.

A Pair of Leather Clogs,
March 1888, oil on canvas,
Van Gogh Museum,
Amsterdam, the
Netherlands, 32.5 x 40.5cm
(13 x 16in)

This sturdy still life was
among the paintings by
the artist exhibited at the
famous Armory Show of
1913 that introduced
modern European art to
America. These leather clogs,
like his famous image of the
boots, suggest the wearer
and so stand for the simple
dignity and hard work he
associated with peasant life.

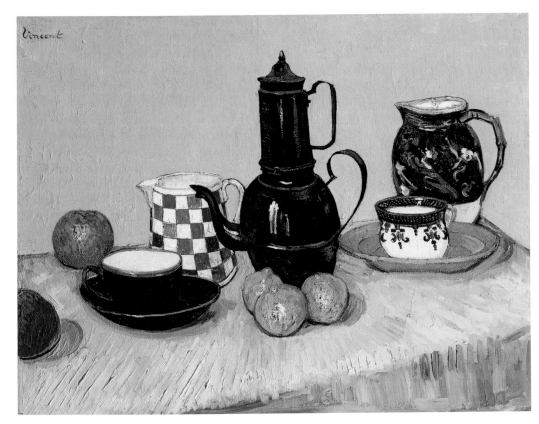

*Still Life: Blue Enamel
Coffeepot, Earthenware and
Fruit*, May 1888, oil on
canvas, Liechtenstein Private
Foundation, 65 x 81cm
(25.6 x 32in)

Van Gogh was very proud of
this painting, which he
completed during the first
weeks of his time at Arles. It
is a still life in the tradition of
Chardin, extolling the worth
of simple, humble objects,
but illuminated by the
brilliancy of light that Van
Gogh found in the south of
France. This modest work
suggests vividly the
significance that Van Gogh's
work would have for Henri
Matisse and other colourists
of the 20th century.

Encampment of Gypsies with Caravans, August 1888, oil on canvas, Musée d'Orsay, Paris, France, 45 x 51cm (17.5 x 20in)

In a sermon that he gave in England, Van Gogh said: "I am a stranger on the earth". In this poignant image, he paints the gypsy family, outsiders like himself, resting in the shade of their colourful caravans. Painted in thick impasto, a broken horizontal locks the separate elements of the composition into one decorative whole.

Tarascon Diligence, October 1888, oil on canvas, Princeton University Art Museum, NJ, USA, 72 x 92cm (28.5 x 36in)

A simple everyday object becomes an unforgettable image in Van Gogh's eyes: he wrote in a letter to Theo, "Looking at the stars always makes me dream. Why, I ask myself, shouldn't the shining dots of the sky be as accessible as the black dots on the map of France? Just as we take the train to get to Tarascon or Rouen, we take death to reach a star."

Seascape at Saintes-Maries, June 1888, oil on canvas, Van Gogh Museum, Amsterdam, the Netherlands, 51 x 64cm (20 x 25.2in)

Van Gogh was stunned by the colours and light of the Mediterranean. This is a magnificent vision of the ever changing forms and colours of the sea, painted with a speed and vigour that perfectly matches the subject matter. The triangular forms of the sails echo the breaking foam and the distant clouds.

Fishing Boats on the Beach at Saintes-Maries, June 1888, oil on canvas, Van Gogh Museum, Amsterdam, the Netherlands, 65 x 81.5cm (25.6 x 32.1in)

At first sight, this is a simple composition made up of elegant areas of colour, with reds and yellows set against the cool blue tones of the sea and sky. However, on closer inspection its subtlety reveals itself – the apparent straightforward placing of the boats distracts the viewer from the masterly arrangement of the masts against the sky. Van Gogh's fondness for investing inanimate objects with human qualities finds here one of its most touching expressions. The third boat's name written on its prow is clearly legible: *'Amitié'* – friendship.

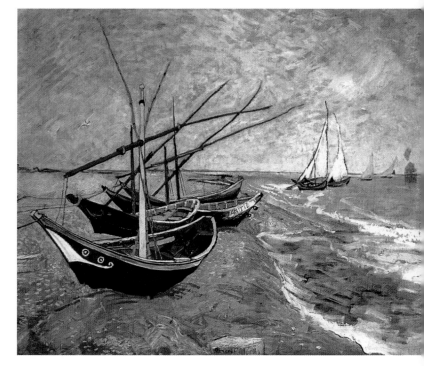

Fishing Boats on the Beach at Saintes-Maries, June 1888, drawing, private collection

This masterly drawing, one of a number he produced on the beach, shows how Van Gogh used his graphic techniques of dots and strong lines to suggest the vibrant presence of the four boats. Van Gogh followed the sketch closely in his final painting.

Les Alyscamps, November 1888, oil on canvas, private collection, 92 x 73.5cm (36 x 29in)

Although Van Gogh showed little or no interest in the architectural beauties of Arles, he was drawn to Les Alyscamps (Elysian Fields), where the people of the town would promenade in the early evening, showing off their finery and status. Les Alyscamps was a public park lined with Roman sarcophagi: a subject redolent of themes of mortality. In this painting he is uniting the world observed with the powerful, expressive effects of drawing and colour.

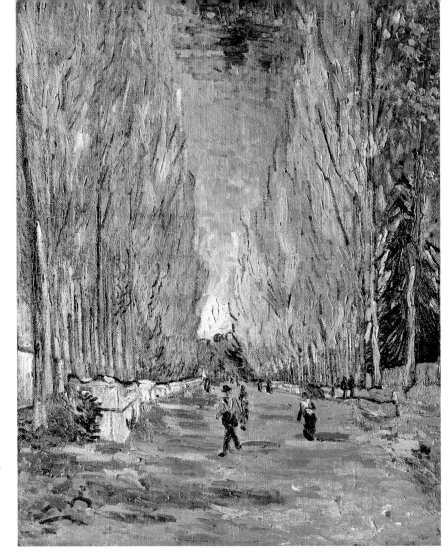

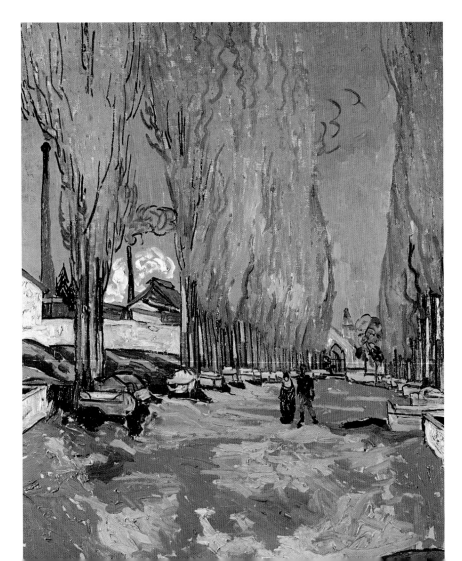

Les Alyscamps, October 1888, oil on canvas, private collection, 93 x 72cm (36.6 x 28.3in)

This work was completed shortly after Gauguin's arrival in Arles. The two painters worked side by side; Van Gogh's interpretation is forthright in approach with a powerful and immediate emotional effect; Gauguin's paintings are much more cerebral in character, painted with greater deliberateness and restraint.

Public Garden with Couple and Blue Fir Tree: The Poet's Garden III, October 1888, oil on canvas, private collection, 73 x 92cm (28.5 x 36in)

The couple who walk hand-in-hand toward the viewer are thrown into shade by the brooding mass of the tree. Despite Van Gogh's problems with sustaining intimate relationships, this painting, though pictorially dramatic, evidences the sensitivity and humanity that makes his art so unique.

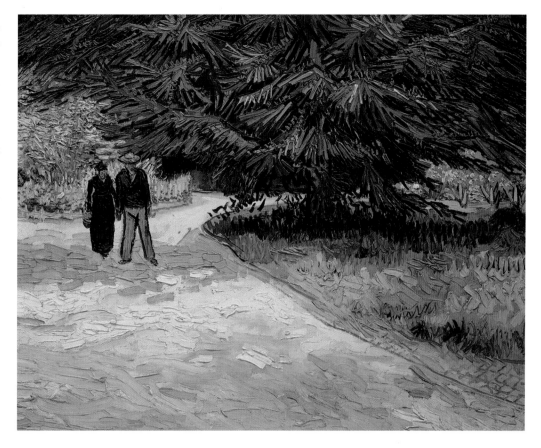

Lawn with Weeping Tree, July–August 1888, ink and pencil on paper, private collection, 31.7 x 24cm (12.5 x 9.5in)

A rich tapestry of calligraphic strokes, dashes and dots describe the complex weave of light and form. A single enigmatic shadow falls on the short stubby grass, giving this composition a strange, otherworldly feel. The sky is almost completely absent as Van Gogh fills the paper with variegated foliage to create a stunning display of virtuoso mark-making.

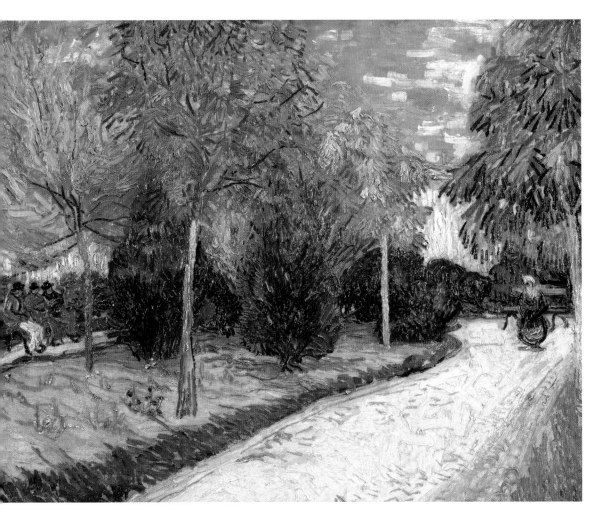

The Public Park at Arles,
October 1888, oil on
canvas, private collection,
72 x 93cm (28.5 x 36.5in)

This painting balances
the spontaneity of
Impressionism with the
more considered approach
of the Neo-Impressionists.
Van Gogh has adopted
their theories concerning
le mélange optique, which
describe the idea that
touches of separate, often
contrasting, colours mix in
the viewer's eye to give the
chromatic effect of real
vision. However, when
applied in small dabs of
pigment, a curious grey
overcast seems to hang
like a veil over the painting.
To avoid this, Van Gogh used
broad strokes, bringing the
colour dynamically alive.

*Entrance to the Public Park
in Arles*, September 1888,
oil on canvas, The Phillips
Collection, Washington,
D.C., USA, 72.5 x 91cm
(28.5 x 35.8in)

An ineffable melancholy
runs through much of
Van Gogh's work. In this
painting, people are shown
at ease, enjoying their
leisure, but the vibrant blues
and greens and the dynamics
of the composition serve
only to suggest a sense of
alienation rather than
engagement. In such works,
Van Gogh seems very
much the outsider.

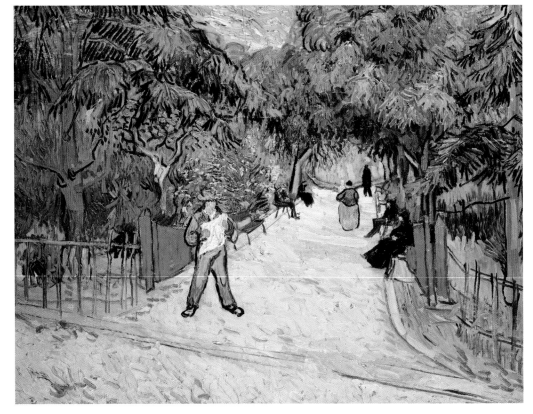

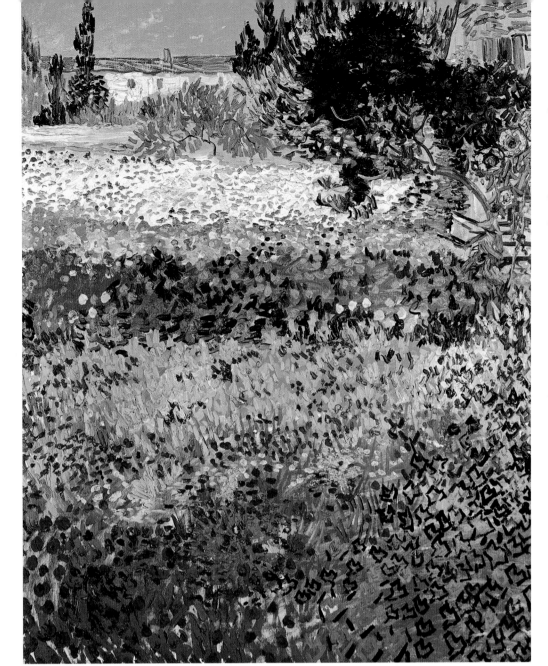

Flowering Garden,
July 1888, oil on canvas,
private collection,
92 x 73cm (36.2 x 28.7in)

Delicately and perfectly
judged touches of the brush
register the complexity of
this flamboyant garden,
which seems to burn in the
full heat of the Provençal
sun. The directional
brushwork describes the
colour and variety of
flowers and vegetation;
dots and dashes of pure
pigment make a visual
skipping movement across
the canvas.

A Garden with Flowers,
August 1888, ink and pencil
on paper, private collection,
61 x 49cm (24 x19.5in)

The differing weight of detail
invites the viewer to move
from the dense patterning of
flowers in the foreground,

along the diagonals that
describe the beds, to the
whiteness of the distant
house. This drawing is a
document of Van Gogh's
powers of observation,
invention and his infectious
exhilaration in the joy of
mark-making.

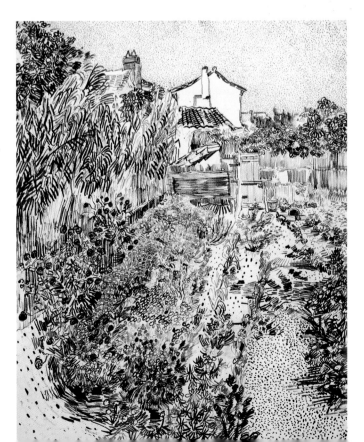

Sower with Setting Sun,
August 1888, pencil, reed
pen and brown ink,
Van Gogh Museum,
Amsterdam, the
Netherlands, 24 x 32cm
(9.4 x 12.6in)

The relationship between
Van Gogh's drawings and
his paintings is always
fascinating. Although an
extraordinary colourist, it is
drawing that holds his
compositions together,
each mark taking its place
as a descriptor and as part
of a larger rhythmic whole.

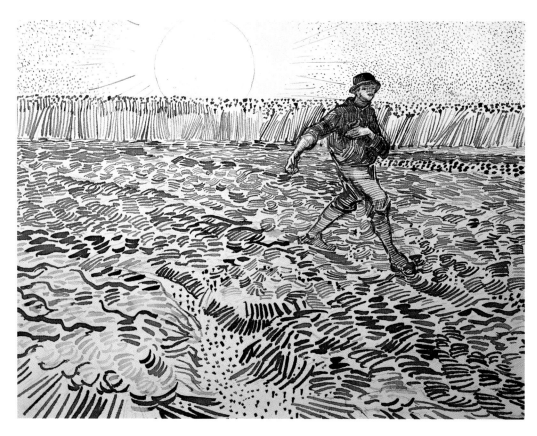

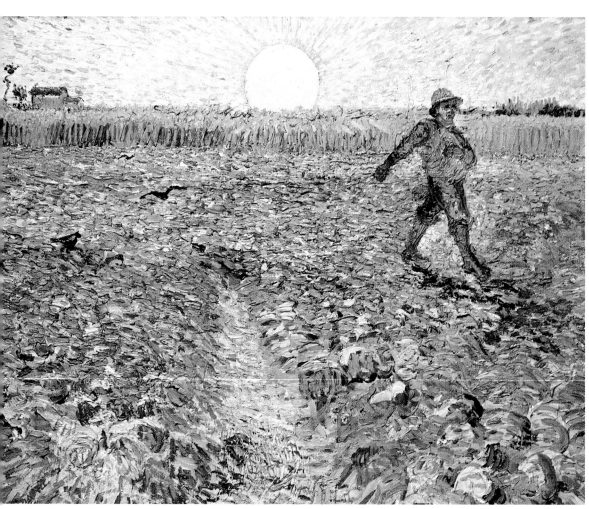

The Sower, June 1888,
oil on canvas, Kröller-
Müller Museum, Otterlo,
the Netherlands, 64 x
80.5cm (25.2 x 31.7in)

The painting shows how
faithfully Van Gogh has
transposed the calligraphic
marks of his drawing into
the final painting. It is an
audacious work in which
short directional touches of
pure colour correspond to
the retinal and emotional
impact of the blinding
presence of the low sun.
The colours – yellows, blues,
oranges, reds, greens and
lilacs – work together to
express not only the thing
seen, but also the thing felt.

The Sower, October 1888, oil on canvas, private collection, 72 x 91.5cm (28.5 x 36in)

The small figure of the sower is lit by the late evening sun. In 1889, Van Gogh wrote, "I feel so strongly that it is with people as with corn: if you are not sown in the earth to take root there, it does not matter, because you will be ground for bread."

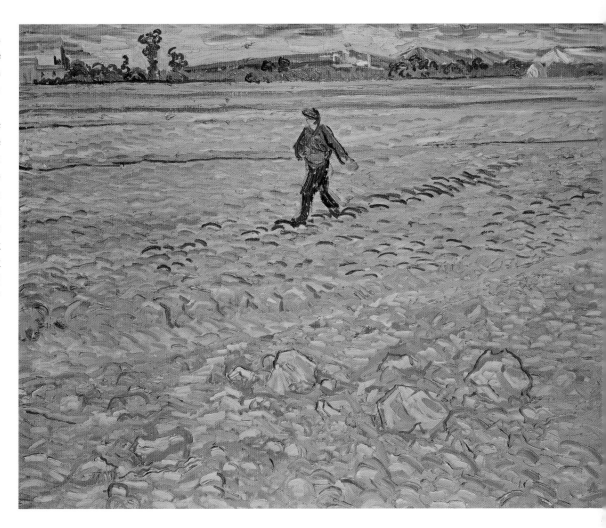

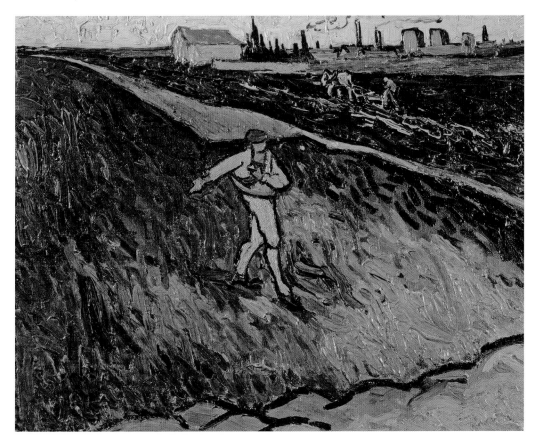

The Sower: Outskirts of Arles in the Background, September 1888, oil on canvas, private collection, 33.6 x 40.4cm (13.2 x 15.9in)

In this painting, one of at least seven versions of the same subject, Van Gogh is revisiting the dark tones of his Nuenen period. What is different is the startling application of paint: the striding form of the sower is set against a thin yellow-green band of the dawn sky, which barely lights the massive field of dark lilac and green. The sower's pose is taken directly from Millet – in such works Van Gogh is continuing to re-invent himself as a latter day incarnation of that famous painter of peasants.

Flowering Garden with Path,
July 1888, oil on canvas,
Gemeentemuseum, The
Hague, the Netherlands,
72 x 91cm (28.5 x 36in)

Van Gogh was careful to
insist that his paintings
should not be "criticized as
hasty" since they were
"calculated long beforehand".
In this freely painted work,
pairs of complementary
colours work together. Red
and green plants are woven
into highlights of muted
oranges and light blue which
themselves are set against
the orange roofs and a
turquoise sky.

Sunny Lawn in a Public Park,
July 1888, oil on canvas,
Kunsthaus Zürich,
Switzerland, 60.5 x 73.5cm
(24 x 29in)

Van Gogh searched to find
in the colours of his
palette the "limpidity of
the atmosphere" and in
works such as this he
realized, "I am getting an
eye for this kind of country".
Looking into the depths of
the landscape, Van Gogh
has converted the scene
before him into an
exhilarating pattern of
thickly painted marks.

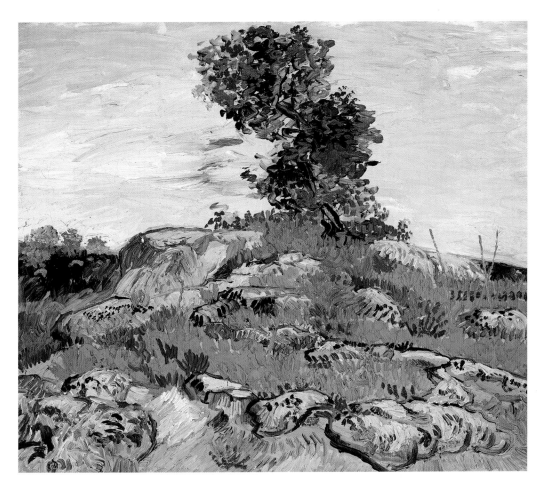

Rocks with Oak Tree, July 1888, oil on canvas, Museum of Fine Arts, Houston, TX, USA, 54 x 65cm (21.2 x 25.6in)

Thanks to his absorption of Japanese art, Van Gogh has been able to reduce the complex and often bizarre landscape around Arles into abbreviated form without losing anything of the physical presence of this jagged, broken rocky outcrop.

The Poet's Garden, September 1888, oil on canvas, The Art Institute of Chicago, IL, USA, 73 x 91.2cm (28.5 x 36in)

The garden is the Parc Lamartine just outside Van Gogh's house and the poet in question was the Italian 14th-century poet, Petrarch. As Petrarch had tutored the great story-teller Boccaccio, so Van Gogh hoped Gauguin would tutor him. The trees carried personal as well as publicly acknowledged symbolic value. The oleander was emblematic of hope, the willow, mourning and loss, while the cypress tree was an image suggesting death and immortality.

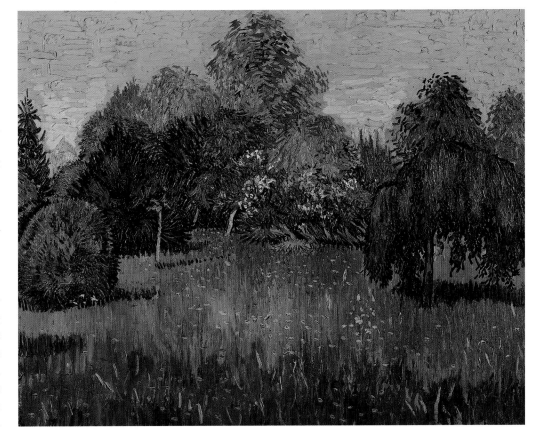

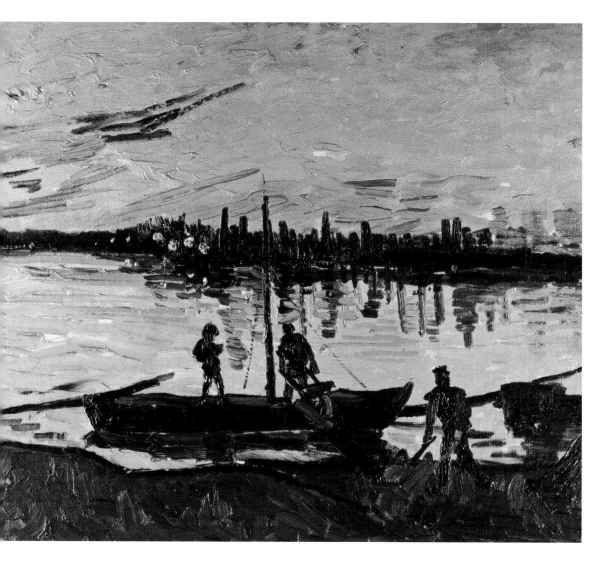

Coal Barges, August 1888, oil on canvas, Museo Thyssen-Bornemisza, Madrid, Spain, 54 x 65cm (21.3 x 25.6in)

In this scene of men at work it is early morning, or perhaps early evening; the brilliant light reflected on the river's surface destroys all picturesque detail and gives a crude urgency to the depiction. The colour scheme is simple, extreme and reveals Van Gogh's debt to Japanese woodblock prints. More significant, perhaps, is the artist's passionate identification with the scene. The hauliers and the boats are suggestive of exotic journeys to distant places and the actual reality of the job of hauling coal is subsumed beneath its decorative and emotional emphasis.

Quay with Men Unloading Sand Barges, August 1888, oil on canvas, Museum Folkwang, Essen, Germany, 55.1 x 66.2cm (21.5 x 26in)

Van Gogh uses his high viewpoint to make the most of one of his favourite colours, malachite green; the tricolour waving gaily from the yellow ochre mast makes a point of contrast and draws attention to the almost invisible work of a labourer unloading sand. Despite the similar subject matter, the atmosphere of this painting could not be more different from *Coal Barges*, above.

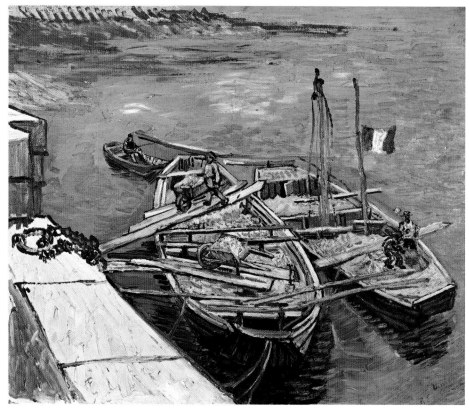

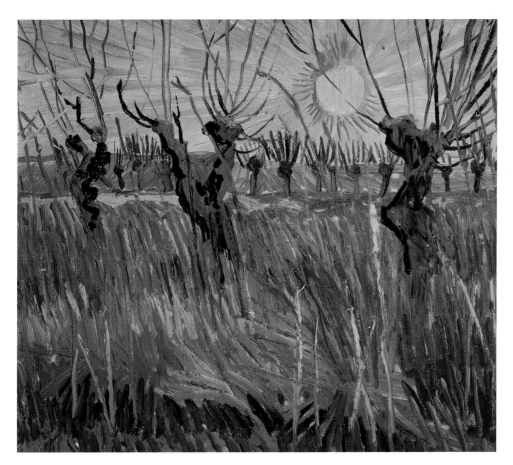

Willows at Sunset, autumn 1888, oil on card, Kröller-Müller Museum, Otterlo, the Netherlands, 31.5 x 34.5cm (12.5 x 13.5in)

Van Gogh came south to seek the sun. Here, at sunset, its power is nearly spent, and its low light brings the dramatic, almost human silhouettes of the trees into relief. The time Van Gogh spent at Arles was very productive; over 200 paintings and about 100 drawings have survived from the 444 days he lived in the locality.

Trunk of an Old Yew Tree, late October 1888, oil on canvas, Helly Nahmad Gallery, London, UK, 91 x 71cm (35.8 x 28in)

Although many of Van Gogh's compositions present panoramas laid out for our visual consumption, he also liked to focus his attention on his immediate field of vision. Here he has created a portrait of a tree, as distinctive and characterful as any of his portraits of people.

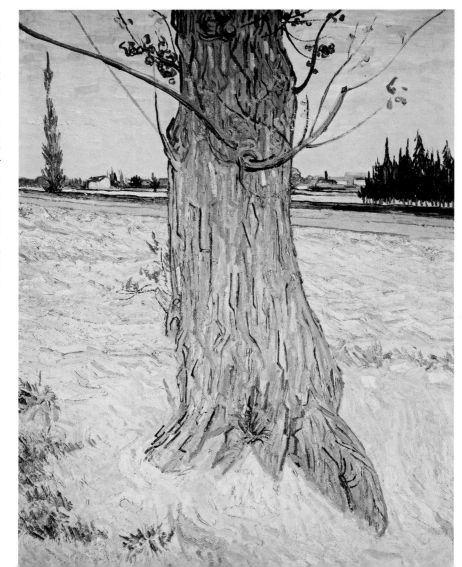

Harvest in Provence, June 1888, oil on canvas, Israel Museum, Jerusalem, Israel, 50 x 60cm (19.5 x 23.5in)

Van Gogh described such paintings as this as "landscapes, yellow – old gold – done quickly, quickly, quickly, and in a hurry just like the harvester who is silent under the blazing sun, intent only on the reaping."

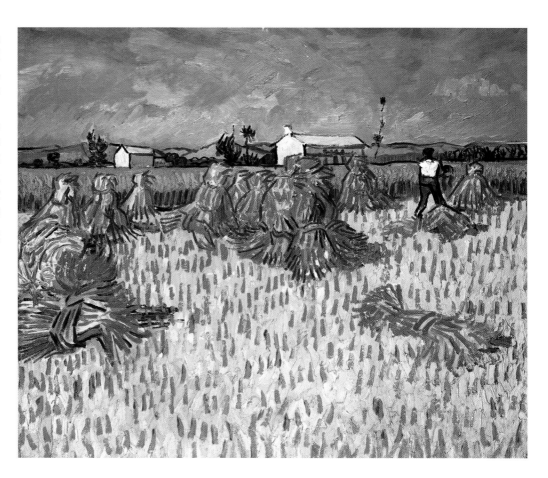

Ploughed Field, September 1888, oil on canvas, Van Gogh Museum, Amsterdam, the Netherlands, 72.5 x 92.5cm (28.5 x 36.5in)

Once again, the visual clash of horizontals and verticals creates a dynamic tension, augmented by contrasting bands of colour and agitated brushwork. Van Gogh has utilized the weight and density of undiluted oil paint to suggest the heaviness of the turned earth and the turbulent September sky.

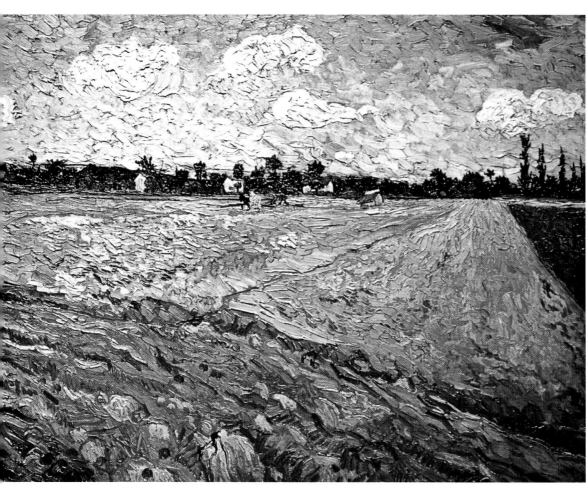

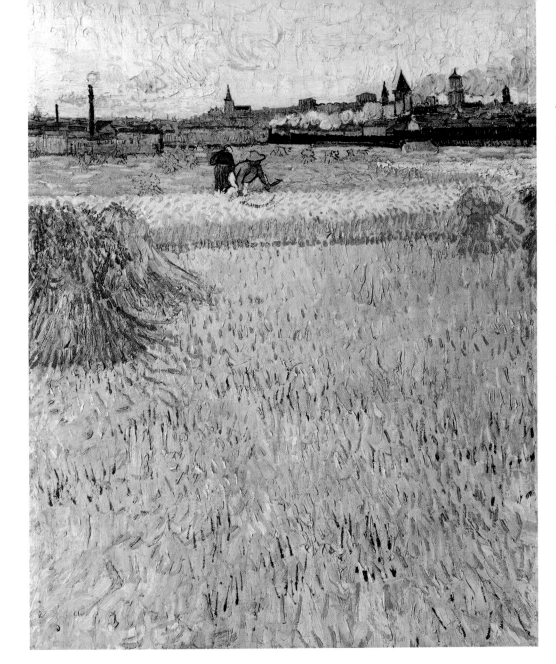

Arles: View from the Wheat Fields with Sheaves, 1888, oil on canvas, Musée Rodin, Paris, France, 73 x 54cm (28.5 x 21.5in)

Van Gogh has developed a calligraphic way of painting in which each detail of the landscape is generalized into a rich, rhythmic pattern of colour and line. These images capture the burning heat of the summer sun. The workers are seen against the silhouette of the town as a train rushes past – a symbol of the modern world.

Wheat Field with Sheaves, June 1888, oil on canvas, Honolulu Academy of Arts, HI, USA, 52.2 x 66.6cm (21 x 25in)

The ebullient forms of the gathered wheatsheaves rise up like the spume of a breaking wave against the field of wheat. Once again Van Gogh has used one of his favourite compositional devices, dividing the canvas into horizontal bands, each characterized by a different coloration or handling of paint.

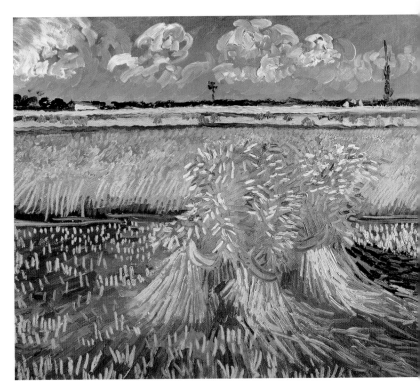

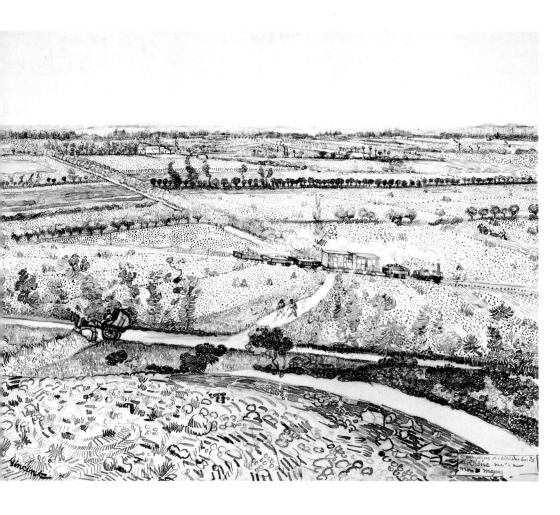

Landscape near Montmajour with Train, July 1888, brown ink drawing over black chalk, The British Museum, London, UK, 72 x 92cm (28.3 x 36.2in)

Van Gogh had had a difficult time painting out of doors in Paris and the surrounding region. Indeed it seems toward the end he had been forbidden to paint out of doors at all. Here in the countryside of the south of France he took the opportunity to draw and paint in the open air. This drawing reveals the originality of his vision and his ability to find simple graphic equivalents for the most complicated of visual effects.

The Blue Cart, June 1888, graphite, black chalk, oil pastel, brown ink, watercolour and gouache on paper, Fogg Art Museum, Harvard University Art Museums, Boston, MA, USA, 46 x 36cm (18.1 x 14.2in)

In this drawing Van Gogh is emulating Rembrandt and the Japanese art he loved so much by using one of the most technical means – graphite, chalk and touches of watercolour. All the variety and richness of visual experience is recorded by these means. The marks that Van Gogh uses are abstract: dots, dashes and hatching to create a tapestry-like effect.

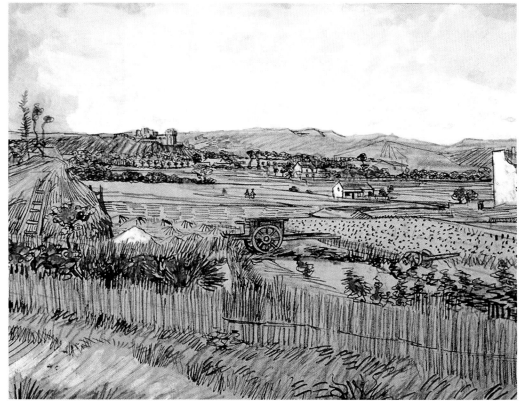

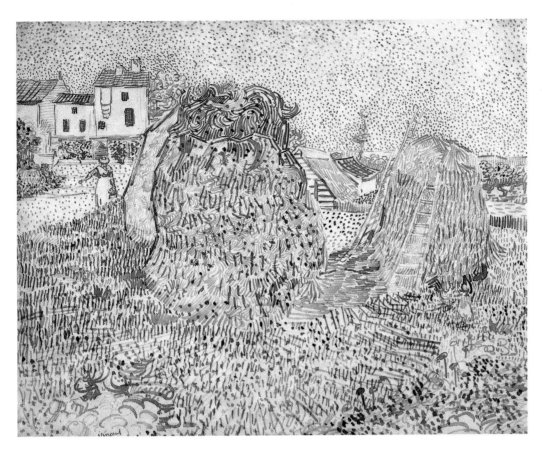

Haystacks near a Farm,
July–August 1888,
Reed pen, quill and ink
over graphite on paper,
Philadelphia Museum of Art,
PA, USA, 24.1 x 31.8cm
(9.5 x 12.5in)

An extraordinary drawing –
the immediacy of the
artist's visual response to
the sculptural bulk of the
stacks is translated at speed
into an astonishing display
of calligraphic pyrotechnics.
The entire scene seems to
shimmer in the haze of the
summer light.

Olive Trees, Montmajour,
July 1888, pen and ink on
paper, Musée des Beaux-
Arts, Tournai, Belgium,
73.6 x 92.7cm (29 x 36.5in)

In drawing and painting
these scenes, Van Gogh
is following an idea shared
by many of the artists
and writers of the time, who
looked to the countryside to
find images that would
counteract the encroachment
of industrialization upon
an apparently unchanging
rural landscape.

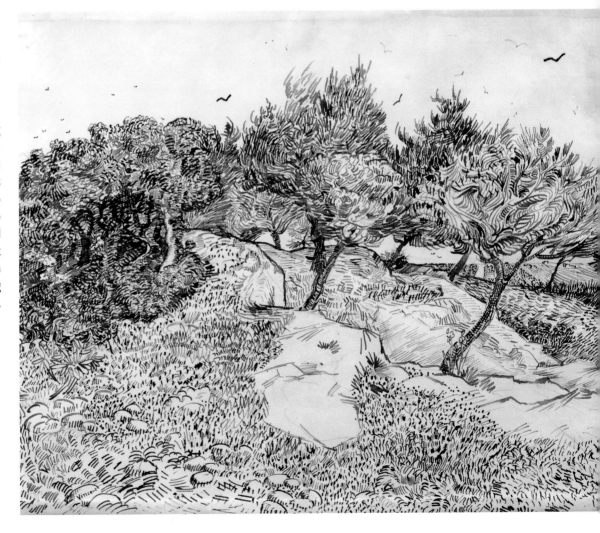

Interior of the Restaurant Carrel, August 1888, oil on canvas, private collection, 54 x 64.5cm (21.5 x 25.5in)

Yellows and blues dominate this painting. The serried ranks of tables and chairs are punctuated by the carafes that echo the mostly solitary figures sitting at the distant tables. Perspective is skewed to dramatic effect and touches of vermilion enliven the composition.

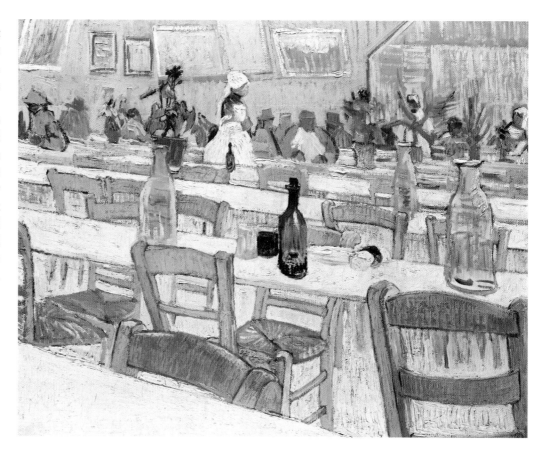

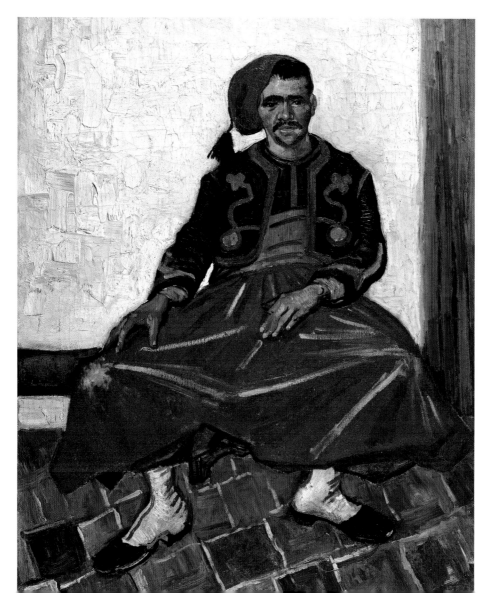

The Seated Zouave, June 1888, oil on canvas, private collection, 81 x 65cm (32 x 25.5in)

Lieutenant Milliet, an officer in the regiment of Zouave stationed at Arles, was one of Van Gogh's few friends. Like Van Gogh, Milliet was an outsider in the town. His swarthy complexion is set off by the rich vermilions and blues of his uniform and the Japanese-inspired background against which he sits.

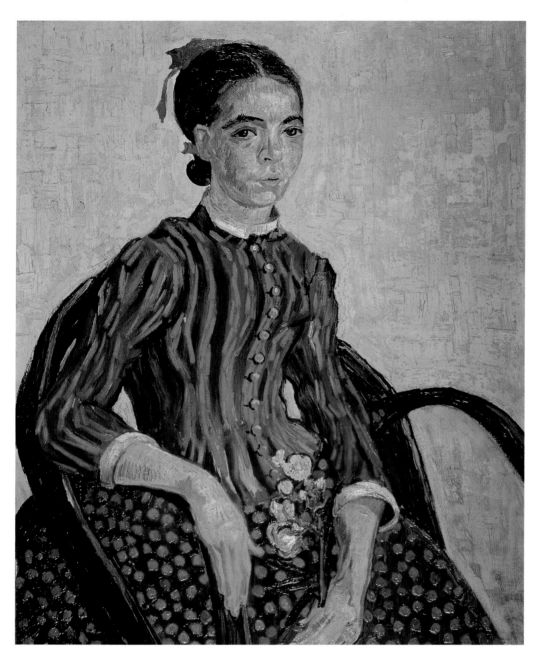

La Mousmé, Sitting July 1888, oil on canvas, National Gallery of Art, Washington, D.C., USA, 74 x 60cm (29 x 23.6in)

Having just finished reading *Madame Chrysanthemum,* the new novel by French author Pierre Loti, Van Gogh told his brother that a "mousmé is a Japanese girl – Provençal in this case – twelve to fourteen years old." The identity of this young girl is unknown; she sits in iconic splendour on an extraordinary chair; her stunning dress painted in emulation of a Japanese kimono. The thick dabs of red paint stand out against the cool blue of her skirt; her bodice echoes these colours with strongly drawn stripes.

La Mousmé, Sitting, 1888, ink on paper, Pushkin Museum, Moscow, Russia, 32.5 x 24.5cm (13 x 9.5in)

La Mousmé was an ongoing series of portrait studies that Van Gogh produced at this time. This is one of several drawings that he produced of 'La Mousmé' in preparation, or more likely as a record, of his painting, a practice he did often throughout his correspondence to his brother Theo and his friend Émile Bernard.

L'Arlésienne: Madame Ginoux with Books, 1888–9, oil on canvas, Metropolitan Museum of Art, New York, NY, USA, 91.4 x 73.7cm (40 x 29in)

Marie Ginoux was the proprietress of the Café de la Gare, where Van Gogh lived in Arles between May and September 1888, before he moved into the nearby Yellow House. The rich, saturated yellow makes a wonderful foil for the black of her traditional costume, and the influence of the Japanese masters is clearly evident. Van Gogh gave this portrait as a gift to the sitter.

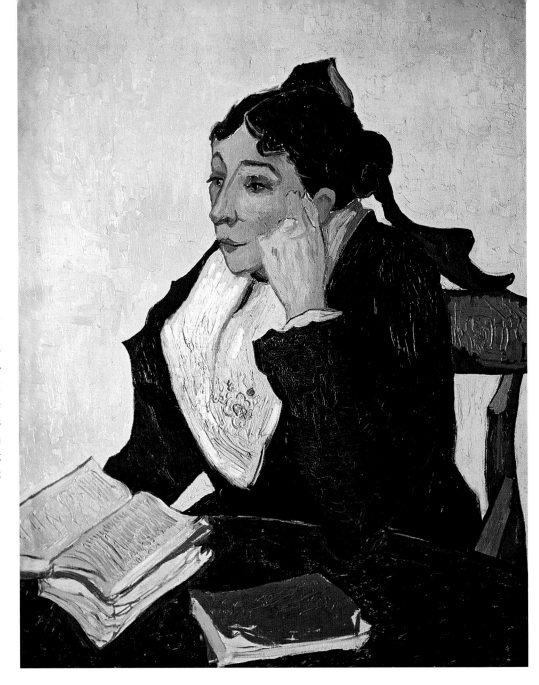

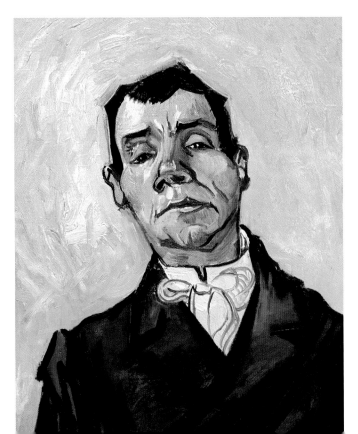

Portrait of Joseph-Michel Ginoux, December 1888, oil on canvas, Kröller-Müller Museum, Otterlo, the Netherlands, 65 x 54.5cm (25.6 x 21.5in)

Joseph-Michel and his wife Marie were fond and protective of their artist friend. Van Gogh produced at least seven portraits of Marie. Here Joseph-Michel is seen from below and gazes quizzically, and perhaps affectionately, at the artist.

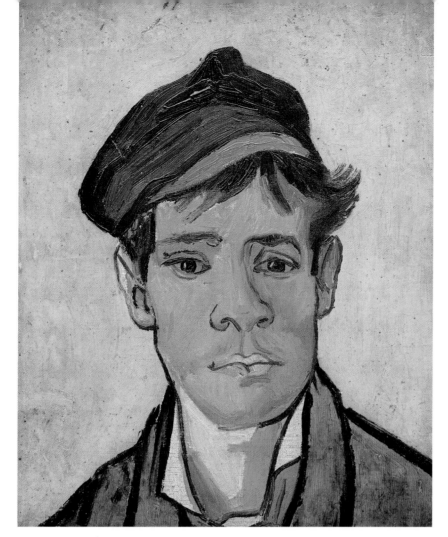

Young Man with a Cap, December 1888, oil on canvas, private collection, 47 x 39cm (18.5 x 15.5in)

Van Gogh's portraits are direct responses to humanity. Here, strong bounding contour lines hold the areas of clean colour in place and establish an underlying asymmetry that gives this jaunty painting life. The boy's identity is unknown, but his proximity and the directness of his gaze create a tremendous sense of his presence.

The Novel Reader, November 1888, oil on canvas, private collection, 73 x 92cm (28.7 x 36.2in)

With its artificial coloration and heavy outlines, this is the most direct example of Van Gogh trying to emulate Gauguin's ideas in his painting. The painting celebrates the intellectual illumination of the young woman as she reads one of the contemporary French novels of the Realist school, which were published with yellow covers – hence, perhaps, another reason for the dominant yellow note.

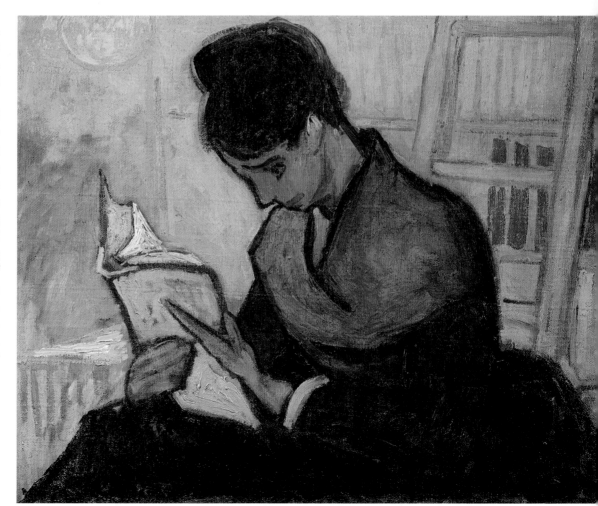

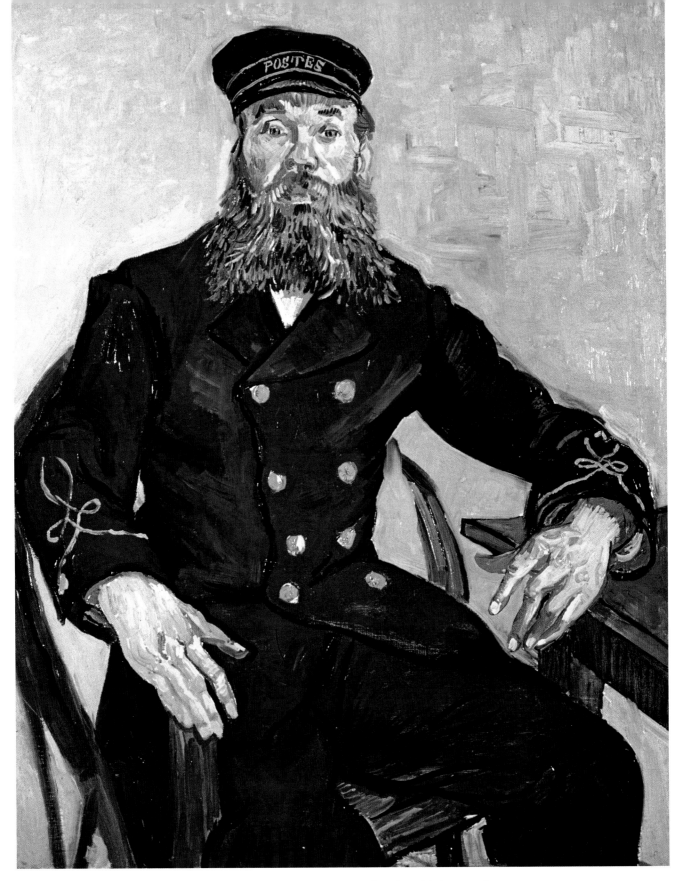

*Portrait of the Postman
Joseph Roulin*, oil on canvas,
August 1888, The Detroit
Institute of Arts, IL, USA,
64.1 x 48cm (25 x 19in)

Joseph Roulin was an official
in the post office and he and
his family became deeply
important to Van Gogh.

They lived just a
few doors away from the
Yellow House and became
a surrogate family to the
artist. Van Gogh described
his Republican friend –
his "silent gravity and
tenderness" – with great
sensitivity in his letters.
Van Gogh was drawn to

the pictorial drama of
Roulin's flamboyant golden
beard, his florid complexion
and the clash of blue and
yellow in his elegant cap
and uniform. He sits on
the same chair as La
Mousmé, his body open
and relaxed where hers is
closed and tense.

Portrait of the Postman Joseph Roulin, April 1889, oil on canvas, Museum of Modern Art, New York, NY, USA, 64 x 54.5cm (25 x 21.5in)

In this portrait, the individual elements of line, colour and brushstroke work together to create a formidable pictorial architecture. The features, uniform and background lock together in a rhythmic whole. Touches of green in Roulin's moustache and beard complement the warm tones of his lips and cheeks and are echoed in the vigorous patterning of the wallpaper.

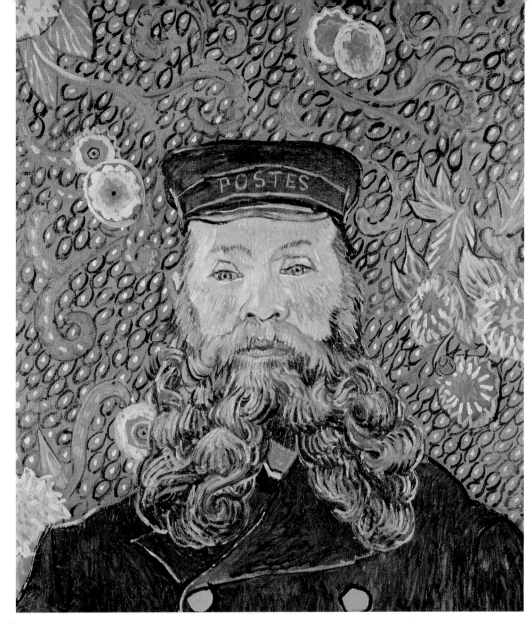

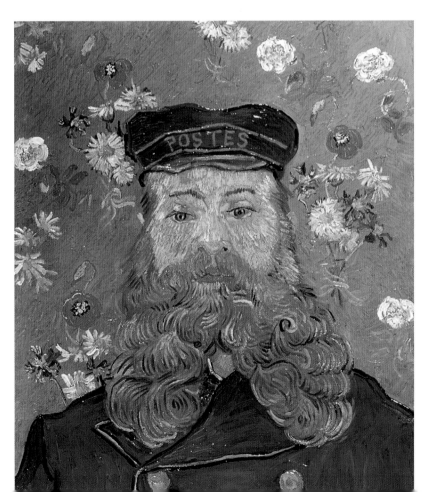

Portrait of the Postman Joseph Roulin, April 1889, oil on canvas, Kröller-Müller Museum, Otterlo, the Netherlands, 65 x 54cm (25.6 x 21.3in)

This painting of Van Gogh's "Socratic" friend exudes a sense of calm and vitality. Van Gogh has used the flowing moustache and beard to express something of Joseph's inner energies, and allowed those rhythms to spill over into the extraordinary liveliness of the wallpaper that surrounds him.

Portrait of Armand Roulin,
November–December
1888, oil on canvas,
Museum Folkwang, Essen,
Germany, 65 x 54cm
(25.5 x 21.5in)

Although Van Gogh is
so well known for his
landscapes, he considered
portrait-painting to be the
supreme challenge for
the artist. His portraits
are characterized by an
extreme sense of intimacy
and encounter. "Portraiture,"
he wrote in 1888, "is the
only thing in painting that
moves me to the depths,
and it makes me feel closer
to infinity than anything else."

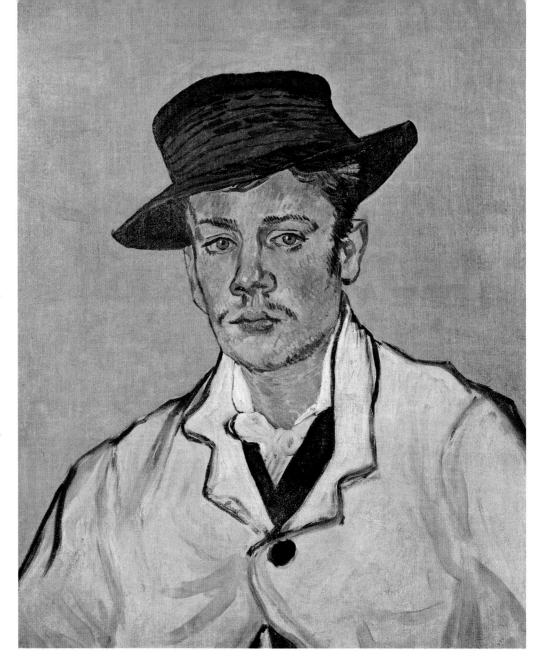

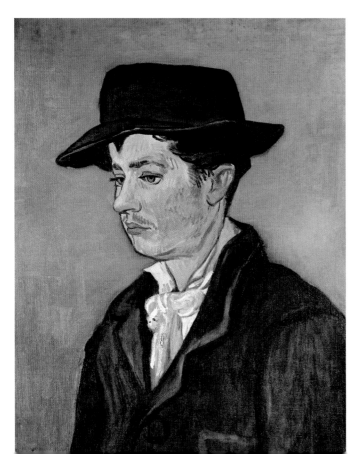

Portrait of Armand Roulin,
November–December
1888, oil on canvas,
Museum Boijmans Van
Beuningen, Rotterdam, the
Netherlands, 65 x 54cm
(25.5 x21.5in)

Van Gogh's two portraits
of his friend Joseph Roulin's
son are completely different
in feel – one sets the young
man in profile and offers a
discreet and interiorized

vision, while the other looks
out directly, as if to confront
the viewer's gaze. The fine
chiselled features of this
delicate young man are
carefully outlined in blue, the
rest of the painting is made
up of simple blocks of
colour, given life by the
dynamics of the drawing.
Van Gogh never merely
colours in – he makes each
area of the canvas as
significant as any other.

The Schoolboy (Camille Roulin), December 1888, oil on canvas, Museu de Arte, São Paolo, Brazil, 63 x 54cm (25 x 21.5in)

This is a painting that clearly foreshadows the development of Expressionist painting in the 20th century, which could be succinctly described by Van Gogh's simple statement: "Instead of trying to paint exactly what I see before me, I make more arbitrary use of colour to express myself more forcefully." The sharp, angular drawing, the dissonant colours and the convincing psychological characterization of this young boy make it a resonant precursor to the paintings of artists as various as Ernst Ludwig Kirchner and Chaïm Soutine.

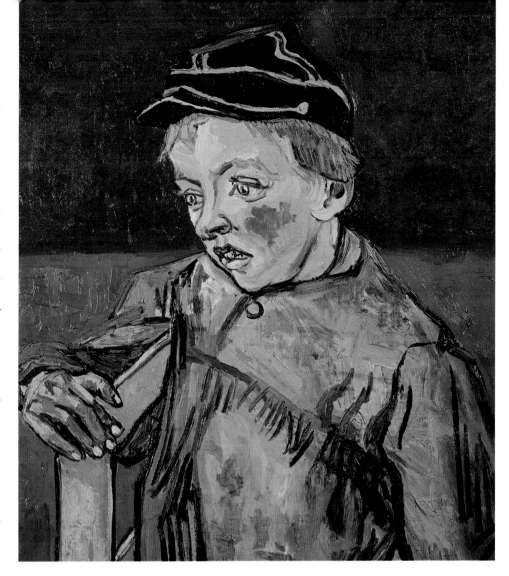

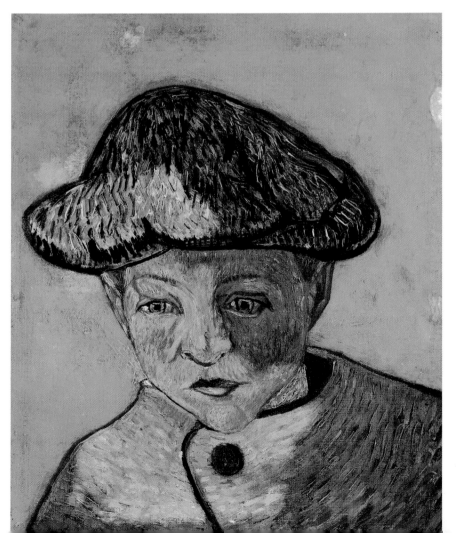

Portrait of Camille Roulin, November–December 1888, oil on canvas, Philadelphia Museum of Art, PA, USA, 43 x 35cm (16.9 x 13.8in)

There is a genuine sense of sympathy and engagement in this strong but delicately observed study. Camille was the son of Joseph Roulin and is shown here in pensive mood. It is a powerful colouristic statement: the insistent contour lines hold the agitated brushwork in place and a touch of red in the buttons animates the otherwise predominantly yellow, blue and green colour balance.

Mother Roulin with her Baby,
November–December
1888, oil on canvas,
Metropolitan Museum of
Art, New York, NY, USA,
63.5 x 51cm (25 x 20in)

A proud Augustine Roulin
holds her baby to have its
portrait painted by the
eccentric Dutch artist. She is
seen in profile, fully conscious
of her responsibility, while the
baby's face is seen front-on,
its body cradled and
protected by the beautifully
realized hands of its mother.

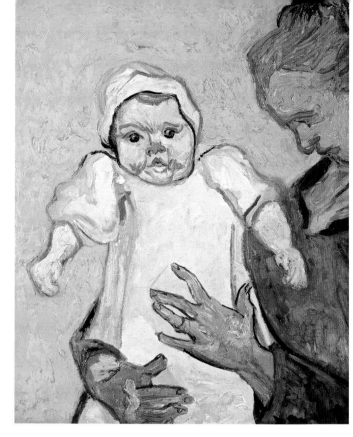

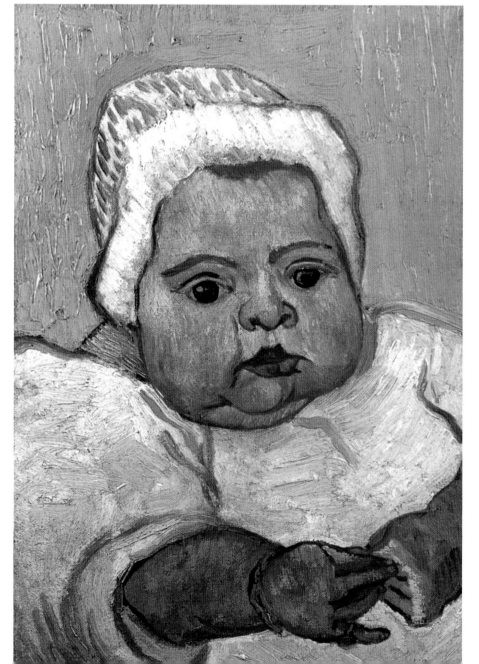

The Baby Marcelle Roulin,
December 1888, oil on
canvas, Van Gogh Museum,
Amsterdam, the
Netherlands, 35 x 24.5cm
(14 x 9.5in)

Van Gogh's affection for the
Roulin family is marked by
the number of canvases he
painted of them. He sent
this work to Theo and his
pregnant wife Johanna.
In a letter of the time, he
fantasized about painting
their baby as he had
painted that of Augustine
and Joseph Roulin.

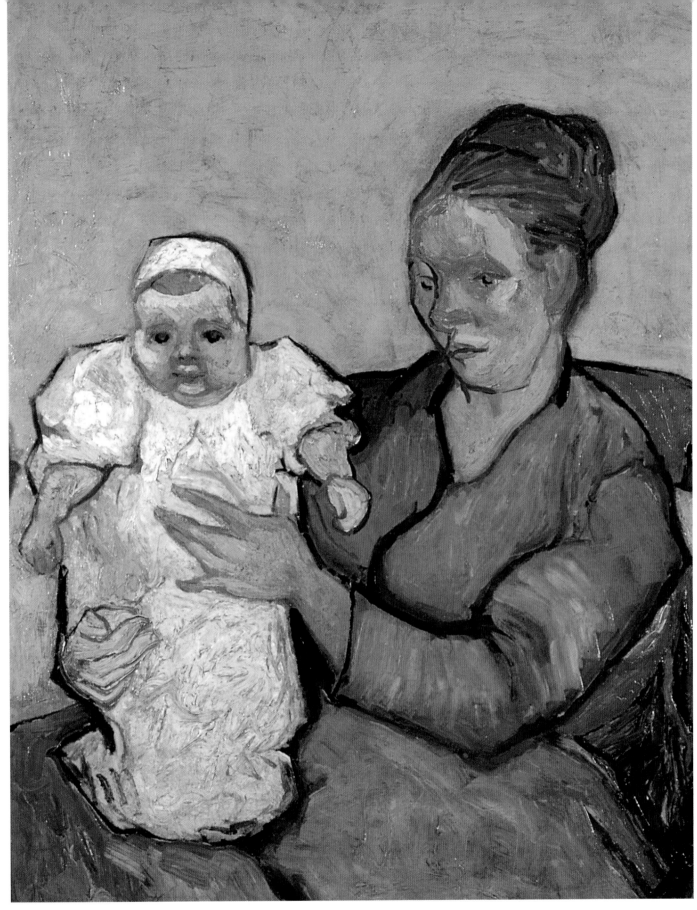

Mother Roulin with her Baby,
November–December
1888, oil on canvas,
Philadelphia Museum of
Art, PA, USA, 92 x 73.5cm
(36.2 x 28.9in)

The theme of mothers and motherhood was of the particular significance to Van Gogh and to 19th-century artists in general. Many of Van Gogh's preferred artists and writers made this theme central to their work. The development of industrialization and urbanization had put traditional patterns of living and social organization under pressure. Van Gogh has once again fused the intimate and the domestic with the religious and hierarchical.

Self-portrait with Pipe and Straw Hat, August 1888, oil on canvas, Van Gogh Museum, Amsterdam, the Netherlands, 42 x 30cm (16.5 x 12in)

A rapidly executed self-portrait study showing Van Gogh as a peasant. Startling juxtapositions of reds, lilacs and blues ring together to create the vibrancy of Van Gogh's momentary encounter with himself in the mirror. In the early years of the next century Matisse and his friends Derain and Vlaminck would all emulate such paintings.

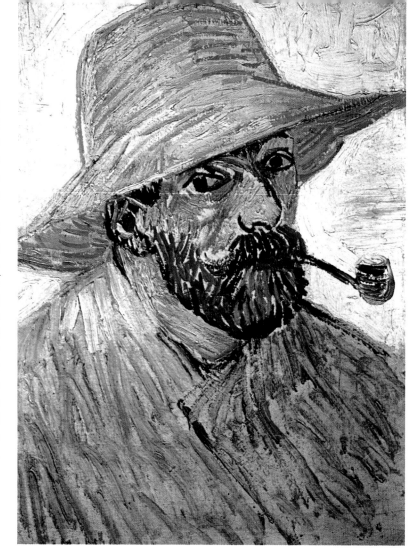

Portrait of Eugène Boch, September 1888, oil on canvas, Musée d'Orsay, Paris, France, 60 x 45cm (23.5 x17.5in)

The period in which Van Gogh was painting, the 1880s, was the heyday of Symbolism. Van Gogh described his friend Boch as "an artist who dreams great dreams, who works as the nightingale sings because it is his nature…. I paint infinity a plain background of the richest intensest blue I can contrive, and by the simple combination of the bright head against the rich blue background, I get a mysterious effect, like a star in the depths of an azure sky." Van Gogh painted this work in two sittings over a single day.

Portrait of Patience Escalier, August 1888, oil on canvas, private collection, 69 x 56cm (27.2 x 22in)

All of Van Gogh's paintings are studies in colour and line, but like Rembrandt's great portraits they also evoke a sense of personality. Patience Escalier is a man of the local region, his skin burnt and furrowed through years of exposure to the elements. The blue of his smock contrasts with the yellow of his straw hat, while red is used to punctuate and highlight the features of his face.

Portrait of Patience Escalier, August 1888, brown ink over graphite on paper, Fogg Art Museum, Harvard University Art Museums, Boston, MA, USA, 49.4 x 38cm (19.5 x 15in)

The richness of colour in the painting of Patience Escalier is translated here into black and white. Matisse, the great colourist of the 20th century, bought two Van Gogh drawings early in his career and used them as a benchmark in his prolonged investigation into how to make black a colour.

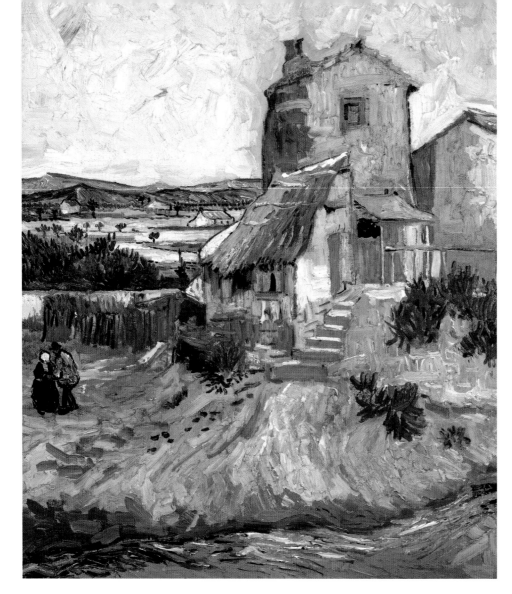

The Old Mill, September 1889, oil on canvas, Albright-Knox Art Gallery, Buffalo, NY, USA, 64.5 x 54cm (25.4 x 21.3in)

A painting that reminds us of Van Gogh's geographical and artistic proximity to Cézanne. Two figures are shown in conversation beside the rushing waters of a fast-flowing stream. Blues and lilacs are laced through the warm tones of the buildings, with the orange roof tiles making a bold statement against the blue-green of the sky. In the distance are set the deep blue of the mountains and the distant fields and habitations of the Arles countryside, the whole scene held together by the diverse but always rhythmically united brushwork.

Pollard Willows, April 1889, oil on canvas, Collection Niarchos, 55 x 65cm (21.5 x 25.5in)

A familiar subject in Van Gogh's oeuvre is here transfigured into an emotionally charged response to the landscape. He has applied heavily saturated strokes of pure colour – shocking pink, deep blues and verdant greens – using different brushstrokes for the different parts of the landscape: short, directional ones for the wall and foliage; long ones following the line of the road, overlaid with short stubby dabs; and vertical slabs of blue for the sky. A bounding line of deep blue is used to contain the outer limits of the forms.

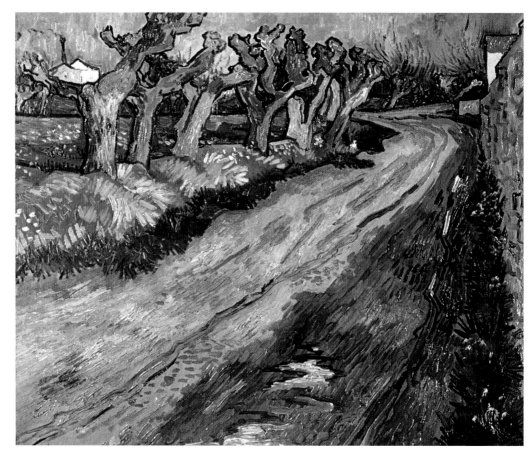

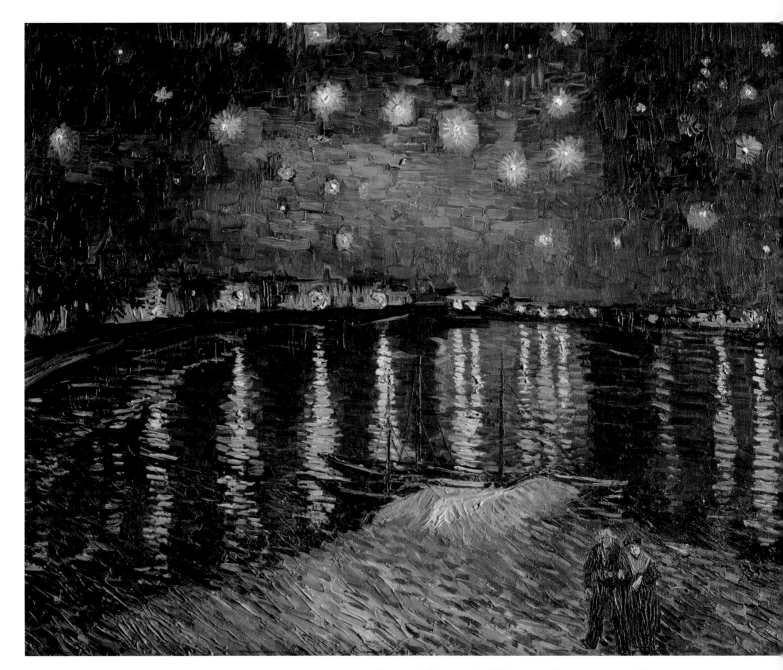

Starry Night over the Rhône, September 1888, oil on canvas, Musée d'Orsay, Paris, France, 72.5 x 92cm (28.5 x 36in)

Van Gogh wrote, "When I have a terrible need of – shall I say the word – religion, then I go out and paint the stars."

Recent research has shown that such paintings show an actual physical phenomenon of the night sky. However, like every artist, Van Gogh has then reorganized experience to make a powerful pictorial statement. Many paintings of this period have an intense, almost devotional, mood.

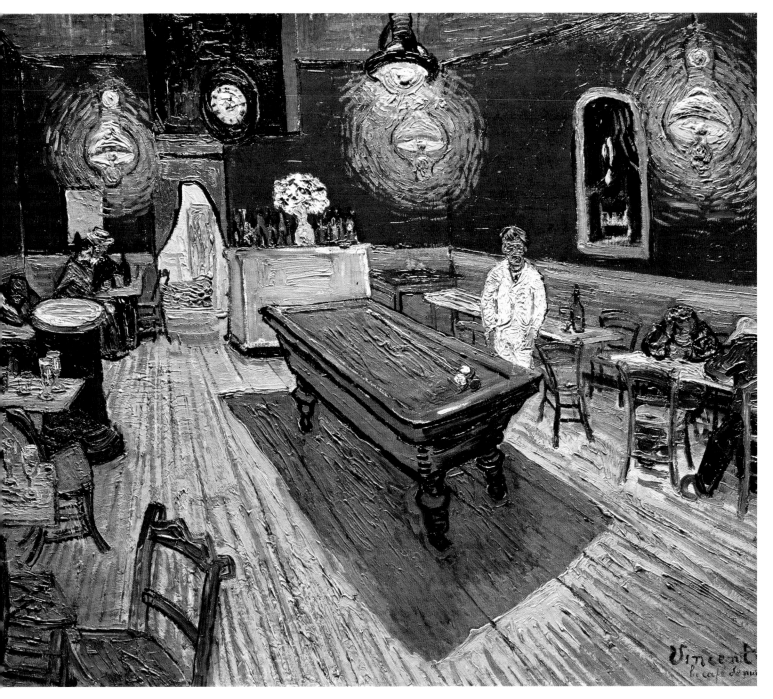

The Night Café in the Place Lamartine in Arles, September 1888, oil on canvas, Yale University/Snark Archives, New Haven, CT, USA, 70 x 89cm (27.6 x 35in)

The "café de nuit" was open all night, and was a suitable haven for "night prowlers" – those too drunk or too broke to find lodgings. "I have tried to express the terrible passions of humanity by means of red and green. The room is blood red and dark yellow with a green billiard table in the middle; there are four lemon-yellow lamps with a glow of orange and green. Everywhere there is a clash and contrast of the most alien reds and greens, in the figures of little sleeping hooligans, in the empty dreary room, in violet and blue. The blood-red and the yellow-green of the billiard table, for instance, contrast with the soft tender Louis XV green of the counter, on which there is a rose nosegay. The white clothes of the landlord, watchful in a corner of that furnace, turn lemon-yellow, or pale luminous green."

The Café Terrace on the Place du Forum, Arles, at Night, September 1888, oil on canvas, Kröller-Müller Museum, Otterlo, the Netherlands, 81 x 65.5cm (32 x 26in)

Painted concurrently with *The Night Café*, this work has nothing of its hellish atmosphere. The yellows, greens and oranges of the brightly lit café frontage, illuminated by a gaslight, counterpoint the variegated blues of the night sky, dotted with its brilliant canopy of stars. The sharp perspective is set into tension by the astonishingly varied marks used to describe the scene.

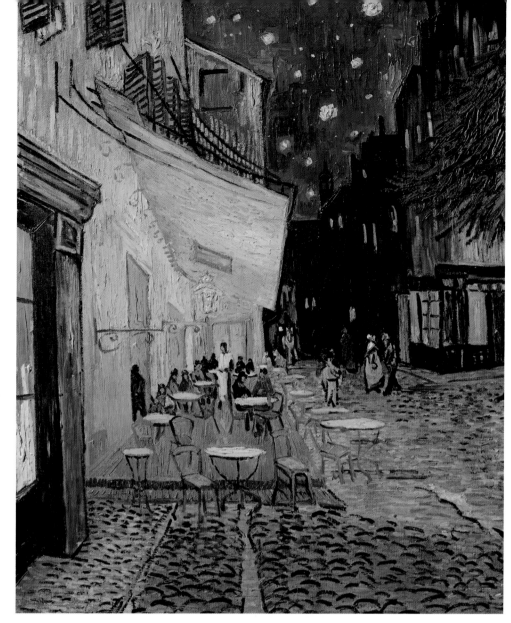

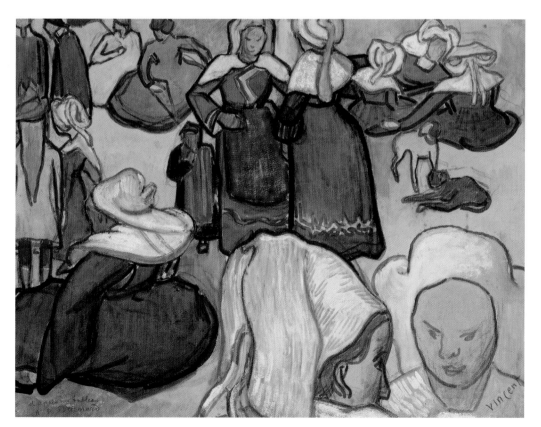

Breton Women (after Émile Bernard), December 1888, watercolour, Civica Galleria d'Arte Moderna, Milan, Italy, 74 x 92cm (29.1 x 36in)

Bernard painted his original version of this picture in emulation of Japanese prints and medieval art to create an evocation of a way of life more mysterious and closer to nature than that possible in the urban environment of the big cities. Such attitudes were adopted by many painters including Cézanne, Monet and Van Gogh himself.

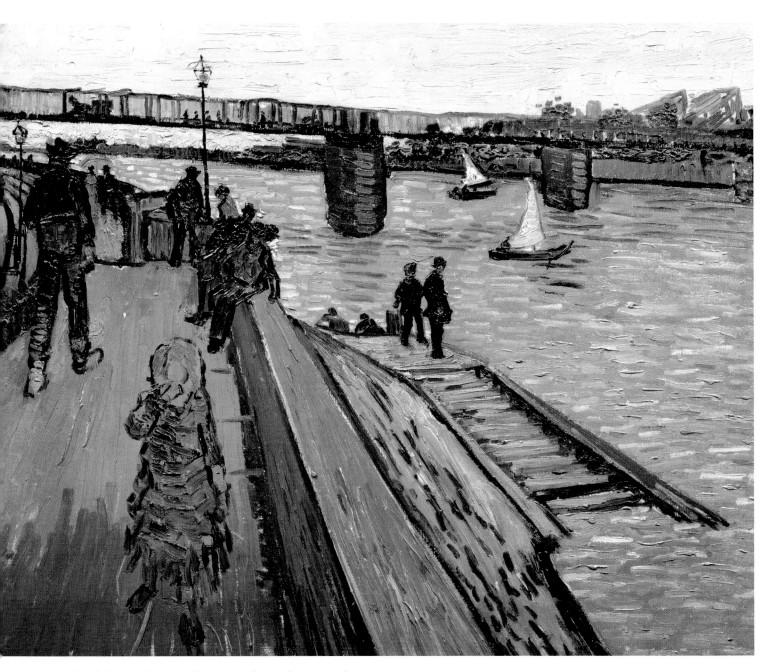

The Bridge at Trinquetaille,
June 1888, oil on canvas,
Joseph Hackmey collection,
Israel, 65 x 81cm
(25.6 x 32in)

This painting depicts the
quayside and part of a
railway bridge that
stretches over the River
Rhône. The dynamic
diagonals sweep the eye
to the horizon past the
figures, who refuse to obey
the constricting rules of
perspective. The resulting
impression is of an intensely
subjective experience,
being translated into paint
– a private apprehension
of the world made
accessible to the public.

The Railway Bridge over Avenue Montmajour, Arles, October 1888, oil on canvas, private collection, 71 x 92cm (28 x 36.2in)

Van Gogh did not paint the historical quarters of Arles, but chose instead areas reminiscent of the working-class suburbs of Paris that he had painted with Bernard and Signac. He was fascinated by the alienating effects of the exaggerated perspective, and paintings such as this, with its arbitrary colours and divergent perspectives, would be inspirational for the German Expressionist artists of the early 20th century.

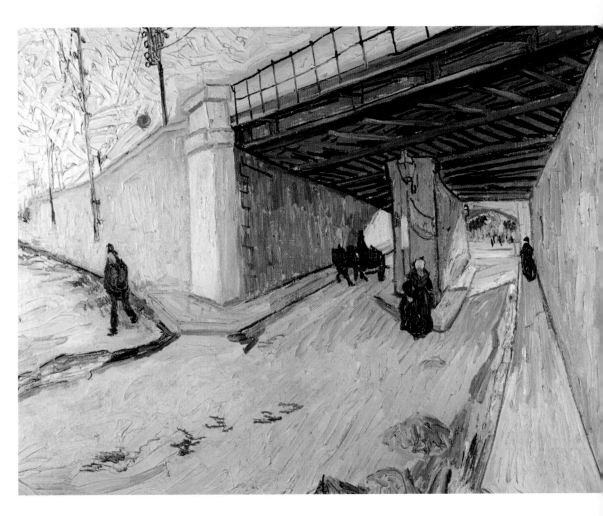

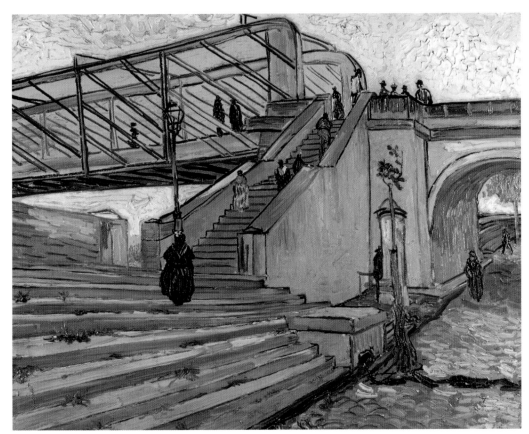

The Trinquetaille Bridge, October 1888, oil on canvas, private collection, 73.5 x 92.5cm (29 x 36.5in)

In this painting, the cool colours are locked into a strong geometrical framework of diagonals and verticals. Two trees are shown struggling against the manmade structures that surround them. Touches of red enliven the pictorial surface and the paleness of the sky may be the result of the colour having faded; Van Gogh sometimes complained that Père Tanguy supplied paint of poor quality.

Vincent's Bedroom in Arles, October 1888, oil on canvas, Van Gogh Museum, Amsterdam, the Netherlands, 72 x 90cm (28.5 x 35.5in)

The room is empty – but everything in it is paired to suggest the imminent arrival of Gauguin. Van Gogh believed that the colour would evoke rest and sleep. The dramatic perspective impels the viewer to share its space. Compositionally, the painting is very similar to *The Night Café*, but in meaning it could not be more different. Notice the simple, homely furniture and the two portraits of his friends, Eugène Boch and Paul-Eugène Milliet.

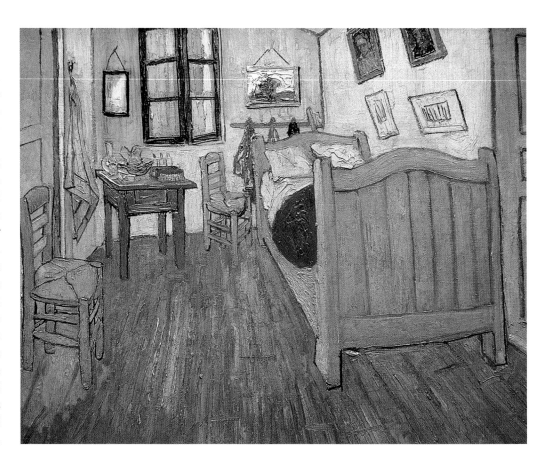

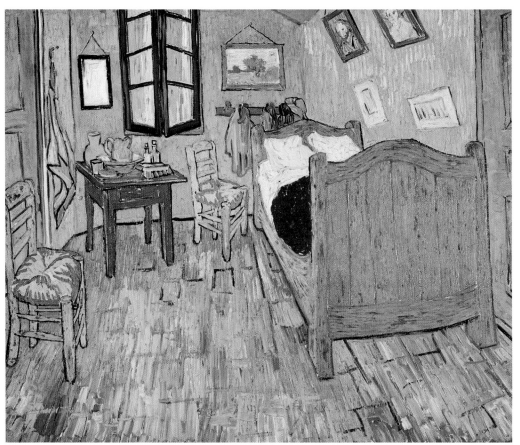

The Bedroom, September 1889, oil on canvas, Art Institute of Chicago, IL, USA, 73.6 x 92.3cm (29 x 36.3in)

This version of the painting was actually made in St-Rémy. When the original version, above, was damaged, Theo advised Van Gogh to make a replica before having it restored. Pleased with Theo's estimation of its worth, he complied and made two further versions, one of which he sent as a gift to his mother and sister. This version is different from the original, but keeps the same quirky perspective – the room was in reality oddly proportioned, but Van Gogh has exaggerated the lines for expressive impact, as he has with its colour.

Vincent's House in Arles (The Yellow House), September 1888, oil on canvas, Van Gogh Museum, Amsterdam, the Netherlands, 72 x 91.5cm (28.5 x 36in)

Finding his lodgings too expensive, Van Gogh rented some rooms in this ramshackle building facing on to the public square. He called it the 'Yellow House' and wished it to be the hub of an artists' community, the 'Studio of the South'. In October 1888, Paul Gauguin arrived at the Yellow House to find that Van Gogh had decorated its interior with a host of specially painted works designed to welcome his friend to their collaborative venture, which he hoped would mark the start of a new phase of modern art.

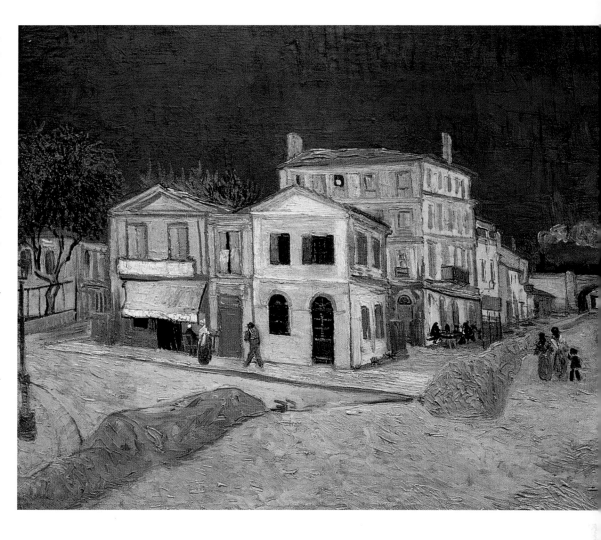

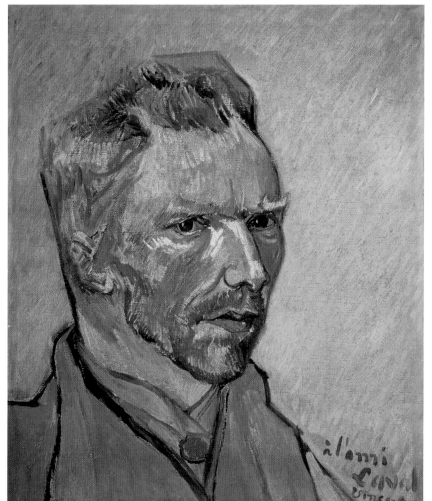

Self-portrait, November–December 1888, oil on canvas, private collection, 46 x 38cm (18.1 x 15in)

This self-portrait is dedicated to Charles Laval, a painter who had earlier accompanied Gauguin on his trip to Martinique. Although each of Van Gogh's many self-portraits are different in colour and character, they are all united by the intensity of his gaze.

Still Life: Vase with Fifteen Sunflowers, August 1888, oil on canvas, National Gallery, London, UK, 93 x 73cm (36.6 x 28.7in)

Excited by the prospect of Gauguin's impending arrival, Van Gogh decided to create a decorative cycle of what was planned to be a dozen or so paintings of sunflowers. He painted four versions at this time and three more followed in 1889. Of all of Van Gogh's paintings it seems that Gauguin was most impressed by the *Sunflowers*. The artist's signature is on the simple Provençal vase.

Still Life: Vase with Twelve Sunflowers, August 1888, oil on canvas, Neue Pinakothek, Munich, Germany, 91 x 72cm (35.8 x 28.3in)

Van Gogh would rise early and paint the flowers as quickly as possible before they wilted in the heat of the day. He has collected the warmth of the sun and imbued these flowers with its character. The flowers are shown at different stages of growth and decay. Van Gogh later revisited the theme long after the season for sunflowers was over.

Still Life: Vase with Twelve Sunflowers, January 1889, oil on canvas, The Philadelphia Museum of Art, PA, USA, 92 x 72.5cm (36.2 x 28.5in)

These flower paintings are not just portraits of individual blooms; they are latter-day holy icons. They are images of the transitoriness of life and beauty; they can be read as religious works intended for a modern, secular audience. They speak of the spiritual with no pretention or bombast and are accessible to anyone.

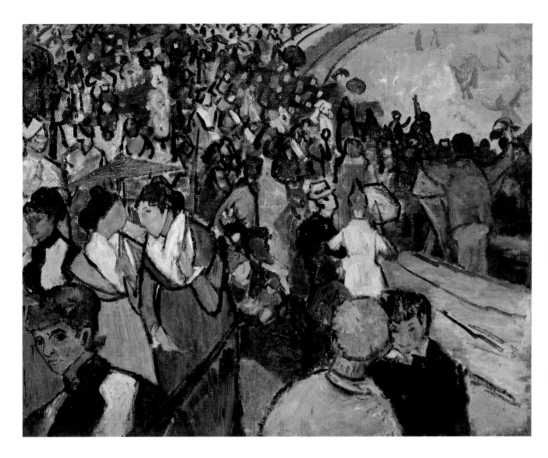

Spectators in the Arena at Arles, December 1888, oil on canvas, State Hermitage Museum, St Petersburg, Russia, 72 x 92cm (28.5 x36in)

Van Gogh was fond of the *corrida* (bullfight) and has painted this scene from memory, adopting the techniques of Gauguin and Émile Bernard in an attempt to use line, colour and form to register not the world of everyday vision, but the world as experienced within the imagination. The heavy black lines and awkward grouping together of disparate studies into a single compositional unit reveals Van Gogh's deep unease with such an agenda.

The Dance Hall in Arles, December 1888, oil on canvas, Musée d'Orsay, Paris, France, 65 x 81cm (25.5 x 32in)

Van Gogh found Gauguin's intellectualized and imaginative approach to art at odds with his essentially realist approach to the motif. Although in this painting Van Gogh is using Gauguin's flatter colour and strong decorative outlines to conjure up the atmosphere of everyday Arles, he would not remain the willing acolyte of Gauguin for long.

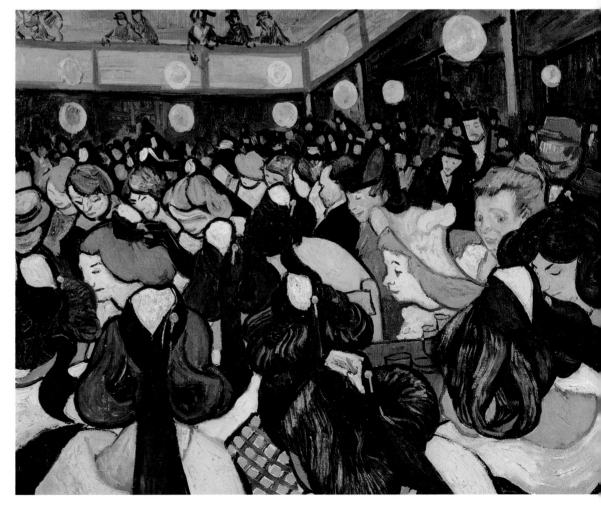

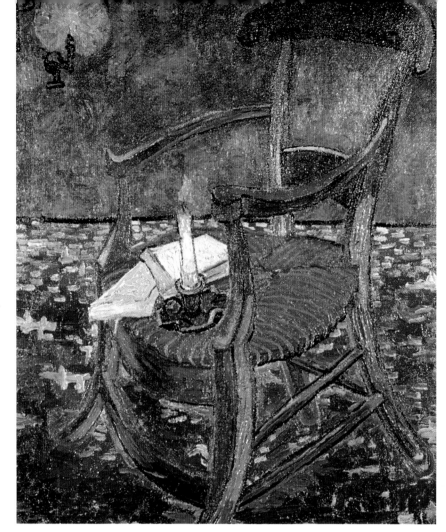

Paul Gauguin's Armchair,
December 1888,
oil on canvas, Van Gogh
Museum, Amsterdam,
the Netherlands,
90.5 x 72.5cm
(35.5 x 28.5in)

This was produced around
the time when it became
clear that, due to the
differences between the two
friends, Van Gogh's dream of
a 'Studio of the South' would
come to nothing, and the
painting may signify the
absence of Gauguin. It is
night-time and the chair is an
armchair, made for relaxation
and reverie. The candle and
novels suggest the intellectual
and imaginative illumination
that comes from reading.

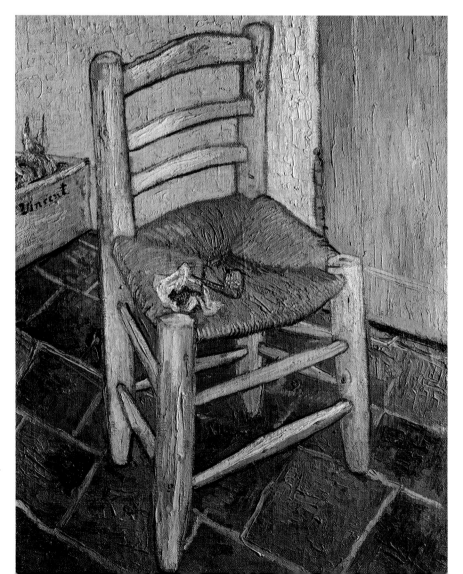

Vincent's Chair with His Pipe,
December 1888–January
1889, oil on canvas, National
Gallery, London, UK,
93 x 73.5cm (36.5 x 29in)

Painted shortly after *Paul
Gauguin's Armchair*, this work
was conceived as a partner
to the earlier piece.
Both paintings reveal the
essential incompatibility
of the two men. Van
Gogh shows his chair, a
simple kitchen chair on
a red terracotta tile floor,
illuminated by the brightness
of the sun. In the corner, in a
box which bears Van Gogh's
name, two onions sprout.
New life, new hope.

Self-portrait with Bandaged Ear and Pipe, January 1889, oil on canvas, private collection, 51 x 45cm (20 x 17.5in)

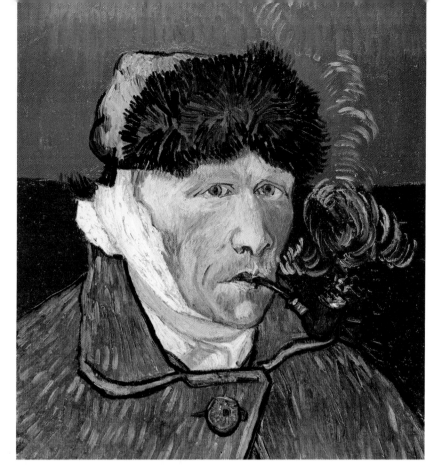

This painting is deliberately crude and aggressively painted. Reds and oranges clash with greens and blues, and the break in the background behind Van Gogh's head cuts right through his eyes. It was paintings such as this that made such an impact on the artists of the early 20th century. Foremost among these was Maurice Vlaminck, who famously said: "I loved Van Gogh…more than my own father."

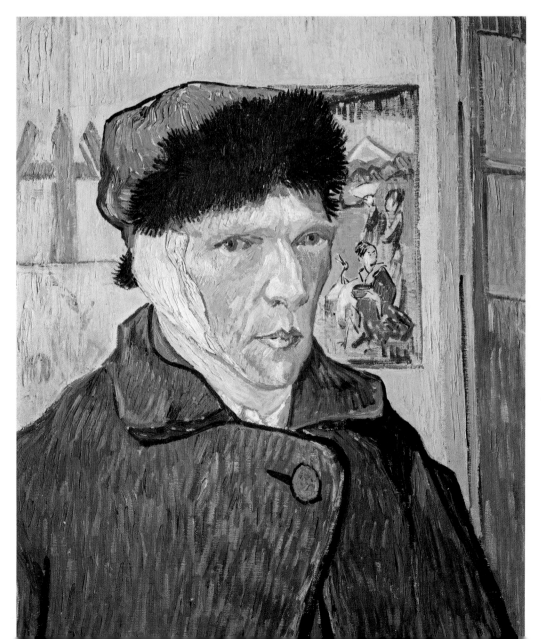

Self-portrait with Bandaged Ear, January 1889, oil on canvas, The Courtauld Gallery, The Courtauld Institute of Art, London, UK, 60 x 49cm (23.6 x 19.3in)

It is winter and Van Gogh's utopian dreams are shattered. He looks out from the depths of his agony, like some persecuted saint showing his wounds to the people. His suffering has been, and is, for his art – this is one of the few self-portraits to show him as an artist. The sparseness of the studio setting, in authentic Japanese fashion, is enlivened by a single print.

Portrait of Doctor Félix Rey,
January 1889, oil on canvas,
Pushkin Museum, Moscow,
Russia, 64 x 53cm
(25 x 21in)

Félix Rey (1867–1932) was
Van Gogh's doctor in the
hospital at Arles, and it
seems that in gratitude for
his treatment Van Gogh
painted the doctor's portrait.
Van Gogh needed all the
support he could get, as the
citizens of Arles were setting
up a petition against his
return. This painting was
lost for something like twenty
years and was discovered
keeping rain from a
hen coop. The artist's
splendidly ostentatious
signature echoes the vibrant
curvilinear elements of
the doctor's jacket and the
background wallpaper.

*Still Life: Drawing Board, Pipe,
Onions and Sealing Wax,*
January 1889, oil on canvas,
Kröller-Müller Museum,
Otterlo, the Netherlands,
50 x 64cm (19.5 x 25in)

Van Gogh made an
apparently rapid recovery
from the injury to his
ear and found his painting,
as ever, a route to health.
The objects in this work
refer to his hope for
his future recovery. Laid
out before us we see a
self-help medical publication
popular at the time, a letter
(probably from his brother),
his pipe and tobacco, what
looks like an empty wine
bottle, a candle and some
sprouting onions.

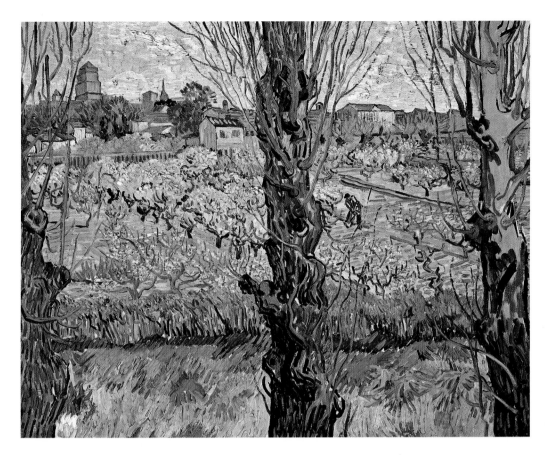

Orchard in Blossom with View of Arles, April 1889, oil on canvas, Neue Pinakothek, Munich, Germany, 72 x 92cm (28.5 x 36in)

By mid-April Van Gogh was well enough to leave the hospital. This landscape, looking through the poplar trees and across the river toward the town of Arles, is a highly effective image of his exclusion from its community. Once again Van Gogh has taken the decorative aspects of Japonisme and given them a raw emotional charge.

La Crau with Peach Trees in Blossom, April 1889, oil on canvas, The Courtauld Gallery, Courtauld Institute of Art, London, UK, 65.5 x 81.5cm (25.8 x 32.1in)

Van Gogh felt well enough to make a number of excursions into the surrounding landscape at Arles. In this painting he revisits the subject of some of the canvases that he had painted a year before. It is painted in a decorative, measured manner, in which the artist's energy is kept under control to produce a network of variegated marks that suggest the lightness and sensibility of Neo-Impressionism.

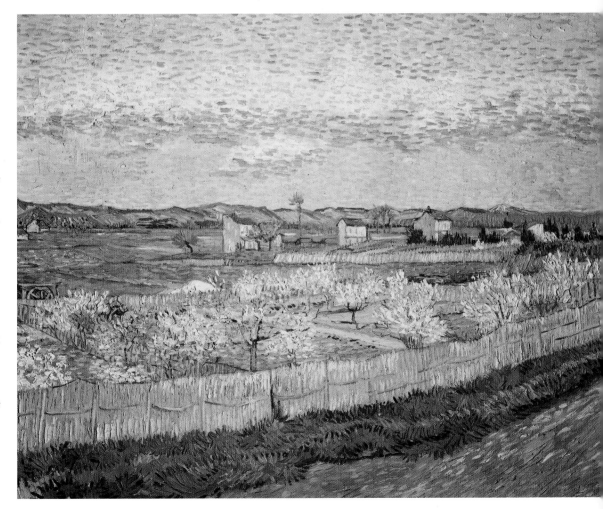

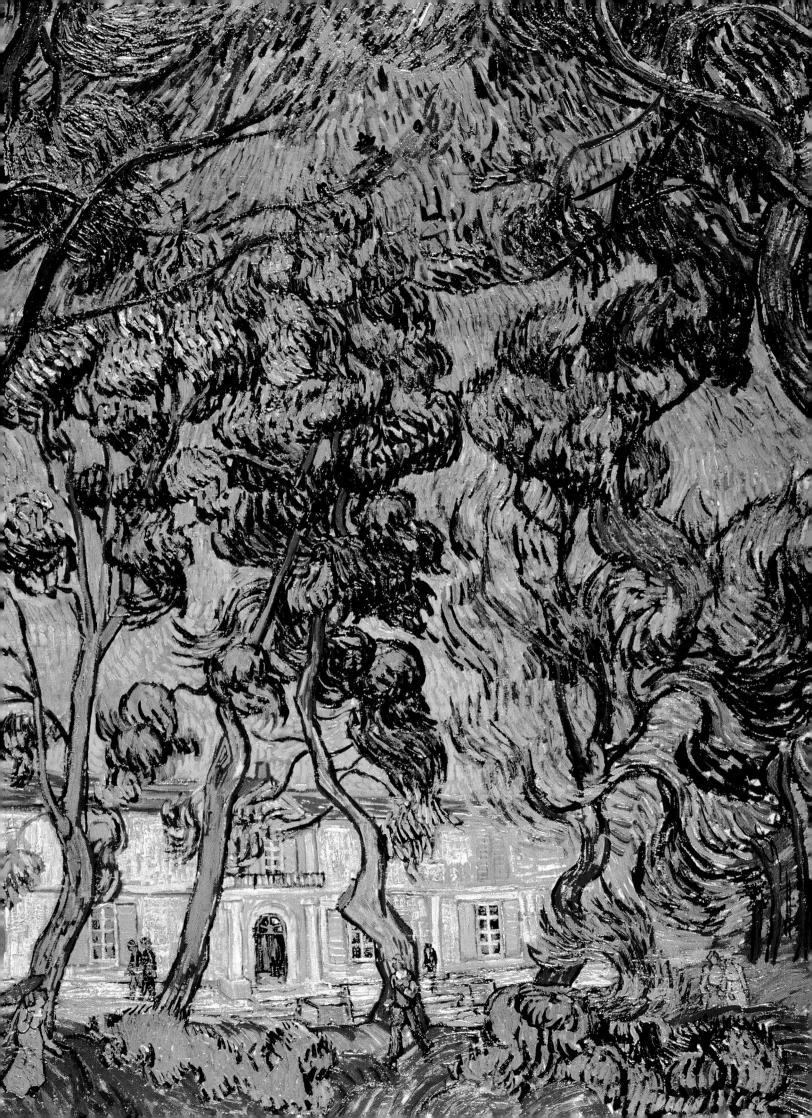

ST-RÉMY

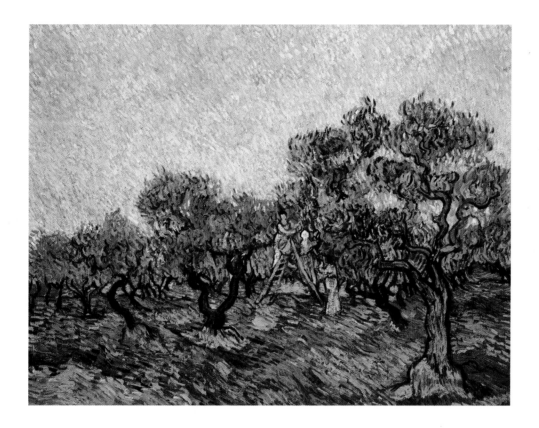

In May 1889 Van Gogh's continuing anxiety over his mental health led him to enter the asylum at St-Rémy. More than 200 paintings and about 100 finished drawings survive from the 444 days he lived there. At St-Rémy Van Gogh was able to concentrate on healing himself and on developing his work without the many interruptions and complications that had taken place in Arles. His compositions become ever more daring and original; his colours become more subtle. He enjoys using mid-tones, yellow ochres, blues and olive greens. The seclusion of the hospital can be felt in his concentration on motifs taken from the asylum itself and the surrounding hillside. His compositions are often dominated by the presence of the sun – always for the artist an image of life and health.

Above: Olive Picking, *December 1889. In the olive grove women tend the trees, and the religious references are resonant. Left:* Trees in the Garden of Saint-Paul Hospital, *October 1889. The trees within the courtyard reach up to the sky to escape the confines of the buildings.*

Lilacs, May 1889, oil
on canvas, Hermitage State
Museum, St Petersburg,
Russia, 72 x 92cm
(28.5 x 36in)

Van Gogh wrote to his
brother that he had found
two suitable subjects in
the asylum's unkempt
garden – a bank of irises
and a lilac bush just coming
into bloom. The rich
verdant greens spring
forth making an unruly
diagonal that fills the
central area of the canvas
almost, but not quite,
hiding the enclosing wall
of the hospital.

Cypresses, June 1889, oil on canvas, Metropolitan Museum of Art, New York, NY, USA, 93.3 x 74cm (36.5 x 29in)

The tall silhouettes of the trees are used to create the essential vertical presence that was needed to enliven an otherwise horizontal landscape. Van Gogh was particularly impressed by the dark, evocative forms of cypresses that reminded him of Egyptian obelisks. Cypress trees, long associated with images of death, are used for that purpose in Van Gogh's art.

Cypresses, 1889, reed pen, graphite, quill and brown and black ink on paper, Brooklyn Museum of Art, New York, NY, USA, 62.3 x 46.8cm (24.5 x 18.5in)

"Drawing is the root of everything." This was made by Van Gogh after a painting, above, of the same subject. Like the Barbizon artists, Van Gogh had a special relationship with trees; for him each tree had a unique character and he draws and paints them with the care and incisive vision that he brought to bear upon everything else that he depicted.

The Starry Night,
June 1889, oil on canvas,
Museum of Modern Art,
New York, NY, USA,
73 x 92cm (28.7 x 36.2in)

In this painting, which became one of his best-known, Van Gogh has once again created a startling image of the union of the earth and the sky, of the small and the large. The cypress tree links the earth with the cosmos that swirls around it. The moon and stars illuminate the night landscape. Echoing the forms of the sky are the rolling hills; echoing the form of the cypress tree is the church, which seems to be reminiscent of those of his home country.

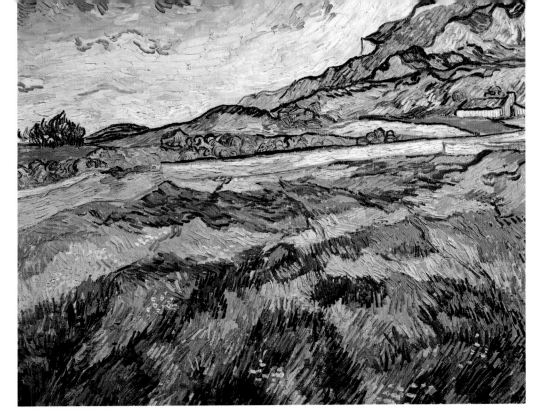

Green Wheat Field, June 1889, oil on canvas, private collection, 73 x 92cm (28.5 x 36in)

In the paintings of this period Van Gogh's colour harmonies become more subtle; he makes use of olive greens, different shades of ochre and blue-grey, "because to my mind the sombre greens go well with the ochre tones; there is something sad in it which is healthy". Such thoughts appear at odds with the interlocking diagonals that give this landscape a tense energy.

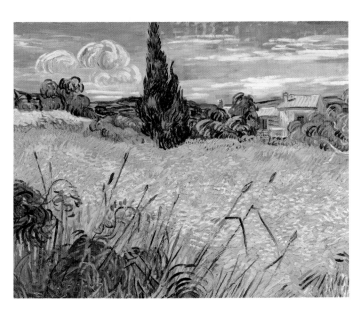

Green Wheat Field with Cypress, mid-June 1889, oil on canvas, Narodni Gallery, Prague, Czech Republic, 73.5 x 92.5cm (28.9 x 36.4in)

Van Gogh's vision of the world is never stable, and the world for him is in constant movement. In such paintings, Van Gogh seems to come close to seeing the world afresh, as if experienced for the first time – in the words of William Blake, "with our five senses crown'd". The low viewpoint, common in Van Gogh's art, gives a strong sense of immediacy and presence to his landscapes. The confidently asserted foreground detail and visible brushwork make the material nature of the painting evident.

Field with Poppies, June 1889, oil on canvas, Kunsthalle Bremen, Germany, 71 x 91cm (28 x 35.8in)

The artist is on a ridge looking down at the cultivated landscape; by taking such a close viewpoint Van Gogh has excluded the sky and surrounding landscape to maximize the visual impact of the tilled fields and luxuriant growth. Van Gogh was always attracted to the agricultural cycle of sowing, nurturing and harvesting and for him, the field itself was a biblical image that represented the ceaseless round of life and death.

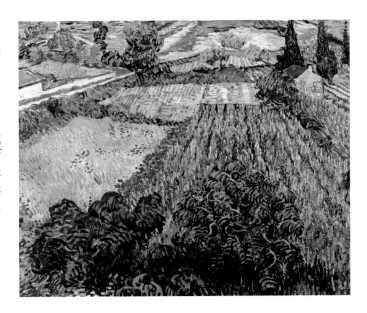

Mountains at St-Rémy with Dark Cottage, July 1889, oil on canvas, Solomon R. Guggenheim Museum, New York, NY, USA, 71.8 x 90.8cm (28.3 x 35.7in)

In this painting the sky is as fully energized as the landscape; both are described in the broken swirling rhythmic movements that seem to spill out from the curving road to fill the whole canvas. Van Gogh hoped more than ever that painting out of doors would help restore his physical and mental equilibrium.

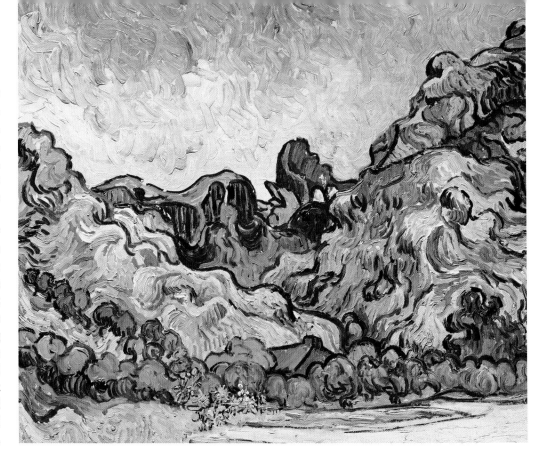

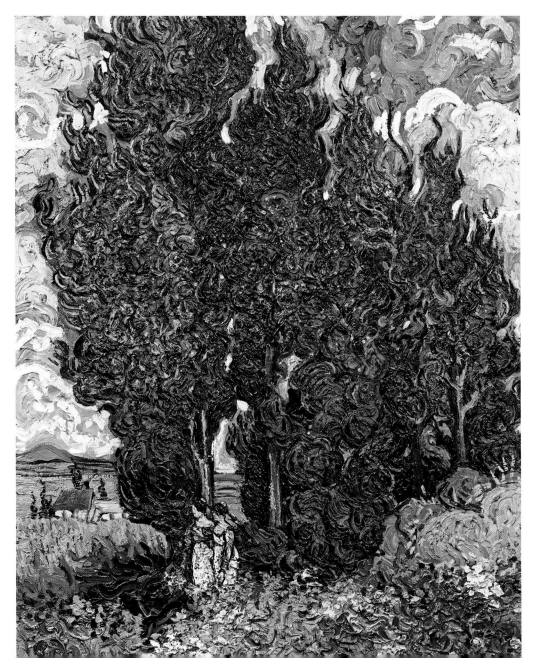

Cypresses with Two Female Figures, June 1889, oil on canvas, Kröller-Müller Museum, Otterlo, the Netherlands, 92 x 73cm (36.2 x 28.7in)

Van Gogh took this painting of a group of flame-like cypress trees, added the two figures at its base and sent it as a gift to Albert Aurier, the young Symbolist art critic who had praised his work – too fulsomely, in the artist's opinion – in the 7 January 1890 issue of the prestigious journal, the *Mercure de France*. It was an apposite offering for Aurier, who had signalled the symbolic significance of such trees as being of special importance in "the strange, intense, and feverish work of Vincent van Gogh".

Wheat Field with Cypresses, September 1889, oil on canvas, National Gallery, London, UK, 72.5 x 91.5cm (28.5 x 36in)

Van Gogh felt cypress trees to be "inherently expressive" and he compared their dark mysterious coloration to notes of music – equivalences between the two arts had always fascinated him. In his mind, they were "the contrast and yet the equivalent" to his sunflowers, which he always associated with ideas of happiness and plenitude.

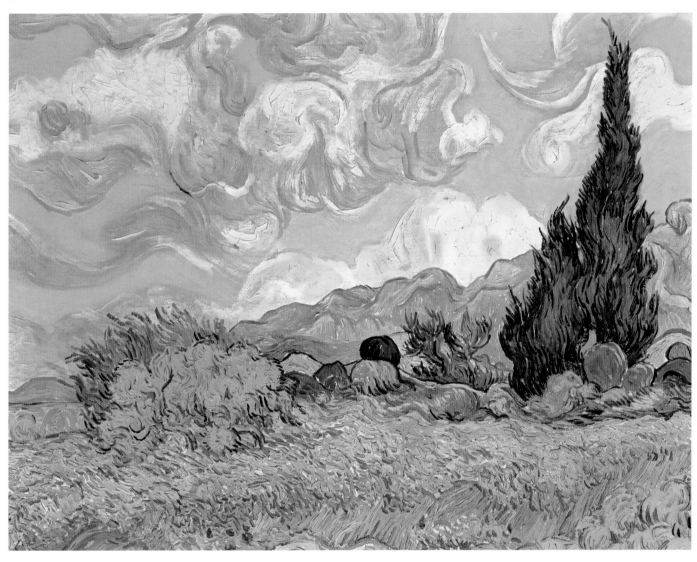

Wheat Field Behind Saint-Paul Hospital with a Reaper, September 1889, oil on canvas, Museum Folkwang, Essen, Germany, 59.5 x 72.5cm (23.4 x 28.5in)

Van Gogh's art centres upon images of generation – growth, maturation, death, decay and regeneration, the cycle of life that is so familiar in art of all cultures. This painting suggests that Van Gogh was concerned that the industrialization of the modern age was destroying age-old ways of living with the natural rhythms of the seasons.

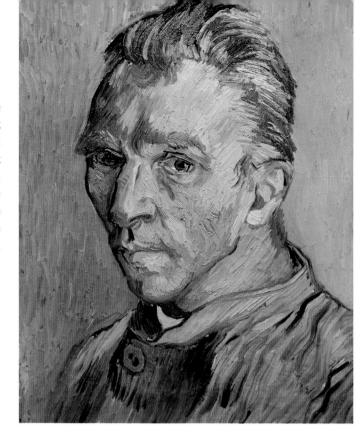

Self-portrait, September 1889, oil on canvas, private collection, 40 x 31cm (15.5 x 12in)

Van Gogh painted this self-portrait just after he had shaved himself. This straightforward three-quarter view of the artist is one of the most engaging of his career. His expression is caught somewhere between openness and wariness; the colour contrasts are kept simple and the brushwork restrained.

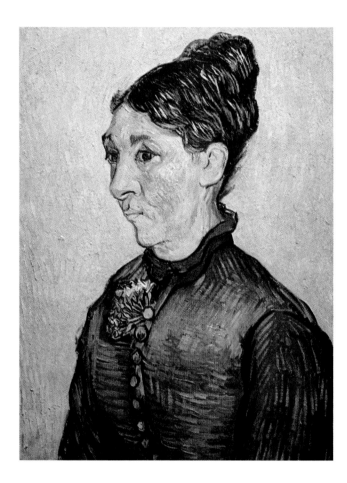

Portrait of Madame Trabuc, September 1889, oil on canvas on panel, Hermitage State Museum, St Petersburg, Russia, 64 x 49cm (25.2 x 19.3in)

Madame Trabuc was the wife of the kindly head warden of the Saint Paul-de-Mausole hospital at St-Rémy. She was 55 at the time and in a letter Van Gogh commented upon her withered, tired face, sunburnt and pockmarked. And yet in this painting, at least, she exudes an engaging and sympathetic presence.

Portrait of Trabuc, Attendant at the Clinic, September 1889, oil on canvas, Kunstmuseum Solothurn, Switzerland, 61 x 46cm (24 x 18in)

Charles Trabuc (or 'the Major', as he was known to the inmates) seems to have been something of a friend to the artist. Van Gogh told Theo of the Major's "very interesting face" like that of "an old Spanish grandee". Thinly painted and rapidly executed, the same flame-like forms that describe Van Gogh's cypress trees and that feature in the turbulent background of his self-portrait of 1890 are found in the snaking lines of Trabuc's jacket.

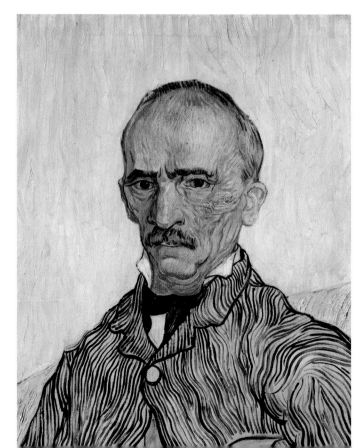

The Garden of Saint-Paul Hospital, November 1889, oil on canvas, Museum Folkwang, Essen, Germany, 73.1 x 92.6cm (28.8 x 36.5in)

Van Gogh was restricted to the confines of the asylum for about six weeks. In the relative tranquillity of the hospital, Van Gogh, like Monet in his garden at Giverny, created a series of magisterial canvases that capture the immediacy of experience, sight, sound, smell and touch.

The Garden of Saint Paul Hospital, October 1889, oil on canvas, private collection, 65 x 49cm (25.5 x 19.5in)

Van Gogh was concerned about the "high yellow note" of his Arles paintings and wondered whether it had precipitated his nervous attacks. Anxious not to fall into abstraction, he reminded himself that the basis of good art was the importance of things "really observed". In this rapidly executed painting the vitality of nature is only just held in check by the artist's brush.

The Road Menders, November 1889, oil on canvas, The Phillips Collection, Washington, D.C., USA, 71 x 93m (28 x 36.6in)

At this time Van Gogh's mental health was deeply fragile and he may have taken comfort in such mundane images as this: an ordinary activity aimed at putting something right. Now Van Gogh is thoroughly his own man; any doubts he may have had about the strength, originality and power of his art are set aside and however difficult his private life might have been, his artistic life is in full flower.

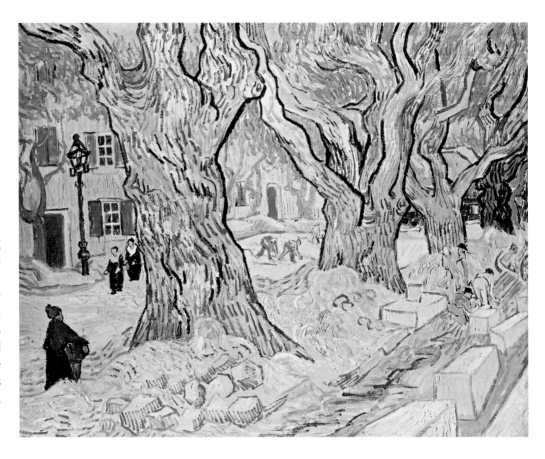

Trees in the Garden of Saint-Paul Hospital, October 1889, oil on canvas, private collection, 73 x 60cm (28.7 x 23.6in)

The swirling organic rhythms of the composition reveal the ideas that would animate the Art Nouveau movement, which became popular across Europe in the fine and decorative arts during the 1890s. The entire canvas surface is engulfed in a richly worked series of interlocking arabesques that suggest the restless energies of the natural world. The light blue that is used to describe the shadowed tree trunks is a brave and telling inspiration.

Pine Trees with Figure in the Garden of Saint-Paul Hospital, November 1889, oil on canvas, Musée d'Orsay, Paris, France, 51 x 45cm (20 x 17.7in)

There was nothing academic about Van Gogh's conception of drawing: his art is a fertile interaction between drawing and painting that becomes completely fused into one creative action, during his time in Arles and in St-Rémy. In works such as this, the visual shorthand he has developed becomes an endlessly inventive action, as each mark builds to catch the dynamic flux of life itself.

Corridor of Saint-Paul Asylum in St-Rémy, October 1889, watercolour, Metropolitan Museum of Art, New York, NY, USA

The painting powerfully conveys the heightened sense of a subjective awareness of space. A claustrophobic atmosphere is suggested by a series of diminishing shapes. Light spills through the open archways. The interior is represented by short straight strokes of the brush – outside, beyond the door, lies fear and death, inside some measure of security and hope for recuperation.

The Entrance Hall of Saint-Paul Hospital, October (or May) 1889, watercolour, Van Gogh Museum, the Netherlands

The door is open to the courtyard of the asylum; it is light-filled and welcoming – suggestive of Van Gogh's hopes for a return to health? Both this and *Corridor of Saint-Paul Asylum in St-Rémy*, above, are watercolours, a possible indicator of his nervous state – Van Gogh was unable to paint in oils when ill.

Self-portrait, September 1889, oil on canvas, Musée d'Orsay, Paris, France, 65 x 54cm (25.6 x 21.3in)

A fragile line separates the formidable opposition of the blue-green organic forms of the background and the rippling energies of Van Gogh's clothing. His steely gaze looks out from his pale-toned face, framed by his hair and beard, flecked with short decisive parallel hatchings of paint – ochres and reds, tawny yellows and yellow-greens. The highlight on his temple echoes the white-blue of his collarless shirt.

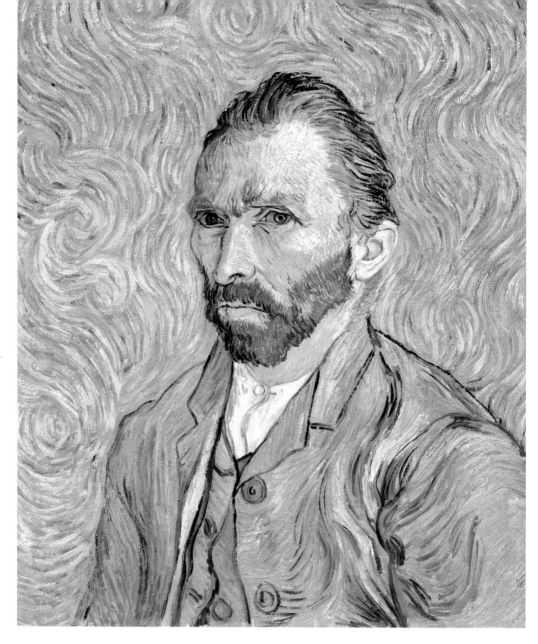

Wheat Field in Rain, November 1889, oil on canvas, Philadelphia Museum of Art, PA, USA, 74.3 x 93.1cm (29.3 x 36.7in)

Inspired by the example of Millet, Van Gogh set out to paint a series of pictures of changing weather and different landscapes around the region of St-Rémy. In this painting the rural landscape is almost obliterated by a torrential downpour of rain – perhaps indicative of the artist's psychological mood at the time.

The Mulberry Tree, October 1889, oil on canvas, Norton Simon Museum, Pasadena, CA, USA, 54 x 65cm (21.5 x 25.5in)

The exuberant colours and expressive handling evident in this painting correspond to the vigorous growth of the tree itself, and the picture perhaps represents what Van Gogh saw as the forces of health and renewal to be found in the countryside. "This is almost a lush countryside…there is so much well-being in the air."

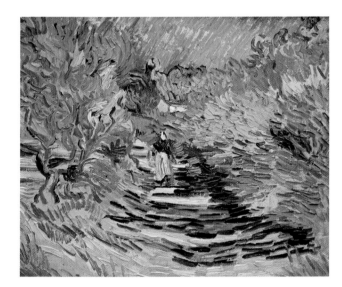

A Road at St-Rémy with Female Figure, December 1889, oil on canvas, Kasama Nichido Museum of Art, Japan, 32.2 x 40.5cm (12.5 x 16in)

In his periods of lucidity, Van Gogh worked constantly, creating dazzlingly original compositions constructed with great energy and spontaneity. In June, he was allowed to walk in the landscape beyond the asylum and, like Monet and Cézanne, he forged his own pictorial language to produce a synthesis of self, painting and his environment. People and landscape merge into one symbiotic system of mark-making, texture and coloration. These are unique works, although they owe something to late landscapes of Millet. He is painting not what is seen, but what is experienced.

Enclosed Wheat Field with Peasant, October 1889, oil on canvas, Indianapolis Museum of Art, IN, USA, 73.7 x 92.1cm (29 x 36in)

Stricken by renewed attacks, Van Gogh used his art as a means of painting his way back to some kind of equilibrium. He saw a correspondence between the life-enhancing quality of his actions and those of the peasants he was painting. Works such as these reveal the acknowledged debt he owed his predecessor Millet.

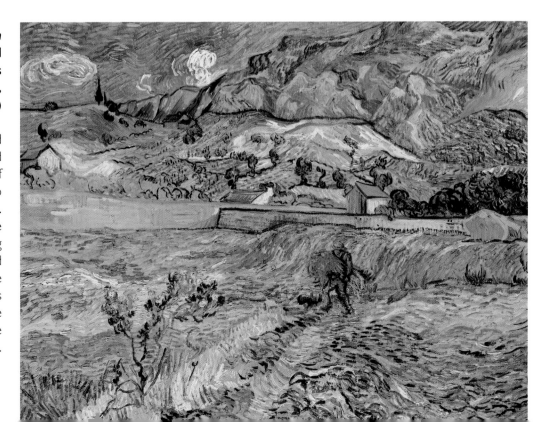

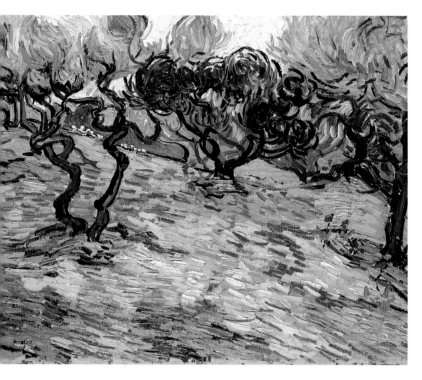

Olive Trees: Bright Blue Sky, November 1889, oil on canvas, National Gallery of Scotland, Edinburgh, Scotland, 49.2 x 62.9cm (19.5 x 25in)

During the last half of 1889 Van Gogh painted at least 15 landscapes that feature olive trees. He wrote to Theo about how he was "struggling to catch [the olive trees]. They are old silver, sometimes with more blue in them, sometimes greenish, bronzed, fading white above a soil that is yellow, pink, violet tinted orange…very difficult… it is too beautiful for us to dare to paint it or to dare to imagine it." In this painting the chaos of nature is barely kept under control – the brushmarks move tumultuously across the entire surface of the canvas, as each shape locks into its neighbour, to bring all the separate elements of the landscape into one single, emotionally charged whole. Van Gogh also explained how he was beginning to feel dissatisfied with the heavy impasto that he had been using over the last few years, relating its use to his more violent moods.

Olive Trees with Yellow Sky and Sun, November 1889, oil on canvas, Minneapolis Institute of Arts, MN, USA, 73.7 x 92.7cm (29 x 36.5in)

Van Gogh told his brother that, feeling calmer, he was looking for a new, controlled way of painting. Although inspired by the direct visual experience of the olive groves, these paintings are imbued with a transcendental quality. For Van Gogh, in his troubles, nature offered the consolation that he had previously found in religion.

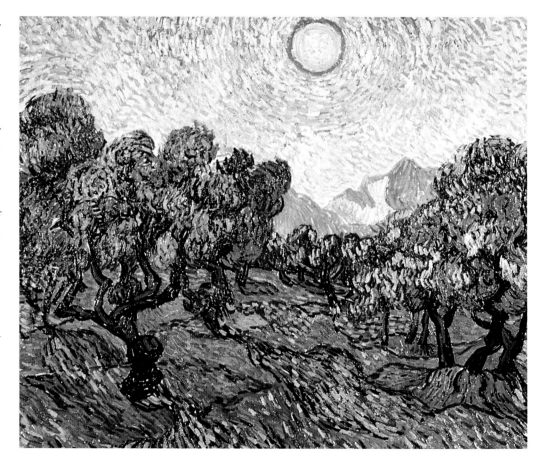

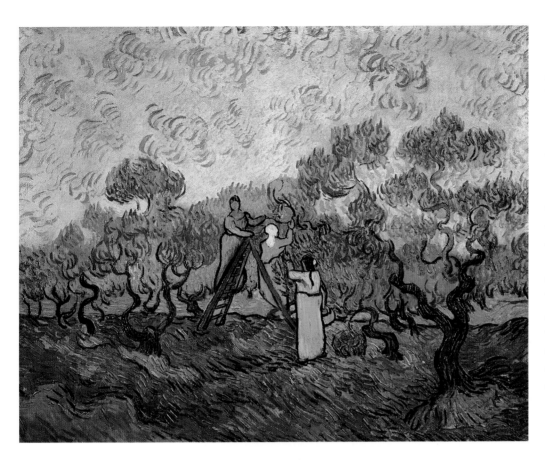

Olive Picking, December 1889, oil on canvas, Metropolitan Museum of Art, New York, NY, USA, 72.4 x 89.9cm (28.5 x 35.5in)

The theme of manual labour runs through much 19th-century avant-garde art. Van Gogh was pleased to find, just outside the asylum walls, the age-old practice of harvesting the olives from the nearby olive grove. The figures of the women are almost lost within the embracing forms of the landscape, and the entire surface of the canvas quivers with energy.

Olive Picking, December 1889, oil on canvas, National Gallery of Art, Washington, D.C., USA, 73 x 92cm (28.5 x 36.2in)

Painted from memory, the figures in this painting are imaginative representations of Van Gogh's mother and sister. The subject was one taken up by many artists at this time, including the classically inspired painter, Pierre Puvis de Chavannes, whom Van Gogh admired, as well as Renoir, Berthe Morisot and Mary Cassatt.

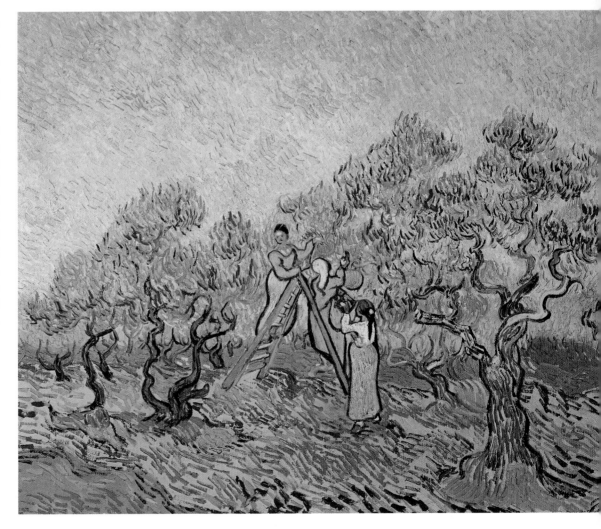

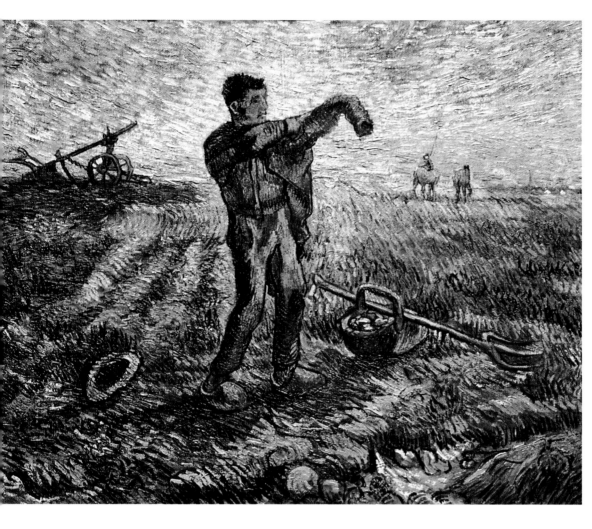

Evening: The End of the Day (after Millet), November 1889, oil on canvas, Menard Art Museum, Komaki, Japan, 72 x 94cm (28.5 x 37in)

In the autumn and winter of 1889–90, while still a voluntary patient at the hospital at St-Rémy, Van Gogh painted 21 copies after Millet's works. He thought of these not as mere technical exercises, but as interpretations, similar to how the work of a composer is given life by the activities of the musician. Van Gogh advocated painting from nature, rather than inventing a motif from the imagination, and worried that these works might be criticized as mere copies; he told his brother that they were an intelligent way, "to make the legacy of Millet more accessible for the common people".

The Sower (after Millet), October 1889, oil on canvas, private collection, 80.8 x 66cm (31.8 x 26in)

In painting this image of the sower after Millet, Van Gogh is once again returning to the past. Indeed he was never much concerned with the contemporary, but was clearly dedicated to creating images that would transcend time and place.

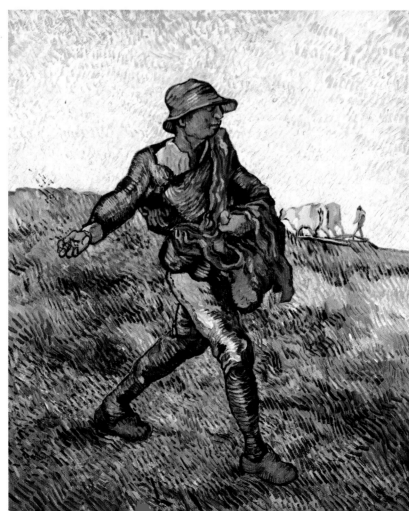

Reaper with Sickle (after Millet), September 1889, oil on canvas, Van Gogh Museum, Amsterdam, the Netherlands, 44 x 33cm (17.5 x 13in)

This picture shows further evidence of Van Gogh using his art, and that of those other artists he admired, to express his darker thoughts. It is an image associated with life and death and is taken from a painting by Millet. Van Gogh saw it as "an image of death as the great book of nature speaks of it."

Evening: The Watch (after Millet), October 1889, oil on canvas, Van Gogh Museum, Amsterdam, the Netherlands, 74.5 x 93.5cm (29.3 x 36.8in)

A scene of domestic tranquillity, taken from a print of one of Millet's paintings. It could almost be a Rembrandt. The lamplight illuminates the baby and the concentrated activity of its parents. The circular brushmarks that describe the radiating light in yellow striations merge imperceptibly with the horizontal and vertical lines that dominate the rest of the composition. It is an image of hope and comfort painted when Van Gogh was in a dark place.

Two Peasants Digging (after Millet), October 1889, oil on canvas, Stedelijk Museum, Amsterdam, the Netherlands, 72 x 92cm (28.5 x 36in)

This is one of many images by Millet that Van Gogh took up at this time. The monochrome nature of the original prints allowed Van Gogh to give full range to his colouristic imagination. Van Gogh's paintings are never copies; he explained his role as being like a composer sitting at the piano to improvise around the work of a fellow musician.

Noon: Rest from Work (after Millet), January 1890, oil on canvas, Musée d'Orsay, Paris, France, 73 x 91cm (28.5 x 36in)

Van Gogh knew Millet's *Four Hours of the Day* images all his professional life and spent much time making free interpretations of them. In the heat of the noonday sun, a young couple rest contentedly after a hard morning's work. Everything in this picture suggests peace, tranquillity and companionship.

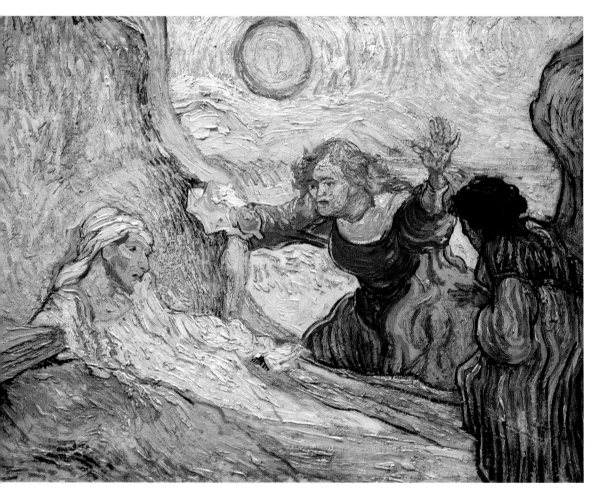

The Raising of Lazarus (after Rembrandt), May 1890, oil on paper, Van Gogh Museum, Amsterdam, the Netherlands, 50 x 60cm (19.5 x 23.5in)

Van Gogh's interest in Rembrandt was a constant throughout his life. When he visited the newly opened Rijksmuseum in 1885, he declared that he would willingly have given 10 years of his life to have been able to sit for 14 days in front of *The Jewish Bride* "with barely a crust of dry bread to eat". Van Gogh memorably wrote that Rembrandt was an artist whose work was able to say things "for which no words exist in any language".

Half Figure of an Angel (after Rembrandt), September 1889, oil on canvas, private collection, 54 x 64cm (21.5 x 25in)

This image is something of an oddity in Van Gogh's surviving oeuvre. He had attempted to paint something similar before Gauguin's arrival, but declaring it a failure he erased it. This painting is like an apocalyptic or ecstatic vision, as if, like in the story of St Paul, an angel had burst into Van Gogh's confinement to take him to some other place.

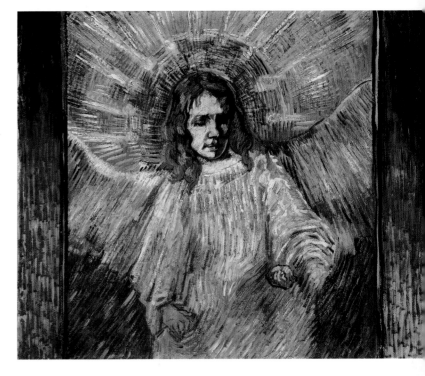

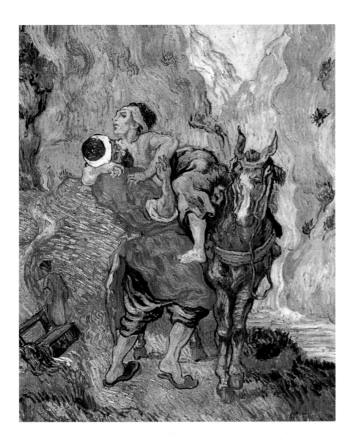

The Good Samaritan (after Delacroix), May 1890, oil on canvas, Kröller-Müller Museum, Otterlo, the Netherlands, 73 x 60cm (28.7 x 23.6in)

"Now that I am ill I am trying to create something that will soothe me and bring pleasure to me personally." Isolated and starved of visual excitement, Van Gogh began to reinterpret his favourite images from his collection of prints. His reinterpretation of Delacroix's painting had a deep resonance for his own position, which was dependent upon the kindness and professional care of so many people.

The Pietà (after Delacroix), September 1889, oil on canvas, Van Gogh Museum, Amsterdam, the Netherlands, 73 x 60.5cm (28.5 x 24in)

Van Gogh admired Delacroix's uniting of expressive colour and draughtsmanship to create a convincing spiritual art. While he was confined to St Paul's, Van Gogh spent time painting versions of some of his most treasured images. All of them relate directly to his hopes, desires and anxieties. Here, the Virgin Mary supports the dead Christ who carries the features of the artist himself.

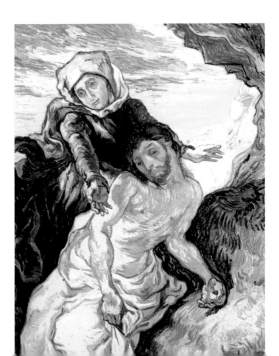

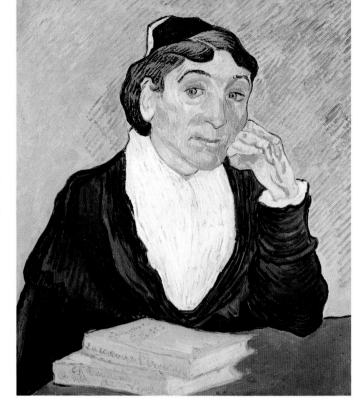

L'Arlésienne (Madame Ginoux), February 1890, oil on canvas, Museu de Arte de São Paulo, Brazil, 65 x 54cm (25.6 x 21.3in)

One of four versions of this portrait. Van Gogh painted these pictures of Marie Ginoux as he recuperated in the asylum at St-Rémy.

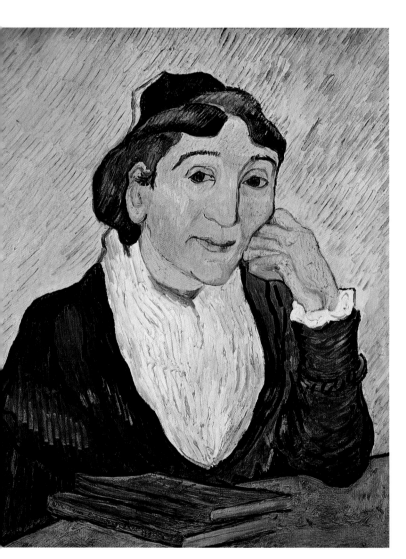

L'Arlésienne (Madame Ginoux), February 1890, oil on canvas, Galleria Nazionale d'Arte Moderna, Rome, Italy, 60 x 50cm, (23.6 x 19.7in)

Van Gogh wanted to make a visit to Madame Ginoux, who was unwell.

He wished to present her with one of the four portraits he had painted of her in the asylum from a drawing by Gauguin, done in November 1888. En route to Arles he fell ill himself and was taken back to the asylum.

L'Arlésienne (Madame Ginoux), February 1890, oil on canvas, private collection, 66 x 54cm (30 x 21.3in)

In May 2006, this version of Van Gogh's portrait of Madame Ginoux sold at auction in New York for over $40 million.

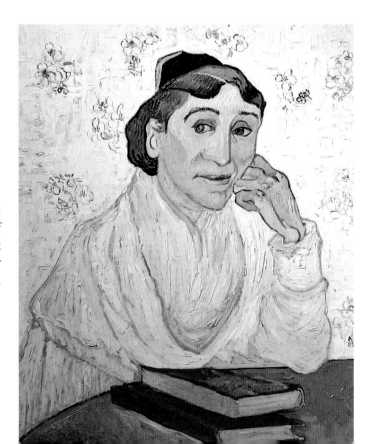

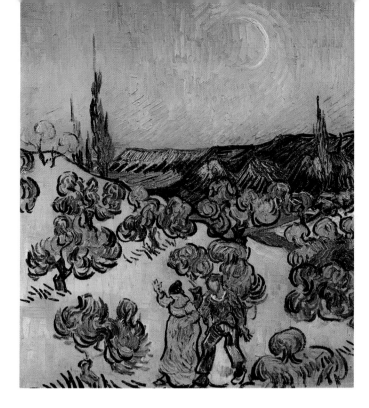

Landscape with Couple Walking and Crescent Moon, May 1890, oil on canvas, Museu de Arte de São Paolo, Brazil, 49.5 x 45.5cm (19.5 x 18in)

Van Gogh's desire to make something more of Impressionism was shared by many artists in the 1890s. Even Monet and Degas, arch Realists, wanted at this time to bring a certain mystery and enigma back into their work. This painting shows a landscape transfigured by the human imagination.

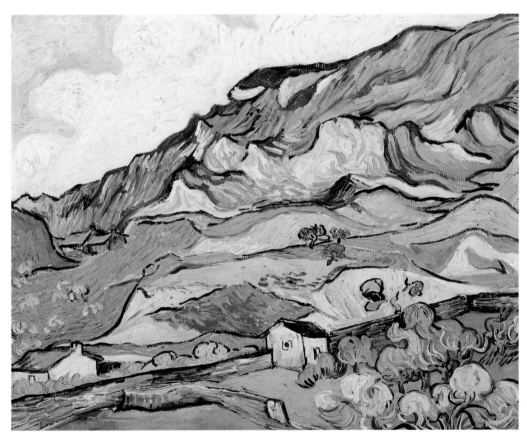

Les Alpilles, Mountainous Landscape near St-Rémy, May–June 1889, oil on canvas, Kröller-Müller Museum, Otterlo, the Netherlands, 59 x 72cm (23 x 28.5in)

The Alpilles is an extraordinary low-lying range of mountains that abuts the fields and olive groves around St-Rémy. Close by are the magnificent remains of a Roman settlement. Typically, Van Gogh chose to ignore the monuments of man and painted instead the architecture of nature. The forms of these limestone mountains are often strange and bizarre.

Meadow in the Garden of Saint-Paul Hospital, May 1890, oil on canvas, National Gallery, London, UK, 64.5 x 81cm (25.5 x 32in)

Although short of money and concerned about his brother, Van Gogh was working as ever with a furious passion. It is hard not to read some reference to the fragility of human experience in this image of a landscape with butterflies. Theo's new son suffered from poor health and the ephemeral nature of a butterfly's life might reflect this.

Roses and Beetle, April–May 1890, oil on canvas, Van Gogh Museum, Amsterdam, the Netherlands, 33.5 x 24.5cm (13.2 x 9in)

Always a lover of the minutiae of nature as well as its vastness, his seclusion in the psychiatric hospital gave him the opportunity to recover from bouts of illness by painting. Unable to go out into the landscape, he painted a number of extraordinary still lifes. The presence of the beetle recalls such details often found in Dutch 17th-century still lifes.

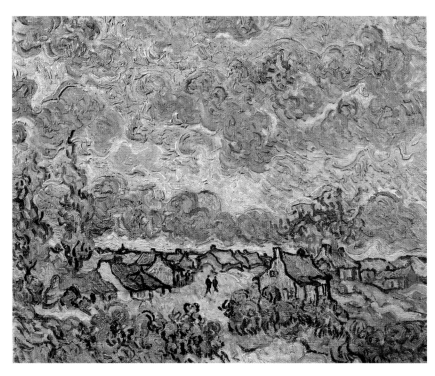

Cottages and Cypresses: Reminiscence of the North, March–April 1890, oil on canvas, Van Gogh Museum, Amsterdam, the Netherlands, 29 x 36.5cm (11.5 x 14.5in)

A few months before his death Van Gogh wrote, "I love art very much indeed." In paintings such as this one, Van Gogh's imaginative powers have taken flight; as in the last paintings of Millet, the boundaries that close in the world and keep things separate seem to dissolve, leading to an almost transcendental experience.

Old Man in Sorrow (On the Threshold of Eternity), April–May 1890, oil on canvas, Kröller-Müller Museum, Otterlo, the Netherlands, 81 x 65cm (32 x 25.5in)

Here Van Gogh has taken up an image that he had first created earlier in his career. In it we find the familiar repertoire of simple cottage furniture, an empty fireplace and an old man in despair. This work, more than any other, reminds us that, although Van Gogh enjoyed periods of good health, he was becoming increasingly aware that the nature of his seizures was recurrent and that he could find consolation for his condition only through his art.

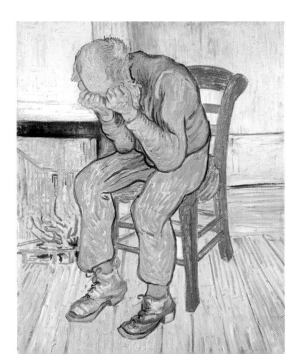

Still Life: Vase with Irises against a Yellow Background, May 1890, oil on canvas, Van Gogh Museum, Amsterdam, the Netherlands, 92 x 73.5cm (36 x 29in)

In this energetic portrayal of flowers, Van Gogh has closed in on a small corner of cultivated nature, but the energies he captures are reminiscent of those of Jackson Pollock painting in the latter part of the 20th century. His painting is fast but sure and the drawing is incisive, decorative and energetic. He called painting "the lightning conductor for my illness". The use of the yellow and ochre background to highlight the blue of the flowers and green of the spear-sharp leaves is a brilliant formal invention. French art critic Octave Mirbeau, one of Van Gogh's earliest supporters, and who owned the large *Irises*, wrote of Van Gogh: "How well he has understood the exquisite nature of flowers!"

Still Life: Pink Roses in a Vase, May 1890, oil on canvas, The Metropolitan Museum of Art, New York, NY, USA, 92.6 x 73.7cm (36.5 x 29in)

For Van Gogh flowers were joyous and life-affirming. They bloomed "riotously" and were "continually renewing" themselves. Here a profusion of white roses is set against a green background. It was part of a group of four still lifes – two of irises and two of roses – that Van Gogh completed shortly before he left the asylum at St-Rémy in 1890. It has recently been discovered that this painting was originally very different. The background colour was a deep resonant red, but unfortunately, over time, the pigment has faded and what we see today is a pale shadow of its original splendour. We can perhaps put some of the blame for this at the feet of Père Tanguy, for in Van Gogh's correspondence there is an extended complaint against the quality and expense of some of his colours.

AUVERS-SUR-OISE

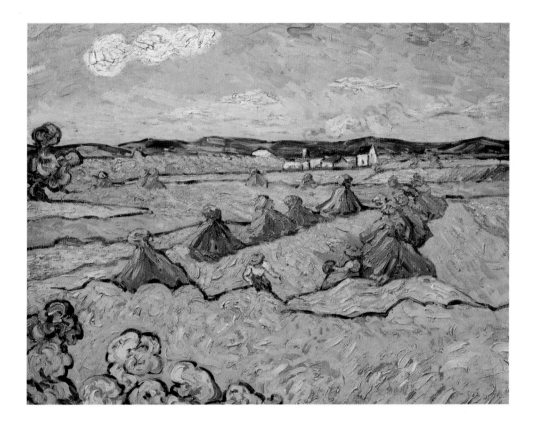

Van Gogh arrived in the village of Auvers-sur-Oise, near Paris, in May 1890, taking lodgings at the modest inn owned by the Ravoux family. The inn was well-known to artists throughout the 19th century; the painter Daubigny had previously lived there, as well as Cézanne, Pissarro and Corot. In a period of less than three months, Van Gogh produced an astonishing amount of work, under the care of Dr Gachet, a friend of Cézanne and the Impressionists. He died of a self-inflicted gunshot wound on 27 July 1890. Reportedly, his last words were: *"La tristesse durera toujours"* ("the sadness will last forever").

Above: Wheat Fields with Stacks with Reaper, *1890. Left:* The Church at Auvers, *June 1890. Out of a simple local church Van Gogh has made an image of transcendent power; the atmosphere is brooding and troubled, the architecture of the church seems to buckle and break, its forms barely contained by the picture's composition.*

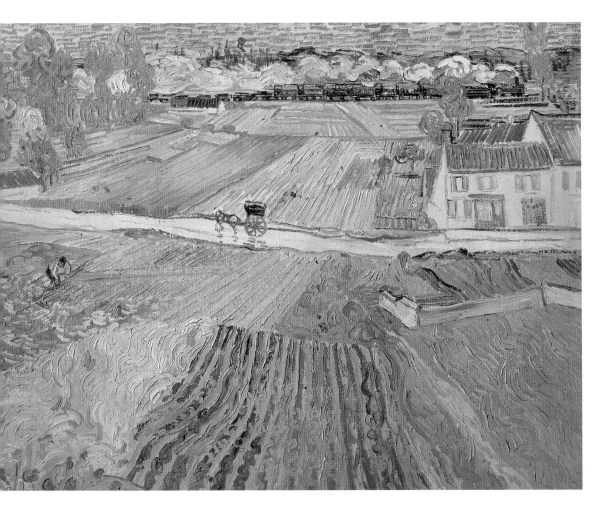

Landscape with Carriage and Train in the Background, June 1890, oil on canvas, Pushkin Museum, Moscow, Russia, 72 x 90cm (28.5 x 35.5in)

Many of Van Gogh's canvases of this period are eager responses to the changeability of northern weather. He loved Auvers, thinking it "very beautiful", and he appreciated the familiar feature of thatched roofs and its picturesque charm. The composition is enlivened by a telling contrast between the horse-drawn carriage and the speeding train.

Blossoming Chestnut Branches, May 1890, oil on canvas, Bührle Collection, Zurich, Switzerland, 72 x 91cm (28.3 x 36in)

This powerfully realized study excludes everything except the vigorous tracery and delicate flowers of the chestnut tree. As he had done on his arrival in Arles, Van Gogh is painting signs of new growth – the beginning of a new cycle of life. It is one of the first paintings completed after his arrival in Auvers.

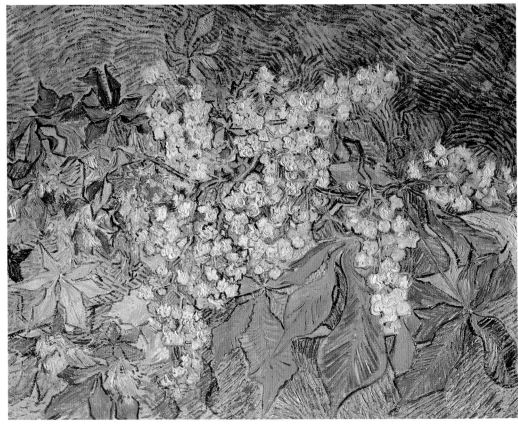

Plain near Auvers, July 1890, oil on canvas, Neue Pinakothek, Munich, Germany, 73.5 x 92cm (29 x 36in)

During the last few months at St-Rémy, Van Gogh was sustained by his desire to return to the North. Incapacitated for two months and now in relative health, he was determined to make use of what he had learned in the South. In Auvers, he could be cared for and paint in a landscape familiar to some of the most famous names of 19th-century French landscape painting.

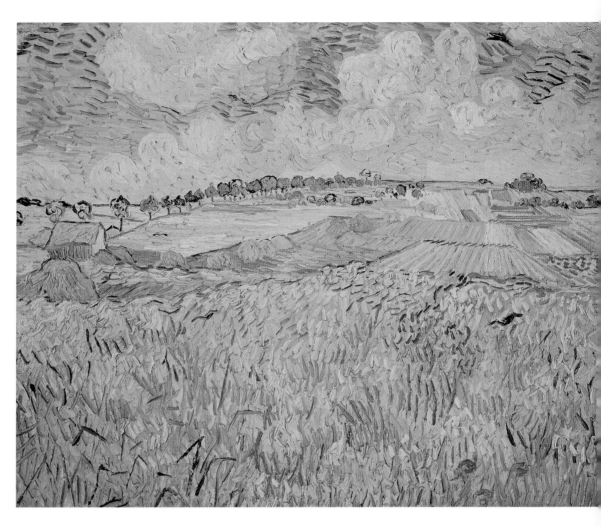

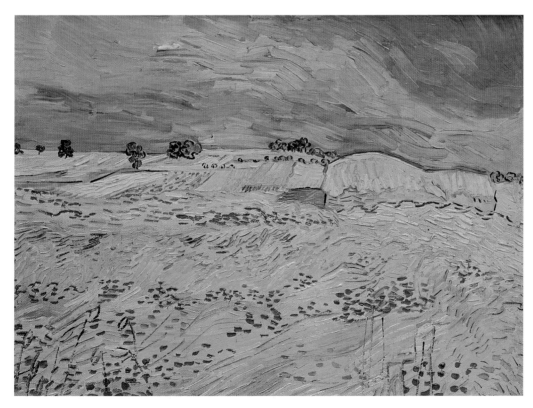

The Fields, July 1890, oil on canvas, private collection, 50 x 65cm (19.5 x 25.5in)

The local landscape was unspoilt by modern developments and Van Gogh looked forward to what he thought would be a period of prolonged artistic activity close to his brother and his fellow professionals in Paris. Once again, the new landscape reminded Van Gogh of the landscapes of Holland. He welds his radical coloration and dynamic draughtsmanship to a deep sympathy with the topographic school of Dutch landscape painting.

Doctor Gachet's Garden in Auvers, May 1890, oil on canvas, Musée d'Orsay, Paris, France, 73 x 52cm (28.5 x 20.5in)

This is another of the first canvases painted by Van Gogh after his arrival in Auvers. Dr Paul Gachet's house was perched on a steep terrace high above the Oise Valley and the garden accordingly consisted of small terraced areas. Van Gogh has taken advantage of this fact to give himself a high vantage point from which to do justice to the vigorous growth of the garden.

Thatched Cottages, May 1890, oil on canvas, Hermitage State Museum, St Petersburg, Russia, 60 x 73cm (23.5 x 28.5in)

Van Gogh took up the theme of painting the houses and cottages of Auvers. These are not picturesque representations of peasant life, but portraits of domiciles, places of home and security. Throughout his career Van Gogh considered houses as symbolic of the human condition, both in general and specific ways.

Village Street in Auvers, May 1890, oil on canvas, Ateneum Art Museum, Helsinki, Finland, 73 x 92cm (28.5 x 36in)

These paintings give the impression of rapid improvisation. The major components of the composition are noted down in a single fluid line of paint, cutting toward the centre of the canvas and opening out again into the sky – empty except for an open mosaic work of oblong swatches of blue, each one the result of a separate twist of the wrist.

Ears of Wheat, June 1890, oil on canvas, Van Gogh Museum, Amsterdam, the Netherlands, 64.5 x 48.5cm (25.5 x 19in)

Van Gogh used this study as the backdrop for one of his portraits of the time. In a letter to Gauguin he wrote how he hoped the painting would be evocative of the "soft rustle of ears of grain swaying back and forth in the wind".

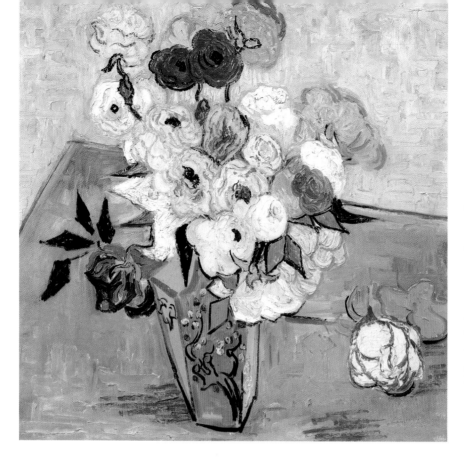

The high viewpoint of this painting brings out the decorative effect of this rather flamboyant collection of simple flowers. The reddish-pink table top is artfully tilted to give background colour to the two blooms, lilac and light pink, that break free from the main group.

Van Gogh exults in the sculptural spikiness of these wild flowers: "At the moment I am working on a bunch of wild plants, ears of wheat, and sprays of different kinds of leaves – the one almost red, the other bright green, the third turning yellow…"

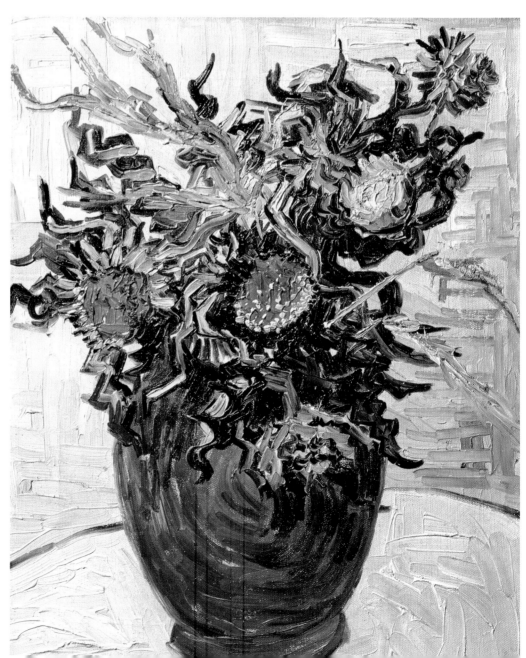

Vase with Rose-mallows, June 1890, oil on canvas, Van Gogh Museum, Amsterdam, the Netherlands, 42 x 29cm (16.5 x 11.5in)

Emphatic broken contour lines containing separate areas of simple colour worked into a richly encrusted paint surface would become the hallmark of the young Picasso. On his arrival in Paris in 1900, the Spanish artist took Van Gogh as one of his artistic models.

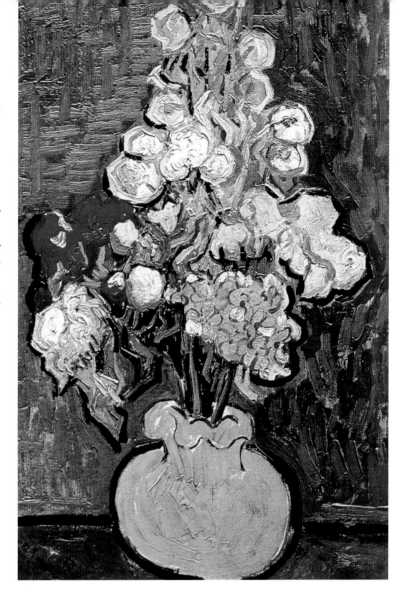

Wild Flowers and Thistles in a Vase, June 1890, oil on canvas, private collection, 67 x 47cm (26.4 x 18.5in)

Finding himself in new surroundings, Van Gogh makes use of the still life to consolidate his discoveries of the last few years, in order to use them on more ambitious subjects. This is a constant in Van Gogh's artistic procedures and resulted in some of his most attractive canvases. This is a fresh and vigorous study of wild flowers, in which strong calligraphic marks describe the complexity of their forms, while simple contained areas of pure colour celebrate the splendour of these everyday blooms.

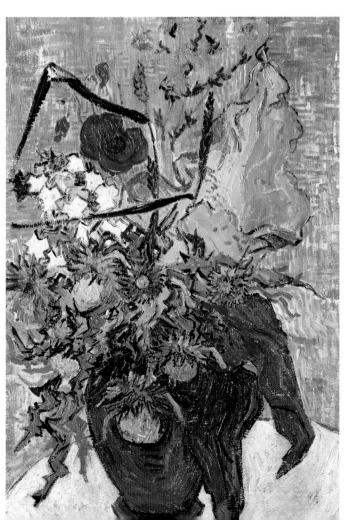

Young Peasant Woman with Straw Hat Sitting in the Wheat, June 1890, oil on canvas, private collection, 92 x 73cm (36 x 28.5in)

This portrait reveals Van Gogh's interest in painting types, symbols of humanity as well as individuals. This young girl is the very embodiment of rude health, set against the strong verticals of the corn; her face is ruddy from the effects of the sun – her cheeks are almost as red as the resplendent poppies behind her.

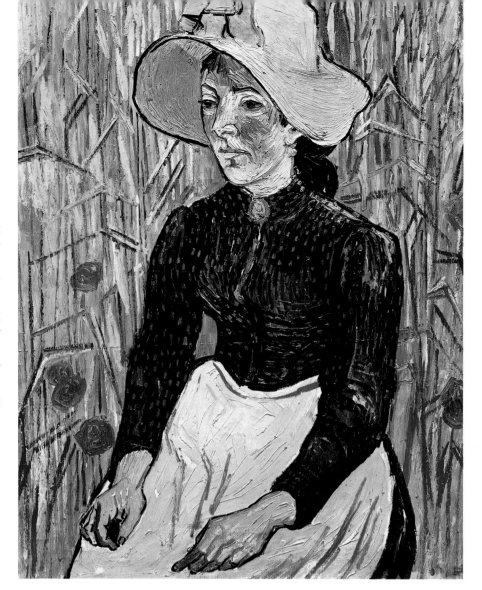

Blossoming Acacia Branches, June 1890, oil on canvas, Nationalmuseum, Stockholm, Sweden, 32.5 x 24cm (13 x 9.5in)

Painted at high speed, the freedom of handling and cropped composition of this painting recalls the immediacy and 'rightness' of Chinese old master landscape paintings. Around 76 canvases survive from the last two months of Van Gogh's life; many of the paintings have the quality of painted sketches rather than fully resolved works.

Portrait of Doctor Gachet: L'Homme à la Pipe, May 1890, etching, Bibliothèque Nationale, Paris, France, 18 x 14.7cm (7 x 6in)

Dr Gachet was an enthusiastic amateur etcher and this print was made under his supervision. It shows the doctor himself, pipe in hand, with the same melancholic expression we find in the painted portraits. This was to be Van Gogh's only foray into etching and in it we see the vigour of his drawing undiminished.

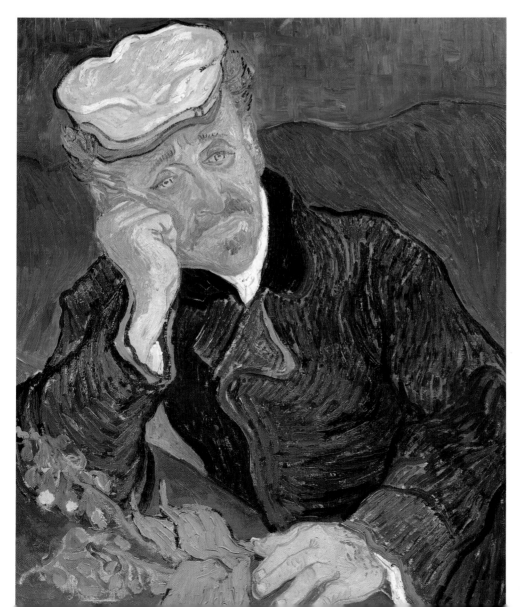

Portrait of Doctor Gachet, June 1890, oil on canvas, Musée d'Orsay, Paris, France, 68 x 57cm (27 x 22.5in)

Van Gogh became friendly with the enigmatic Dr Gachet, a man who, like Van Gogh himself, suffered from melancholy. The artist was struck by the irony that a doctor, suffering from a heart condition, could not, for all his training, bring himself back to health. In his hand he holds a foxglove, which is often associated with heart trouble, as a traditional herbal treatment. The doctor's melancholy is evident in his pose, his furrowed brow and the overall blue coloration of the composition. Even the wallpaper takes on the sombre mood of the painting, the single wavy line suggesting the all-enveloping nature of his sickness.

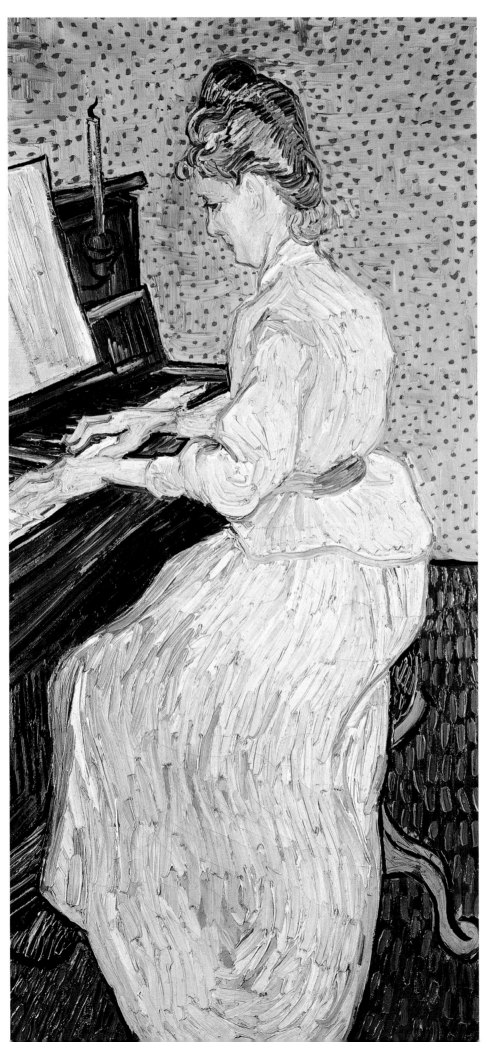

Marguerite Gachet at the Piano, June 1890, oil on canvas, Kunstmuseum, Basel, Switzerland, 102.6 x 50cm (40.5 x 19.5in)

Possibly inspired by a painting by Toulouse-Lautrec, this vertical canvas reminds us that the 1890s was the decade of Art Nouveau. By painting Dr Gachet's daughter at the piano, Van Gogh is asking us to consider the canvas as a piece of visual music. This is not painting as description, but painting as evocation. The strong, slabby marks of green set against the red of the floor are transformed into red dots on a green background and the angular shape of the piano is contrasted with the flowing forms of Mlle Gachet herself.

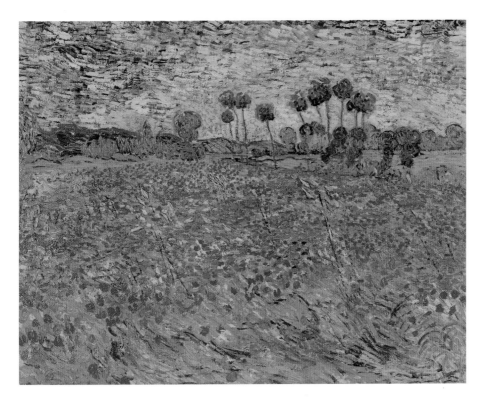

Field with Poppies,
June 1890, oil on canvas,
Gemeentemuseum, The
Hague, the Netherlands,
73 x 91.5cm (28.5 x 36in)

Van Gogh's unerring and
original sense of design is
strongly evident in these late
canvases, where the colour
values are subtle, even
subdued, compared to his
early work. The changeability
of the weather is masterfully
evoked and the simple
colour contrasts are brought
into harmony by the lyrical
sweep of his brushwork.

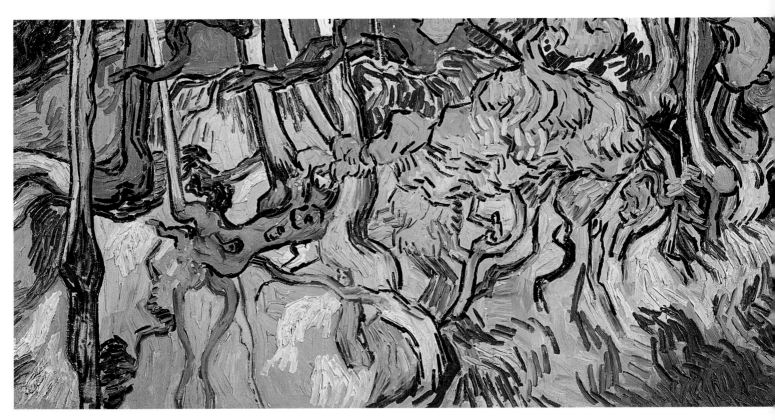

Tree Roots and Trunks, July
1890, oil on canvas, Van
Gogh Museum,
Amsterdam, the
Netherlands, 50 x 100cm
(19.5 x 39.5in)

Van Gogh produced an
extraordinary amount
of work at this time,
ceaselessly experimenting
with new ways to represent
experience. Here we are
presented with a close-up,
decontextualized view of
the forceful growth of
some tree roots. There is
no human interest and no
horizon. The broadly
painted areas of a few
simple colours bring this
image close to the
boundaries of abstraction.

Memories of his early
childhood, spent wandering
the countryside of the
Brabant, are laid out here
on the double-square format
favoured by Daubigny,
one of the painters of the
Barbizon school.

Thatched Sandstone Cottages in Chaponval, July 1890, oil on canvas, Kunsthaus Zürich, Switzerland, 65 x 81cm (25.5 x 32in)

In this series of paintings dedicated to cottages and houses, Van Gogh reveals his mastery of making simple, accessible images of great resonant power. For him, especially during his earlier Nuenen period, his images of the domicile are firmly associated with his personal situation – the tensions within his immediate family. Perhaps now that his brother had a new baby these apparently cosy images are, in fact, signs of his own exclusion from domestic fulfilment?

Thatched Cottages at Cordeville, June 1890, oil on canvas, Musée d'Orsay, Paris, France, 72.0 x 91.0cm (28.5 x 36in)

These cottages are embedded into the very substance of the hillside; in Frank Herbert's science fiction novel, *Dune* (1965) this painting is imagined as one of the few objects to survive Earth's destruction. "Remind me, Vincent," writes Herbert, "of where I came from and what I yet may do." Rich arabesques echo the style of the emerging Art Nouveau, the celebration of the movement and energy of the organic.

Cows (after Jordaens),
July 1890, oil on canvas,
Musée des Beaux-Arts,
Lille, France, 55 x 65cm
(21.7 x 25.6)

A memory of Holland
– a homage to the
17th-century painters of
cattle such as Aelbert Cuyp
(1620–91) and, above all,
Paulus Potter (1625–54),
whose famous painting of
The Bull (c.1647) Van Gogh
knew well. However, here
the influence of Japanese
prints has allowed him
to create a startlingly
original composition.

Two Children, June 1890, oil
on canvas, Musée d'Orsay,
Paris, France, 51.2 x 51cm
(20.2 x 20.1in)

Van Gogh's time in Auvers
seems to have been a
time of optimism and
excitement. He would stop
people and ask to paint
their portraits. Deliberately
crude, the portraits echo
the earthy directness of the
novels by Zola that he
admired so much.

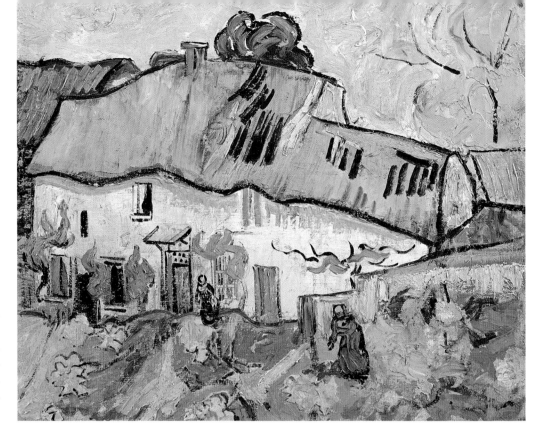

Farmhouse with Two Figures, May–June 1890, oil on canvas, Van Gogh Museum, Amsterdam, the Netherlands, 38 x 45cm (15 x 17.7in)

Van Gogh seems to have delighted in painting the local communities around Auvers and many of his canvases, particularly those painted in June, a month before he died, are suggestive of domestic tranquillity. He paints children, farm animals and the environs of the village. Alongside these pictures, however, are those which suggest a darker agenda at work.

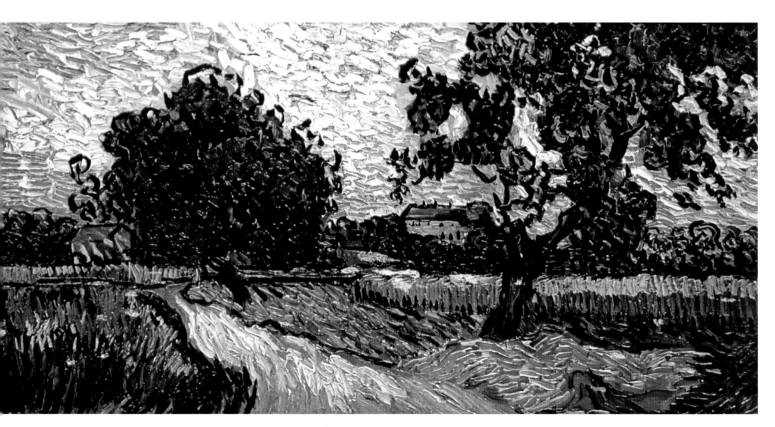

Landscape with the Château of Auvers at Sunset, June 1890, oil on canvas, Van Gogh Museum, Amsterdam, the Netherlands, 50 x 101cm (19.5 x 40in)

The dilapidated château was built in the 17th century. Van Gogh shows it, small, insignificant even, bathed in an evening light, the two pear trees, "quite black against a yellowing sky". It is a chromatically vibrant painting, comprised of large chunky brushmarks. Once again, the familiar forking path moves urgently into the painting, only to disappear into a sharp point, cut by the low horizon.

Houses in Auvers, May 1890, oil on canvas, Museum of Fine Arts, Boston, MA, USA, 72 x 60.5cm (28.3 x 23.8in)

Throughout his later life, Van Gogh thought of his art as a form of secular religion. He longed to make an art that would be accessible to the widest number of people and act as an evangelical tool to bring delight and consolation into the world.

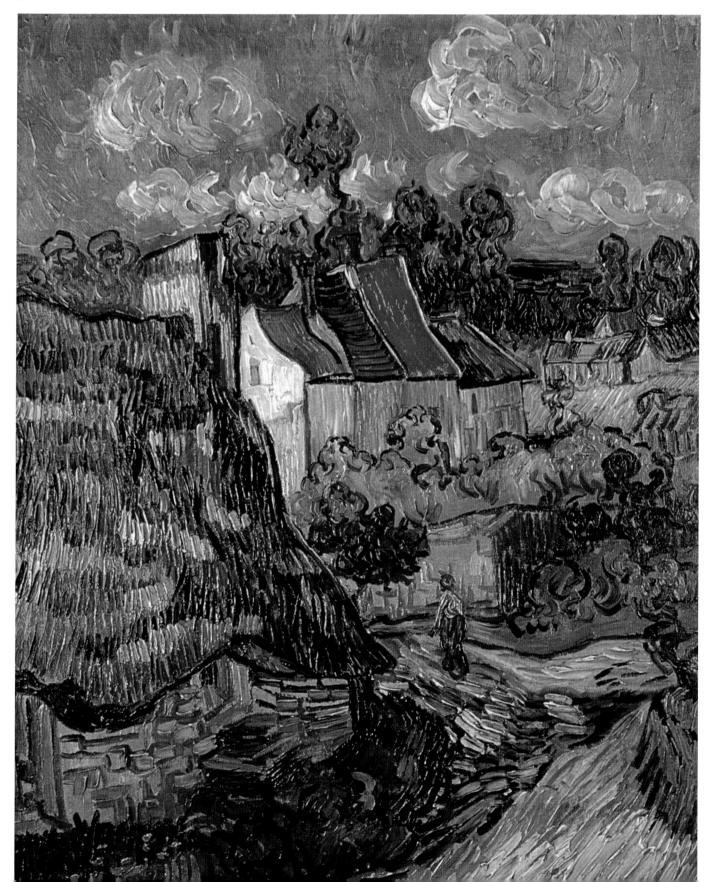

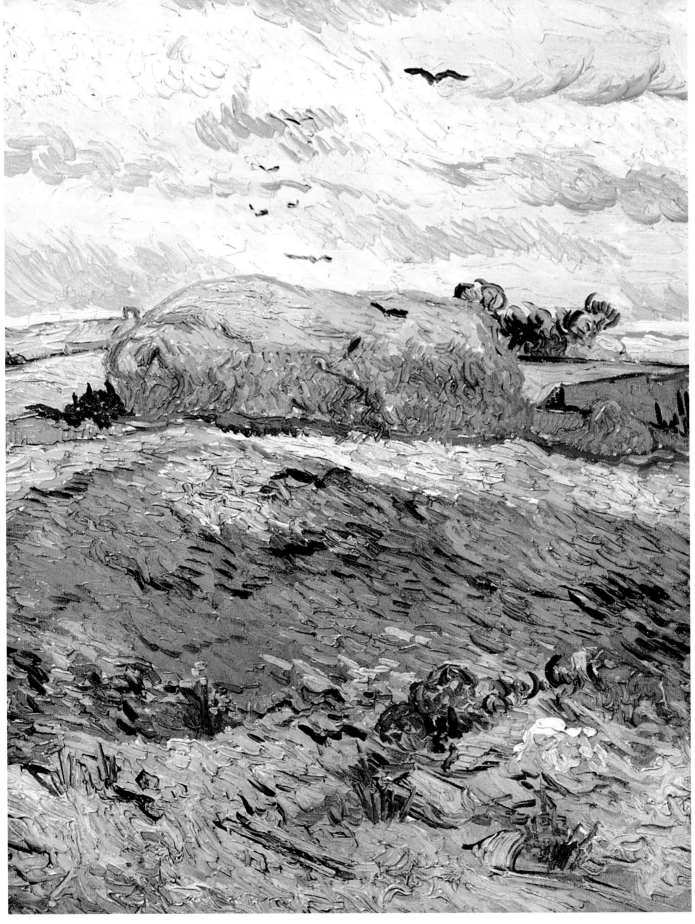

Haystacks under a Rainy Sky,
July 1890, oil on canvas,
Kröller-Müller Museum,
Otterlo, the Netherlands,
64 x 52.5cm (25.2 x 20.7in)

Painted in the last few weeks of his life, this image of harvest suggests a buoyant, optimistic mood. But the variegated strokes of blue that move across the lower half of the field might presage the onset of a change in the weather, or perhaps in the emotional language of the painting. The black staccato notes of the birds embellish the large masses of the composition, almost as if strokes of paint were removing themselves from the canvas and flying free.

Marguerite Gachet in the Garden, June 1890, oil on canvas, Musée d'Orsay, Paris, France, 46 x 55cm (18 x 21.5in)

Dr Gachet's house was some distance from Van Gogh's lodgings in the centre of the town and in this painting he celebrates the friendship and warmth he found within the household. In the background of the garden four large cypress bushes make their presence felt. The white-dressed Marguerite in her yellow sunhat, passing her time in a suburban garden, becomes transformed into a latter-day incarnation of the white-robbed goddesses and chaste maidens of Pierre Puvis de Chavannes.

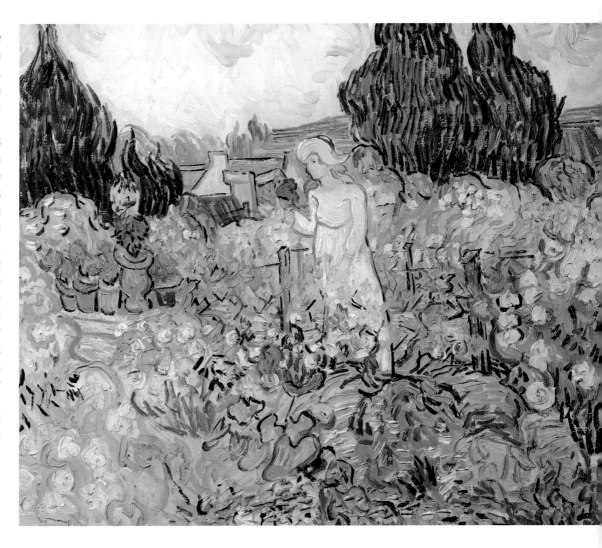

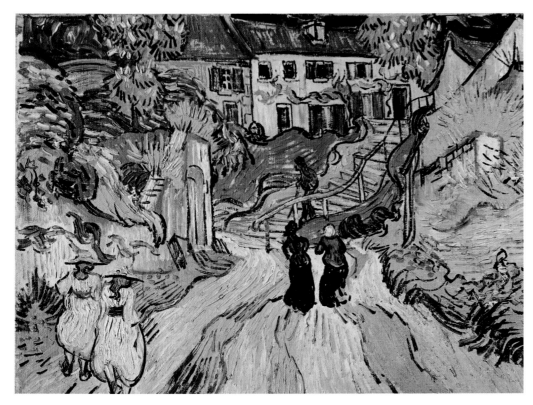

Village Street and Steps in Auvers with Figures, May 1890, oil on canvas, St Louis Art Museum, MO, USA, 49.8 x 70.1cm (19.5 x 27.5in)

One of Van Gogh's very last paintings; the colours and brushmarks are barely contained within the composition, with its wild, exaggerated lines suggesting energies that give form to experience. The effect of the figures set against the converging lines, twisting as they move to the central point of the canvas, is overwhelming.

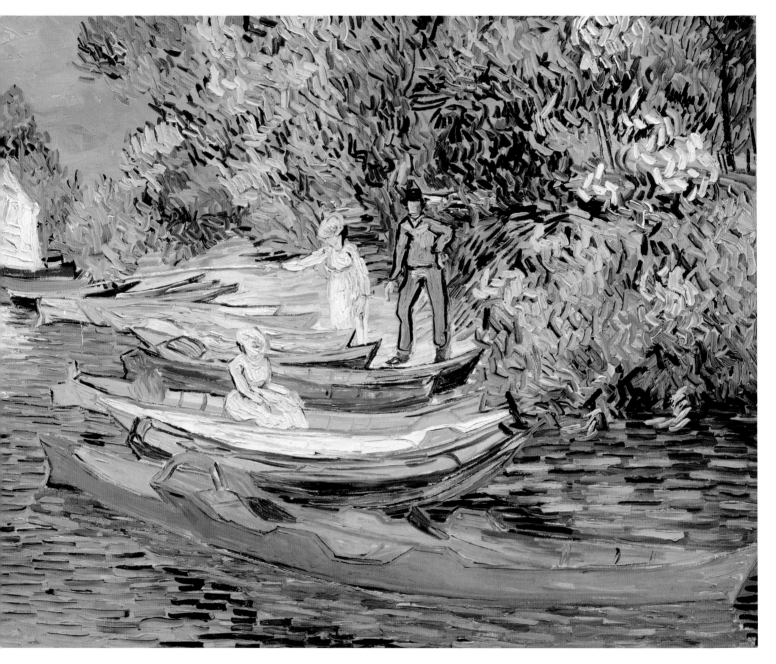

Bank of the Oise at Auvers,
July 1890, oil on canvas,
The Detroit Institute of
Arts, IL, USA, 73.3 x
93.7cm (29 x 37in)

A vibrant harmony of
blues and greens enlivened
by broad passages of
ochre, red and blue, this
painting looks back
to the Impressionist
experiments of the 1870s,
which tried to capture the
ephemeral nature of light
itself. Van Gogh is not
concerned with capturing
a specific time of day, but
in creating an analogy for
experience itself.

Landscape at Auvers in the Rain, July 1890, oil on canvas, National Museum and Gallery of Wales, Cardiff, Wales, 50 x 100cm (20 x 39.5in)

In this extraordinary painting a solitary crow battles its way through a rainy landscape. A series of diagonal, broken blue lines form a veil that partially obscures the distant town, which is hedged between the muted ochres of the corn fields. The colours are subdued mid-tones and the forms of the town are obscured by the trees.

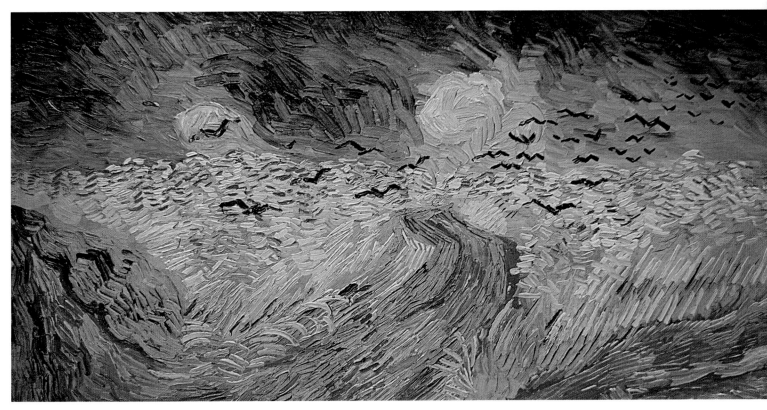

Wheat Field with Crows, July 1890, oil on canvas, Van Gogh Museum, Amsterdam, the Netherlands, 50.5 x 103cm (20 x 40.5in)

The famous film of Van Gogh's life, *Lust for Life*, suggests that this painting was his last work, but this is not the case. His last painting was probably one he made of Daubigny's garden. Here he shows the wheat fields to the north of Auvers, the dark sky and the scattering of crows suggesting a change of weather. There is no peace, no stability, no sense of the friendly, fecund face of nature, but instead an image of fierce, unbridled energy that seems to leave no space for man. Three paths break out from the bottom of the painting, cutting the wheat field into segments. Van Gogh wrote: "About such paintings, I consciously tried to express sadness and extreme loneliness in them."

INDEX